P9-DSZ-545

THE SPLENDOR OF DRESDEN

The exhibition is being made possible through a grant from the International Business Machines Corporation, with additional funding from the Robert Wood Johnson Jr. Charitable Trust, the National Endowment for the Arts, and the National Endowment for the Humanities. This exhibition is also supported by a federal indemnity from the Federal Council on the Arts and the Humanities.

The Splendor of Dresden:
Five Centuries of Art Collecting

An Exhibition from the State Art Collections
of Dresden, German Democratic Republic

National Gallery of Art, Washington

June 1—September 4, 1978

The Metropolitan Museum of Art, New York

October 21, 1978—January 13, 1979

**The Fine Arts Museums of San Francisco
California Palace of The Legion of Honor**

February 18—May 26, 1979

ON COVER:

Detail of *Dresden from the Right Bank of the Elbe,*
by Bernardo Bellotto, 1748

Publication designed by Peter Oldenburg
Composition by Wrightson Typographers, Newton, Massachusetts
Printed by Eastern Press, New Haven, Connecticut

Copyright © 1978 The Metropolitan Museum of Art
German text © by State Art Collections of Dresden
Second printing, with additions and corrections, 1979

LIBRARY OF CONGRESS CATALOGING IN PUBLICATION DATA

Main entry under title:

The Splendor of Dresden.

 Bibliography: p.
 1. Art—Exhibitions. 2. Dresden. Staatliche Kunstsammlungen—
Exhibitions. I. United States. National Gallery of Art. II. New
York (City). Metropolitan Museum of Art. III. Fine Arts Museums
of San Francisco.

N5020.W52N378 707'.4'013 78-6542
ISBN 0-87099-177-9

Hardcover edition distributed by George Braziller, New York
ISBN 0-8076-0901-3

Statement by

HANS-JOACHIM HOFFMANN

Minister for Culture, G.D.R.

The development of cultural relations between nations and the mutual desire to get acquainted among those who have pledged their art and culture to humanism are of foremost importance in the striving of all peace-loving and democratic forces of the world for the relaxation of tensions, for peace and security. This exhibition by the Staatliche Kunstsammlungen Dresden, composed of outstanding masterpieces from nearly all of its museums, is to be understood therefore as a contribution of the German Democratic Republic in this endeavor. It will be shown for a period of well over a year in famed art centers, rich in tradition: the National Gallery in Washington, The Metropolitan Museum of Art in New York, and The Fine Arts Museums in San Francisco. In this way a large segment of the people of the United States is being offered a view of such famous collections as the Green Vault, the Paintings Gallery of Old Masters, the Paintings Gallery of New Masters, the Kupferstich Kabinett, the Porcelain Collection, the Sculpture Collection, and the arms and armor collection. At the same time the American people will have an opportunity to get an impression of the striving of the inhabitants of Dresden and their socialist state to care for the works of art of the past and the present, to preserve them in their multifariousness, and to make them accessible to the people in the most comprehensive manner possible.

The realization of this impressive exhibition—an endeavor that will doubtless be recorded in the history of museums—was made possible, first of all, by the responsible work, filled with enthusiasm for art, of the scientists and their coworkers of the Staatliche Kunstsammlungen Dresden, and the initiative and thoughtful cooperation of their colleagues in the United States. The Ministry of Culture of the German Democratic Republic furthered the preparation and execution of the project in the conviction that it would contribute to a better acquaintance between our nations, and to the development and strengthening of the relations between our states. In this sense, my wish is that the exhibition will be a great success.

Statement by

MANFRED BACHMANN
Director General, State Art Collections Dresden

The eleven museums of art and cultural history that are united as the Staatliche Kunstsammlungen Dresden accommodate three million visitors annually. As a center of famous collections, Dresden has a very good reputation in many countries all over the globe. The cultural and scientific connections between the museums of the city on the Elbe and the most important museums of the world are many. A busy traffic in loan exhibitions is an expression of the political principles of the German Democratic Republic in response to the recommendations of Helsinki.

Two decisive historical events have shaped the basis for the successful museological and scientific work of the colleagues of the Staatliche Kunstsammlungen. Full of gratitude, we remember the friendly deed of the Soviet people, whose sons tore the art treasures of Dresden away from the jaws of doom amidst the ruin of the last days of World War II, and whose skilled restorers and scientists undertook the conscientious care of these works of art during the period before their complete return to the German Democratic Republic in 1955 and 1958. With this event Dresden could once again be ranked among the top group of the most splendid art and museum centers of the world. As the second event, we recognize the creative conservation of our humanistic cultural heritage in the hands of the working class, whose diligence and socially oriented cultural politics created new museums for these art treasures in the framework of the reconstructed cultural centers of the city on the Elbe.

"The Splendor of Dresden" not only gives a display of selected outstanding works from eight museums, but offers at the same time basic information about the history of the city. We hope that the exhibition will contribute greatly to the development of cultural relations between the G.D.R. and the U.S.A. May this comprehensive presentation of five centuries of the work of the art museums of Dresden stimulate a spirited art discussion among its visitors and help to further mutual knowledge and understanding between our nations.

Foreword

BY J. CARTER BROWN
Director, National Gallery of Art

PHILIPPE DE MONTEBELLO
Acting Director, The Metropolitan Museum of Art

IAN McKIBBIN WHITE
Director, The Fine Arts Museums of San Francisco

We believe this exhibition to be the first in which the history of art collecting, rather than the history of art, is so comprehensively explored. Dresden offers what can be described as the ideal case in which the development of collecting, as part of our Western heritage, can be followed and understood step by step, in conjunction with the unfolding of a cultural history of extraordinary richness and complexity.

It was in Dresden that the northern Renaissance idea of the collection as a microcosm of the world and a summary of man's scientific curiosity was suddenly transformed into the baroque vision of the collection as an extension of the political grandeur of the prince and the magnificence of the aristocratic state. There, gradually, with the birth of the modern era, with its neoclassical passion for the rediscovery of the antique and its romantic enthusiasm for the achievements of the many cultures of the past, the idea of the public museum was born. Public access rather than private delectation became the objective, along with a new emphasis on national schools of art.

Accordingly, this exhibition is not a conventional selection of "treasures." Great works from the Dresden museums are presented not as isolated masterpieces, but rather in the function of the history and character of the collections of which they formed a part. After a stage-setting introduction devoted to the city itself, the exhibition is articulated in three clearly defined parts. The first evokes the nature and aspect of the sixteenth and seventeenth century curiosity cabinet and armory. The second tries to convey the eighteenth century diversification into specialized, royal art galleries (the Green Vaults, the Porcelain Collection, the Collection of Bronzes, and the Old Masters Picture Gallery). The third reflects the reorganization of the collections into public museums in the nineteenth and twentieth centuries and the collection of contemporary art. Rather than offer here a section-by-section summary of these themes, we have placed our comments as brief introductions to each of the twelve sections of the catalogue.

An undertaking of this scale and complexity naturally involves a great number of people over a long period of time. When the Ambassador to the United States from the German Democratic Republic mentioned the possibility of a loan exhibition from Dresden to the Director of the National Gallery at a luncheon at the embassy, shortly after that embassy had been established, Ambassador Rolf Sieber had no way of knowing that the Gallery's Director had registered his intention to pursue such a quest with the Department of State the summer before, in August 1974, on the morning in which the re-establishment of diplomatic relations was announced in the press.

Successive discussions in Washington resulted in high-level attention in Berlin, and when David Rockefeller was there in June 1975, the Prime Minister of that time, Horst Sindermann, broached to him the possibility of a Dresden show coming to the United States. Mr. Rockefeller mentioned the possibility to the President of the Metropolitan Museum, Douglas Dillon. In November 1975, Thomas Hoving, then Director of the Metropolitan, went with Philippe de Montebello to the German Democratic Republic, where they discussed plans for a great exhibition drawn from all the collections of Dresden. In April 1976 their visit was reciprocated by Dr. Hans Rost, Administrative Director of the Staatliche Kunstsammlungen in Dresden, and Dr. Joachim Menzhausen, Director of the Grünes Gewölbe, who proposed to structure the exhibition around the history of the Dresden collections and discussed other aspects with the staffs of the museums in New York, San Francisco, and Washington.

At this juncture, Carter Brown indicated that the idea of a show on the history of collecting would fit perfectly the occasion of inaugurating the temporary exhibition spaces in the National Gallery's East Building, then under construction. A month later, members of the curatorial staff of the Metropolitan Museum spent a week in Dresden refining the conception of the exhibition and establishing most of the preliminary selections, while, on a separate trip, members of the National Gallery of Art negotiated further in Berlin and Dresden.

The culmination of these various visits came in April 1977, when the authors of this introduction, after drafting a participants' agreement, returned to Dresden and Berlin together with a curatorial and administrative team consisting of Olga Raggio, Helmut Nickel, Jack L. Schrader, and James F. Pilgrim for the Metropolitan Museum, Andrew Robinson, Jr., Sir Francis Watson, and Jack C. Spinx for the National Gallery. As a result of that busy week, an almost totally revised list of paintings, a new list of drawings, and a final list of objects was agreed upon. The complex practical details were finally worked out in Berlin, in a week of discussions in September 1977, with the American side represented by the National Gallery's Assistant Director, Charles Parkhurst, and by the Metropolitan's Deputy Director for Curatorial Affairs, James Pilgrim.

There remained, however, the question of the financial support needed to supplement the resources provided by the American museums. First came the pledge of a magnificent grant from the International Business Machines Corporation, for which we are extremely

grateful. Additional and very welcome support was subsequently provided by the Robert Wood Johnson Jr. Charitable Trust, the National Endowment for the Arts, and the National Endowment for the Humanities, and the Museum Society of the Fine Arts Museums of San Francisco. The exhibition was also given a federal indemnity to the maximum allowable limit by the Federal Council on the Arts and Humanities. To all of these public-spirited organizations we wish to express our warmest thanks for having made this exhibition financially possible.

Many others have contributed their assistance. On the German side, in addition to Dr. Helmut Tautz and his able staff at the G.D.R. Ministry of Culture and Ambassador Professor Dr. Rolf Sieber and the staff at the G.D.R. embassy in Washington, we should like to express our gratitude to Hans-Joachim Hoffmann, Minister of Culture of the German Democratic Republic, and to Professor Dr. Manfred Bachmann, Director General of the State Art Collections in Dresden. We would also like to express our thanks to all our colleagues in the Dresden museums who have helped from the beginning to realize the conception of the exhibition, and who have so diligently prepared the material for this catalogue and rendered assistance in countless ways. Dr. Joachim Menzhausen, as project director for the Dresden side, has played a crucial role in the generation of the exhibition, while Dr. Hans Rost, as Administrative Director of the Dresden museums, has coped with a myriad of practical details. Our thanks go as well to Dr. Anneliese Mayer-Meintschel, Director of the Gemäldegalerie Alte Meister, and to Dr. Harald Marx, Assistant Curator of the Gemäldegalerie Alte Meister, Dr. Joachim Ulitzsch, Director of the Gemäldegalerie Neue Meister, Dipl. phil. Johannes Schöbel, Director of the Historisches Museum, Dipl. phil. Werner Schmidt, Director of the Kupferstich-Kabinett, Dipl. phil. Ingelore Menzhausen, Director of the Porzellansammlung, Dipl. phil. Martin Raumschüssel, Director of the Skulpturensammlung, and all their dedicated staffs. Werner Schmidt did the main work of editing the German catalogue entries. The bibliographical notes were prepared by Käthe Neumann, Director of the Central Art Library of the State Art Collections, Dresden.

On the American side, we wish particularly to thank the former United States Ambassador to the German Democratic Republic and Mrs. John Sherman Cooper for their intense interest in this show, and the current United States Ambassador, David L. Bolen, and his staff, particularly Edward Alexander. In addition, we should like to thank former Assistant Secretary of State for Educational and Cultural Affairs, John Richardson, and his able adviser on the arts, Peter Solmssen, who followed the progress of the exhibition from the beginning. The two chairmen of the National Endowments, Livingston Biddle and Joseph Duffey, have taken a particular interest in the exhibition, as has the Chairman of the House Committee on Appropriations for the Department of Interior and Related Agencies, Congressman Sidney Yates, and the Chairman of the Board, International Business Machines, Frank T. Cary.

Finally, our heartfelt thanks go to the staff members, too many to name individually, of the three American museums that are the joint organizers of the exhibition. Olga Raggio,

Chairman of the Department of European Sculpture and Decorative Arts at the Metropolitan, has contirbuted her vast knowledge and energies to the exhibition and to this catalogue. The German text was translated by Helmut Nickel, Curator of Arms and Armor, and Vera K. Ostoia, both of the Metropolitan Museum; Helmut Nickel's generous enthusiasm and knowledge have been of great help in many aspects of the exhibition as well. Gaillard Ravenel of the National Gallery and his design team made repeated trips to Dresden, some of long duration, and have labored to capture the spirit of collecting there, and to create settings that can be transported from museum to museum. Earl A. Powell III, the coordinator for the National Gallery, James Pilgrim in New York, and in San Francisco Michael Conforti, Curator of Sculpture and Decorative Arts, and Susan Levitin, Curator of Exhibitions at The Fine Arts Museums of San Francisco, deserve our special gratitude.

In a sense, the catalogue that follows continues our acknowledgments, for it reminds us of our debt to the creators of so many breathtaking works of art, and to those collectors in Dresden who made possible their assembly, their preservation, and their service to all humanity.

Contents

Five Centuries of Art Collecting in Dresden

JOACHIM MENZHAUSEN

Director, Green Vault

If one draws two lines on a map of Europe—one north to south, from Copenhagen to Rome, the other west to east, from Paris to Warsaw—they will intersect in the lowlands of Saxony. Here were the crossroads of the ancient Continental trade routes. Here various cultures merged. Here too were battlefields—where in 1547 at Mühlberg the league of the Lutheran princes and cities was broken by the centralist forces under Emperor Charles V, where in 1632 King Gustavus Adolphus of Sweden was killed at Lützen, where in 1813 Napoleon was overthrown in the Battle of the Nations at Leipzig, and where the Soviet and American armies met at the end of World War II. The war devastations suffered by Saxony were numerous and vast, and the appearances of its cities changed repeatedly and often abruptly. The country's central position, disadvantageous in times of war, was of great advantage in times of peace. The entrance gallery of our exhibition shows the changing appearance of Dresden, the Saxon capital, at key periods in its history: when the Renaissance city of the sixteenth-century electors of Saxony had to make room for the royal residence of the baroque period, and when, in turn, the baroque city was destroyed in 1945, to be rebuilt as a modern metropolis with large integral open spaces.

The area that today is called Saxony was settled originally by Slavic tribes. Then, starting in the tenth century, the country was conquered by German feudal lords and became Christianized. Even so, many place names in the fertile lowlands and along the rivers are still of Slavic origin, comparable to the survival of Indian place names in the United States. The mountainous south of the country was practically uninhabited up to the end of the twelfth century, when rich silver deposits were discovered there. The resulting "silver rush" started an industrial development whose momentum continued, in spite of occasional setbacks, for centuries. After the silver, the prospectors discovered tin, copper, and iron in such abundance that the region became known as the Erzgebirge—the Ore Mountains. In addition, the mountains proved to be rich in semiprecious stones: jasper, agate, serpentine, colored

15

marbles, garnets, amethysts, opals, smoky quartz, and topaz. Later, cobalt and bismuth were found and exploited. The immigrant miners were followed by entrepreneurs, artisans, and merchants. Town after town was founded, their commerce based on silver smelting plants, hammer mills for iron and copper, and foundries for iron and tin. The forests covering the mountains provided fuel and raw material for the manufacture of glass, ceramics, and paper. In the fourteenth century a textile industry began. In 1789 Johann Caspar Riesbeck wrote in his *Letters of a Frenchman Traveling in Germany*: "One is led to believe that the entire huge mountain mass along the Bohemian border is all tunneled through and hollowed out. There is one mine shaft next to another, and all ravines ring with the sound of hammer mills. I have never seen anywhere a more industrious people than these Saxons. The entire mountain range teems with them. They defy the very rocks to yield food for them, they not only work and process the rocks and minerals in the most versatile way, but their towns also have their own manufacturing industries, which produce linen fabrics, laces, ribbons, fustian, cloth, flannel, and anything else of this kind, wherewith they keep innumerable hands busy." It was against such a background as this that the collections of the dukes and electors in Dresden grew, beginning in the fifteenth century.

Saxony had been a prosperous country during the Middle Ages. In many of its towns the skyline is even now dominated by the huge, looming roof of the Hallenkirche—a local type of late Gothic church with three naves of equal height. Some of these churches still contain their carved altarpieces, often filled with an abundance of figural decoration. An impression of the richness and high quality of the goldsmiths' work that used to be present in just one of the major churches is given by the printed inventory of the 117 reliquaries of the Wittenberg palace chapel, published in 1509 with woodcut illustrations by Lucas Cranach. But with the advent of the Reformation, led by Martin Luther, the production of entire branches within the decorative arts came to a sudden halt. Furthermore, the iconoclasts destroyed many of the existing works of art. Large churches were no longer built; more altarpieces were destroyed than were commissioned; processional crosses, reliquaries, and gold-embroidered ecclesiastical vestments were suddenly without function. Only the buildings themselves remained, and in them their main altars and communion silver, tolerated by Luther. Everything else disappeared without trace. In place of the art that was swept away we find the first stirrings of a secular art, notably in Lucas Cranach's portrait of Duke Heinrich the Pious, seen in our exhibition.

This development was, of course, decisively influential on the great holdings of silverware in the possession of the Saxon rulers. We know, for instance, that as early as 1469 there was a silver vault in the palace in Dresden, and that around 1530 it contained silver objects with a total value of 128,393 Güldengroschen. Truly, this was an extraordinary treasure, worthy of the lords of the silver mountains, yet not a single piece of this treasure can be identified today, though it may be that the Greifenklauen—the decorative drinking horns of the fourteenth and fifteenth centuries (to be seen in the Kunstkammer part of our exhibition)—are remnants of this hoard that disappeared in the Reformation.

The question arises: Was this silver treasure already a *collection* or was it only an amount

of practical though prestigious tableware? There is some evidence that collecting, as we know it, started in Dresden around 1500. The single fact that there is an unusually large number of Greifenklauen and other vessels of agate, jasper, and crystal in medieval mountings among the holdings of the Green Vault—objects taken over from the Kunstkammer—indicates that there must have been other, older objects, no longer in use, in the contents of the original silver trove. Furthermore, there is evidence that the beginning of the collections of coins and medals and arms and armor fall into these same years. With this, we have introduced three museums that still exist in Dresden. At the latest, in this quest for origins, it was Elector Georg (reigned 1500-39) who can be considered the first of the princely collectors. It was he who introduced the architectural style of the south German Renaissance into the still Gothic city of Dresden.

It would be incorrect to say that collecting as such got its start in the Renaissance, since, long before, cathedral treasuries had been gathered with definite aims and functions. But in the period around 1500 there began in Europe a type of collecting, independent of the Church, that had new motives and structures. Most of the great collectors of this time were at least princes. Not only did they enjoy extraordinary financial means and high standards of education, they had an interest in the political function of their collections. After all, whatever the first man of any state does, it carries a political accent. Personal involvement blends with the cultural prestige of the dynasty, the enlargement of its holdings, and the advancement of the education of the middle classes and national economic productivity. The idea of the sovereign secular state, as it was then emerging, played an important role in the development of collecting. "This was the epoch," wrote Friedrich Engels, "in which royal power, supported by the burghers of the cities, broke the power of the feudal nobility and founded the great monarchies, essentially based upon nationalities, in which the modern European nations and the modern bourgeois society found their origin and development."

In Germany, this development came to a temporary halt after the defeat of the peasants in the Peasants' War (1525) and through the strengthening of the position of the territorial rulers, one result of the Reformation. For these reasons the new style of collecting flourished at the princely courts particularly.

Specialized collections of works of art were rare during this early period. After all, the precondition for the collecting of art is the realization that it constitutes a separate realm in its own right, apart from science and technology, and this way of thinking was barred to the religiously oriented European of the Middle Ages. It could be developed only during the Renaissance, and then at first only in that country where the attitude had held sway once before: Italy. Here, in the land south of the Alps, the relative autonomy of the aesthetic was held to be part of a great tradition. This is why, essentially, art collections as we understand them today, began in the south, with the earliest northern collections following decades later.

A characteristic stage in this development is seen in the first important Saxon collection, the treasury of the palace chapel in Wittenberg, brought together by Elector Friedrich the Wise around 1500. Its nucleus was the 117 reliquaries already mentioned. They contained more than five thousand relics, acquired by Friedrich from all over Europe and the Near East, and the treasury's illustrated publication promised indulgences from purgatory of up to 1443 years as a reward for their pious study. The pillars of this church were furnished with paintings by contemporary masters, commissioned by Friedrich the Wise in Nuremberg, Augsburg, Italy, and the Netherlands, obviously in cultic connection with the relics. Among the works were major paintings by Dürer: his *Adoration of the Kings* (now in Florence), *Martyrdom of the Ten Thousand Christians* (now Vienna), and *Seven Sorrows of the Virgin*, the central panel of which is today in Munich while its seven side panels are in the Dresden Paintings Gallery. In Friedrich's selection of such artists and in his appointment of Cranach as his court painter (1504) one sees an early and refined art appreciation. The influence of the then modern humanism, shaped by patrician points of view, is evident in the Elector's founding of the University of Wittenberg (1502), which in turn became the reason for the dispersal of his Janus-faced collection. For it was here, on the very door to the collection, that Martin Luther, then a professor of theology at the university, nailed his 95 theses against the Church's indulgences (31 October 1517). In the ensuing iconoclasm, reliquaries and relics perished, to be followed by a dispersal of the paintings, which now lacked a liturgical function.

It was only toward the end of the sixteenth century that art collectors in the modern sense appeared: Emperor Rudolph II in Prague and Elector Albrecht V in Munich. In the Protestant principalities and free cities of the empire this development ran into counter-forces, like the one that destroyed the collection of the Wittenberg palace chapel.

The cult of the saints and the veneration of the Virgin Mary had produced innumerable images during the Middle Ages. These were of the most varied kinds, ranging from figural reliquaries and embroideries to paintings of altarpieces and cycles of architectural sculpture. During the Renaissance, the themes and forms of this system changed, but with the Reformation, the system itself was destroyed. The sheer beauty of the new kind of representation of traditional Catholic themes, in sensuous embodiments borrowed from classical antiquity, must have appeared to Protestant eyes as the unadulterated expression of Roman paganism, of that babel of sins which Luther stormed against. The Protestant iconoclasm was the most radical consequence of this conviction, yet we should not draw the conclusion that the cultural reaction of the Protestant parties was always negative. The strengthening of the position of the territorial ruler in Lutheran Saxony, mentioned earlier, led to the production of a secular art. New architectural types with an iconography of their own developed. Yet the break with the Catholic art tradition led also to an ignoring of its progressive features. One of these, originating in the Italian Renaissance, was that art contained a spiritual element that distinguished it from mere craftsmanship. Wherever the innovations of the Italians were acknowledged as models, the medieval communities of

artists and artisans came to an end. In the Protestant capitals, which very soon fell prey to orthodoxy and a cultural isolationism, the traditional concept remained intact, and the fine arts did not become emancipated from the crafts until well into the seventeenth century. For them there was no conceivable reason to separate paintings and sculptures from clocks, carved gem stones, and marquetry caskets. Such was the framework of ideas for the structure, in Dresden, of the Kunstkammer, founded in 1560.

This universal museum, one of the earliest collections of this originally German type, was somewhat paralleled, a decade later, by the Studiolo of Francesco de' Medici in the Palazzo Vecchio, Florence, although the Dresden Kunstkammer was not established for philosophical contemplations, but for the practical sciences in the widest sense of the word, even including magic. The founder, Elector Augustus (reigned 1553-86), an outstanding economist among the princes of his period, indisputably had the interests of his state in mind. His Kunstkammer was a kind of university of technology and science for himself and his sons, who were here educated for their future positions as rulers of an economically highly developed country. Since the production of art was still considered to be just another industrial activity, the Kunstkammer contained works of art along with its products of the decorative arts and its objects of historical, ethnographic, or geographic significance. The technical and scientific objects predominated, since, after all, this was then the most comprehensive collection of technical tools and scientific instruments in the world. Today, the Mathematical-Physical Salon in Dresden, even after its losses of important objects during the second World War, offers us an idea of the Kunstkammer's universality and the collector's delight in the mechanical precision of his objects, their different metals shimmering, their engraved surfaces expressive of nobility. Even the visitor to the Cluny Museum in Paris gets an impression of this delight when he comes face to face with the long, richly inlaid wire-pull work bench of Elector Augustus, which ended up there.

From the Kunstkammer, cartographers, mathematicians, architects, and artists borrowed either instruments or models for their work. It is not accidental that precisely at the time of the Kunstkammer the arts and crafts flourished in Saxony. Metalworkers—iron founders, pewter casters, goldsmiths, medalists, gunsmiths, armorers, and clockmakers—as well as workers in earthenware, glass, and stone all achieved high artistic levels. A number of their objects will be found in our exhibition, together with paintings by Lucas Cranach the Younger, who worked in Wittenberg for the Elector, and his pupil, the Dresden court painter Zacharias Wehme, who painted the portrait of Augustus holding the Arch Marshal's state sword, the visible symbol of the dignity of the electors of Saxony.

An institution of sensational novelty, the Kunstkammer also functioned as an object of state prestige. The guest book of one of its early curators contains the autographs of many princely visitors. But there were collections in Dresden that served the demands of prestige even better, collections either founded by Elector Augustus or significantly enlarged by him. One of the most interesting to us was the Armory—the Rüstkammer—which has been

accorded two rooms of its own in our exhibition. The Armory contained the princes' own armor and equipment for pageantry, tournaments, and battle, as well as that of the Traban-ten, a bodyguard of some seventy men, and ancestral heirlooms of arms and armor. Elector Augustus brought together objects from the best workshops of Europe, adding to these objects received as diplomatic presents from other sovereigns. His passion for the martial arts was well known, and he was an enthusiastic jouster. Through him, Dresden obtained the nucleus of one of the finest collections of parade armor of the late Renaissance period.

The most important of the prestige institutions was the Treasury. Originally this was a vault for state documents, gold, and precious objects, located beneath the Elector's living quarters and accessible by means of a secret stairway. This Geheime Verwahrung—Secret Storage Vault—was familiarly known as the Green Vault, after the color of its walls. The Italian vessels carved from crystal, the German amber objects, and the Electoress' jewels, all stored here and taken out on special occasions, became important elements of the Treasury Museum that was later constructed in this same part of the palace, retaining its old name: the Green Vault. The amber candlestick that we exhibit in the Kunstkammer (70) and the lapis lazuli necklace and pendant with the letter A (297) that we show in the Green Vaults came, in all probability, from the Secret Storage Vault of Elector Augustus.

Finally, we mention three specialized collections of this ruler—not represented in our exhibition—since these collections still exist. His library, uniformly bound by outstanding artists, was one of the most important of its time. The Coin Cabinet, established at the beginning of the century by Elector Georg, was enlarged by Augustus. His Anatomie-Kammer exhibited human and animal skeletons, including anomalies and fossils. Corre-sponding to this material were the sets of surgeons', dentists', and optometrists' instruments in the Kunstkammer.

Elector Augustus' successors increased the holdings of the various collections, some of them adding masterpieces that even today are essential for the fame of the collections. Christian I (reigned 1586-91) bought the panels of the *Seven Sorrows of the Virgin* and nearly 200 graphics by Albrecht Dürer. Christian II (1601-11) acquired many vessels carved from semiprecious stone and displayed them in the newly built Belvedere on the fortress wall at the river front. Here the influence of Emperor Rudolph II is recognizable. His collection is to be seen in the Kunsthistorisches Museum in Vienna; pieces from the smaller, but neverthe-less excellent parallel collection in Dresden are to be seen in our Green Vaults selection.

The Thirty Years War led to frightful devastations in Saxony. The country lost its leading position in the Protestant League and the economy suffered severely. The consequences in the area of culture were provincialism and a reduction in collecting. It was only in the last third of the seventeenth century that a recovery came. Interestingly enough, the orientation was now toward the baroque—Italian, French, and south German. It appears, as we look back on it, like an attempt to find a new beginning. Of the greatest importance for our subject is the fact that religious reservations had now disappeared, and works of art, as such, were bought in increasing numbers. In a record of the Kunstkammer in 1671 are mentioned

paintings by Dürer, Cranach, Rubens, Lucas van Leyden, Titian, and Tintoretto. Though some of these attributions were erroneous, they indicate a new approach. At the same time Melchior Barthel, an artist summoned from Venice, worked in Dresden as a court sculptor. A superb ivory Venus (63), probably by Barthel, documents Dresden's interest in the international high baroque. Only a few years later, in 1678, the palace in the Grosse Garten was built in this same spirit. This was the first major palace building in Germany after the Thirty Years War.

All these attempts at a new beginning in Saxony were coordinated and brought to an astonishing fruition by Elector Friedrich Augustus I, called Augustus II when he became king of Poland in 1697 and known to the history of art and culture as Augustus the Strong. The connection between the Saxon industrial might and the Polish agrarian economy triggered a strong economic upsurge, and this was judiciously strengthened by the ruler's support of the manufacturing industry. More manufacturing plants were established during his reign (1694-1733) than during the previous century and a half. The best known of these ventures was the porcelain factory in Meissen, established in 1710. Its economic importance can be estimated from the fact that it held for a time the monopoly on porcelain production in Europe, and later its products were the models for all other porcelain factories.

The Porcelain Collection, as represented in our exhibition, demonstrates the artistic quality, technical perfection, and richness of invention in the Meissen manufacture from the very beginning. The viewer should keep in mind that this high standard, which seemingly emerged full grown, like Athena from the brow of Zeus, originated from an artistic atmosphere that had been organized in Dresden with the greatest ambition within a single decade.

Laws regulating construction, supported by subsidies, made possible a rapid transformation of the old-fashioned Renaissance city into a splendid baroque royal capital. The number of inhabitants doubled. The production of furniture, stoves, wallpaper, glass, and silver tableware increased enormously. Saxon products, known for their quality, were in great demand in other countries. Benefiting from liberally framed and administered censorship legislation, Leipzig grew into a center of the book trade. Its university flourished. The reform of the German theater began there, and music reached perfection here in the works of the cantor of St. Thomas, Johann Sebastian Bach. The bourgeois middle class expanded and became more prosperous. To this day, the visitor in Saxony's towns will find in their market squares the broadly spreading town halls, surrounded by comfortable burghers' houses of the eighteenth century. It should not be forgotten, however, that the peasants, though the largest portion of the population by far, still carried the heavy burden of the feudal states.

In studying baroque Dresden the connoisseur notices with surprise that the most heterogenous influences cross-fertilized here: influences from France, England, Italy, and Austria, from China, Japan, India, and Turkey, from ancient Rome and even ancient Egypt. Many artists in Dresden had traveled widely, many had done research in the Library, the Kupferstich Kabinett, or the Kunstkammer, studying newly arrived works of art. Thus, they

had the entire history of art, as far as it was then known, spread before their eyes. The porcelain painter Höroldt used Renaissance paintings as models for his chinoiseries; the sculptors Thomae and Herrmann studied works of classical antiquity; the goldsmith Dinglinger read archaeological treatises and current travel accounts, from which he developed parade pieces of encyclopedic ambition, representing, for instance, an ancient Egyptian altar or the court of the Grand Moghul at Delhi; the architect Pöppelmann adapted Far Eastern motifs and created a chinoiserie palace. These works, all so different among themselves, share a unity in their forceful and elegant proportions, their wealth of shapes and motifs, their expressions of vitality and serenity, and their finesse of execution, sometimes bordering on the unbelievable. It appears that the universality of the Kunstkammer played its part in all this. And the Kunstkammer, too, appears to have been the starting point for the type of passionate collecting for which we remember Augustus the Strong. Netherlandish and Italian paintings, Roman marble statues, Chinese and Japanese porcelains, French baroque statuettes, German fifteenth-century prints, drawings and etchings by Rembrandt, Meissen porcelain and objets d'art by Dresden jewelers, clocks and scientific instruments, coins and medals, arms and gem stones—he collected them all and made them the principal material of the collections. Interspersed among these things are Indian miniatures, exotic weapons, and Egyptian antiquities. But Augustus was more than a tireless collector. In addition, he sent the first scientific zoological expedition to Africa. He commissioned the first ethnological publication on Saxon folk costumes. His interests extended back into the depths of time, also. From the oldest known documents of human culture to those of the day, everything was covered and represented, rounding out all that could then be known of art and culture by an educated person.

At the age of fifty Augustus the Strong began one of his most important endeavors, the founding of his specialized collections. In this he was evidently inspired by the prototypes created by Louis XIV. Paintings galleries had been established before this, in Vienna, Munich, and Düsseldorf, but in Dresden considerably larger financial support was available, it seems, and the span of interest was wider, as can be seen by the collections themselves even today. Augustus had drawings and graphic works detached from the Kunstkammer, and with them he founded the Kupferstich Kabinett. He brought together the paintings of highest quality to form the Paintings Gallery. Combining the most precious contents of the Kunstkammer, the Silberkammer, and the Secret Storage Vault, he founded the Green Vault as the first treasure museum open to the public. For the Porcelain Collection he built the Japanese Palace. After substantially increasing the holdings of firearms in the Armory, he built a Firearms Gallery. He bought antique Roman marble sculptures from the Chigi and Albani collections in Rome and from the electors of Brandenburg; in this way he formed the most important collection of classical antique art in northern Europe. Clocks and instruments from the Kunstkammer went into a newly established Mathematical-Physical Salon in the Zwinger. An anatomy collection, a zoological museum and a collection of minerals were founded. The Royal Library was moved to the Zwinger, and spaces were found there for the

still surprisingly large remnants of the Kunstkammer. The complex of buildings and installations, now called the Royal Palace of Sciences, was the first series of scientific museums anywhere with a modern aspect. The custodians were immediately set to the task of making new inventories. These old volumes are valuable even today as the start for scientific work in any of the collections. And the departmentalization created in those days has remained effective, for all these museums are still in existence.

The dividing up of the Kunstkammer and the classification of its objects into artistic, scientific, and technological fields is to be explained as a result of the Age of Reason. The extension of interests, spatially and chronologically, as it is represented in the collections, is to be understood as an element of that great European movement whose heirs we are today. The scientific education of the artist of that time had the same roots. Their cultural aspect in the German sphere, as a unified complex, first appears in Dresden of the baroque period. It is not by accident that this occurred in Saxony, the country that was so strongly molded by its bourgeoisie. This point of view may also account for the clarity, the classical influences, the optimistic, worldly attitude of Dresden's artistic productions, and explain why many authors, confronted by the serenity of the Dresden baroque, conceived of it as anticipating the rococo.

The establishment of the Dresden collections represents an important step in the development of the museum as an institution. For Dresden, as a cultural center, it meant the long overdue emancipation of the arts. It was for this reason that Johann Joachim Winckelmann, in his *Gedanken über die Nachahmung der griechischen Werke in der Malerei und Bildhauerkunst* (Dresden, 1755), his programmatic pamphlet for neoclassicism, wrote that the reign of Augustus the Strong was "the crucial and fortunate point in time when the arts, as a foreign colony, were introduced into Saxony."

In 1733 Augustus III succeeded his father. He proved to be an insignificant monarch who left affairs of state to his Prime Minister, Count Heinrich Brühl. The collapse of Saxony during the Seven Years War and the resultant hegemony of Prussia over Germany are in part attributable to Augustus. As a collector, however, he played an outstanding role. His interests were not universal, and he took scant notice of most of the existing collections. In partial explanation, some of the collections were creations in a late baroque spirit, such as the Green Vault and the Porcelain Palace of Augustus the Strong—riots of colors and swirling shapes, enough to turn away a more subtle nature at the beginnings of the international rococo period. Instead, Augustus III collected paintings and graphic art, not only with great financial involvement but extraordinary connoisseurship. Because of him, the Paintings Gallery owns major works of practically every great master of European painting of the sixteenth and seventeenth centuries. It was he who managed to bring Raphael's *Sistine Madonna* from Piacenza to Dresden, after most difficult negotiations and immediately before the outbreak of the Seven Years War, and it is quite credible that to put the painting, on its arrival, in the most favorable light, he pushed aside the throne in the throne room with his own hands, saying: "Make room for the great Raphael!"

Thanks to Augustus' influence, Carl Heinrich von Heinecken, working in the Kupferstich Kabinett, built essential foundations for the history of graphic art. His *Idée générale d'une collection d'Estampes* (1771) represented an important step in the development of museology. At that time, in the aftermath of the Seven Years War, Saxony was in ruins and impoverished, the singers of the Opera—until then acclaimed as the finest in Europe—had been dismissed, and all collecting activity had come to an end.

The differences in the art interests of Augustus the Strong and his successor were not only a matter of individual tastes but differences of an objectively historical nature. The collecting practice of the elder patron came from the universality of the Kunstkammer. It led smoothly to a rational structuring and subdivision of all fields of collecting, according to the modern spirit of the Age of Enlightenment, and this scheme still determines the structure of museums worldwide. His collecting practice, as already noted, demonstrated the prestige of the state, and the collections themselves had an overwhelmingly spectacular value, not in any way different from the festival pageants, the châteaux with sumptuously gilded interiors, the parks with sculpture-lined promenades. All of these were Gesamtkunstwerke—total works of art—in which the individual element was subordinated to the decorative ensemble, and in which the aim was the exciting of emotions, in the manner of a late baroque church. The decorative principle, deeply symbolic, made possible a system of artistic order in which all parts were subject to a centralistic organization, much as human individuals were supposed to be subject to the idea of absolute monarchy.

The collecting activities of Augustus III, though they were based on the established divisions of the collections, were different from those of his predecessor. He collected in a quite modern way, as a connoisseur, an expert, a patron not seeking spectacular effects and decorative ensembles, a man interested in the individual work. It was—on the highest level—*amuser le roi*. In relation to the achievements of the preceding period, it was like the relation of the Petit Trianon to the palace of Versailles. With its claim for education and individuality in art collecting as well as other fields, the bourgeoisie gradually stepped into the monarch's shoes.

In the first gallery of our exhibition one sees Bellotto's painting of Dresden's Kreuzkirche, destroyed in the bombardment by Frederick II of Prussia in 1760. This picture might serve here as a symbol for an end. Hardly ever again was there a city that was such a graceful work of art. After all, it was a singular characteristic of the Dresden baroque that its buildings were embedded in the landscape in such a way that they enhanced but did not dominate it. Perhaps this can be seen as an example of romantic chinoiserie. Today it is only through Bellotto's scientifically exact paintings, done with a camera obscura, that this image of fortunate perfection is preserved.

The rulers of Saxony, without the crown of Poland, remained electors, but the country ceased to play a role in European politics. In contrast to this decline there remained the enduring effect of the Dresden museums. A history of collecting ought to deal with these

effects, little explored though they are, and difficult to measure. Some words may be offered here in this cause.

Three portrait statues of women, excavated at Herculaneum in 1715, came to Dresden in 1736 from the collection of Prince Eugen in Vienna. The contrast between these tall, serene antique figures, whose robes allowed the body shape to be recognized beneath the draped folds, and the contemporary women of Europe, with their whalebone bodices, corseted décolletages, and hoop skirts, must have been a matter for astonishment. It was in front of these very statues, in Dresden, that Winckelmann found his formula of "noble simplicity and quiet grandeur" in Greek art, establishing a new humane ideal in the arts, a parallel to the social ideal of the French encyclopedists, an ideal that was to influence the culture of all Europe, and a short time later—as a political formulation—came to the fore in the Constitution of the United States. For this reason, we exhibit one of the "Herculanean maidens" with a portrait bust of George Washington, commissioned in 1823 by a Dresden citizen, a former volunteer in the Philadelphia militia, out of his admiration for this great republican. The sculptor, J. C. Herrmann, proudly signed it with the additional note that he had finished it in Thorvaldsen's atelier in Rome. It was Bertel Thorvaldsen, the leader of the classical revival, who had given Winckelmann's vision a reality in its purest form.

Goethe visited the Dresden collections in 1768, when he was a student in Leipzig. He wrote of this experience in 1799: "Even before the end of my academic career a new outlook, one that should become decisive for my entire future life, was to be opened before me: I found the opportunity to see Dresden. With what a delight, even a daze, did I roam through the shrine of the gallery! How many dim feelings came into clear view! How many gaps in my historical knowledge were filled here, and how greatly my perception widened as I took in the splendid, multilayered edifice of the arts." Goethe made Ruisdael's *Jewish Cemetery* (561) the subject of an essay in which he reflected on the symbolism of the subject, about the painter as a poet, and concluded: "Whoever is fortunate enough to see the originals will be penetrated by the realization of how far art is able to go, and how far it should go." His reflections might be reread with profit in our own time, when artists struggle with the problem of articulate expression of the inner content of a work of art. This same painting by Ruisdael had a deep influence on Caspar David Friedrich, whose painting *Dolmens in the Snow* (604) can be thought of as an answer to it, in much the way that Dahl's *Dresden under a Full Moon* (11) was based on Bellotto's views of the city. In general, then, the Dresden museums were an academy for the romantics, and not only for the German romantics. In the second half of the eighteenth century the Paintings Gallery and the Sculpture Collection were considered to be the ideal museums of their kind. Only during the course of the nineteenth century were they surpassed by institutions elsewhere.

It was in the nineteenth century, during Saxony's period of greatest cultural efficiency, that the country suffered a blow which reduced it—politically and economically—to a second-rate power, even within Germany. The decisive battle of the European Alliance against Napoleon took place on Saxon territory in 1813: the Battle of the Nations. Here, at

Leipzig, the Saxon regiments fought on the French side, and the peace treaty required Saxony to cede half of its territory and a third of its population to Prussia. The remaining part of the country was considered to be not fit for survival, and its disintegration was thought to be only a matter of time. However, the most important centers of Saxony's industries were left to her in the truncated state, and a gradual recovery occurred. At the same time there was a growing instability in domestic politics, for the industrial centers were the breeding grounds for republican and socialist ideas.

In 1847 a new building for the Paintings Gallery was begun, designed by Gottfried Semper, director of the Dresden School of Architecture—this for the reason that the upper floors of the Stallgebäude, the home of the paintings after its reconstruction by Augustus the Strong, had never really been sufficient. In 1849, together with Richard Wagner, the conductor of the royal orchestra, Semper was a member of the bourgeois revolution. Lingering feudalism, helped by Prussian bayonets, was victorious once more, and many democrats, Semper and Wagner among them, had to leave their country. Many went to the United States. Semper went to London where, in 1852, he exercised a decisive influence upon the foundation of what was to become the Victoria and Albert Museum.

The new Paintings Gallery was finished according to Semper's plans, and with the completion of this building the bourgeois museum as such became institutionalized in Dresden, publicly and with a claim to monumentality. According to Semper, the gallery was to dominate the Zwinger, of which complex it was a part. Its stories are set at a higher level than those around it, and its grave and dignified neo-Renaissance architecture was quite consciously chosen to oppose the sinuous rhythms of the baroque. Semper's temple of bourgeois education and culture rose as the crown of a development started in the eighteenth century.

In 1781 the porcelain collection of Augustus the Strong was dismantled and stored in the cellars of the Japanese Palace, an operation that implied enormous losses and amounted to a reckoning with the past. The collection of antiques, the Coin Cabinet, and the Library were installed in the Japanese Palace—a change that represented the transition from the royal museum of the age of absolutism to the bourgeois educational museum. From here on, the decorative arts were regarded as inferior, while the fine arts were seen as revelations of the spirits of great personalities—of individuals—who, in the era of idealism, stood in the center of attention and admiration. (In fact, the fine arts were identified as the genii of mankind in the iconographical program of the architectural sculpture for Semper's Paintings Gallery.) In line with this thought, the constitution of Saxony, when the period of constitutional monarchy was initiated (1831), took the museums away from the immediate ownership of the crown and had them administrated by the government. The state now not only supported the museums but, with the building of the new gallery, catered to the growing masses of educated citizens and their need to experience works of art in both a formal framework and isolated setting. The collections had once been exhibited in cramped

conditions, sometimes in only a makeshift way; they were now to be expanded, spatially and categorically, for the benefit of the bourgeoisie. Clear up to World War II, in fact, efforts continued to get all of the collections properly on exhibition according to their relative importance and with regard to the growing masses of visitors. During the same period new museums were set up, too, following new historical and aesthetic needs: the Museum of the Saxon Society of Antiquities (1839), the Museum for Decorative Arts (1876), and the Museum for Saxon Folk Art (1897).

The expansion of the contents of the old feudal collections was a result of increased art historical comprehension. In the nineteenth century, collecting focused on the closing of gaps left by baroque taste and subjective inclinations of former princely patrons. This is a simplification, of course, since the conditions in each collection were different, and the projects and possibilities differed also. The collection of arms and armor and the Green Vaults were a special case. Both had received important additions at the time of the dissolution of the Kunstkammer in 1835 (incidentally, a deplorable move, since important Saxonica were thereby dispersed world-wide). The old Rüstkammer, now strengthened with pieces of memorial value from the House of Wettin, was renamed the Historical Museum. In view of the preciousness, rarity, and even uniqueness of objects in these two museums, it was out of the question for them to expand for the purpose of art historical comprehensiveness. Their only subsequent additions were individual pieces that would complement and enhance those already present.

For the Porcelain Collection the move to expand was much more unfortunate. The aim was to change the character of the original porcelain palace to that of a universal museum of ceramics. With purchase funds lacking, this was done mainly by exchange, and the losses to the original collection were considerable.

The Kupferstich Kabinett, on the other hand, had surprisingly few gaps in its collections of prints and drawings. As a result, its nineteenth century experts were able to concentrate on the study and acquisition of recent art—a tradition to the present day—along with the judicious rounding out of the collection to present a complete history of the graphic arts.

The Paintings Gallery, during the 1870s, succeeded in closing conspicuous gaps in its quattrocento holdings with the acquisition of several works that effortlessly came up to the standards of the older holdings, notably a *Holy Family* by Mantegna and a *Saint Sebastian* by Antonello da Messina. Efforts were made to acquire works by important Dresden artists, but the professors of the Academy, who had their say in such matters, were unwilling to acknowledge outsiders. For this reason it was only in 1840 that the first painting by Caspar David Friedrich, *Two Men Contemplating the Moon* (605) was acquired; it came to the Gallery from the artist's estate. Another such outsider was Ferdinand von Rayski, one of the best of German portraitists; his paintings were bought only twenty years after his death. A change for the better came toward the end of the century, beginning with the calling to the Academy of the Belgian painter Ferdinand Pauwels in 1876. It was Pauwels (incidentally the painter of

the *Abolition of Slavery* in the U.S. Capitol) who broke away from the reigning idealistic convention, so heavily indoctrinated by the Nazarene school. In the ensuing period Dresden developed into one of the centers of German impressionism and Jugendstil, and the acquisitions policy of the collection reflected this trend.

Between 1885 and 1889 the old Arsenal was remodeled to house the Sculpture Collection, and now renamed the Albertinum. In addition to Greek marble sculpture, Greek statuettes and decorative arts—hitherto lacking in the collections—were acquired, also ancient Egyptian and Near Eastern sculpture. A contemporary department was founded, dominated by works of Rodin, Meunier, and Klinger.

During these decades the Dresden collections were also centers for scholarly research, and the publications of Lehrs, Zimmermann, Sponsel, Woermann, Treu, Berling, Haenel, von Seydlitz, Schwinkowski, and the brothers Erbstein, issued then, are even today indispensable for any specialist.

At the time when the Nazis came to power (1933), the museums of Dresden had encompassed the entire history of art, in nearly all its fields. The city was known as a modern art center. The artists' group Die Brücke had been founded here; Kokoschka and Dix were teaching at the Academy. The catastrophe immediately struck the cultural sector—not different from the political. The modern artists were dismissed. Acquisition funds were reduced or canceled. As "degenerate art," hundreds of works of art were extorted from the museums, to be destroyed or else sold in foreign countries. Then, with the outbreak of the war, the personnel of the museums had the task of crating and evacuating hundreds of thousands of objects. During the chaos at the end of the war many of these objects were moving on senselessly ordered flight routes because the Nazi leaders, as the Soviet army drew near, ordered the material that had been stored in places east of the Elbe to be moved to western depots. On the night of 13 February 1945, in the heaviest conventional air raid of the war, the historic inner city of Dresden was destroyed by the Anglo-American air forces. On this occasion two hundred paintings, among them Courbet's *Stonebreakers*, were burned in the firestorm while on transport through the city.

Immediately after the surrender of the Third Reich and the entry of the Red Army into Dresden, a Soviet special command of art historians, museum experts, restorers, and artists began the rescue of the art treasures. Not a single museum building was left standing. Even the Museum of the Saxon Society for Antiquities, a baroque palace in a large park at the edge of the city, was a burned out shell. It had been thought that the medieval sculptures in this isolated building would be safe, but this was not the case—and so no Saxon Gothic sculpture is left to be shown in our exhibition. The Soviet specialists collected the works of art—widely dispersed, for the most part—patched up damages, quickly dried paintings endangered by dampness, and rushed everything for intensive care to Moscow, Leningrad, and Kiev, where necessary repairs and restorations could be executed in the required thorough way. Today, the preservation of the core of the Dresden collections appears almost like a miracle.

Without doubt it is thanks to this swift rescue operation, managed under the most difficult circumstances imaginable. Afterward, the Patriotic Order of Merit of the German Democratic Republic was awarded to three members of the rescue team, representing all the participants: art historian Natalia Sokolova, in 1945 Major Sokolova, senior officer of the 164th Batallion, today member of the Academy of Arts of the Soviet Union; Captain Tshurakov, later chief restorer at the Pushkin Museum, Moscow; and Major Perevostshikov.

In 1945, when, after a resolution of the government of the Soviet Union, the 1240 saved paintings were returned to Dresden, the reconstruction of the destroyed residential areas in the center of the city had already begun and some portions of the Zwinger had been restored. The Semper Gallery, however, was still in ruins; it was to be rebuilt in two stages. In 1958 the complete collections of six other museums were returned: the Green Vault, the Historical Museum, the Kupferstich Kabinett, the Porcelain Collection, the Coin Cabinet, and the Sculpture Collection. But beyond the newly reconstructed Semper Gallery, the only building fit for use was the Museum for Decorative Arts. A pressing task, then, was the rebuilding of the museum structures. Along with this there were needs to re-establish the functions of the museums in public education, to enlarge them, to organize special libraries, and to train qualified experts and restorers.

For the Kupferstich Kabinett, the Coin Cabinet, and the Green Vault only temporary accommodations could be found, though these continue to be adequate. The Paintings Gallery of New Masters, established as a museum in its own right, was set up permanently in the Albertinum, the Museum for Decorative Arts was installed in Pillnitz Castle, east of the city, and the Porcelain Gallery received a quarter section of the Zwinger.

Today, Semper's Opera House is being reconstructed. Other buildings will be restored in the near future. When the program is completed, the museums will have more space than ever before. The reason for this expansion is much the same as that which necessitated the building of the Gallery 130 years ago. Museum visits are strongly supported in socialist countries, and interested people are there in undreamt of numbers. Approximately twelve percent of Dresden's inhabitants have year-long admission tickets to the museums. Even in winter, when there are no tourists in Dresden, the galleries are well frequented. This development, which includes new social levels of visitors, new approaches, and new needs, has to be taken into account by the institutions. All necessary financing comes from the government of the German Democratic Republic.

The main effort of the museums is directed toward these tasks, of course, but collecting still continues. Special attention is paid to making up the losses of works by German expressionists, suffered through the Nazis. This is demonstrated in our exhibition by the recently acquired works by Karl Schmidt-Rottluff and Otto Dix. Further, the strong German social-critical and antifascist art of the twenties and thirties gets preferential treatment in acquisitions, as exemplified here by works of the Dresden painter Hans Grundig. Collecting is also aimed at the works of contemporary artists of the G.D.R. and other socialist countries.

The Paintings Gallery of New Masters, the Sculpture Collection, and the Kupferstich Kabinett have all established departments for this contemporary art. The Porcelain Collection is completing its holdings by acquiring hitherto overlooked Meissen porcelain from the nineteenth and twentieth centuries, and the Museum for Decorative Arts has established new departments for the art of the late nineteenth century and products of industrial design. These are the main trends. Aside from these, the other museums continue to close their art-historical gaps.

THE SPLENDOR OF DRESDEN

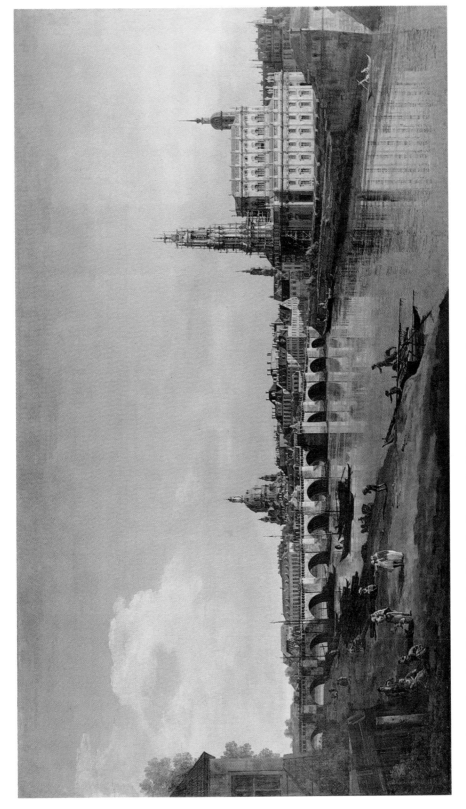

Dresden from the Right Bank of the Elbe, by Bernardo Bellotto, 1748 (no. 5)

33

Casket by Wenzel Jamnitzer, 1562 (no. 25)

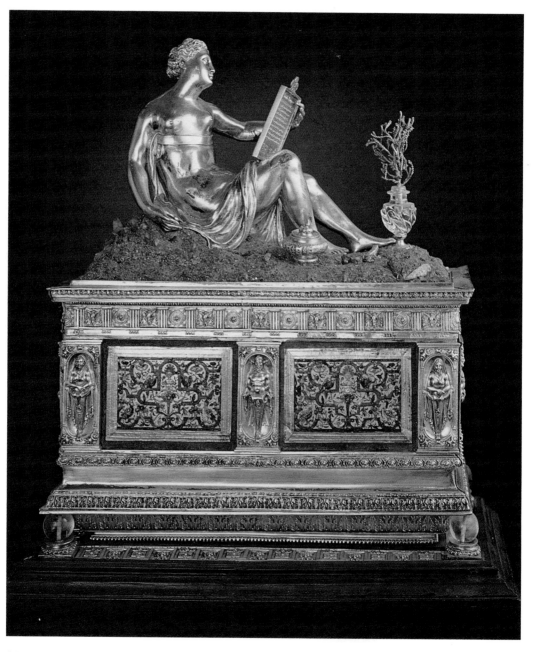

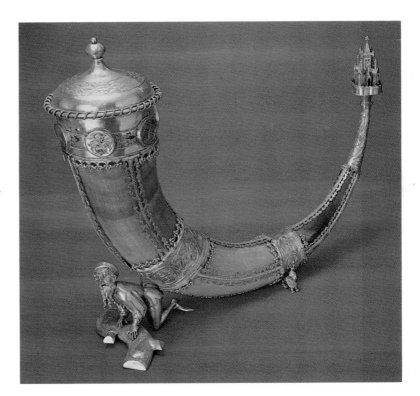

Drinking horn, Nuremberg (?),
end 14th century (no. 20)

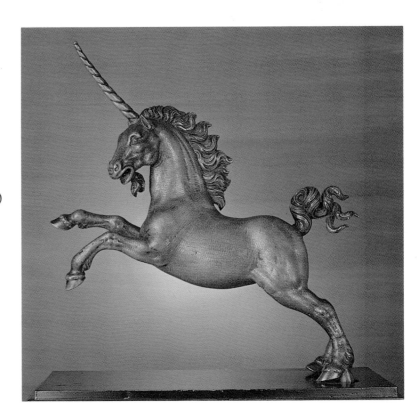

Leaping Unicorn,
Augsburg, 1570-80 (no. 49)

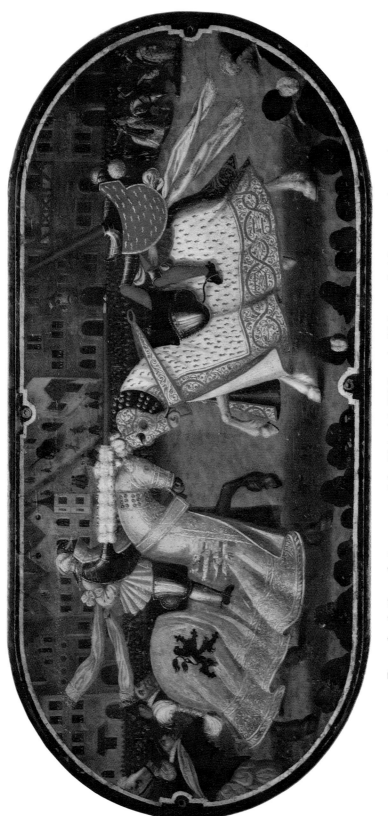

Record painting of a tournament, by Heinrich Göding the Elder, end 16th century (no. 135)

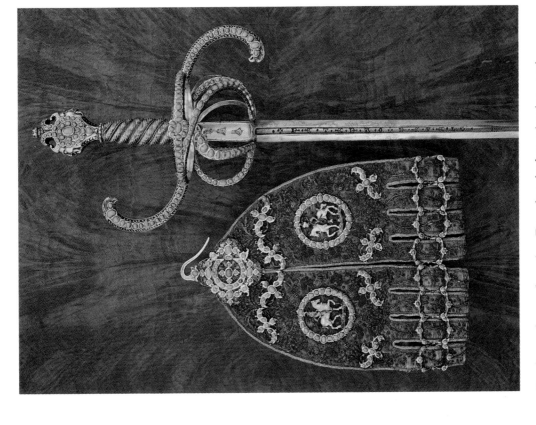

Rapier and sword carrier, Dresden, before 1605 (no. 149)

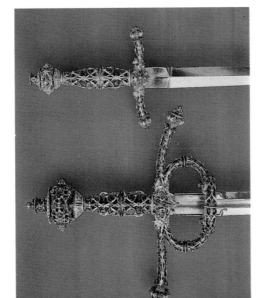

Rapier and dagger, Spanish (?), before 1562 (no. 148)

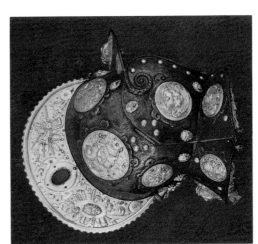

Burgonet, Augsburg, about 1600 (no. 144)

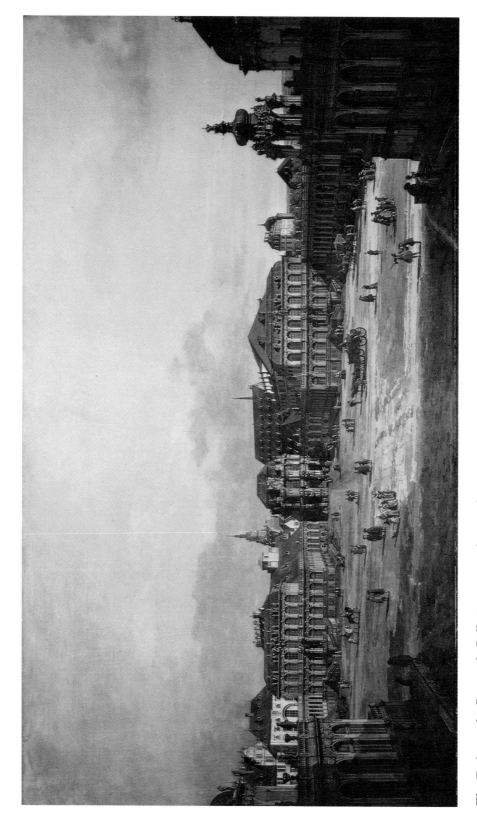

The Zwinger, by Bernardo Bellotto, 1749-53 (no. 212)

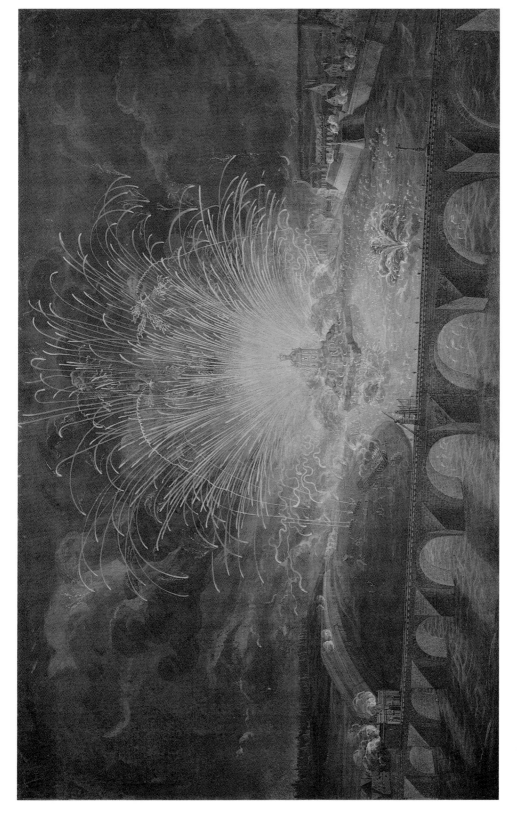

Fireworks on the Elbe, 6 June 1709, by C.H. Fritzsche (no. 206)

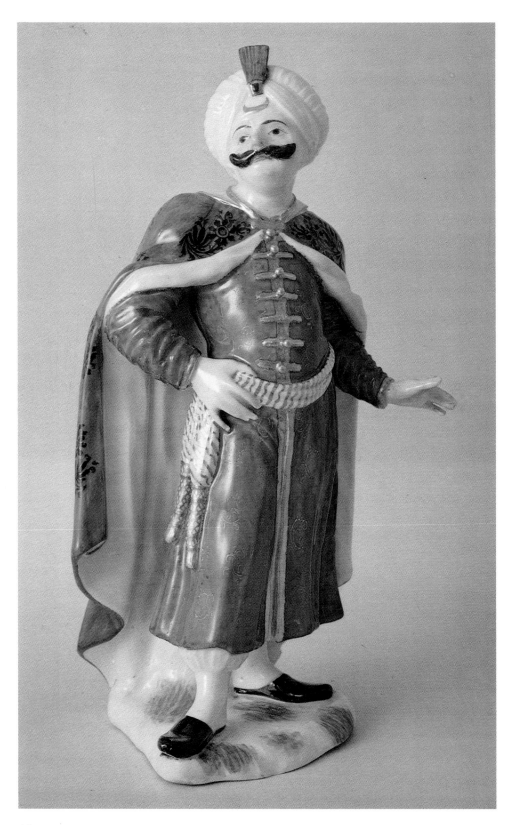

The Grand Turk, model by J. J. Kändler, 1741-42 (no. 238)

Parade helmet worn by Frederick IV of Denmark during state visit to Dresden, 1709 (no. 216)

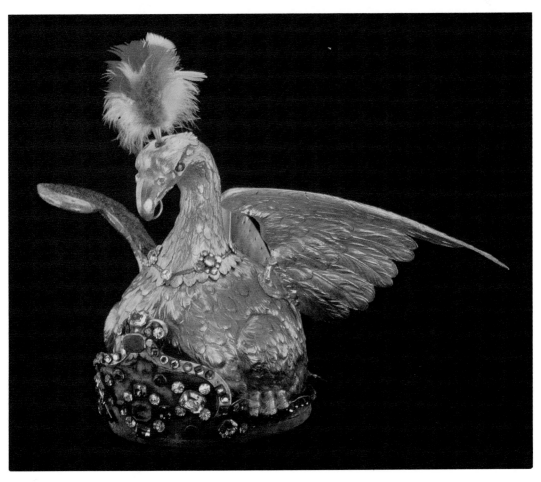

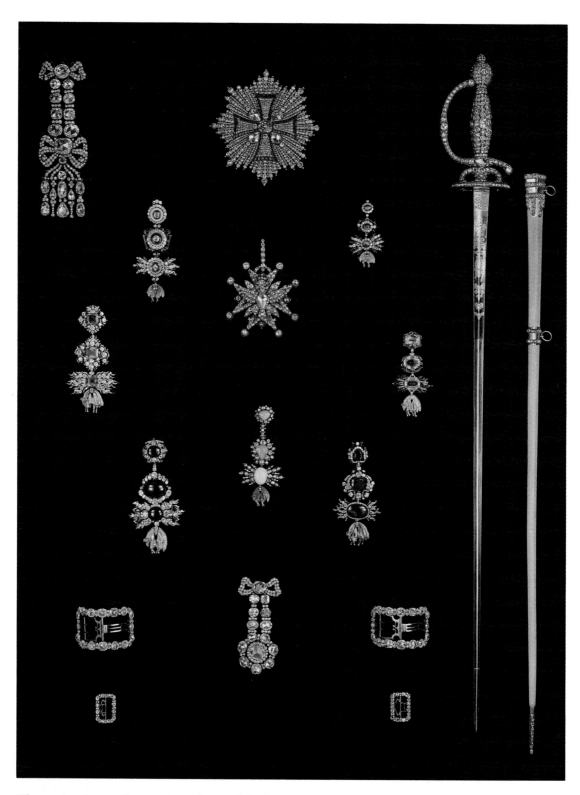

Elements of rose-diamond garniture of the Saxon Crown Treasure (no. 301)

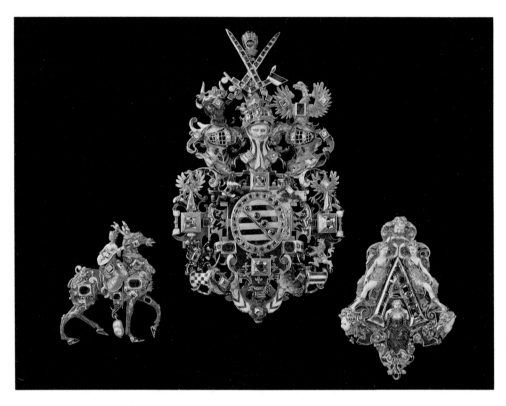

Jeweled pendants, 1570-1610:
Woman on stag (no. 298); Letter A (no. 297); Arms of the Elector of Saxony (no. 300)

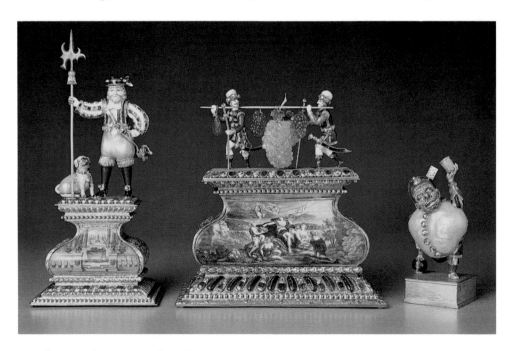

Jewelers' sculptures, early 18th century:
Dancing dwarf (no. 302); Joshua and Caleb (no. 306); Halberdier with dog (no. 304)

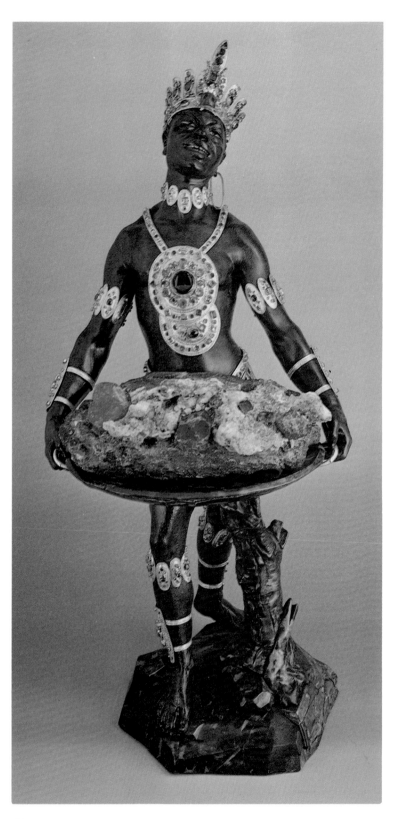

**Blackamoor with matrix of
South American emeralds,**
about 1724 (no. 291)

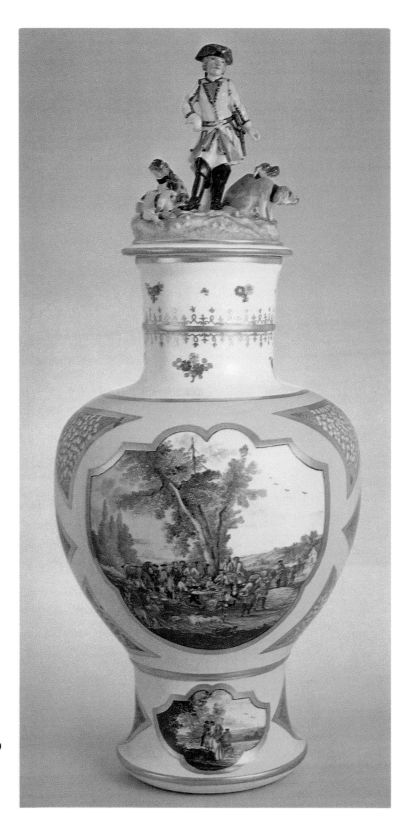

Hunting vase, Meissen, 1739
(no. 499)

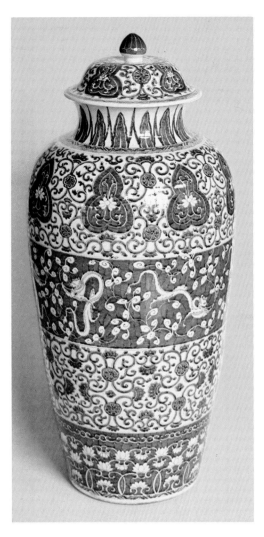

Monumental Chinese vase
("dragoon vase"), about 1700 (no. 356)

Coffeepot painted in enamel and set with gem
stones, Meissen, about 1770 (no. 449)

Japanese porcelain, late 17th-early 18th century:
Candlestick, assembled in Europe (no. 409)
Box with figures on cover (no. 408)

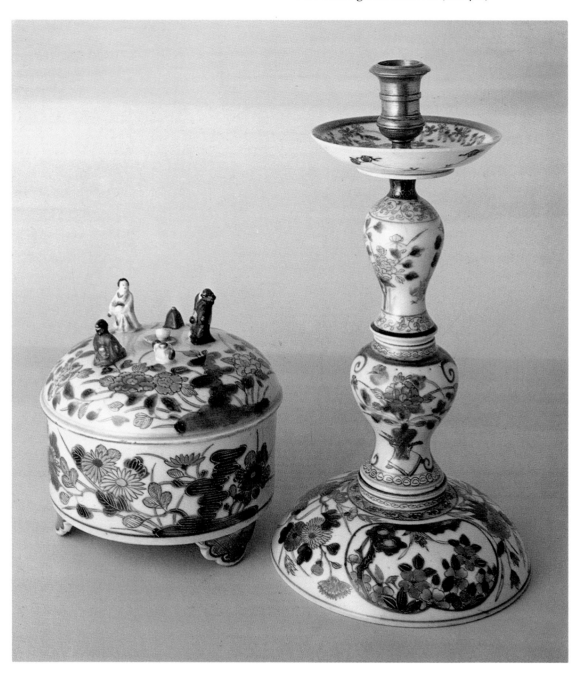

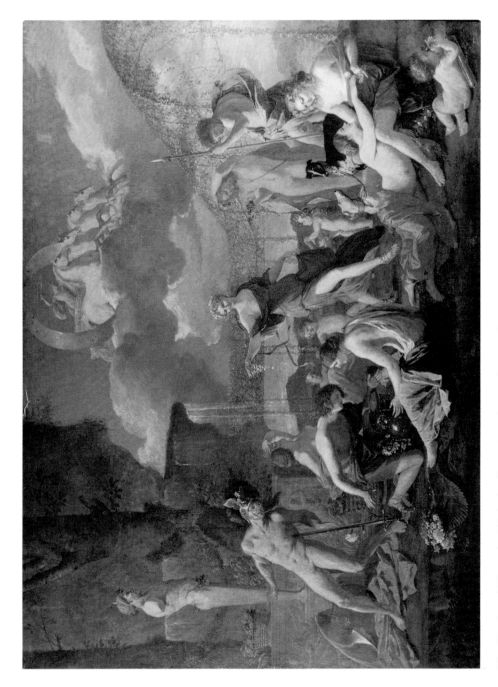

The Realm of Flora, by Nicholas Poussin, 1631-32 (no. 529)

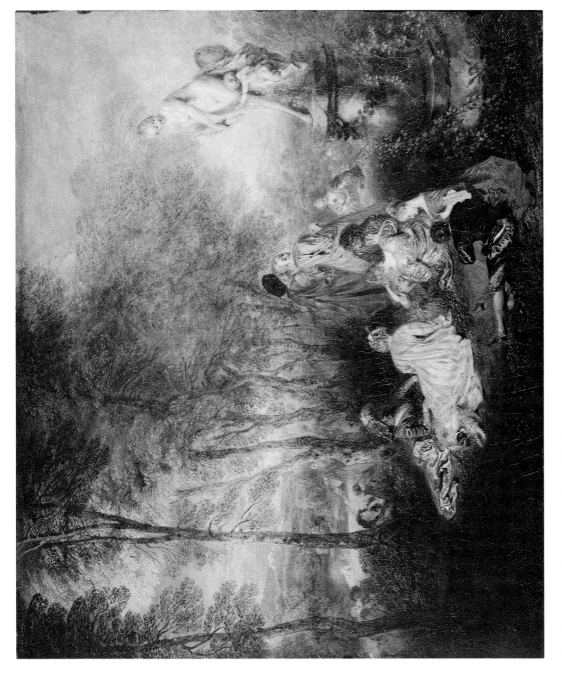

The Banquet of Love, by Antoine Watteau (no. 532)

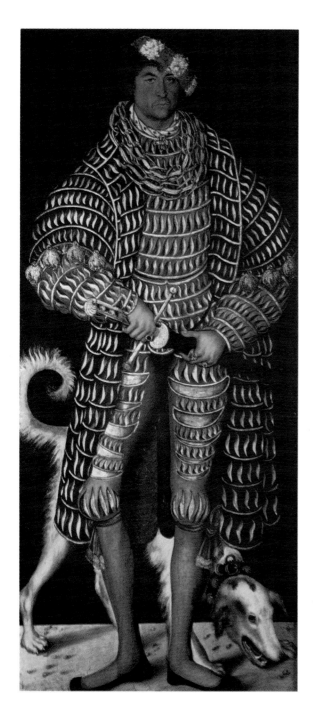

Duke Heinrich the Pious,
by Lucas Cranach the Elder, 1514 (no. 535)

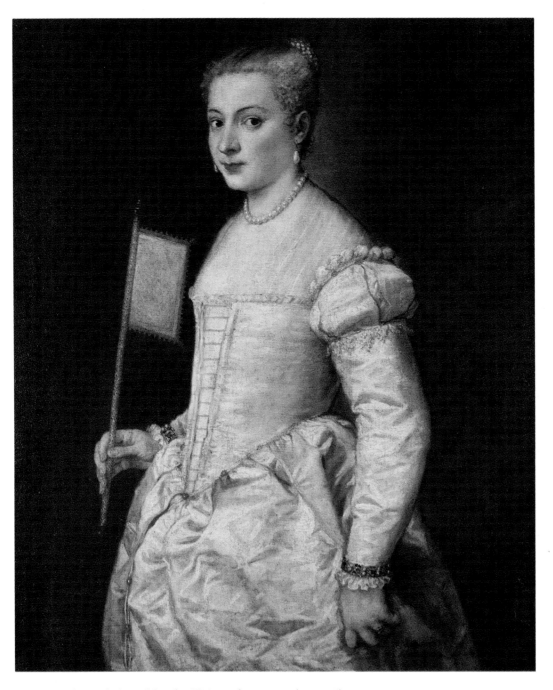

Portrait of a Lady in White, by Titian, about 1555 (no. 516)

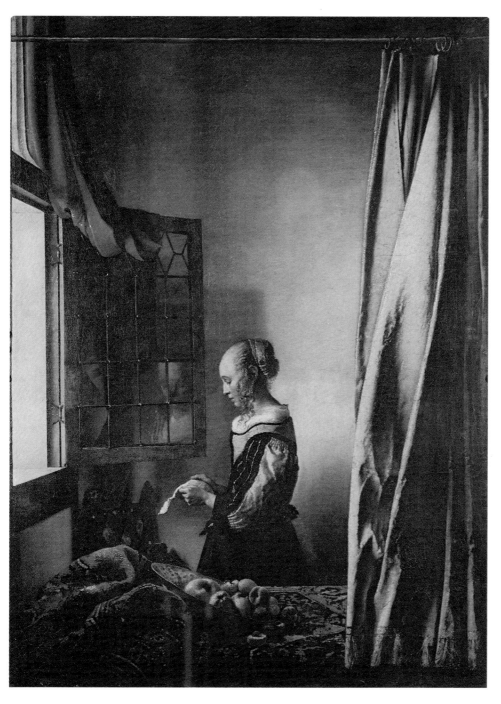

Girl at a Window Reading a Letter, by Johannes Vermeer, about 1658 (no. 559)

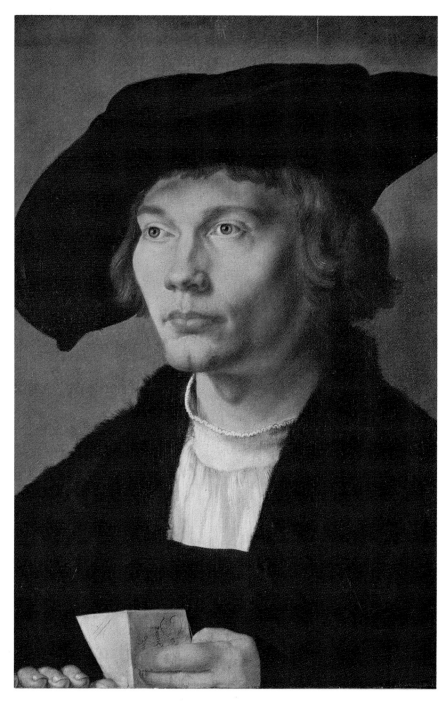

Bernhard von Reesen, by Albrecht Dürer, 1521 (no. 537)

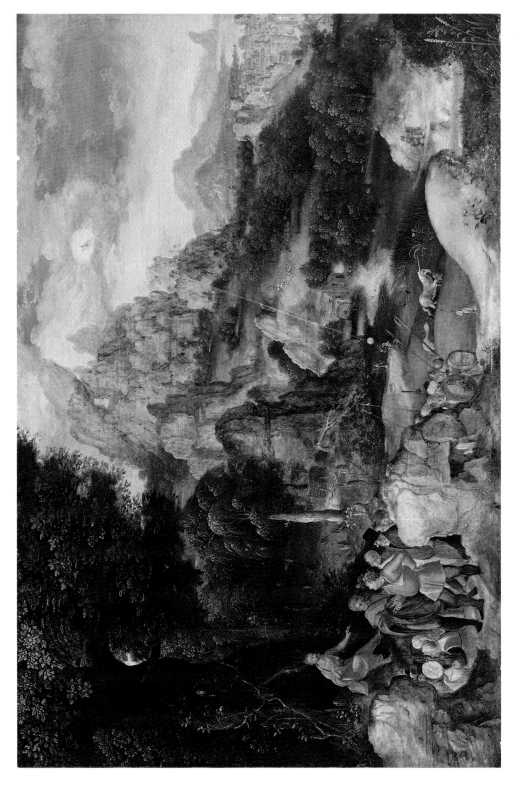

Sermon of Saint John the Baptist, by Herri met de Bles (no. 541)

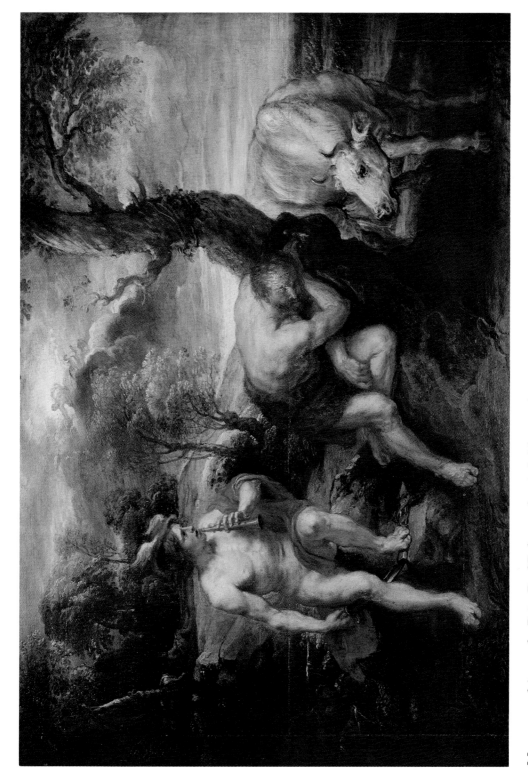

Mercury and Argus, by Peter Paul Rubens, about 1638 (no. 549)

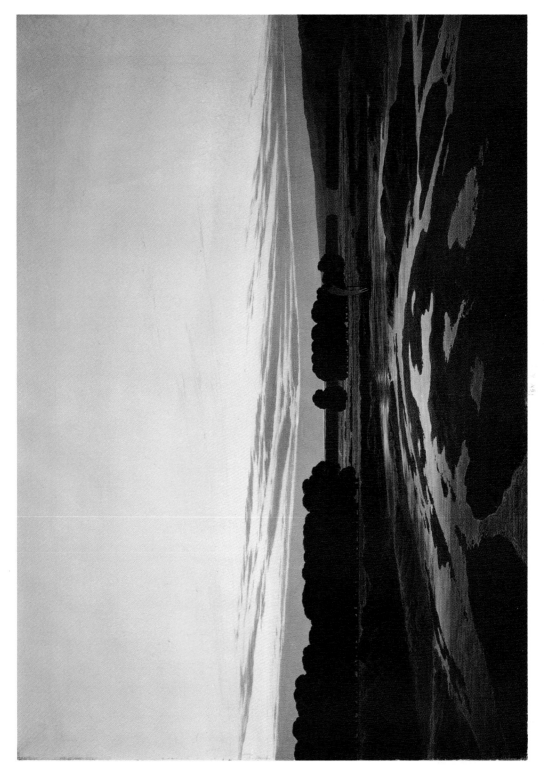

The "Grosse Gehege" near Dresden, by Caspar David Friedrich, 1832 (no. 606)

CATALOGUE

*S*etting the stage for the entire exhibition, this section records the scene of Dresden's long history of art collecting. The changing face of Dresden, from an electoral capital in the Renaissance to a modern city rising from the ashes of World War II, has been set down by succeeding generations of artists, each from the viewpoint of his own time. Four great mid-eighteenth-century views by Bernardo Bellotto, a Venetian, evoke the glory of baroque Dresden at its height. Panoramas of nearby castles and the neighboring town of Meissen record the environs of Saxony's capital, lying in the fertile valley of the Elbe and dramatically encircled by distant mountains. The romantics' vision of the city is here as well.

Bellotto's view of the Ruins of the Church of the Holy Cross, destroyed by the Prussian bombardment during the Seven Years War in 1760, appears almost as a prefiguration of the destruction of the city in World War II, recorded in a painting and two drawings by Wilhelm Rudolph. A decade before it occurred, the Allied air attack of February 1945 was envisioned in the central panel of Grundig's triptych entitled The Thousand-year Reich, painted in protest against the rise of Nazism. In the bustling modern city, Dresden's collections are once again on view, the extraordinary witness to the centuries of collecting activity documented in the succeeding portions of this catalogue.

Dresden: Images of a City

Few cities developed in such a "pictorial" way as old Dresden. The architectural profile of the city, set within the surrounding landscape, virtually invited artists to translate into painting what already was picturesque. A rhythmically accented whole composed of many different elements—a dominating cupola and slender steeples, buildings of the Middle Ages, the Renaissance, the baroque period, and the nineteenth century—challenged both painters and poets to create their liveliest images.

The most striking impression was probably the one experienced by the stranger who entered the city by way of the Neue Königstadt (called Neustadt for short) and then crossed the ancient bridge, remodeled in 1727-31 by the architect of the Zwinger, Pöppelmann. Let us quote the poet Jean Paul as a typical visitor. "When you step onto the Dresden bridge," he wrote in a letter in 1798, "palaces the size of towns lie before you, and beside you the river Elbe flows from one distant realm into another. You see faraway mountains, plains, solitary little ships, and on the bridge itself an ever-changing procession of people, a long avenue, and the bustle of life engulfs you. . . ." The prospect Jean Paul described, a classic painter's motif, includes the bridge, whose numerous arcades span the flat meadows and the river, and unfolds in a panorama that has no equal. Its beauty is all of this world, yet at the same time it is wrapped in a magic that led Hans Christian Andersen to say, "As I came onto the Augustus bridge that I knew so well from engravings and paintings, it seemed to me as if I had already been here in a dream."

Whether one approaches Dresden by the road through the Neustadt, or by the river, or from the hillside vineyards of the Lössnitz, or from Pillnitz, or even from the heights that frame the Elbe valley, the city, with its architecture related to the landscape setting, appears as a harmonious unit, the product, nevertheless, of centuries of growth, ripened in the baroque period and turned into a modern large city in the nineteenth and early twentieth centuries.

But as the quotations from Jean Paul and Andersen and countless drawings, paintings, engravings, and lithographs confirm, there was and indeed there still is a point from which the city is best seen, despite the destruction of the cupola of the Frauenkirche. This is the view afforded by crossing the bridge from the Neustadt. The old city walls, the so-called Brühlsche Terrasse, are like the edge of a stage, and the buildings rising beyond are endowed with an almost theatrical quality, overpowering and magical.

59

Founded in the Middle Ages, Dresden attained great importance during the Renaissance, when it became the residence city of the electors of Saxony. The period of greatest influence on the architectural character of the city came in the first half of the eighteenth century, during the reigns of Augustus the Strong and his son Augustus III. Such famous architects as Matthäus Daniel Pöppelmann, Zacharias Longuelune, Jan de Bodt, Gaetano Chiaveri, George Bähr, and Johann Christoph Knöffel worked in Dresden then. Although comparatively little of the fantastic projects for the city's transformation was ever realized, what *was* built was impressive enough and sufficed to make Dresden one of the most beautiful cities in Europe. To such medieval monuments as the Kreuzkirche (Church of the Holy Cross) in the Old Market (destroyed in 1760) and the Residenzschloss, enlarged and reconstructed in the sixteenth century under Duke George the Bearded and Elector Moritz to become one of the most important of German Renaissance palaces, were added buildings that changed the entire skyline: George Bähr's Frauenkirche, with its stone cupola, and Gaetano Chiaveri's Catholic Hofkirche. On the opposite bank of the Elbe the Neue Königstadt arose on a star-shaped ground plan, built according to a truly baroque design by Wolf Caspar von Klengel after a fire (1683) demolished the old city on that side of the river.

Although the baroque dominated Dresden's aspect, up until the destruction of the city in 1945, one must not forget that the medieval plan of the streets and squares within the Altstadt was preserved. Furthermore, the Renaissance and the seventeenth century are still clearly evident in such buildings as the Residenzschloss, the Stallhoff (today's Johanneum), the Lange Gang, and the Zeughaus (today's Albertinum), even though all of these were altered in the course of later reconstructions. Finally, there remained the powerful fortifications, dating from the sixteenth century, impressive parts of which still exist in the Brühlsche Terrasse—Goethe's "balcony of Europe"—and in the area of the Zwinger.

It was significant for its architectural image that "baroque" Dresden did not have a dominating baroque palace at its center, to serve as the starting point of a great axis laid across the city plan; neither were there wide, magnificent streets lined with palaces of the Saxon nobility. Instead, the Altstadt preserved the layout of the medieval settlement, when Dresden was just one of many burgher towns, far inferior in importance to Meissen, for example, or Freiberg.

The nineteenth century, too, contributed to the shaping of the city's appearance, as shown by such buildings as the Kunstakademie (Academy of Fine Arts) on the Brühlsche Terrasse, the Opera, and the Paintings Gallery, the latter two built by Gottfried Semper. Apparently the character of already existing buildings exerted an influence on the nineteenth-century architects. For how else can it be explained that even today the classic view of Dresden gives us the impression of a baroque town, even though not a single building of the eighteenth century, excepting Chiaveri's Hofkirche, can now be seen in the panorama?

The early twentieth century saw the addition of the new City Hall, whose tower rises above all others, the State Parliament building by Paul Wallot (which replaced the old Palais

Brühl), and two government office buildings on the Neustadt side of the Elbe, not to mention all the buildings that rose on the periphery of the old city.

The oldest pictorial views of Dresden appeared in the sixteenth and early seventeenth centuries, either as topographical records or as background settings in representations of notable events. In these works, beginning with the oldest engravings, such as that by Heinrich Clef of 1553 and continuing through the panoramic drawing by Gabriel Tola (1), the seventeenth-century engravings of Matthäus Merian and G. J. Schneider, the paintings and etchings by Bellotto and Thiele as well as the graphics of the nineteenth century, the riverside location and setting of the town into its landscape played important roles. The Austrian poet Franz Grillparzer noted in his travel diary, 2 September 1826: "I do not know whether it is because I have been spending my days in the Galleries, or whether it is because of the peculiarity of nature here, but each view appears to me to be very much like a painting. I have never known this to happen to me to such a high degree."

In 1746, at a time when the Court understandably wished to preserve the architectural character of the city in pictures, Johann Alexander Thiele painted his *View of Dresden with the Augustus Bridge* (4). This impressive canvas, the beginning of a long line of Dresden *vedute*, calls for comparison with the Dresden views of Bernardo Bellotto, which started in 1747. With their clarity of design, correct perspective, lifelike exactness in all details, and neutral lighting, these paintings by Bellotto represent an entirely different direction in view painting. Thiele's buildings remain schematic within the landscape; Bellotto's sculpturally compact buildings determine the structure of his paintings.

Bellotto came to Dresden in 1747. He began painting large panoramic views of the town as seen from across the river, but he soon turned to views of individual squares and streets, creating in all a series of twenty-five, several of which were repeated with variations. The series of large etchings that Bellotto himself made after his Dresden paintings is possibly paralleled at this time only by Piranesi's views of Rome.

Bellotto's paintings and etchings have contributed so much to making Dresden into the exemplary "baroque" city, if not actually into a myth, that it is difficult for us to appreciate other important periods in the history of the town. However, it is worth noting that periods as contrary to the spirit of the baroque as German romanticism and German expressionism also had their centers of activity here, and so we ask ourselves how these intellectual trends and artistic currents are reflected in the character of the city.

The romantic Caspar David Friedrich, although he did use Dresden architectural motifs in some of his paintings, transformed them into something beyond reality. Johann Christian Clausen Dahl, on the other hand, captured the fairy-tale mood of the city by full moonlight, seen from the "classic" point of view, across the Elbe (11). The city appeared in a still different manner to the artists of the mid-century. From 1840 to 1888 Adolph Menzel sketched again and again in Dresden, and his drawings of the Zwinger, the palace, and the Altstadt show the sensitivity of a great artist who discovered the beauty of forgotten corners and recorded them with the devotion of a realist. A lithograph after a drawing by Adolph Eltzner (12),

made about 1855, shows the entire city in a bird's-eye view, a vantage point that was popular at the time for views of important European cities, the most brilliant examples of these being the engravings of A. Appert of views of Paris, London, Rome, and Naples.

With the passing of the romantic-realist generation, large-size representations of the city were no longer made. "In the works of Dresden artists there is hardly any trace of the indescribable beauty of the majestic skyline, its picturesque and magnificent nooks and corners, and above all, none of the ancient Elbe bridge, which, after all, is one of the most beautiful bridges, if not the most beautiful bridge in the world. . . . Where are the eyes of the academicians?" So wrote Alfred Lichtwark in 1898, speaking of the seventies and eighties. Lichtwark later praised Gotthardt Kuehl, in whose work representations of Dresden attained a new importance. Kuehl became a professor at the Academy in 1895. His work combined Bellotto's precise, solid compositions, teeming with life, and Thiele's and Dahl's interest in the effects of light and atmosphere. At the same time Kuehl was not unresponsive to the innovations of the French impressionists. Full of the breath of life, his paintings depict the greatness and beauty of the old city, yet at the same time they show the growth of modern Dresden. As a Residenzstadt, Dresden did not suffer greatly from industrialization, even as it grew considerably in size, was filled with new, busy administrative and commercial activity, and saw the construction of buildings that often bore the imprint of historism.

In the early twentieth century Dresden became the center of activity of a group of artists known as Die Brücke, the Bridge, but for these artists the city's views had no importance. They focused on details from the proletarian Dresden of the suburbs rather than on the beauty of the baroque Residenzstadt. Of this group only Ernst Ludwig Kirchner produced a kind of *veduta* in pastel. But with the expressionist Oskar Kokoschka, who worked in Dresden for seven years after the first World War and was a professor at the Academy beginning in 1919, the distinctive image of Dresden again exerted its inspiring power; the view from the window of his studio in the Academy, looking onto the Brühlsche Terrasse and across the Elbe to the Neustadt, became for him a motif to use and reuse in various ways, although he had not yet found the style that distinguished his later town views.

Also active in Dresden during this period was Otto Dix, a professor at the Academy from 1927. In his early works, in the words of Werner Schmidt of the Kupferstich Kabinett, he used "Dresden motifs as backdrops full of manifold allusions" and perceived the city, redolent with culture, "as a friction surface," while decades later, in 1955, he "dedicated his only *veduta*-like work . . . as an expression of admiration for the new and old Dresden, to the majestic sight from the Brühlsche Terrasse to the Hofkirche and the Opera House."

In his painting *Lot with His Daughters* (1939), Dix expressed the horrible presentiment of a burning Dresden, with the prominent silhouettes of the Frauenkirche and the Hofkirche. Even earlier, in 1936, in the central panel of Hans Grundig's triptych *The Thousand-year Reich* (14), images of a destroyed city appeared, anticipating the reality of 13 February 1945, more horrible than the most horrible vision.

Wilhelm Rudolph's painting of 1952, *Dresden Destroyed* (17), with the ruin of the Frauen-

kirche to the left and the City Hall tower in the background, brings us face to face with the dead city and communicates the shattering experience of the total destruction of life and all its values. Rudolph does not show us the catastrophe itself, as Grundig did, but rather the desolate expanse and doleful silence of the city's ruins, through which new paths have already been trodden.

Meanwhile, in the course of more than thirty postwar years, the picture of a new, socialist Dresden has taken shape. As shown in the painting by Bernhard Kretzschmar (19), Dresden now reaches out into the countryside, with its light-colored buildings remaining closely tied to the landscape, for this continues to be understood as an essential component of the beauty of the city.

In the course of its rebirth, Dresden faced three possibilities: the construction of a completely new, modern city, without any reminiscences from the past; a total historical reconstruction, carried out as a program of monumental preservation; or a middle way, with, on the one hand, new planning of the cityscape and new construction, and, on the other, a reconstruction of selected, particularly important buildings.

The third possibility was chosen. The reconstruction of such buildings as the Zwinger and the Paintings Gallery was followed by the erection of new buildings like those in the Altmarkt, where an effort was made to find a stylistic accord with traditional baroque forms, and by the opening through the heart of the Altstadt of an axis parallel to the river, which created vistas formerly unknown. While this has resulted in a great change for the city as a whole, the panorama along the river—with the exception of the destroyed Frauenkirche— has been resurrected. In this manner, transcending the catastrophe of 13 February 1945, Dresden has preserved its characteristic aspect. It will continue to live in this alliance of the old and the new.

HARALD MARX

Assistant Curator
Paintings Gallery of Old Masters

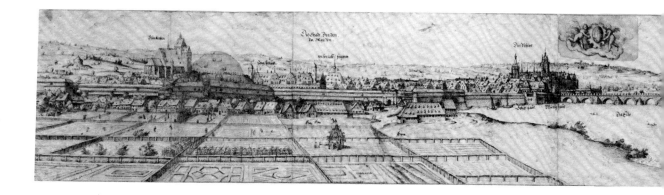

Dresden: Images of a City

ENTRIES BY: Glaubrecht Friedrich [1-3, 8, 9]

Harald Marx [4]

Angelo Walther [5-7, 10]

Hans Joachim Neidhardt [11]

Gertraute Lippold [12]

Waltraut Schumann [13, 14, 17, 19]

Hans-Ulrich Lehmann [15, 16, 18]

Gabriel Tola
Brescia 1523—Dresden 1583

1. New Dresden and Old Dresden Seen from the East (before 1572)

Pen and brown ink on darkened paper, 250 x 1965 mm.
Dresden, Institute and Museum for the History of the City of Dresden, no. 00

This oldest view of the town was the source for the print by Franz Hogenberg in Georg Braun's *Civitates orbis terrarum*, Cologne, 1572. Rising above the city wall, from left to right, are the Gothic Kreuzkirche (Church of the Holy Cross, built 1492-98, destroyed 1760), the Zeughaus (Arsenal, today's Albertinum) of 1563, the Frauenkirche (Church of Our Lady, demolished 1727), and the Renaissance castle. To the right of the river Elbe is Altendresden (later renamed Dresden-Neustadt) with its Dreikönigskirche (Church of the Three Kings), built after 1404. Records show that the stone bridge across the river was in place as early as 1287.

Georg Jakob Schneider
D. Nuremberg 1721

2. The Residence of the Electors of Saxony, the Castle at Dresden

Etching, 424 x 335 mm.
Illustration from: *Antonius Weck, Der Chur-Fürstlichen Sächsischen weitberuffenen Residentz und Haupt-Vestung Dresden Beschreib: und Vorstellung.* Nuremberg, 1680, p. 31
Kupferstich Kabinett inv. no. Sax. top. II, 1, 4

This etching is after a wooden model of the castle made about 1620. Built in several sections, beginning in 1530, the castle is one the earliest and most important Renaissance buildings in Germany. Its sgraffito decorations were created shortly after 1550 by the brothers Tola and Francesco Ricchino.

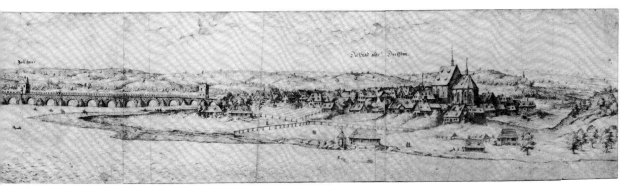

1

Johann Alexander Thiele
Erfurt 1685—Dresden 1752

3. View of Meissen (1726)

Etching, 365 x 555 mm.
Kupferstich Kabinett inv. no. A 27276

On the Elbe about thirty kilometers downriver from Dresden, Meissen was the political and eccelesiastical center of Saxony during the Middle Ages, before Dresden became the ducal residence in 1485. The Albrechtsburg, the citadel of Meissen, was founded in 928 and built in its present form between 1471 and 1485. From 1710 to 1865 the Meissen porcelain factory was located in the Albrechtsburg.

Johann Alexander Thiele

4. View of Dresden with the Augustus Bridge

Inscribed at lower right: Prospect von der alt. und Neu Stadt Dresden, zu sammt der Brücken ad vivum pinx par A Thielen, 1746
Canvas, 104 x 153 cm.
Gal. no. 3660. Originally in the Paintings Gallery; transferred to the Royal Chief Court Marshal's Office' 1870; in the Royal Palace or the adjacent Taschenberg Palace, 1914; presented by the House of Wettin to the State Theater, 1924; transferred back to the Paintings Gallery, 1967

At the right, still under construction, one sees the Catholic Hofkirche (Court Church) by Gaetano Chiaveri, and the cupola of the new Frauenkirche (Church of Our Lady), by George Bähr. The Augustus Bridge was rebuilt by Pöppelmann between 1727 and 1731. On the Neustadt bank, at the left end of the bridge, is the Blockhaus of Zacharias Longuelune (built 1730-

32). This impressive picture can be classed with Bellotto's views of Dresden, although it is different in conception. Thiele's buildings appear simply as elements within the landscape, whose rhythm is the determining factor of the composition, while in Bellotto's work, the architecture determines the picture's structure. The desire of the Court to preserve the architectural image of the city in paintings attracted Bellotto to Dresden, and may also explain why Thiele turned to architectural landscape painting.

2

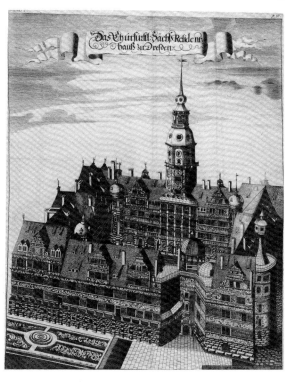

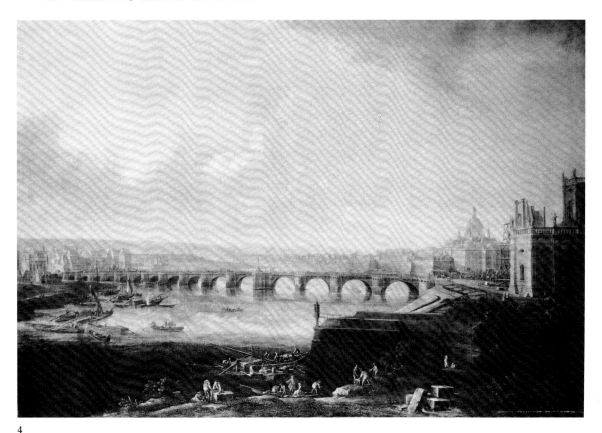

4

Bernardo Bellotto, called Canaletto
Venice 1721 — Warsaw 1780

5. Dresden from the Right Bank of the Elbe, below the Augustus Bridge

Signed at bottom center: Bernardo Bellotto detto/
Canaletto F. ano. 1748
Canvas, 133 x 237 cm.
Inventory of 1754: I 543
Gal. no. 606

This painting shows the characteristic skyline of Dresden, its basic features determined by the building programs of the first half of the eighteenth century. The sandstone bridge, one of the oldest and at that time largest stone bridges in Germany, had been rebuilt by Pöppelmann, the architect of the Zwinger, only a few years earlier. Above the bridge is the Brühlsche Terrasse, named after Count Heinrich von Brühl, who had commissioned a number of the important buildings and formal gardens that were constructed along the Elbe bank on the site of the former Jungfernbastei, a bastion of the old city fortifications. Among the new buildings one recognizes the long, single-storied

Brühlsche Gemäldegalerie, Brühl's private paintings gallery, for which Bellotto painted a second set of city views. Further to the right is the Palais Brühl and next to it the Palais Fürstenberg, where, a few years later, the Academy of Fine Arts was located. In the background looms the cupola of the Protestant Frauenkirche, built 1726-43. To the right of the bridgehead, in front of the Residenzschloss and partly obscuring it, is the Catholic Hofkirche, built 1738-55 by the Roman architect Chiaveri. To the left, in the distance, one sees the steeple of the Kreuzkirche at the Altmarkt. Beyond the nave of the Hofkirche is the Schlossturm, the tower of the Residenzschloss.

Bernardo Bellotto

6. The New Market at Dresden as Seen from the Moritzstrasse (1749/50)

Canvas, 135 x 237 cm.
Inventory of 1754: I 541
Gal. no. 613

This view is dominated by the dome of the Frauenkirche. The architect George Bähr had the dome built

entirely of stone, a construction technique that was unusual for the area, and that at first caused deep concern over the dome's stability. The rotunda with its fusion of altar area and space for congregational use answered the demands of Protestant doctrine, at the same time that the cupola, modeled on that of the Santa Maria della Salute in Venice, contributed the desired Italian note. In front of the church is the Guard building, erected in 1715 and destroyed in 1760 during the bombardment by the Prussians. The gallows and wooden stocks served the purposes of military justice. The structure on the left, with its Renaissance gables, is the Gewandhaus (Garment House, originally the home of the cloth trade), where the shops of shoemakers and butchers were located. Here, too, the Landtag (House of Representatives) held its sessions, while at other times it housed theatrical performances. At the extreme right is the Türkenbrunnen, or Turks' Fountain, surmounted by Irene, the goddess of victory, commemorating the defeat in 1683 of the Turks at Vienna, where Saxon troops were the majority of the relieving army. Behind the Gewandhaus, in the distance, is one strongly foreshortened side of the Stallgebäude, the wing of the palace that housed the Paintings Collection after about 1731.

Bernardo Bellotto

7. The Old Market as Seen from the Schlosstrasse, Dresden (1749-51)

Delivered to the Gallery by the artist in 1751
Canvas, 137 x 238 cm.
Gal. no. 614

From the Schlosstrasse (Castle Street), the east and south sides of the market square spread out before the viewer, while to the west is a much foreshortened view of the City Hall, recognizable by its roof turrets. In the background is the late Gothic Kreuzkirche, its spire finished 1579-84. This church was destroyed in 1760 during the Prussian bombardment and was rebuilt in the neoclassical style. The many-storied buildings around the square reflect the prosperity of their owners, noblemen and burghers alike. Many are still Renaissance in style, and almost all display the shingled roofs of shops and merchants' booths on the ground floor. The second to last house on the east side was the old Marienapotheke (Pharmacy of St. Mary's). In later years the painter Anton Graff and the composer Carl Maria von Weber, lived in the third house from the left on the south side. The low building at the

6

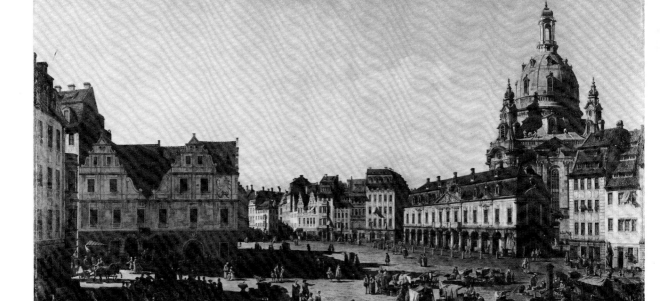

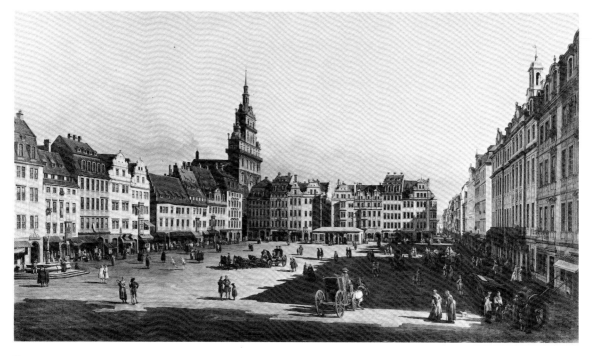

7

south end of the square was the headquarters of the Rats-Chaisenträger (the sedan-chair carriers), whose business was the transportation of both persons and goods. In the left foreground is the Justitiabrunnen (Fountain of Justice). The wooden barrels near the entrance to the City Hall hold water to extinguish fires. The royal coach, drawn by six horses, rolls across the square, which bustles with other vehicles and pedestrians. Two runners clear the way for the coach.

Johann August Corvinus
Leipzig 1683—Augsburg 1738

8. Moritzburg Castle (1733)

Engraving, 528 x 845 mm.
Kupferstich Kabinett inv. no. Sax. top. V-VIII, 2

The hunting château of the rulers of Saxony, thirteen kilometers north of Dresden, built 1542-46 for Elector

8

Moritz, was rebuilt and enlarged (1723-36) by Matth-
äus Daniel Pöppelmann, at the order of Augustus the
Strong. In this view we see an unrealized project for
the château by Zacharias Longuelune.

Christian August Günther
Pirna 1759—Dresden 1824

9. Pillnitz Castle (c. 1800)

Etching, colored, 510 x 700 mm.
Kupferstich Kabinett inv. no. Sax. top. V-VIII, 7

A Lustschloss, or pleasure palace, built 1720-21, after
designs by Matthäus Daniel Pöppelmann, for Augus-
tus the Strong, located on the right bank of the Elbe,
upriver from Dresden. The baroque architecture has
exotic characteristics in keeping with the current fash-
ion for chinoiserie. The castle belongs to the Staatliche
Kunstsammlungen, Dresden, and is now the seat of
the Museum for Decorative Arts.

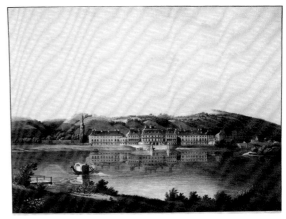

9

Bernardo Bellotto

10. Ruins of the Church of the Holy Cross

Signed at bottom center BERNAR: BELOTO DE CANALETTO. FEC.
A. MDCCLXV

10

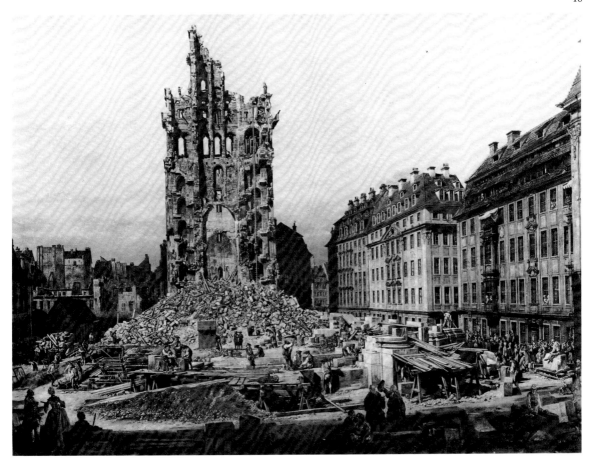

10. *continued*

> Delivered by Bellotto to the Academy of Fine Arts in 1765.
> In 1885 transferred to the Paintings Gallery
> Canvas, 80 x 110 cm.
> Gal. no. 638

In 1760, during the Seven Years War, 226 buildings within the inner city, as well as the suburbs outside the city walls, were destroyed by the Prussians under Frederick II. One of the casualties of the bombardment was the Kreuzkirche; only the lower part of the steeple was left intact. It was planned that this part should be integrated into the reconstruction, which began in 1764. On 22 June 1765, however, the eastern wall collapsed. A journeyman bricklayer named Künzelmann volunteered to climb the ruin and start the necessary demolition. For this he used ladders made of a single upright pole with inserted rungs. Bellotto, who had lost his own house and property in the siege, climbed the endangered steeple to better comprehend the destruction of this area of the city. The ruined building, its skeleton like an open corpse, has been represented by Bellotto with unsurpassed realism, offering, together with the burned-out houses in the background, a striking image of the desolation wrought by war. In contrast, new sandstone blocks appear in the fore-ground, ready for the foundations. Bellotto has documented very clearly the technology of the reconstruction work and has portrayed workmen and spectators in a lifelike fashion. Though he was under contract for a fixed salary and was expected to produce his paintings without extra compensation, he was given 200 thalers for this painting, "out of compassion."

Johann Christian Clausen Dahl
Bergen, Norway, 1738—Dresden 1857

11. Dresden under a Full Moon

Signed bottom center: Dahl 1839
Oil on canvas, 78 x 130 cm.
Gal. no. 2206 D

This view is one of a series painted for Count Colloredo, the Austrian ambassador in Dresden; other views are in collections in Hannover (1841) and Bergen (1838 and 1843). The silhouette of the Altstadt with the Frauenkirche, the Hofkirche, and the palace tower is easily recognizable. Dahl's vantage point on the Neutstadt bank was the same as the one selected by Bellotto for his panorama of 1748 (5).

11

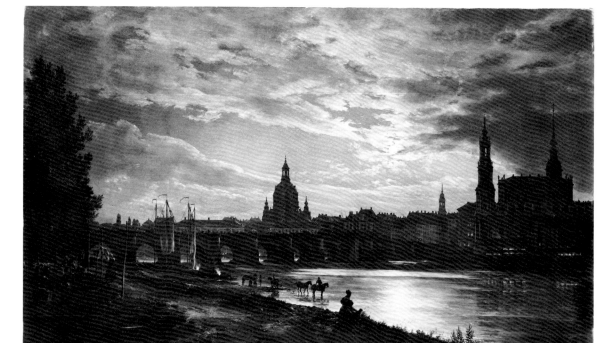

Heinrich Walter

Active Heidelberg 1841

12. Bird's-eye View of Dresden (c. 1855)

After a drawing by Adolph Eltzner
Lithograph in two colors, white paper, 365 x 600 mm.
Kupferstich Kabinett inv. no. Sax. top. I,5,17

Looking south from the Neustadt, one sees the
Zwinger (with its moat filled in), the first Opera House
by Semper (1841), the Hofkirche, and the Brühlsche
Terrasse in the center of the city. In the suburbs there
are indications of growing industrialization—factories
and railroads. The Leipziger Bahnhof (railroad sta-
tion), constructed 1837-39 for the first long-distance
railroad on the Continent, is at the far right, and at the
top is the Böhmische Bahnhof, constructed 1850-52,
today the Hauptbahnhof (main railroad station).

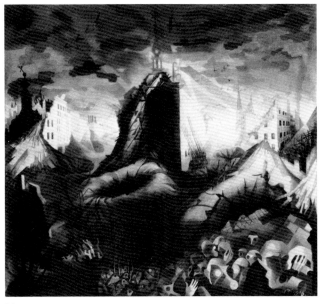

14

Gotthardt Kuehl

Lübeck 1850—Dresden 1915

13. The Augustus Bridge in Snow (before 1899)

Signed bottom left: Gotthardt Kuehl
Oil on canvas, 75.5 x 110 cm.
Gal. no. 2324

At the far left of the Brühlsche Terrasse, partly cropped
by the edge of the picture, is the Opera House. Prior to
his appointment as professor at the Dresden
Academy, in 1895, Kuehl had lived in Paris, where he
had been in close contact with French impressionism.
As a result of this experience he exerted an important
influence on the Dresden art scene at the beginning of
the twentieth century.

Hans Grundig

Dresden 1901-58

14. The Thousand-year Reich (Triptych):
Central Panel, Vision.

Signed, bottom right: H. Grundig 1936
Canvas, 130 x 152 cm.
Gal. no. 2981

Consisting of three large panels and a predella, this is a
key work of German antifascist art. The first panel,
Karneval, shows a weirdly masked bogey, driven by
fear and crime; the second, *Vision,* depicts the destruc-
tion of cities; in the third, *Chaos,* wolves hold sway.

The predella represents, according to the artist's
widow—herself an important graphic artist—*The
Sleepers* and embodies the warning: "Do not sleep, or
you will burn."

Wilhelm Rudolph

Chemnitz (today Karl-Marx-Stadt) 1889—lives in
Dresden
From the cycle **Dresden Destroyed** 1945/46

15. Corner of Schnorrstrasse and
Gutzkowstrasse

Pen and ink with graphite, 314 x 430 mm.
Kupferstich Kabinett inv. no. C 1959-87

16. Rietschelstrasse

Pen, ink, and wash, with graphite, 108 x 436 mm.
Kupferstich Kabinett inv. no. C 1959-95

The entire old city center was involved in the air raid
on Dresden, 13 February 1945. A few days later,
Rudolph began his cycle of documentary sketches, to
which he devoted a year and a half, producing in all
150 drawings. Without sentimentality, he factually il-
lustrated the historic phenomenon of a completely
destroyed city.

Wilhelm Rudolph

17. Dresden Destroyed

Signed bottom right: W. Rudolph 1952
Canvas, 110 x 150 cm.
Gal. no. 2986

This painting is a bitter comment on the destruction of
a culture. The central image is the wrecked Frauen-
kirche; the surviving fragments still suggests its
baroque beauty while the interior of the church is like a
huge wound. The row of houses to the right of the
church is surmounted by the dark tower of the City
Hall. The houses seem to be coming to life mysteri-
ously under changing lights and shadows, while men
have beaten a path to the church through the waste-
land of the ruins.

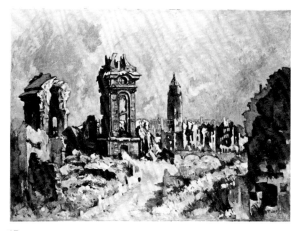

17

Otto Dix

Untermhaus near Gera 1891—Hemmenhofen, Boden-
see, 1969

18. The Hofkirche with the Opera House (1955)

Pastel, gray paper, 480 x 643 mm.
Kupferstich Kabinett inv. no. C 1969-89

This sketch, which originated during one of Dix's
yearly visits to the lithograph workshop at the Dres-
den Academy, is to be understood as an indication of
his attachment to the city in which he had lived from
1909 to 1933. It conveys an impression of the conserva-
tion work then going on in the historic buildings
around the Theaterplatz.

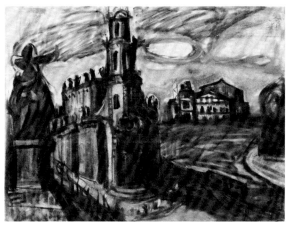

18

Bernhard Kretzschmar

Döbeln 1889—Dresden 1972

19. Dresden from the Räcknitzhöhe (1969-72)

Pressboard, 101 x 164 cm.
Museum der Bildenden Künste, Leipzig, inv. no. 2353

Kretzschmar belongs to the same generation of artists
as Wilhelm Rudolph. Emerging from late impres-
sionism, and briefly involved with expressionism,
they developed a painterly style, which in its use of flat
bright colors was characteristic of the art produced in
Dresden until about 1970. In this picture the view
opens from the hills south of the city, the Räcknitz-
höhe, toward the new Dresden. Among the lightly
colored groups of newly constructed buildings looms
the tower of the City Hall. This view, painted so re-
cently, is already an historical document; since it was
painted an electrical plant and apartment houses have
been built in the field immediately below the hill.

LITERATURE

Anton Weck, *Der Chur-Fürstlichen Sächs. weitberuffenen Resi-
dentz- u. Haupt-Vestung Dresden Beschreibung u. Vorstellung.*
Nuremberg, 1680.

Iccander, *Auf dem höchsten Gipfel seiner Vollkommenheit und
Glückseligkeit prangende Königliche Dresden in Meissen.* Leip-
zig, 1726.

Benjamin Gottfried Weinart, *Topographische Geschichte der
Stadt Dresden.* Dresden, 1777; reprint Leipzig, 1974.

Johann Christian Hasche, *Umständliche Beschreibung Dresdens
mit allen seinen äussern und innern Merkwürdigkeiten, his-
torisch und architektonisch.* Leipzig, 1781.

Karl Wilhelm Dassdorf, *Beschreibung der vorzüglichsten
Merkwürdigkeiten der Churfürstlichen Residenzstadt Dresden
und einiger umliegenden Gegenden.* Dresden, 1782.

*Beschreibung der Königlich-Sächsischen Residenzstadt Dresden
und der umliegenden Gegend für Fremde bearbeitet.* Dresden,
1807.

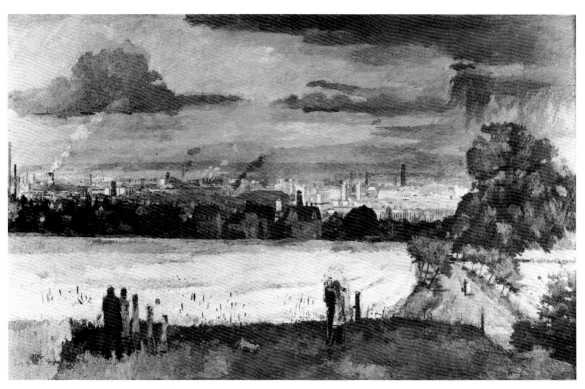

19

Wilhelm Adolph Lindau, *Dresden und die Umgebung*. Dresden, 1820.

Karl Justi, *Winckelmann in Deutschland*. Leipzig, 1886.

Oscar Doering, *Des Augsburger Patriciers Philipp Hainhofer Reisen nach Innsbruck und Dresden*. Vienna, 1901.

Cornelius Gurlitt, *Die Kunstdenkmäler Dresdens*, 21-23. Volumes in series. Dresden, 1903.

Cornelius Gurlitt, *Die Kunstdenkmäler von Dresdens Umgebung*, 24. Volumes in series. Dresden, 1904.

Mary Endell, *Dresden. History, stage, gallery*. Dresden, 1908.

Paul Schumann, *Dresden*, 46. Volume in series. Leipzig, 1909.

Georges Servières, *Dresden*. Paris, 1911.

Alfred Lichtwark, *Deutsche Königsstädte*. Berlin, 1912.

Erich Haenel and Eugen Kalkschmidt, *Das alte Dresden. Bilder und Dokumente aus zwei Jahrhunderten*. Leipzig, 1941.

Eberhard Hempel, *Gaetano Chiaveri. Der Architekt der katholischen Hofkirche zu Dresden*. Dresden, 1955.

Fritz Löffler, *Das alte Dresden. Geschichte seiner Bauten*. Dresden, 1955.

Hubert Georg Ermisch, *Der Dresdner Zwinger*. Dresden, 1956.

Lothar Kempe, *Schlösser und Gärten um Dresden*. Dresden, 1957.

Werner Lange, *Die Frauenkirche zu Dresden*. Volume in series *Das christliche Denkmal*. Berlin, 1959.

Eberhard Hempel, *Der Zwinger zu Dresden. Grundzüge und Schicksale seiner künstlerischen Gestaltung*. Berlin, 1961.

Helmut Fränzel, *Moritzburg*. Dresden, 1962.

Hans Joachim Neidhardt, *Schloss und Park Pillnitz*. Leipzig, 1964.

Waltraud Volk, *Dresden. Historische Strassen und Plätze heute*. Berlin, 1974.

Fritz Löffler, *Der Zwinger in Dresden*. Leipzig, 1976.

Gerhard Schmidt, *Dresden und seine Kirchen. Eine Dokumentation*. Berlin, 1976.

The Dresden Kunstkammer, or "cabinet of curiosities," was founded in 1560 by Elector Augustus I and occupied rooms on the top floor of the electors' palace. Embracing both natural and man-made objects, it embodied the late medieval and Renaissance encyclopedic vision of the world. Although the Kunstkammer no longer exists—Augustus the Strong transferred its contents to several independent collections in 1721—its inventories, dating from 1587, permit a re-creation of its appearance.

Like similar cabinets of other German princes, the Dresden Kunst-kammer reflected the specific tastes and interests of its owners, notably in its many scientific and technical objects, since Saxony, a country rich in minerals, owed much of its early importance to mining and manufacturing. But along with its mechanical instruments and clocks, its tools and natural-history specimens, the Kunstkammer contained works of art in a variety of media, including paintings by Cranach, prints by Dürer and Lucas van Leyden, and Filarete's statuette of Marcus Aurelius, the earliest dated Italian Renaissance bronze. It was the Kunstkammer, then, that established the concept of art collecting at the court of Saxony.

The Electoral Kunstkammer

The name Kunstkammer was given to the private museums that some German princes began to establish after 1550. These were something more than simply private collections in that they were, to a degree, open to the public. At a time when sources of information of any kind, not to mention actual scientific instruments, were still quite rare, a Kunstkammer encouraged the improvement and advancement of the sciences and arts. A Kunstkammer was also useful, of course, in demonstrating the cultural attainments of a prince's state.

At first entirely a German phenomenon, the Kunstkammer differed from all other contemporary types of collections by virtue of its universality. Everything was included in it that—in the eyes of that past world—appeared to be remarkable and worthy of attention and study. No distinction was made between objects provided by nature or manufactured by man, nor was there a differentiation among artistic, technical, or scientific objects; all, insofar as they were of interest in any way, were considered to be products of one universal creativity. Beyond this common base, these princely collections differed considerably, one from another. To begin with, as private collections, they reflected the personal interests and tastes of their founders and owners, and in the course of generations, such interests and tastes naturally changed. Obviously, the character of the princely Kunstkammer during the sixteenth century was primarily scientific, but a century later the emphasis had generally shifted to collecting for the prestige of the state.

This was the case with the Kunstkammer in Dresden, founded in 1560. In its first inventory, made in 1587 on 317 double pages, the objects are mostly implements and scientific instruments. Hundreds of tools—for gardening and the chase, for work in wood and metal, all of them executed in the most elegant fashion and richly decorated—were assembled in company with surgical instruments, instruments for astronomy and ballistics, musical instruments, and even objects used in magic rituals. Evidently, the intention was to encompass every variety of human activity that in some way depended upon the use of instruments. Particularly numerous were small cabinets, similar to the ebony specimen with silver mountings in our exhibition (97), containing sometimes hundreds of extraordinary objects in their many drawers. Often the cabinets were designed to double as writing desks, and they were equipped with quills, inkwell, and pounce box. Some contained scales,

measuring devices, fishhooks, weights, and drinking vessels made of such rare and exotic materials as coconuts, ostrich eggs, and nautilus shells.

Among the objects from the natural world in the Dresden Kunstkammer was a splendid collection of mineral specimens, the showpiece of which was a cluster of emeralds from Colombia. For this, Augustus the Strong later ordered a blackamoor figure to be carved as a stand (291). Notable among the scientific instruments were the clocks, the mechanics of which embodied the comprehensive astronomical knowledge of the period. They indicated the hours and minutes, months and days, the changing lengths of days and nights through the seasons, the courses of the planets, the signs of the zodiac, the days of the saints for the entire year, the phases of the moon, and on top of all this, some of these programmed machines could serve as alarm clocks. An excellent specimen of the type is shown in the clock (36) made, according to its inscription, by Master Andreas Schellhorn in Schneeberg, one of the centers in the south of Saxony famous in the sixteenth century for its silver mines. Related to the clocks were the automata, designed to ride clattering across a banquet table, say, while their finely tuned clockwork made them execute unpredictable gestures and maneuvers. Next to the automata on the Kunstkammer's shelves were hundreds of lathe-turned ivory goblets. Shortly after 1600 the mechanic-artists of Dresden succeeded in inventing lathes that carved practically any shape desired. The ingenious products of these machines were greatly admired. The seventeenth-century lathes differed not at all from modern automated lathes in ability, but only in the sorts of material they could shape.

The portable work table with tool kit of Elector Johann Georg I (97), who reigned from 1611 to 1656, is a significant monument to the mechanical sciences, which had been held in the highest esteem since Copernicus, Kepler, and Galileo. As was befitting the ruler of one of the most highly industrialized countries in Europe, the Elector was fascinated by mechanical skills and techniques. He himself practiced lathe-turning of ivory into the most complicated shapes. He even carried his tool kit with him to the remote châteaux he visited on official travels through his dukedom.

Taken together, these varied objects present a picture of the Renaissance as it developed north of the Alps, a Renaissance directed not toward classical and sensual artistic beauty, but toward speculative scientific thinking. By means of the newly developed sciences and technologies, results were achieved of a precision of execution and functional quality not previously known. The technical and scientific revolution documented in the Dresden Kunstkammer is the one that has today produced computers and space flights.

The fine arts were not as prominently represented in the collection as might appear from the selections in our exhibition. Such works were then regarded less as art than as documents or as evidence for the solution of some technical problem. Examples of such documents were the bust of Elector Christian II by Adriaen de Vries (52), Dürer's print of a rhinoceros (128), the portrait of Elector Moritz by Lucas Cranach the Younger (112), and the portraits of Luther and Melanchthon from the workshop of Lucas Cranach the Elder (110, 111). The fact that the

Saxon rulers were perfectly satisfied with workshop portraits of the two great heroes of the Reformation indicates that the important thing for them was not the unique work of art as such, but its function as a document. Or consider the beautiful bronzes by Giovanni di Bologna, sent from Florence to Dresden as a gift in 1585: these were doubtless regarded first of all technically, as models for the most modern and elegant manner of representing the movements of the human body. Such works were useful for study by goldsmiths, sculptors, architects, and painters, all of whose creations served official or ceremonial purposes but were not considered to be works of art in their own right.

The Dresden Kunstkammer was founded in 1560 as one of the first collections of its kind. It scientific-technical character was dominant until 1600, when the emphasis shifted toward a more determined demonstration of the prestige of the state. Works of art began to be acquired in greater numbers only in the second half of the seventeenth century. In 1720 Augustus the Strong decided that the objects suitable for the newly created specialized museums should be removed from the Kunstkammer. What remained could be viewed there until 1835, when the collection was sold at auction.

JOACHIM MENZHAUSEN

The Electoral Kunstkammer

ENTRIES BY:

Gerald Heres and Werner Kiontke [20-46, 49-51, 53-72]

Martin Raumschüssel [47, 48, 52]

Dieter Schaal [73-93]

Gisela Haase [94-97]

Klaus Peter Arnold [98-100]

Friedrich Reichel [101-105]

Harald Marx [106-114]

Anneliese Mayer-Meintschel [115]

Glaubrecht Friedrich [116-129, 131]

Christian Dittrich [130, 132]

Goldsmiths' Work

20. Drinking horn, "Greifenklaue" (Griffin's Claw)

Nuremberg (?), end 14th c.
Horn, silver gilt, enamel
H. 34, L. 48 cm.
Inv. no. IV 333

21. Drinking horn, "Greifenklaue," with coat of arms of von Salza family (Thuringia)

German, 14th c.
Horn and silver gilt
H. 31.2, L. 46 cm.
Inv. no. IV 331

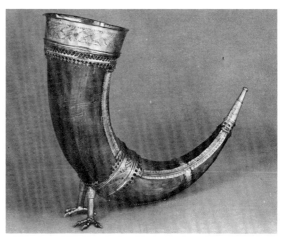

21

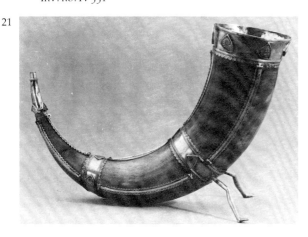

22. Drinking horn, "Greifenklaue," resting on birds' claws

German, beginning 15th c.
Horn and silver gilt
H. 30.1, L. 40.7 cm.
Inv. no. IV 324

23. Double cup

German, 15th c.
Jasper, silver gilt
H. 16.1 cm.
Inv. no. V 523

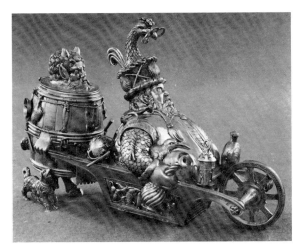

On the reverse is an arithmetical table labeled "tabula Pythagorea" and examples of arithmetical calculation. Jamnitzer was both a pioneer of Renaissance art in Germany and an innovator in methods of stamping and casting. His contemporaries praised his novel use of cast ornaments made from nature: "And what they cast in silver and use for decorating silver vessels—tiny animals, little worms, plants, and snails—had never been heard of before."

26. Nautilus cup in shape of sailing ship

Hans Anton Lind
Nuremberg, c. 1600
Nautilus shell, silver, parcel gilt
H. 40.2 cm.
Inv. no. III 149

24. Wheelbarrow group

Christoph Lindenberger (master 1546, d. after 1573)
Nuremberg, c. 1550
Silver gilt
H. 19 cm.
Inv. no. IV 337

The devil, dressed in a wine barrel, pushes an obese glutton—according to one of the inscriptions "God Bacchus" himself—in a wheelbarrow. The barrel is hung with kitchen ware and meats; a small bell is attached to its bottom. Bacchus wears a cuckold's cap decorated with pilgrims' scallop shells and carries a wine bottle in his hand. Before him are a lantern and a pilgrim's bottle. Barrel and wheelbarrow are inscribed with rhymes in which Bacchus proclaims: "I took my pleasure with beautiful wenches so much that now I have to be carried along like this" and "Therefore let my Epicurean life be recommended to everybody. Whenever he is thirsty, even early in the morning, he will find me ready to join him night or day."

25. Casket containing writing implements

Wenzel Jamnitzer (1508-85, master 1534)
Nuremberg, 1562
Silver, parcel gilt, velvet, rock crystal, ebony, enamel, ore
H. 31, W. 24, D. 11 cm.
Inv. no. V 599

This entered the Kunstkammer in 1623 from the legacy of Sophie, widow of the Elector Christian I. The reclining figure of a woman on the cover, a personification of Philosophy, holds a tablet with a eulogy to Science in Latin: "Science revives mortal things in man's memory; she builds true monuments to the arts and recalls to life what had sunk into darkness—1562."

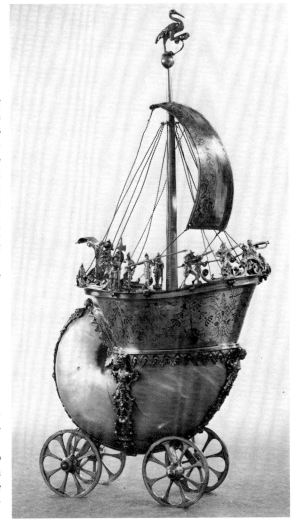

27. Plate

Zöblitz, c. 1600
Red serpentine
D. 24 cm.
Inv. no. 1967/2

28. Traveling chest

Box probably Persian
Mounts by Elias Geyer (master 1589, d. 1634)
Leipzig, before 1602
Mother-of-pearl on wood, silver gilt, black putty filler,
 velvet
H. 26.8, L. (without the lion feet) 38.5, W. (without the
 feet) 22.6 cm.
Inv. no. III 247

The interior consists of several compartments and
drawers with tableware and toilet articles, writing
equipment, gaming chips, etc.

29. Drinking vessel in shape of an ostrich

Elias Geyer
Leipzig, before 1610
Ostrich egg, silver
H. 46 cm.
Inv. no. III 115

30. Drinking vessel in shape of a basilisk

Elias Geyer
Leipzig, before 1610
Shell, silver gilt, traces of polychromy
H. 33 cm.
Inv. no. IV 158

31. Barrel with seven nested beakers

Martin Borisch (1583-1649)
Dresden, before 1650
Silver, parcel gilt
H. 26.3 cm.
Inv. no. IV 346

32. Drinking vessel in shape of a frigate

German, mid-17th c.
Rock crystal, silver, parcel gilt
H. 37.7 cm.
Inv. no. V 296

33. Cup with dragon handle

German, second half 17th c.
Chalcedony, silver gilt
H. 11 cm.
Inv. no. V 468

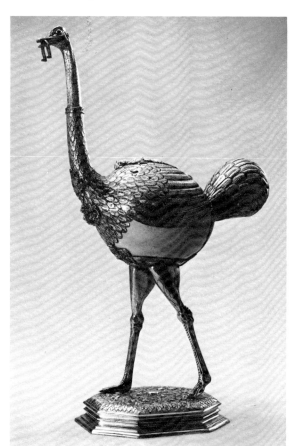

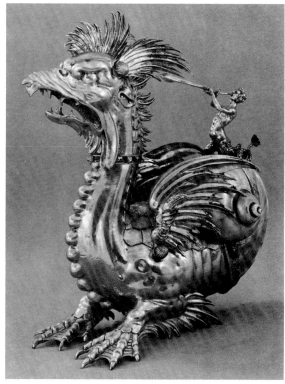

30

34. Drinking cup with bust of African woman

German, end 17th c.
Agate with brownish spots, silver gilt, diamonds
H. 19.5 cm.
Inv. no. V 11

35. Cup with stem in form of a male figure

Probably Dresden, end 17th c.
Saxon jasper, silver gilt
H. 17.5 cm.
Inv. no. V 122

36. Astronomical clock

Andreas Schellhorn
Schneeberg (Saxony), 1570
Brass gilt and silver
H. 39 cm.
Inv. no. IV 3

Originally surmounted by a silver globe. On each side is a dial, its function explained in a Latin inscription on the pedestal. The clock indicates the temporary or un-equal hour, the sign of the zodiac, the day of the year, the day according to the calendar of saints, the month, the equal hour, counting from one through twelve and from one through twenty-four, and the quarter hour. It also has an astrolabe dial and an alarm setting. This is probably the only surviving work by Schellhorn. Its type suggests that he learned his trade in Augsburg, or else was a journeyman there.

37. Automaton clock with pelican

Tobias Reichel
Dresden, beginning 17th c.
Brass, silver, steel
H. 11 cm.
Inv. no. IV 96

38. Astronomical clock

Augsburg, mid-17th c.
Copper gilt, steel, brass, silver, enamel
H. 42 cm.
Inv. no. IV 285

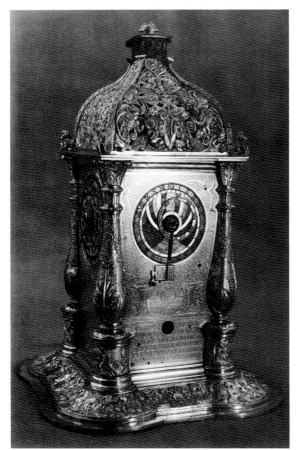

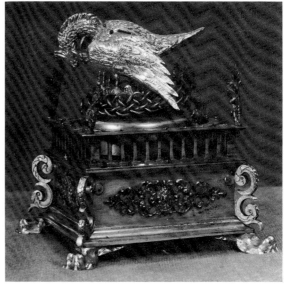

37

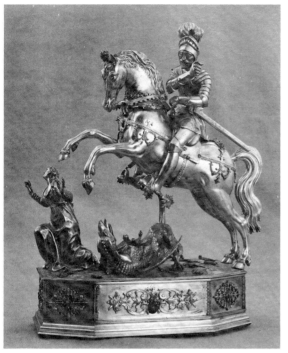

39

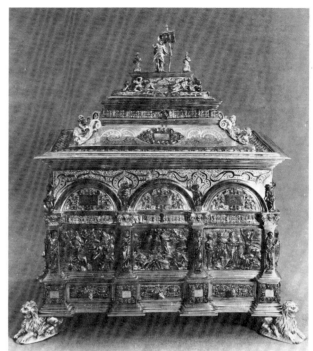

40

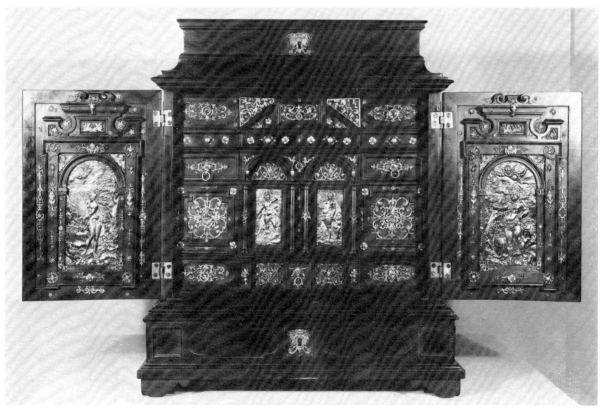

41

39. Automaton with Saint George

Joachim Fries
Augsburg, c. 1600
Silver, parcel gilt
H. 40 cm.
Inv. no. IV 154

40. Jewelry casket with Resurrection scene

South German, c. 1570
Copper gilt, brass, and silver, parcel gilt
41 x 37 x 28 cm.
Inv. no. IV 33

41. Jewelry cabinet

Anton Eisenhoit (?)
Marburg, c. 1600
Ebony, silver
H. 60, W. (open) 84, D. 53.5 cm.
Inv. no. I 35

42. Jewelry casket

Boas Ulrich
Augsburg, c. 1600
Ebony, silver gilt
30.5 x 24.5 x 18 cm.
Inv. no. I 39

43. House altar

Hans Kellerthaler
Dresden, 1608
Silver, ebony
H. 104 cm.
Inv. no. I 18

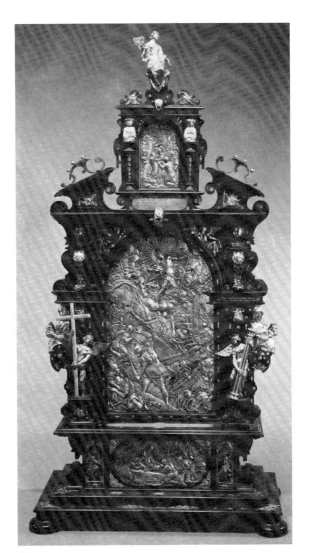

43

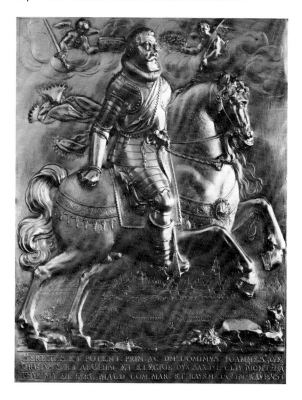

44. Relief with equestrian portrait of Elector Johann Georg I, view of Dresden in background

Sebastian Dattler
Dresden, 1622
Silver, ebony
33.4 x 28.8 cm.
Inv. no. I 22

45. Relief with full-length portrait of Elector Christian I

Sebastian Dattler
Dresden, 1623
Silver, copper gilt, ebony
30.3 x 24.3 cm.
Inv. no. I 28

46. Relief: Adoration of the Shepherds

Daniel Kellerthaler
Dresden, 1637
Silver, wood, stained black
37.7 x 31.5 cm.
Inv. no. I 21

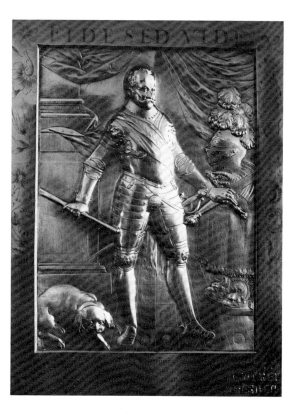

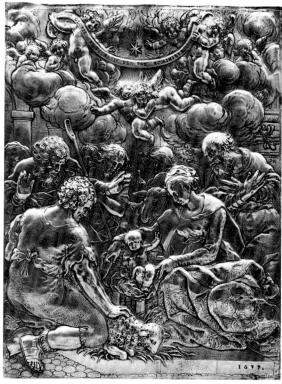

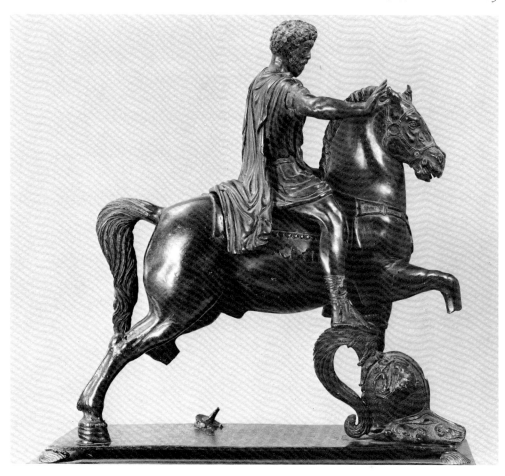

Bronzes

Antonio Averlino, called Filarete

Florence c. 1400—probably Rome c. 1469
Active Florence, Rome, Milan

47. Marcus Aurelius on Horseback

On plinth, Filarete's dedicatory inscription to Piero de'
 Medici, dated 1465
Bronze, hollow cast; blackish brown natural patina
H. 37.1 cm.
Sculpture Collection inv. no. H 155/37

A reduced copy of the antique equestrian statue of the emperor Marcus Aurelius now on the Capitoline Hill in Rome, this bronze was presented in 1465 as a gift from Filarete to his benefactor Piero de' Medici. It follows that this is the earliest signed and dated small bronze of the Renaissance, although the figure could have been created during Filarete's earlier activity on the bronze doors of St. Peter's in Rome, about 1440-45. If so, it would be likely that he cast a new plinth in 1465 with the inscription and the disproportionately large helmet, introduced as a support and showing the earliest Renaissance representation of the rape of Dejanira by the centaur Nessus. The result of a spiritual coming-to-terms with antiquity, this bronze can be considered the first Renaissance statuette in the truest sense. The artist produced, not a mechanical copy, but a free recreation adapted according to the principles of small sculpture; the enamel inlay and gilding on the horse's headgear give it the character of a precious object. The piece was received by Christian I about 1585 as a gift from Guglielmo Gonzaga, Duke of Mantua.

49. Leaping Unicorn

Augsburg, c. 1570-80
Bronze
H. 37.8 cm.
Inv. no. IX 51

50. Dog Scratching

South German, c. 1600
Bronze
H. 6 cm.
Inv. no. IX 17

Adriano Fiorentino
Florence 1440/50-99

48. Bust of Elector Frederick of Saxony

Signed inside: HADRIANUS · FLORENTINUS · ME · FACIEBAT
Dated: ANN(O) · SALUT(IS) · MCCCCLXXXXVIII
Inscription on front: FRIDERICUS · DUX · SAXONIAE · SACRI · RO ·
IMPERII · ELECTOR
Bronze of a brassy color. H. 62.7 cm.
Sculpture Collection inv. no. H.1/1

Probably originally part of the old décor of the castle of
Hartenfels, above Torgau, one of the residences of
Frederick the Wise, this bust came to Dresden around
1815. There is little likelihood that Adriano modeled
and cast the bust in Saxony—the claim that he worked
in Saxony cannot be substantiated. From 1497 to 1498
Elector Frederick stayed mostly in the entourage of
Emperor Maximilian in the Tirol and in southern Ger-
many. The cast medal of Degenhard Pfeffinger, the
chamberlain who accompanied Frederick the Wise,
was created by Adriano at about this time, probably in
connection with the bust. With this portrait bust, the
prototypical Italian Renaissance bust first came to the
north.

Adriaen de Vries
The Hague 1545 — Prague 1626
Active Italy, Augsburg, and, after 1601, Prague

51. Nymph and Faun

Bronze
H. nymph 34.6, faun 48.2 cm.
Inv. nos. IX 20, IX 36

From the estate of the court architect Giovanni Maria
Nosseni, who possibly brought the group from Italy in
1588. The faun's pose derives from an antique figure.
The nymph, who holds what remains of an oval mir-
ror, shows similarities with the work of Giovanni
Bologna, teacher of de Vries.

Adriaen de Vries

52. Bust of Christian II, Elector of Saxony

Inscription: ADRIANUS FRIES HAGENSIS FECIT 1603
Bronze, hollow cast; dark brown lacquer patina. H. 95.6
cm.
Sculpture Collection inv. no. H 1/4

Christian II received this as a gift from Emperor Rudolf II on the occasion of a visit to Prague in 1607. The head seems to have been modeled after an earlier prototype, as—according to the evidence of contemporary pictures—Christian wore a full beard from 1601 on. The composition of the bust, with two supporting nude figures flanking the base, goes back to a bust of Charles V in Vienna, executed by Leone Leoni in 1555. The interlocked hands of the socle figures and the bundle of arrows under the coat of arms are symbols of harmony testifying to the good will between Christian and Rudolf II, whose likeness appears on the medallion on the young Elector's chest.

Ivories

53. Beaker with cover

Dresden, before 1586
Ivory, silver gilt
H. 33.2 cm.
Inv. no. II 328

Believed to be the work of Elector Augustus himself, this once held hunting whistles. On the cover are the Elector's coat of arms and name, in verre eglomisé.

51

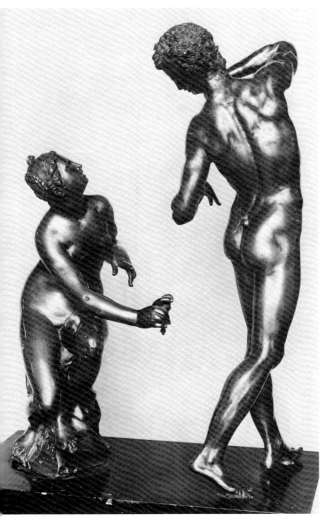

52

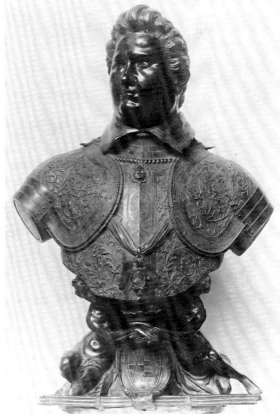

54. Beaker with cover

Dresden, 1586
Ivory
H. 17.3 cm.
Inv. no. II 65

This unfinished piece, which bears the initials of Elector Augustus, is said to be his last work made on the lathe.

55. Virtuoso carving (Kunststück)

Georg Wecker
Dresden, 1587
Ivory
H. 21.7 cm.
Inv. no. II 34

In the shape of a goblet on three globular feet; the goblet appears to be composed of four nested beakers.

56. Virtuoso carving

Georg Wecker
Dresden, 1588
Ivory
H. 22.2 cm.
Inv. no. II 260

In the shape of a goblet with hemispherical cup, a spiral finial on the cover.

57. Cup and cover

Georg Wecker
Dresden, 1588, signed and dated
Ivory
H. 20.2 cm.
Inv. no. II 318

58. Virtuoso carving

Egidius Lobenigk
Dresden, 1588
Ivory
H. 52.2 cm.
Inv. no. II 7

Carved on an ornamental lathe in the shape of a spiral column, this is crowned by a tetrahedron with a spike rising from each of its upper surfaces.

59. Virtuoso carving

Egidius Lobenigk
Dresden, 1590
Ivory
H. 32.8 cm.
Inv. nos. II 242, II 266

Carved on an ornamental lathe, this consists of two oval goblets, one upside down upon the other.

60. Virtuoso carving

Egidius Lobenigk
Dresden, 1590
Ivory
H. 16 cm.
Inv. no. II 184

In the shape of a flat oval dish on a triangular convex foot.

61. Small cabinet

Anton Örtel
Dresden, c. 1620
Ivory, gold
H. 16.5 cm.
Inv. no. II 269 kk

62. Musicians quarreling

German, mid-17th c.
Ivory, wood
H. 31.6 cm.
Inv. no. II 40

After a print by Jacques Bellange.

63. Venus with a mirror

Probably Melchior Barthel
Dresden, c. 1670
Ivory, mirror glass
H. 30.5 cm.
Inv. no. II 335

64. Venus and Amor

Augsburg, end 17th c.
Ivory, silver gilt, verre eglomisé
H. (with base) 32 cm.
Inv. no. II 426

65. Apollo

Augsburg, end 17th c.
Ivory, silver gilt, verre eglomisé
H. (with base) 32 cm.
Inv. no. II 425

66. Cup and cover

Dresden, c. 1600
Ivory
H. 16.6 cm.
Inv. no. II 356

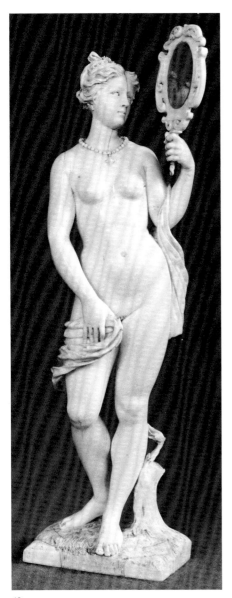

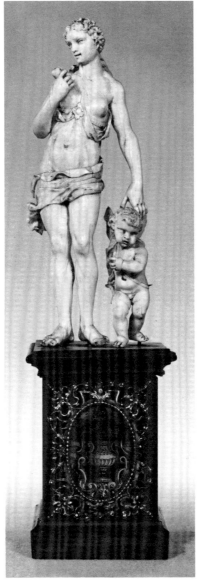

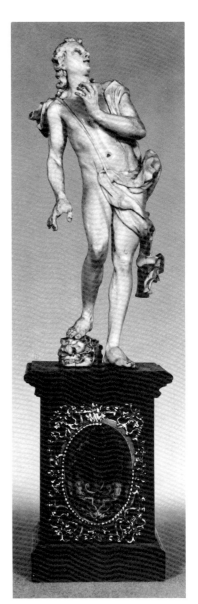

63

64

65

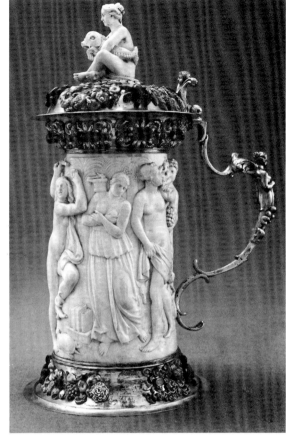

67

68

67. Tankard with representation of women bathing

Dresden, first half 17th c.
Ivory, silver gilt
Carved in the manner of Leonard Kern
Mounts by Martin Borisch
H. 33.2 cm.
Inv. no. II 22

68. Tankard with allegory of the Five Senses

Augsburg, c. 1670
Ivory, silver gilt, enamel
Carved in the manner of Leonard Kern
Mounts by Johann Heinrich Mannlich
H. 38 cm.
Inv. no. II 29

69. Tankard, equestrian portrait of Elector Johann Georg III on cover

Dresden, c. 1690
Unidentified maker's mark on silver mounting
Ivory, silver gilt
H. 27 cm.
Inv. no. II 27

Amber

70. Candlestick

Königsberg, c. 1600
Amber
H. 16.5 cm.
Inv. no. III 105

71. Hexagonal bottle with screw top

Königsberg, c. 1680
Amber
H. 23.5 cm.
Inv. no. III 97

72. Casket with allegorical figure of seated woman with an eagle

Danzig, end 17th c.
Amber
H. 23.5 cm.
Inv. no. III 90

Tools

73. Coping or veneer saw blade

Matthes Schwerdtfeger
Dresden, 1564
Steel, etched, with blackened background, parcel gilt
L.161.5, W. 9 cm.
HMD II/85

74. Fret saw

Nuremberg, 1560-70
Steel, etched, with blackened background, parcel gilt;
 lathe-turned, engraved bone grip
L. 26.8, W. opening 11.5 cm.
HMD II/87

75. Spoon bit

Nuremberg, 1560-70
Steel parts etched and chiseled, with blackened back-
 ground, parcel gilt; lathe-turned with carved wooden
 base
L. 37 cm.
HMD II/90

76. Auger bit

Nuremberg, 1560-70
Steel parts etched, with blackened background, parcel
 gilt; wooden handgrip, carved and lacquered
L. 88 cm.
HMD II/91

77. Jack plane

Nuremberg, 1560-70
Boxwood, carved; steel blade, etched, with blackened
 background
L. 32, W. blade 3.7 cm.
HMD II/2

78. Block plane

Nuremberg, 1560-70
Steel, etched, with blackened background
L. 12.7, W. blade 3.9 cm.
HMD VII/166

79. Block plane

Nuremberg, 1560-70
Steel, etched, with blackened background
L. 12.6, W. blade 3.2 cm.
HMD VII/165

71

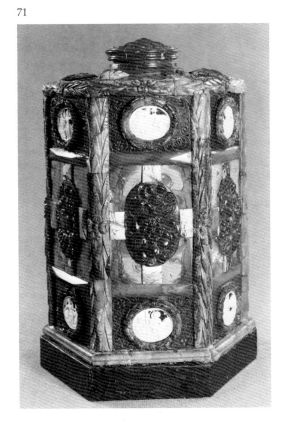

78, 79

80. Ax

Nuremberg, 1560-70
Steel blade, etched, with blackened background; wooden
 handle with engraved bone inlay
L. 28 cm.
HMD III/29

81. Tinderbox

Nuremberg, 1560-70
Steel, etched, with blackened background
9.8 x 7.1 x 2.4 cm.
HMD VII/31

82. Tinderbox with wheel lock

Nuremberg, 1560-70
Steel, etched, with blackened background; gilded
 wheel-cover
HMD VII/33

83. Shears

Steel, etched, with blackened background, carved
 wooden handles with bone mounts
Nuremberg, 1560-70
L. 21.3 cm.
HMD VII/72

84. Drill

Steel shaft, etched, with blackened background; brass
 ball, engraved; lathe-turned and carved wooden
 crossbeam, leather straps
Nuremberg, 1560-70
L. 30.2 cm.
HMD VII/82a

85. Thread-cutter for screws

Boxwood, carved with masks and cartouches
Leonhard Danner
Nuremberg, 1560-70
L. 12.8 cm.
HMD Ia 2

86. Folding multipurpose tool

Iron, etched, with blackened background; 14 individual
 tools of bright steel
Balthasar Hacker
Dresden, c. 1565
15.7 x 3.7 x 3.6 cm.
HMD II b5

87. Anvil

Iron, etched, with blackened background
Leonhard Danner
Nuremberg, 1560-70
W. 13.1, H. 21.1 cm.
HMD V/201

88. Ax

Steel blade, etched, with blackened background; wooden
 handle with engraved staghorn inlay
Nuremberg, 1560-70
L. 47.5 cm.
HMD III/30

89. Spoon bit

Nuremberg, 1560-70
Steel, lathe-turned wooden haft
L. 110.5 cm.
HMD III/95

84

86

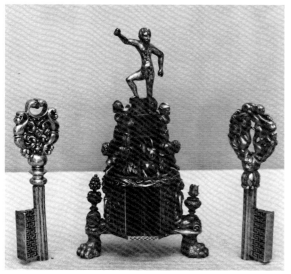

93

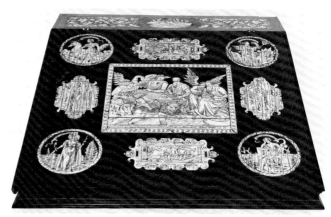

94

90. Spoon bit

Nuremberg, 1560-70
Steel, lathe-turned wooden haft
L. 124.5
HMD III/96

91. Bow saw

Nuremberg, 1560-70
Steel, etched, with blackened background; lathe-turned
 wooden handle with iron ferrule
L. 40.5, W. opening 19.5 cm.
HMD E 101

92. Lock with two keys

Bartholomäus Hoppert (?)
Nuremberg, c. 1675
Iron, chiseled and partly pierced
H. 9, L. keys 12.3, 12.6 cm.
HMD C 5

93. Lock with two keys

Bartholomäus Hoppert
Nuremberg, 1675
Iron, chiseled, upper part cast; gilded figurine of Vulcan
H. 22, L. keys 14.8, 15.2 cm.
HMD C 6

Furniture

94. Portable writing desk of Electoress Anna

Nuremberg, dated 1568
Pine, veneered with ebony, cedar, and kingwood; inlaid
 with engraved ivory; interior veneered with Hungarian
 burl ash; gilded brass mounts
17.4 x 50 x 55 cm.
Inv. no. B 1

Mentioned in the 1732 inventory of the Kunstkammer.
In 1838 it was among the objects displayed in the entr-
ance hall of the Historical Museum. In 1959 it was
transferred to the Museum for Decorative Arts. It be-
longs to a group of desks with ivory and mother-of-
pearl inlays of similar workmanship, all probably
made in Nuremberg. The decoration shows the four
evangelists with their symbols and the inscription: EN
TIBI PRAECONES FIDEI IMMORTALIA CUDUNT ARDUA. UT ALTI VOLANS
ALES. MORTALIA TAURUS: FACTAO DICTA DEI: SEQUITUR SUA SEMINA
QUISQUE FACTO, LEO: CANTAUGELUS, ABDITA NOBIS. 15.68; the per-
sonifications of the four temperaments, SANGUINEUS,
COLERICUS, MELANCOLICUS, FLEGMATICUS; the four cardinal
virtues, JUSTICIA, PACIENTIA, FORTITUDO, CHARITA: Pyramus
and Thisbe, Hercules dragging Cerberus from the un-
derworld, Hercules killing the Hydra, inscription HER-
CULES; and birds in floral scrollwork.

95. Chair

Giovanni Maria Nosseni (1544-1620)
Dresden, c. 1580
Pearwood, stained dark brown, carved, gilded, painted in
various colors. Gray green serpentine, inlaid with black
semiprecious stones, yellow and red jasper, agate
jasper (28 of the original 46 stones replaced in man-
made material, 1976). On chair back, portrait medallion
of Julius Caesar inscribed IVLIVS C.I. Inscription on chair
back: CHRISTIANUS. D. G. DUX SAXO. SAC. (front). ROM. IMP.
ARCHIMARSCHAL. ET ELECTOR (back)
111 x 49 x 48 cm.
Inv. no. B 22

One of twelve chairs, commissioned in 1576 and
among the earliest works by Nosseni in which he
made use of Saxon semiprecious stones. The chairs
proved to be some of the most sumptuous examples of
German late Renaissance seat furniture ever made.
The first example was shown to the Elector Augustus

for his approval in 1579, but the set was not completed
until 1586. It was placed in the newly built rooms of the
Stallhof in 1591. Only seven of the chairs still exist.

96. Chair

Giovanni Maria Nosseni
Dresden, c. 1590
Pearwood, stained dark brown, carved, gilded, painted in
various colors. Gray green serpentine, semiprecious
stones, yellow and red jasper, agate jasper (16 of the 33
original stones replaced in man-made material, seat
partly restored in Kalloplast, 1976). Inscription on chair
back: CHRISTIANUS. D. G. DUX SA: ET ELECTOR
107 x 49 x 52 cm.
Inv. no. B 33

Nosseni's set of twelve chairs consists of two groups,
one lavishly incrusted with stones and bearing a por-
trait bust of a Roman emperor, the other more sparsely
incrusted, lacking the portrait bust, and making more
use of painted decoration. No. 96 is one of the second
group.

97. Traveling service and multipurpose tool box of Elector Johann Georg I

Style of Philipp Hainhofer
Augsburg, before 1636
Top: pine veneered with oak and Macassar ebony, with
engraved silver inlays (Augsburg hallmarks and un-
known master's mark: Rosenberg III/555)
Chest: pine veneered with walnut, oak, Macassar ebony
Top: 145 x 97.4 cm.
Chest: 43 x 79 x 54 cm.
Inv. no. B 5

The top of the box is inlaid with engraved figural silver
decorations: Coriolanus and the women (center field);
Mucius Scaevola before Porsenna, Aeneas and Dido,
the sacrifice of Marcus Curtius, Aeneas carrying his
father Anchises (framing panels); also arms and
trophies. The tool box, opening in front, contains
about 250 different objects: hunting equipment, toilet
articles, surgical and apothecary instruments, pain-
ters', gardeners', and lathe-turners' tools, and equip-
ment for arts and crafts.

Exhibited tools and instruments:

1. On rear wall:
 Jack, iron, blued, L. 35 cm.
 Carbine hook, iron, blackened scroll ornament, L.
 14 cm.
 Pulley hook, iron, blued floral scrolls, L. 10.2 cm.

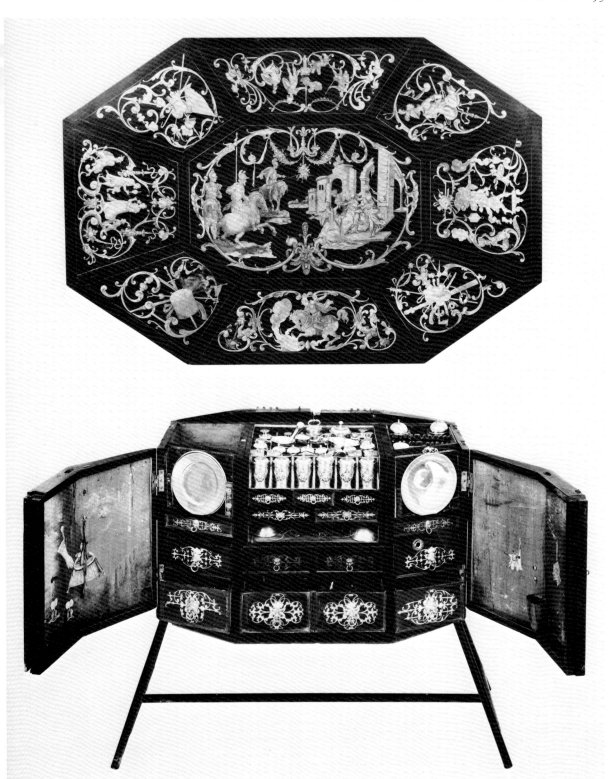

2. Apothecary's instruments in central removable part of top:

Four bottles with screw tops, glass with silver gilt covers, H. 10.5, 7, 7, 8 cm.

Bottle with screw top, silver gilt, H. 11.5 cm. Augsburg hallmarks and unidentified master's marks (Rosenberg III/555).

Covered beaker with strainer and funnel, silver gilt, H. beaker 10.5, strainer 6.5, funnel 6.1 cm. Augsburg hallmarks and mark of Tobias Leuckhardt, (1580-1632) (Rosenberg III/481).

Hourglass, glass, silver gilt, H. 6.9 cm.

Mortar with pestle, brass, silver gilt, H. mortar 6.4 cm., L. pestle 11.5 cm.

Barber's lamp, silver, parcel gilt, engraved, H. 4, L. 12.1 cm. At spout, Augsburg hallmark and mark of Tobias Leuckhardt.

Two cube-shaped jars, each with cover, silver, parcel gilt, H. 4.6 cm. At bottom, Augsburg hallmark and mark of Tobias Leuckhardt.

Three apothecary's jars, cylindrical, each with cover and soldered-on scrollwork mask. Silver, parcel gilt, H. 7.6 cm. At bottom, Augsburg hallmark and mark of Tobias Leuckhardt.

3. Tools in lower drawer below central section:
Wood-carving knife, steel, L. 27.5 cm.
Vise, iron, L. 16 cm.
Door crank, iron, H. 20 cm.
Plane, iron, L. 11.3, H. 11.5 cm.
Turning lathe, iron, H. 19, L. 24 cm.

4. Tools in second drawer on right side:
Ax, steel, ebony, L. 23 cm., detachable handle.
Two hammers, steel, ebony, L. 25.21 cm., detachable handles.

5. Tools in first section third drawer on right side:
Clamp with two screws and nuts, iron, H. 9, W. 10.5 cm.
Fret saw, steel, L. 12.3 cm.
Plane blade, steel, L. 13.7, W. 3.1 cm.
Draftsman's pen with earspoon, iron, L. 15.6 cm.
Six wood chisels, steel, L. 12, 11.3, 10.2, 10.7, 11.2, 9.4 cm.
Two screwdrivers, iron, L. 10.5, 11.8 cm.
Three scoop chisels, steel, L. 10, 11, 11 cm.
Four hand chisels with oblique edges, steel, L. 13, 12, 7, 10.3 cm.
Wood-carving knife, steel, L. 11 cm.

6. Tinderboxes in second section third drawer on right side:
Tinderbox with wheel lock, iron, partly blued, L. 12 cm.
Tinderbox, iron, L. 7 cm.
Powder flask with spanner, iron, L. 10.8 cm.

7. Vintner's tools in second drawer on left side:
Double digging blade, iron, L. 19 cm.
Pruning knife, steel, L. with grip 17.5 cm.
Haft for knife, iron, L. 8.5 cm.
Bow saw with two blades, steel, ebony, L. saw with handle 34.5, blade 14.8 cm.
Pruning shears, steel, ebony, L. with grip 35.5 cm.

All grips and handles detachable.

8. Farrier's tools in third drawer on left side:
Coarse file for hoof, steel, L. 22 cm.
Hammer for shoeing horses, steel, L. 22 cm.
Scoop, steel, L. 26.7 cm.
Nippers, steel, L. 22.5 cm.
Trimming tool, steel, L. 24 cm.

9. In compartments behind the doors on the right and left:

Plate, silver gilt, D. 15 cm. Augsburg hallmark and unknown maker's mark (Rosenberg III/555)

Dish, silver gilt, D. 16 cm. Augsburg hallmark and unknown maker's mark (Rosenberg III/555)

Presumed to be one of the group of multipurpose traveling pieces made in Augsburg at the instigation of Philipp Hainhofer, this box was reportedly delivered to the Dresden Kunstkammer in 1636 by the goldsmith and cabinetmaker Theodosius Haesel (1595-1658), in charge of the Kunstkammer from 1628 on. A similar piece, the work table of the Electoress Magdalena Sibylla, wife of Johann Georg I, is also in the Museum for Decorative Arts.

Ceramics

98. Candlestick

Italian, Faenza (?)
1619-38
Maiolica
H. 17 cm.
Inv. no. 38 223

With nos. 99 and 100, part of a large table service made for Johann Georg I. Round foot decorated with gadroons, bowl-shaped bobèche, and baluster-shaped

99. Ewer

Italian, Faenza (?)
1619-38
Maiolica
H. 25.8 cm.
Inv. no. 38 226

Small round foot, egg-shaped body with vertical ribs, short neck, thick lip. The hoop-shaped handle is in the form of two confronted C-shapes. At the shoulder, a sculptured spout painted in high-fired colors: purple, blue gray, yellow, brown, olive green; the outline in purple, the yellow and olive green partly restored. Beneath the spout, the full coat of arms of the Elector flanked by naked putti, each carrying a vessel from which flames issue. Above, a naked cupid (amor?), stylized flowers, and scrolls. On the back, a crouching grotesque female figure with wings and outspread arms.

socket. On the foot is the full coat of arms of the Elector with mantling on either side, under a foliate crown painted in blue, yellow, brown, manganese black, and olive green. The shield contains the Elector's territorial arms and arms of pretension.

100. Oval dish

Italian, Faenza (?)
1619-38
Maiolica
7 x 50 x 35.6 cm.
Inv. no. 38 176

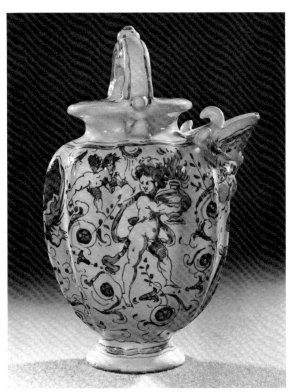

On the oval boss in the center, the full coat of arms of the Elector. Painted with a hilly landscape and an ostrich hunt. The principal colors, light blue and ocher, are supported by blue gray, olive green, and manganese purple. Strong reddish brown is applied as overglaze paint. Nos. 98-100 were transferred in 1962 to the Museum for Decorative Arts.

101. Boat-shaped lamp with representation of the deity of literature, K'uei Hsing

Chinese, Ching-tê Chên
Mid-16th c.
Unglazed porcelain with enamel colors and gilding
 (gilding mostly lost)
H. 9.5, L. 11 cm.
Inv. no. P. O. 3791

One of a group of porcelains that entered the Kunstkammer in 1590 as a present from the Grand Duke of Tuscany. Chinese porcelains seemingly being then unknown in Dresden, the pieces were catalogued as Italian in the inventory of 1595. K'uei Hsing, according to legend, was a brilliant but extraordinarily ugly scholar to whom an official career was denied after he passed the state examinations. When, in despair, he drowned himself in the Yangtze, he was placed among the stars as a god.

102. Small round bowl

Chinese, Ching-tê Chên
Mid-16th c.
Porcelain with cobalt blue underglaze painting inside,
 iron red and gilding (gilding mostly lost) outside
H. 6, D. 12 cm.
Inv. no. P.O. 7916/N. 737

One of four similar bowls (two of which have disappeared) included in the gift from Florence.

103. Small round bowl with figural scenes

Chinese, Ching-tê Chên
Mark and period Chia Ching (1522-66)
Porcelain with cobalt blue underglaze painting
H. 7.3, D. 12.3 cm.
Inv. no. P.O. 1869/N. 75

A bowl of similar type, also painted inside with lotus and herons, was in the gift from Florence. The present bowl was in the Dutch Palace of Augustus the Strong in 1721. Although the Elector, like contemporary French collectors, wanted to acquire old porcelain, it seems doubtful that the true age of this bowl was recognized in his time.

104. Vase with lotus vines and plum blossoms

Chinese, Ching-tê Chên
Mark and period Chia Ching (1522-66)
Porcelain with cobalt blue underglaze painting and
 yellow enamel
H. 21 cm.
Inv. no. P.O. 3716

105. Bottle or tea caddy painted with lotus on blue background and flowers in leaf-shaped reserves

Chinese, Ching-tê Chên
Mid-17th c.
Porcelain with cobalt blue underglaze painting
H. 21.4, W. 9.8 cm.
Inv. no. P.O. 2873

Paintings

Lucas Cranach the Elder
Kronach 1472 — Weimar 1553
German school

106. Saint Catherine (c. 1516)

Lindenwood, 138 x 46 cm.
Inventory of 1722: B 261
Gal. no. 1906 E

Lucas Cranach the Elder

107. Saint Barbara (c. 1516)

Lindenwood, 138 x 46 cm.
Inventory of 1722: B 260
Gal. no. 1906 F

These companion panels may have entered the Kunstkammer in 1588 from the estate of Lucas Cranach the Younger. In 1722 they were recorded as by an unknown master. Attributed to the Cranach workshop in the mid-nineteenth century, by 1884 they were accepted as works of the elder Cranach himself. Friedländer and Rosenberg saw in the extremely elongated figures a resemblance to the idealized figures of Jacopo de Barbari. Since the two panels are wings of an altarpiece, and since neither bears the signature with the serpent, we can assume that Cranach signed the lost central panel.

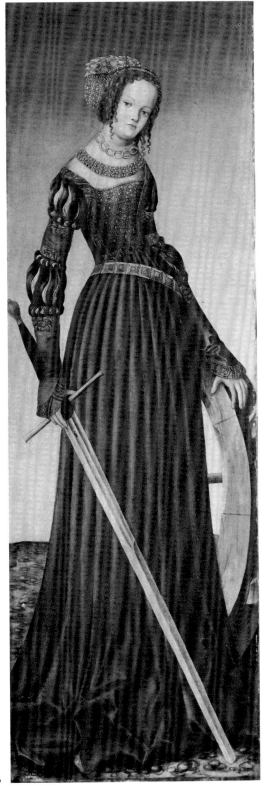

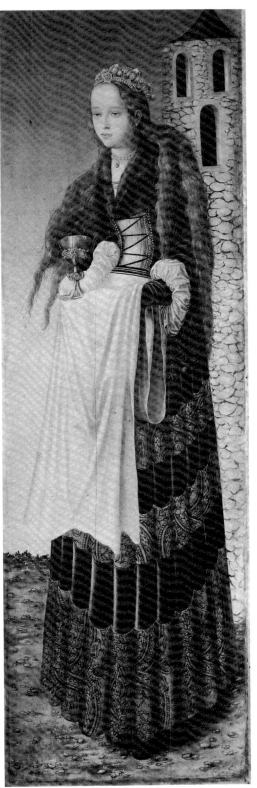

106

107

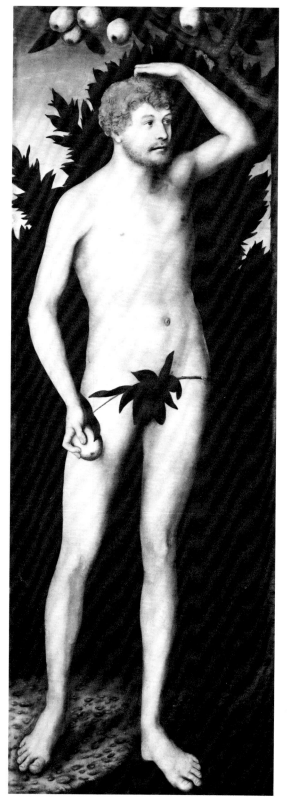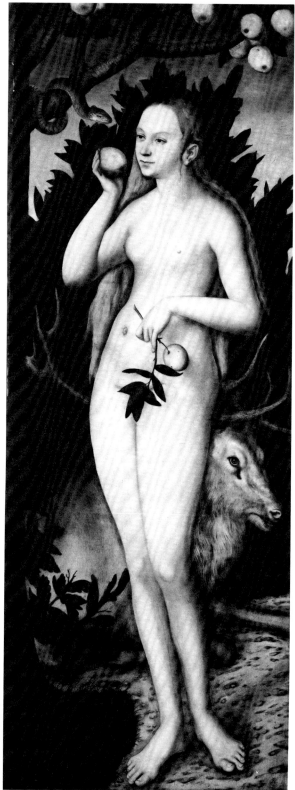

Lucas Cranach the Elder

108. Adam

Lindenwood, 171 x 63 cm.
Inventory of 1722: B 253. Transferred from the
Kunstkammer to the Paintings Gallery
Gal. no. 1916 A

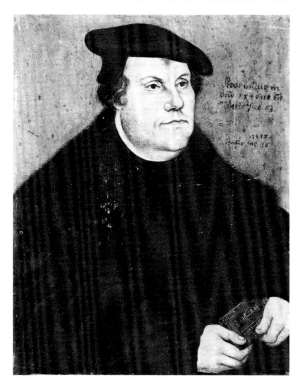

Lucas Cranach the Elder

109. Eve

Signed bottom right corner with serpent with folded
wings
Lindenwood, 171 x 63 cm.
Inventory of 1722: B 250. Transferred from the
Kunstkammer to the Paintings Gallery
Gal. no. 1916 AA

Many paintings of Adam and Eve were produced in
the Cranach workshop. These pendants can be dated
after 1537, on the basis of Cranach's signature. Fried-
länder and Rosenberg believe that all Adam and Eve
panels painted after 1537 should be attributed to
Cranach the Younger; D. Koeplin (verbal opinion,
1970) accepts this attribution.

Workshop of Lucas Cranach the Elder

110. Portrait of Martin Luther

Inscribed top right: Obdormivit in año 1546: 10. Feb.
Aetatis suae 63. 1532. etatis sue 45.
Boxwood, 18.5 x 15 cm.
Inventory of 1722: B 569
Gal. no. 1918

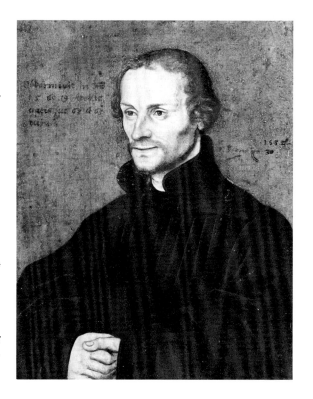

Workshop of Lucas Cranach the Elder

111. Portrait of Philipp Melanchthon

Inscribed at left: Obdormivit in año 1560. 19. Aprilis.
etatis sue 63 et 63 dierum. At right: 1532 etatis sue 30
Boxwood, 18.5 x 15 cm.
Inventory of 1722: B 553
Gal. no. 1919

These companion portraits entered the Kunstkammer
in 1621 from the estate of Giovanni Maria Nosseni.
They were later transferred to the Paintings Gallery.

Lucas Cranach the Younger
Wittenberg 1515—Weimar 1586
German school

112. Portrait of Elector Moritz of Saxony

Signed on left above helmet plume with serpent, dated
 1578
Canvas, 121.5 x 93 cm.
Kunstkammer inventory of 1741: p. 528, no. 8
Kunstkammer inv. no. H 74

With the accession of Moritz (reigned 1521-1553), the
son of Duke Heinrich the Pious, the Saxon Electorate
passed from the Ernestine line to the Albertine line of
the House of Wettin. Moritz fought in the battle at
Mühlberg, 1547, on the side of Emperor Charles V,
against the Protestants allied in the League of Schmal-
kalden. He later abandoned the emperor's cause, and
was killed in the battle at Sievershausen in 1553. This
posthumous portrait, showing him in armor and hold-
ing a war hammer, was based on a model used for
other portraits, such as the life-size, full-figure portrait
of 1554 (Paintings Gallery, no. Mo 2112). It is also
related to the portrait bust in the Sculpture Collection
(no. 1948). The faded, pale colors are typical of the
younger Cranach's late works and give this portrait an
impalpable, unreal quality despite the crispness of the
details.

Zacharias Wehme
Dresden c. 1558—d. 1606
Saxon school

113. Portrait of Elector Augustus of Saxony

Signed, center left: ZW.F.1.5.86
Canvas, 122 x 94 cm.
Historical Museum inv. no. H 208

Until 1886 this portrait was in the library of the
Japanese Palace. It was then in the Paintings Gallery
(no. 1959) until 1920, when it was transferred to the
Historical Museum. The subject, wearing black armor
etched with gold and a red sash with a gold border,
holds in his right hand, shouldered, the Elector's state
sword (shown elsewhere in the exhibition). Augustus
(reigned 1553-1586) was the founder of the Dresden
Kunstkammer. J.-L. Sponsel (*Fürstenbildnisse aus dem
Hause Wettin*, Dresden, 1956, no. 79) has pointed out
that although this portrait was executed in 1586, it
must be based on an earlier model since the head is not
that of an old man. The Elector's sepulchral slab in
Freiberg Cathedral, engraved by Martin Hilliger,
agrees with the present portrait. Details in the paint-
ing, especially the pearl border on the curtain to the
right, show Wehme's liking for precious refinement,
in keeping with the style of court portraits during the
mannerist period.

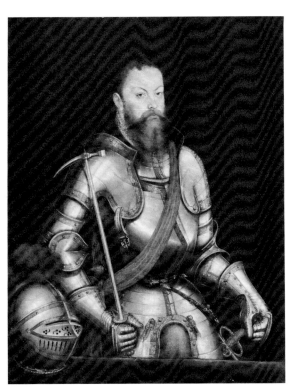

Johann Fink
Freiberg (?) 1628—Dresden 1675
Saxon school

114. Portrait of Elector Johann Georg II of Saxony

Inscribed on reverse: Johann Georg II. von Johann Fink
fecit ad vivum
Canvas, 146 x 118 cm.
Historical Museum inv. no. H. 199 (entered museum in
1928)

Elector Johann Georg II (reigned 1656-80) wears black
armor with gold rivets, a red sash, and, on his chest, a
pendant set with diamonds with the Elector's coat of
arms in the center. This armor and helmet are today in
the Historical Museum. The portrait was painted
about 1670-75, and extols the subject's princely dignity
in a baroque, heavy, somewhat provincial style. Sev-
eral replicas exist. The likeness is based on a model
used by Fink numerous times, for example, in a full-
length portrait of the Elector with one foot on a cannon
(Paintings Gallery inv. no. H 226), and for a double
portrait with Elector Friedrich Wilhelm of Branden-
burg (Paintings Gallery inv. no. H 201).

115

Hans Bol

Malines 1534—Amsterdam 1593
Netherlandish school

115. Abigail before David

Signed and dated on stone, bottom left: HANS BOL 1.5 87
Parchment on oak, 14 x 21.5 cm.
Gal. no. 827

"Sixteen small painted panels" by Hans Bol are mentioned in the Kunstkammer inventory of 1587. This one, acquired later, is first mentioned in the inventory of 1595. The artist was admired for his miniature forest landscapes and the charm of his biblical figures.

Prints and Drawings

Marcus Albrecht (dates unknown)

116. Dedication for the Saint's Day of Duke Johann Georg II, 24 June 1659

Pen, brush, watercolors, gouache on parchment, 401 x 316 mm.
Kupferstich Kabinett inv. no. NIC 1334

With poems praising the Saxon Elector, flanked by Wisdom and Justice.

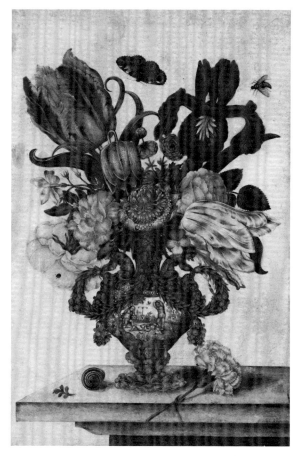

117

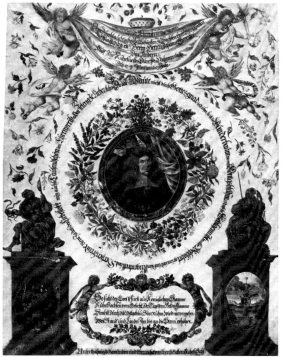

116

German artist of the 17th century, possibly Marcus Albrecht

117. Faience vase with flowers and a snail

Brush, watercolors, gouache on parchment, 382 x 248 mm.
Kupferstich Kabinett inv. no. C 2681

118. Faience vase with flowers and a fly

Brush, watercolors, gouache on parchment, 380 x 249 mm.
Kupferstich Kabinett inv. no. C 2682

Hans Burgkmair the Elder
Augsburg 1473-1531

Triumphal Procession of Emperor Maximilian I (1516-17)

Five double woodcuts from the series, each 390 x 720 mm.
Kupferstich Kabinett inv. nos. A 4866-4897
Literature: Bartsch 81; Franz Schestag, "Kaiser Maximilians I. Triumph," *Jahrbuch der Kunsthistorischen Sammlungen . . .*, Vienna, 1883, p. 154 ff., nos. 1-4, 9-10, 23-24, 27-28.

119. **The herald (right)**
Title page (left)

 Block by Jan Taberit.

120. **The outrider with three mounted pipers (right)**
The drummer on horseback (left)

121. **The outrider of the deer hunters (right)**
Mounted deer hunters with beating sticks (left)

122. **Carriage drawn by camels with musicians**

 Block by Jan Taberit.

124

121

123. **Outrider and horse-drawn carriage with fools and jesters**

 Block by Cornelius Liefrinck.

Burgkmair's drawings were cut by seven different artists. Of the planned 210 illustrations, only 137 were ready at the time of the Emperor's death in 1519, 66 of which were by Burgkmair. The Dresden series of 62 trial proofs in the first state is unique. Various details, especially the banderoles, are not yet finished.

Lucas Cranach the Elder
Kronach 1472—Weimar 1553

124. **Repentance of Saint Chrysostom (1509)**

 Engraving, 255 x 198 mm.
 Kupferstich Kabinett inv. no. A 6718
 Literature: Bartsch 1; Hollstein 1

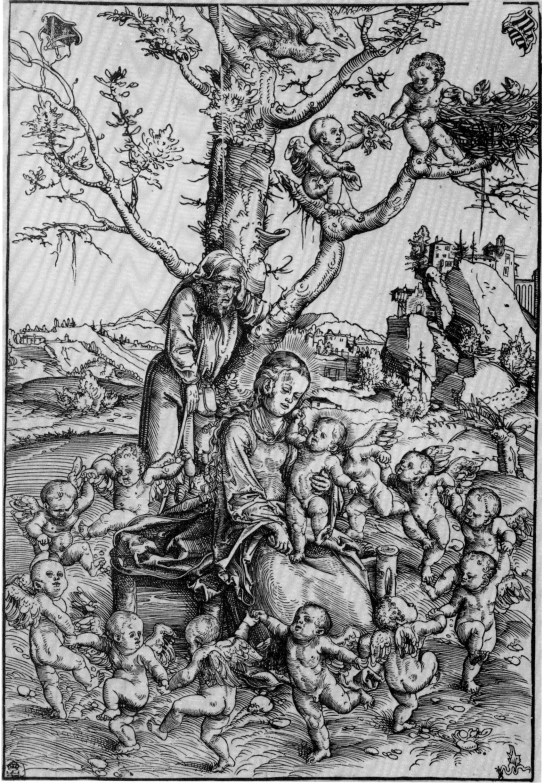

125

127

126

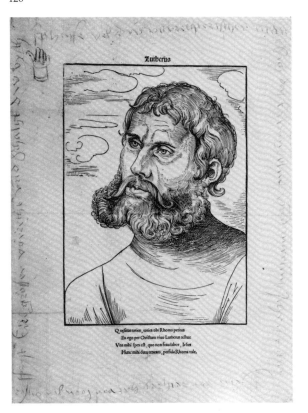

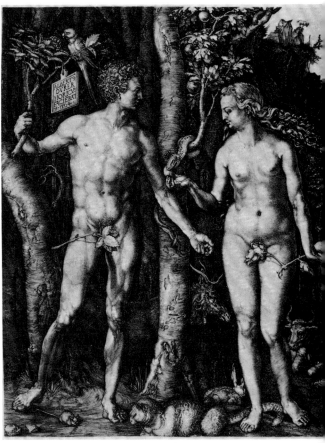

Lucas Cranach the Elder

125. Holy Family in a Landscape (c. 1510-15)

Woodcut, 340 x 238 mm.
Kupferstich Kabinett inv. no. A 5394
Literature: Bartsch 4; Hollstein 8

The court painter of Elector Frederick the Wise in Wittenberg, Cranach added to his woodcuts, besides his winged serpent mark, shields with both Saxon arms.

Lucas Cranach the Elder

126. Martin Luther as Junker Jörg (1522)

Woodcut, 423 x 310 mm.
Kupferstich Kabinett inv. no. A 6645
Literature: Hollstein 132

Placing his art in the service of the Reformation, Cranach created several portraits of his friend Luther. This one was made shortly after the period of 4 May 1521 to 3 March 1522, when Luther, banned by the Worms Reichstag, hid at the Wartburg under the name of Junker Jörg and there translated the New Testament into German.

Albrecht Dürer
Nuremberg 1471—1528

127. Adam and Eve (1504)

Engraving, 245 x 188 mm.
Kupferstich Kabinett inv. no. A 832
Literature: Bartsch 1; Meder 1

Albrecht Dürer

128. Rhinoceros (1515)

Woodcut, 214 x 298 mm.
Kupferstich Kabinett inv. no. A 988
Literature: Bartsch 136; Meder 273

Dürer made this woodcut, of documentary character, after a drawing sent him. An Indian rhinoceros, intended as a gift for the Portuguese king, arrived in Lisbon 20 May 1515, but during the unloading fell off the gangplank and drowned.

Albrecht Dürer

129. Frederick the Wise, Elector of Saxony (1524)

Engraving, 193 x 126 mm.
Kupferstich Kabinett inv. no. A 845
Literature: Bartsch 104; Meder 102

Frederick III (1463-1525), called Frederick the Wise, Elector and Grand Marshal, was one of the most important men of his time in Germany. In 1502 he founded the University of Wittenberg, which became the center of the Lutheran Reformation. A patron of Dürer's, beginning in 1496, he owned a large collection of his paintings. This portrait is based on a silverpoint drawing of 1523 (Winkler 897).

129

128

Lucas van Leyden

Leyden 1494-1553

130. The Magdalen Dance (1519)

Engraving (first state), 287 x 394 mm.
Kupferstich Kabinett inv. no. A 37903
Literature: Bartsch 122; M. J. Friedländer, *Lucas van Leyden*, Berlin, 1963, p. 35

The religious subject has been obscured by the artist to the point that his dancing couples seem more to represent a Garden of Love. By 1664, there were twenty-two engravings by Lucas van Leyden in the Kunstkammer; they were transferred eventually to the Kupferstich Kabinett. In the first catalogue of Lucas' work in the collection, written by Johann Heinrich Heücher, it is said that the *Magdalen Dance* is one of the fourteen sheets for which the German painter Johann Ullrich Mayr "paid to Rembrandt 1400 Guldens."

132

Wilhelm Schober

Active Dresden c. 1675-81

131. Resurrection of Lazarus (1679)

After Jan Lievens
Brush, gouache on parchment, 400 x 314 mm.
Kupferstich Kabinett inv. no. C 1439

Schober was a court painter under Johann Georg III.

Wallerant Vaillant

Lille 1623—Amsterdam 1677

132. Portrait of Johann Georg II of Saxony (1658)

Chalk with highlights in white, blue paper, 549 x 440
mm.
Kupferstich Kabinett inv. no. C 1977-142
Literature: Thieme-Becker, XXXIV, p. 41

One of a series of portraits that Vaillant drew on the occasion of the election of Emperor Leopold I in Frankfort on the Main.

LITERATURE

Tobias Beutel, *Chur-Fürstlicher Sächsischer stets grünender hoher Cedern-Wald . . .* Dresden, 1671; reprint Leipzig, 1975.

Viktor Hantzsch, "Beitrage zur älteren Geschichte der kurfürstlichen Kunstkammer in Dresden," *Neues Archiv für sächsische Geschichte* 23, 1902.

Walter Holzhausen, "Lage und Rekonstruktion der Kurfürstlichen Kunstkammer im Schloss zu Dresden. Zur Geschichte des Grünen Gewölbes und Baugeschichte des Schlosses," *Repertorium für Kunstwissenschaft* 48, 1927.

Joachim Menzhausen, *Dresdener Kunstkammer und Grünes Gewölbe*. Leipzig, 1977.

*C*ontaining some ten thousand pieces, the Armory became a systematic collection in the mid-1500s when royal armor was gathered from various castles and placed under the supervision of a curator in Dresden. The original inventories of the entire holdings are preserved, enhancing the opportunity the Armory provides to study the tastes of a German Renaissance court. The Saxon love of festivals accounts for the splendid array of tournament and parade armor. The jeweled oriental weapons came to Dresden as trophies of victory over the Turks at the siege of Vienna in 1683. The electors of the seventeenth and eighteenth centuries, with their passion for hunting, added the ornate firearms and wheel-lock pistols.

The Armory

The Dresden Armory—or, as the collection has been called since 1832, the Historical Museum—is counted among the oldest collections of arms and armor in Europe. It contains some ten thousand objects of the most diversified types, many of them outstanding masterpieces of the art of the armorer, ranging in date from the beginning of the sixteenth century to the end of the reign of Augustus III (1763): suits of armor, shields, swords, rapiers and other edged weapons, pistols and long guns, hunting weapons and other equipment for the chase, oriental arms, horse harnesses, and lavish costumes from the wardrobes of the dukes, electors, and kings of Saxony. To all this, following the dissolution of the Kunstkammer in 1831, precious glasses, furniture, tools, and other finely made objects or rarities were added.

No exact date can be given for the founding of the Armory. Objects considered worth preserving began accumulating after 1425, when the House of Wettin was endowed with the Electorate. At first these were scattered in castles all over the country. Toward the end of the century the most important of them were gathered together in the palaces of Wittenberg, Torgau, and Dresden, the three residential capitals of the dukes and electors of Saxony. From that period on, these collections were considered to be part of the Saxon state treasure. As early as the reign of the Elector Moritz (1541-53) the collection had become so large that a curator was appointed for it. The Elector ordered rooms set aside in the newly built palace in Dresden, and here the arms and armor were brought together, divided into departments, and housed. One of these departments was the Harnischkammer, which contained the armor, the other was the Rüstkammer, which contained weapons and sundry equipment.

In the course of the sixteenth century it became fashionable for the major princely courts of Europe to build up collections of arms, objets d'art, and rarities as a way of demonstrating their power and wealth. Saxony, as one of the important member-states of the Holy Roman Empire, thanks to its prospering economy and influential political position, was a leader in these enterprises. Moritz' successor, Elector Augustus (reigned 1553-86), began to collect systematically, and it was then that the most important examples of Renaissance art, German and foreign, particularly in the field of the decorative arts, were brought together. Among these were scores of weapons of the highest artistic quality. The most outstanding specimens were placed in the newly founded Kunstkammer; the rest entered the Harnischkammer and Rüstkammer.

There were three basic groups of weapons and armor in this armory. One was a collection of precious arms of great artistic value, either purchased as collectors' pieces or obtained as diplomatic presents. Another was a collection of tournament armor and equipment, which had to be available in quantity for the jousts and mock combats that were

staged so elaborately as court entertainments. Stored in the Harnischkammer, for instance, were more than a hundred suits of tournament armor, fit for every conceivable type of joust and tilt. The third group consisted of the weapons and equipment for the Elector's palace guard—the Trabantengarde—which, in the period of Augustus, numbered about seventy men. Their equipment included armor, helmets, silver-mounted swords, firearms, and accessories. Still another group, consisting of hunting arms and more utilitarian items for the chase, was as a rule not stored in the palace, but kept either in the Jägerhof, the quarters of the Master of the Hunt, or in the hunting châteaux scattered across the country.

As a consequence of the voluminous additions during the thirty-three-year reign of Elector Augustus, the collection required new storage and exhibition space. Augustus' successor, Christian I (reigned 1586-91), ordered a new wing added to the palace. This was the Stallhof, a Renaissance building of generously spacious design, and here the Rüstkammer and Harnischkammer were eventually housed on the upper floor. Christian I continued to collect arms of the finest quality, and during his time leading armorers worked for the court, such as Anton Peffenhauser of Augsburg and the Munich swordsmiths and artists in cut steel Othmar Wetter and Daniel Sadeler, as well as distinguished French and Italian masters and numerous Saxon craftsmen.

During the reign of Christian II (1591-1611) the collection was enriched with extravagantly decorated arms made of precious materials and lavishly jeweled. The succeeding electors, from Johann Georg I through Johann Georg IV, added relatively few objects to the Rüstkammer and Harnischkammer; their interests were more in the field of hunting firearms.

In the eighteenth century, during the reigns of Augustus the Strong and his successors, the Rüstkammer and Harnischkammer were regarded with less interest, although acquisitions continued, particularly in the field of firearms. In the 1720s the Stallhof was reconstructed to give space to the newly founded Paintings Gallery. At the same time a new corridor was built between the Stallhof and the palace, and in this Augustus the Strong established the Gewehrgalerie, gathering into it the precious firearms that had previously been scattered in hunting châteaux and lodges. In this endeavor, as in others, he followed his model, Louis XIV. A firearms collection of unique quality was the result.

After the death of Augustus III (1763), there were few acquisitions of note, and for this reason the chronological and technical development of the historical weapon cannot be studied in the Dresden collection. However, for the very same reason, the Armory or Historical Museum now enjoys an exalted status as one of the very few collections in the world that was completed in its own time and can document its entire holdings with original inventories from the sixteenth century on.

After the collection was handed back by the Soviet Union in 1958, parts of it were shown in a special exhibition, "Preserved for Mankind." Two years later the Historical Museum reopened in the east wing of the Paintings Gallery in the Zwinger.

JOHANNES SCHÖBEL
Director, Historical Museum

The Armory

ENTRIES BY: Dieter Schaal [133-137, 176-203]

Johannes Schöbel [138-175]

133. Life-size mock-up of a tournament (Scharfrennen)

Tournament armors (Rennzeuge):

a. by Siegmund Rockenberger, armorer to the Dresden Harnischkammer, 1554; active before 1554 in Wittenberg; after 1556 in Torgau; d. 1577

> Wittenberg, 1553
> Steel, etched with the arms of the Elector of Saxony
> HMD: M 15

b. by Hans Rosenberger, b. Nuremberg; armorer in Leipzig, 1522-32; armorer to the Dresden court, 1532; d. before 1570

> Dresden, c. 1550
> Steel, etched with the full achievement of arms of Saxony
> HMD: M 14

The horse trappings and other textile elements, as well as the painted parts of the shields, are modern. Scharfrennen was one of the most difficult types of tournament; it needed not only skill, but also a great deal of courage. One aimed to unseat the opponent by a hit with the sharpened tournament lance (Rennstange). The armor for a jouster might weigh up to 90 kg. (200 pounds). The lance measured well over 4 meters (14-15 feet).

134. Record painting of a Saxon tournament (Turnierbild)

Heinrich Göding the Elder, b. Brunswick 1531, d. 1606
Dresden, end 16th c.
Oil on wood
50 x 110.5 cm., oval
HMD: H 251

In scrolled frame surmounted by inscription tablet:

> Eine Halbierung zum andern mahl
> mit Christophen von Wallwitz gethan
> und ist der Walwitz allein gefallen
> zu Dresden hinterm Schloss 1543

(Another course done with Christoph von Wallwitz, and it was Walwitz alone who fell off, at Dresden behind the castle 1543)

135. Record painting of a Saxon tournament

Heinrich Göding the Elder
Dresden, end 16th c.
Oil on wood
51 x 111.5 cm., oval
HMD: H 252

In scrolled frame surmounted by inscription tablet:

> Ein Rennen gethan mit Hansen von
> Schönfeldt der alleine gefallen
> Anno 1544 zu Merseburgk

(A Rennen done with Hans von Schönfeldt, who alone fell off; Anno 1544 at Merseburg)

136. Record painting of a Saxon tournament

Heinrich Göding the Elder
Dresden, end 16th c.
Oil on wood
50 x 111 cm., oval
HMD: H 254

In scrolled frame surmounted by inscription tablet:

> Ein Rennen gethan mit Georg
> Wehsen d. ist alleine gefallen
> Anno 1545 z. Dresden

(A Rennen done with Georg Wehse, who alone fell; Anno 1545 at Dresden)

137. Record painting of a Saxon tournament

Heinrich Göding the Elder
Dresden, end 16th c.
Oil on wood
50.5 x 110 cm., oval
HMD: H 255

In scrolled frame surmounted by inscription tablet:

Ein Rennen gethan mit Heinrichen von Schönbergk
der ist alleine gefallen und S. Churf: Gn.
gemach hernach aus Verursachung des schwarz
Schimmelichten Gauls als der von Plawen bey
Churfürst Moritzen gewesen 1549 zu Meissen

(A Rennen done with Heinrich von Schönbergk,
who alone has fallen off, and his Electoral Grace fell
off afterward, quite leisurely, by fault of the black
dappled horse, as befell the Elector Moritz at
Plauen. 1549 at Meissen)

138

138. Cuirass of a ceremonial armor of a Grand Master of the Order of Teutonic Knights

South German, c. 1510
Steel, etched and partly gilt
HMD: M 142

This is the only surviving armor of a Grand Master of
the Teutonic Knights; his distinctive cross is etched on
the breastplate and backplate. The cross on the
breastplate is surmounted by the letters GVDMTE, for
which two interpretations have been suggested:
Gratia Verbumque Domini Manet Tibi Eterne (The
grace or the word of the Lord remains with you eter-
nally), or Generoso Viro Deus Maximum Tutamen Est
(To the noble-minded man, God is the greatest protec-
tion). Its owner was presumably the last Grand Mas-
ter, Margrave Albrecht of Brandenburg-Kalmbach,
later Duke of Prussia. The rest of the armor is in The
Metropolitan Museum of Art.

139. Armor for man and horse

Anton Peffenhauser, 1525-1602/03
Augsburg, c. 1588
Steel, etched and partly gilt. Enameled in color: the coat
of arms of the Electors of Saxony, with the initials FSV
on chamfron, peytrel, and either side of the crupper.
The letters stand for the motto of Christian I: Fide Sed
Vide (Trust, but be wary)
HMD: M 99

Peffenhauser was one of the most famous armorers of
his time, working for the emperors Charles V and
Ferdinand I, among others. In the period 1582-91 he
produced eighteen individual sets of armor for the
Saxon court alone. This, with its exchange elements, is
the most complex armor garniture in the Historical
Museum, and is counted among Peffenhauser's most
mature works.

140. Boy's armor

Anton Peffenhauser
Augsburg, c. 1590
Steel, blued, etched and partly gilt
HMD: M 85

This complete armor was made for the six-year-old
prince Christian, later Elector Christian II. The Histori-
cal Museum owns nine boy's armors made by different
armorers before 1592.

141. Parade armor

French, c. 1575
Steel, embossed, engraved, and gilt
HMD: M 62

This lavishly decorated armor was presented to Elector
Christian I by Duke Charles Emmanuel of Savoy in
1588. An exchange breastplate decorated en suite be-
longs to the garniture. Armor from the same work-
shop is to be found in the Vienna Waffensammlung
and the National Museum, Cracow. (Exhibited in the
Kunstkammer Gallery.)

142. Parade half armor

Dresden, c. 1590
Silver, richly etched. Skirt (Harnischrock), black velvet
with silver embroidery
HMD: M 63

Of solid silver, this was made for Elector Christian I
together with a second one (also in the Historical
Museum), of the same pattern, for his friend Christian
of Anhalt-Bernburg, in preparation for a court festiv-
ity, 1591.

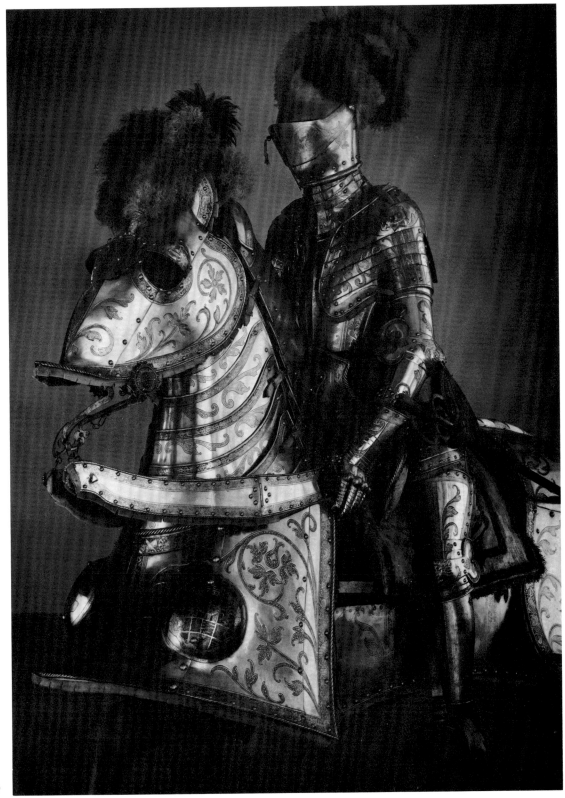

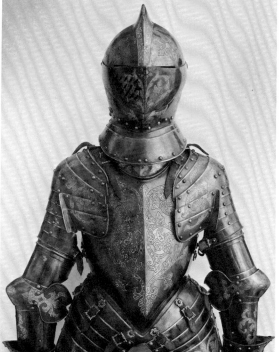

140

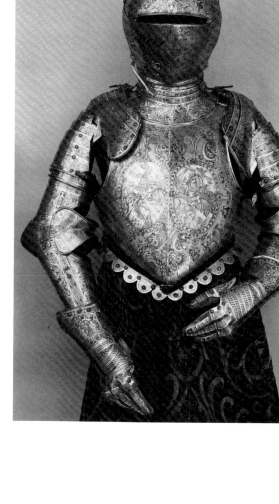

142

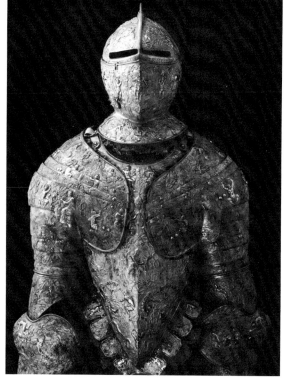

141

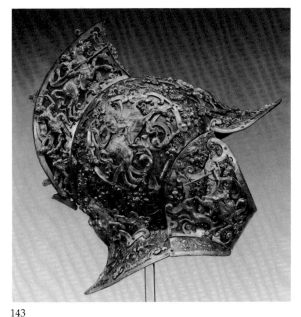

143

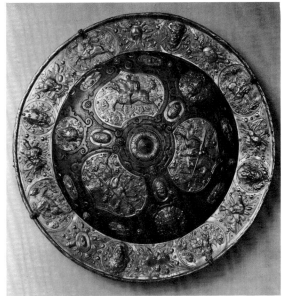

144

143. Parade burgonet

Augsburg, 1599
Dark gray steel, embossed, with copper-gilt openwork
appliqués
H. 36 cm., W. 2660 g.
HMD: M 101

This Sturmhaube is an exchange helmet for a full suit
of armor with saddle en suite, in the Historical Mu-
seum.

144. Burgonet and round shield en suite

Augsburg, c. 1600
Black steel with cast and copper-gilt appliqués
Burgonet: H. 34 cm., W. 3570 g.
Shield: D. 62 cm., W. 6300 g.
HMD: N 142/143

145. State sword (Kurschwert)

Nuremberg, before 1566; blade probably 16th c.
Hilt and scabbard silver gilt with applied silver-gilt
ornaments; on the guard and central mount of the
scabbard, enameled, the arms of Saxony and date
1566
Sword, L. 133.5, blade 89.5 cm., W. 2800 g.
Scabbard: L. 104 cm., W. 2450 g.
HMD: VI/362

This sword was the symbol of the Arch Marshal of the
Holy Roman Empire, a hereditary position of the

145

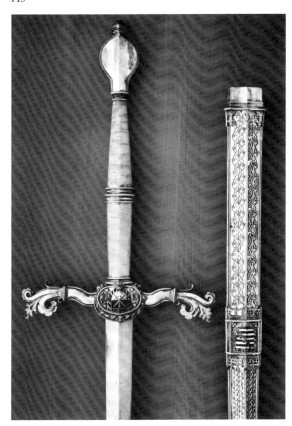

Duke of Saxony, entitling him to be one of the seven electors of the empire. (Exhibited in the Kunstkammer Gallery.)

146. Dagger

South German, first half 16th c.
Hilt silver, blade steel
L. 41, blade 30 cm., W. 280 g.
HMD: p 181

Etched on the blade are these lines:

Herrn dienst unnd aprilen wetter
frawen lieb und rossen spletter
würffel unnd ein karrtten spil
verkeren sich offt unnd vil —

Ein weber mit der kreczen
ein mulner mit der meczen
ein schneider mit der scher
welcher teufel bring die drei dieb her

(Princes' service and April weather
ladies' love and rose leaves
dice and playing cards
turn against you more often than not —

A weaver with his card,
a miller with his measuring cup,
a tailor with his scissors,
what devil brings those three thieves along?)

147. Sword in Landsknecht style

South German, c. 1530
Hilt and scabbard silver, embossed and etched
Sword: L. 102, blade 89 cm., W. 1260 g.
Scabbard: L. 91 cm., W. 680 g.
HMD: VIII/32

Swords with this figure-eight guard were favored by German foot soldiers of the sixteenth century, the Landsknechte. Democratically organized, they elected their own officers. While conforming to the type used by the ordinary soldier, this particular sword was apparently a captain's weapon.

148. Rapier and dagger

Spanish (?), before 1562
Hilts gold, enameled in colors. Rapier blade inscribed DE TOMAS/DE AIALA. Mark of Juan Martinez of Toledo on dagger blade
Rapier: L. 120, blade 104.5 cm., W. 1180 g.
Dagger: L. 36, blade 23.9 cm., W. 351 g.
HMD: VI/416; p 218

In formal fencing, sixteenth-century style, the dagger was held in the left hand to parry the opponent's rapier thrusts. Garnitures of matching rapier and dagger became increasingly popular. This one was given to Elector Augustus by Emperor Maximilian in 1562.

149. Rapier and sword carrier

Dresden, before 1605
Hilt gilded and enameled, richly jeweled with turquoises
On the guard, enameled, the armorial shields of Electoral Saxony and Electoral Brandenburg. Blade signed PEDRO DEL VELMONTE EN TOLEDO/ESPADERO DEL REI
Carrier, gold brocade embroidered with gold thread; golden openwork appliqués studded with turquoises en suite
Rapier: L. 123, blade 107 cm., W. 1450 g.
Carrier: L. 29, W. 21 cm.
HMD: VI/430; I 411

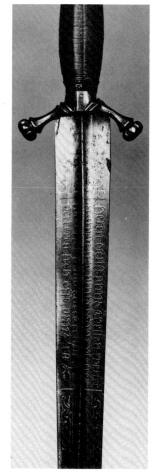

146

The rapier hilt and mounts of the sword carrier were made by the court goldsmith Gabriel Gipfel. Turquoises and other green stones are conspicuously frequent in the decoration of Saxon arms, since the national color was green.

150. Sword with scabbard

Nikolaus Gross, active 1587-1625
Vienna, c. 1590
Hilt silver gilt, blade damascened in gold. Scabbard overspun with silver wire, mountings studded with turquoises
Sword: L. 130, blade 90 cm., W. 1800 g.
Scabbard: L. 93 cm., W. 1500 g.
HMD: Y 351

With nos. 151 and 152, this forms a garniture in the Hungarian-Polish style, in which the wearing of two swords, one straight and one a curved saber, was customary.

151. Saber with scabbard

Nikolaus Gross
Vienna, c. 1589
Hilt silver gilt; heavy single-edged blade. Scabbard overspun with silver wire, silver mountings studded with turquoises
Saber: L. 110, blade 86 cm., W. 1500 g.
Scabbard: L. 87 cm., W. 1030 g.
HMD: Y 352

152. Mace (Pusikan)

Nikolaus Gross
Vienna, end 16th c.
Silver gilt, studded with turquoises
L. 69.7 cm., W. 1121 g.
HMD: Y 379

147

152 151 150

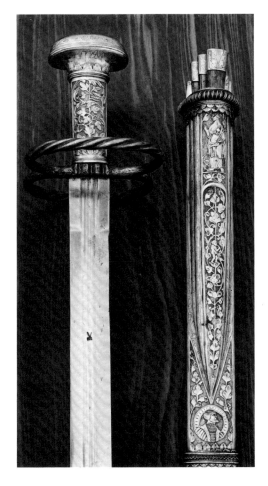

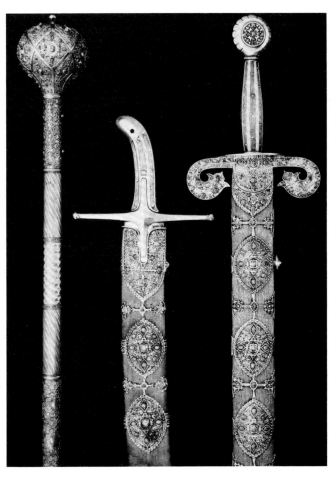

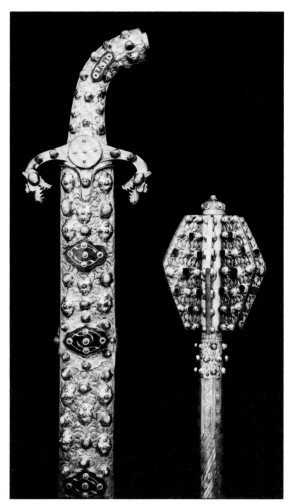

153

153. Mace (Pusikan) and sword (Pallash) en suite

Turkish, early 17th c.
Silver gilt, jeweled with turquoises, rubies, and
 nephrite
Pusikan: L. 79.5 cm., W. 1700 g.
Pallash: L. 100.5, blade 88 cm., W. 1600 g.
Scabbard: L. 91.5 cm., W. 950 g.
HMD: Y 345/344

Presented to Elector Johann Georg I by Emperor Fer-
dinand II in 1620.

154. Dagger with scabbard

Turkish, 17th c.
Wooden grip mounted in silver gilt; scabbard silver, gilt
 and nielloed, set with corals and turquoises
Dagger: L. 33, blade 21 cm., W. 790 g.
Scabbard: L. 29 cm., W. 870 g.
HMD: Y 134

155. Dagger with scabbard

Turkish, early 17th c.
Hilt and scabbard gold, embossed, jeweled with rubies
 and turquoises; blade damascened in gold; in a hol-
 low channel of the blade are two movable pearls
Dagger: L. 39, blade 22.4 cm., W. 220 g.
Scabbard: L. 25.5 cm., W. 103 g.
HMD: Y 139

Presented to Elector Johann Georg I by Emperor
Matthias in 1617.

156. Sword with scabbard, in the style of Japanese samurai sword

Thomas Kapustran
Klausenburg/Transylvania (Romania), 1674
Hilt covered with alternating bands of amethysts and
 colored enamel
Sword guard (tsuba) with colored enamel, inscribed:
 Tho. Kapusino Transilvan fecit 1674. Scabbard cov-
 ered with ray skin, with mountings en suite
Sword: L. 91, blade 77 cm., W. 1350 g.
Scabbard: L. 79 cm., W. 340 g.
HMD: Y 108

157. Rapier and dagger

Saxon, c. 1610
Hilts brass, etched and gilded. In each pommel, a watch
Rapier: L. 119, blade 104 cm., W. 1320 g.
Dagger: L. 31, blade 20.2 cm., W. 173 g.
HMD: VI/434; p 222

158. Rapier

German, end 16th c.
Hilt iron, damascened in silver, appliqués of cast and
 gilded brass in shape of demi-figurines and medall-
 ions. Pommel shaped as a woman's head. Blade
 inscribed DE TOMAS/DE AIALA
L. 115.5, blade 101 cm., W. 1300 g.
HMD: VI/341

159. Rapier

German, end 16th c.
Hilt iron, damascened in gold. Blade inscribed PETTHER
MVNSTEN
L. 114, blade 97.5 cm., W. 1150 g.
HMD: VI/305

160. Rapier

Italian, end 16th c.
Hilt of blackened steel cut in relief with Biblical scenes.
 Blade with gilded ricasso, inscribed ANTONIO PICININO
L. 112, blade 96 cm., W. 1340 g.
HMD: VI/161

156

161. Rapier

Italian, end 16th c.
Hilt blackened iron, cut in relief with equestrian scene.
 Blade inscribed EN TOLEDO
L. 98, blade 80 cm., W. 1100 g.
HMD: VI/223

162. Rapier

Italian, end 16th c.
Hilt blued steel, damascened in gold. Blade with blued
 ricasso, damascened in gold
L. 113, blade 98.5 cm., W. 880 g.
HMD: VI/241

163. Rapier

German, early 17th c.
Hilt cast brass, gilt. Blade inscribed BORTOLAMIO CIVIDAL
L. 119, blade 101 cm., W. 1430 g.
HMD: VI/419

157

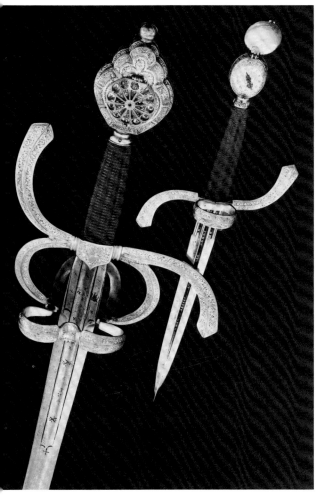

164

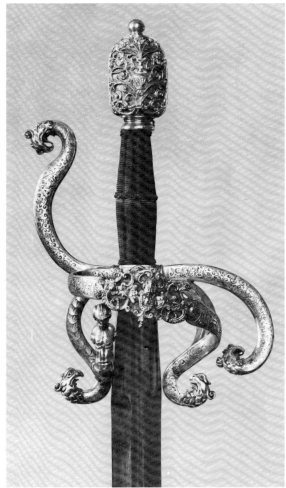

164. Rapier

> German, early 17th c.
> Hilt cast brass, engraved and gilt
> L. 113.5, blade 97.5 cm., W. 1200 g.
> HMD: VI/450

The blade is unusually wide.

165. Rapier

> German, early 17th c.
> Hilt blackened iron; finials and pommel carved as war-
> rior's heads. Blade inscribed IOANES DELAORTA
> L. 118.5, blade 103 cm., W. 1300 g.
> HMD: VI/422

166. Rapier with spring-driven blade, dagger en suite

> Italian (?), before 1575
> Hilt brass, etched and gilt
> Rapier: L. 160, blade 138 cm., W. 2430 g.
> Dagger: L. 35, blade 27 cm., W. 290 g.
> HMD: VI/410

At the push of a button, a hidden mechanism lengthens the blade nearly ten inches. The dagger hidden in the grip would serve as a parrying weapon when one fenced with both hands. Presented to Elector Augustus by Archduke Ferdinand of the Tirol in 1575.

165

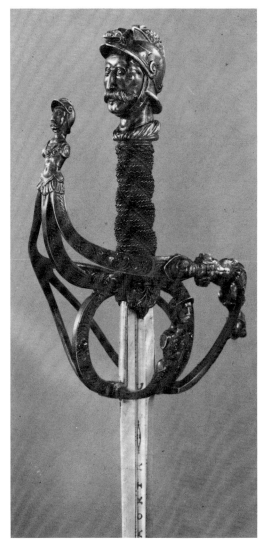

166

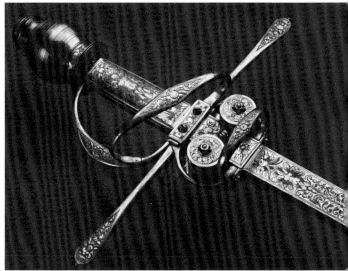

167. Double rapier

German, end 16th c.
Hilts iron, gilt. Blades with etched decoration
L. 128, blades 113 cm., W. 1640 g.
HMD: IX/60

The two halves are held together by a hook and eye on the interior sides. Unhooked, one half served for attack, the other for parrying.

168. Parrying dagger

Italian, c. 1560
Hilt iron, carved and damascened in gold
L. 44, blade 31 cm., W. 440 g.
HMD: p 72

At the push of a button, the two side sections of the blade flip apart, dividing it in three. In formal fencing, one used this in the left hand, to snag the opponent's rapier blade. These daggers were not designed for stabbing, and the spreading sections of the blade—contrary to occasional conjectures—were not for enlarging wounds.

169. Cavalryman's sword (Reitschwert)

German, end 16th c.
Hilt blackened iron, mounted in etched silver. Blade with etched decoration on ricasso
L. 117, blade 102 cm., W. 1750 g.
HMD: VI/85

167

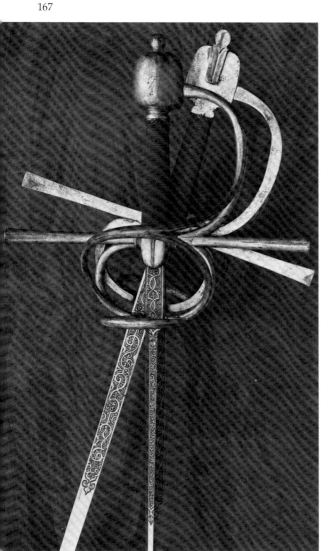

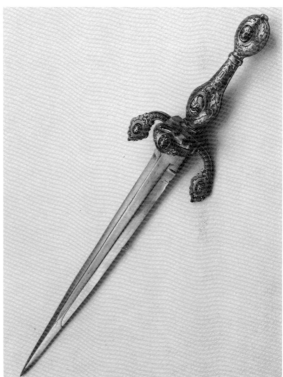

168

Such swords were part of the equipment of the Trabantengarde, the court guard. The etched silver mountings were made by the court goldsmith Hans Dürr the Younger.

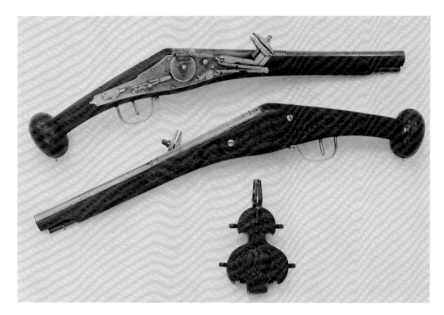

177

170. Cavalryman's sword

German, end 16th c.
Hilt blackened iron, mounted in etched silver
L. 115, blade 100 cm., W. 1680 g.
HMD: VI/113

171. Cavalryman's sword

German, end 16th c.
Hilt blackened iron, mounted in etched silver
L. 115, blade 100 cm., W. 1540 g.
HMD: VI/347

172. Cavalryman's sword

German, end 16th c.
Hilt blackened iron, mounted in etched silver. Blade
 inscribed IOHANNIS
L. 122, blade 107 cm., W. 1520 g.
HMD: VI/353

173. Cavalryman's sword

German, end 16th c.
Hilt blackened iron, mounted in etched silver. Blade
 inscribed IHS
L. 120, blade 105 cm., W. 1800 g.
HMD: 114

174. Cavalryman's sword

German, end 16th c.
Hilt blackened iron, with etched openwork silver
 mounts
L. 115, blade 100 cm., W. 1860 g.
HMD: VI/344

178

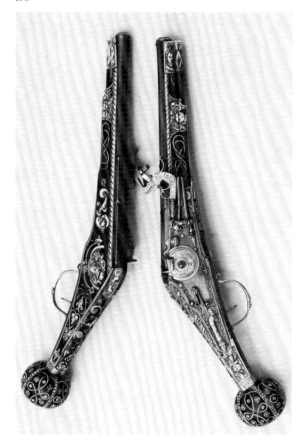

175. Mamluk battle-ax

Egyptian, late 15th c.
Steel blade and shaft, damascened in gold
L. 108.5 cm., W. 2310 g.
HMD: Y 252

176. Two boar-hunting spears

German, 17th c.
Blades steel; shafts veneered in staghorn
L. 161, blades 39 cm.
HMD: X 19/20

Part of a garniture with nos. 187, 188, and 202.

177. Firearms garniture: pair of wheel-lock pistols, and powder flask

Steffan Schickradt, active 1567-96
Dresden, 1567
Barrels and locks iron; stocks veneered in ebony and carved
L. 60, barrels 38 cm., W. 1990 g., caliber 13 mm.
Powder flask: violin-shaped body veneered in ebony and carved; mountings of iron
H. 15.9 cm., W. 200 g.
HMD: X 761

178. Pair of wheel-lock pistols

Zacharias Herold, active in Dresden 1586-1618
Dresden, 1591
Barrels and locks iron, blued; wooden stocks inlaid with engraved staghorn, buttplate engraved silver
L. 40, barrels 23.5 cm., W. 850 g., caliber 9 mm.
HMD: J 171, J 174

179. Pair of wheel-lock hunting guns

Hans Stockmann, active in Dresden 1590-1639
Dresden, 1604
Barrels polished iron, lockplates blued with openwork overlay of gilt brass; wooden stocks with figural scenes inlaid in engraved staghorn; monograms of Elector Johann Georg I and his wife, Sibylle Elisabeth of Württemberg
L. 115.5, barrels 87.5 cm., W. 4900 g., caliber 17 mm.
HMD: G 231, G 232

180. Pair of wheel-lock pistols

Georg Gessler, 1569-1616
Dresden, 1614
Barrels and locks blued iron; stocks ebonized wood
L. 78, barrels 55.5 cm., W. 1940 g., caliber 12 mm.
HMD: J 1378, J 1379

181. Wheel-lock gun

Christian Herold, active 1666-91
Dresden, 1669
Barrel and lock iron, blued, engraved, and partly gilded; wooden stock, inlaid with silver and enamel, set with jeweled rosettes
L. 106.5, barrel 78 cm., W. 4080 g., caliber 15 mm.
HMD: G 360

182. Pair of wheel-lock guns

Johann Georg Erttel, 1700-63
Dresden, c. 1755
Barrels and locks polished and engraved steel; locks partly carved in relief, inlaid with gold; stocks walnut, carved, inlaid with engraved staghorn and mother-of-pearl
L. 117.5, barrels 89 cm., W. 6090 g., caliber 15 mm.
HMD: G 529, G 530

181

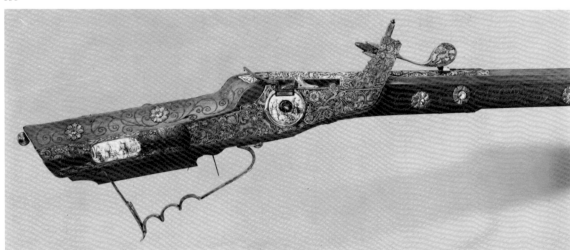

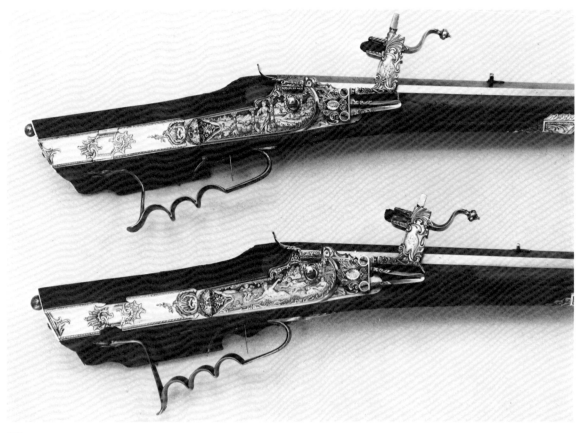

182

183. Combination matchlock-wheel-lock gun (Karrenbüchse)

Nuremberg, c. 1560
Barrel and lock iron, carved and partly gilded; wooden
 stock inlaid with staghorn
L. 260, barrel 217 cm., W. 8900 g., caliber 16 mm.
HMD: G 1974

184. Wheel-lock pistol

Augsburg, c. 1590
Barrel and lock iron, etched and gilded; wooden stock,
 covered with embossed copper-gilt sheets
L. 50.5, barrel 31 cm., W. 1070 g., caliber 15 mm.
HMD: J 59

185. Wheel-lock pistol

Master E.S., stock-maker
South German, early 17th c.
Barrel and lock blued steel, partly engraved and gilded;
 wooden stock inlaid with staghorn, mother-of-pearl,
 and silver
L. 69, barrel 49 cm., W. 1700 g., caliber 11 mm.
HMD: J 431

186. Wheel-lock gun

Martin Kamerer, active 1650-1667
Augsburg, 1654
Barrel and lock blued steel; wooden stock encased in
 partly gilt silver sheets
L. 105, barrel 78.5 cm., W. 3550 g., caliber 14 mm.
HMD: G 170

187. Wheel-lock gun

Martin Kamerer
Augsburg, 1667
Barrel and lock silvered, dot-etched iron; wooden stock
 covered with natural staghorn; silver medallion on
 butt
L. 111.5, barrel 83.5 cm., W. 3300 g., caliber 14 mm.
HMD: G 171

Part of a garniture with nos. 176, 188, and 202.

188. Pair of flintlock pistols

South German, c. 1680

Barrels polished steel; locks gilded; stocks overlaid with
natural staghorn; buttcaps silver, enameled and set
with turquoises
L. 45.5, barrels 30 cm., W. 680 g., caliber 14 mm.
HMD: J 890, J 891

Part of a garniture with nos. 176, 187, and 202.

189. Garniture of flintlock firearms: rifle, shotgun, and pair of pistols

Johann Christoph Stockmar, 1719-47
Heidersbach/Suhl, delivered 1748
Barrels and locks polished steel, carved, with gilded
sunken backgrounds; stocks walnut, carved, with
inlays of silver wire, appliqués of gilded brass
Rifle: L. 101, barrel 62.5 cm., W. 3450 g., caliber 15 mm.
HMD: G 894
Shotgun: L. 136.5, barrel 98 cm., W. 2950 g., caliber 15
mm.
HMD: G 864
Pistols: L. 42.5, barrels 26.5 cm., W. 950 g., caliber 15
mm.
HMD: J 685, J 1389

190. Pair of wheel-lock pistols

Master I.P.
French, early 17th c.
Barrel blued steel, partly engraved and gilded; lock
plain; wooden stock with red brown lacquer sprin-
kled with mother-of-pearl dust
L. 80.5, barrels 60.5 cm., W. 1350 g., caliber 12 mm.
HMD: J 317, J 430

191. Wheel-lock pistol

Master HR
Saxon, 1590
Barrel and lock blued steel; wooden stock, punched,
with ball butt and engraved staghorn inlays
L. 53.5, barrel 32 cm., W. 2100 g., caliber 16 mm.
HMD: J 999

192. Wheel-lock pistol

Master GO
Saxon, 1591
Barrel and lock of blued steel; wooden stock, punched,
with ball butt and engraved staghorn inlays
L. 55, barrel 33.5 cm., W. 2300 g., caliber 16 mm.
HMD: J 1012

193. Wheel-lock pistol

Master GO
Saxon, 1591
Barrel and lock of blued steel; wooden stock, punched,
with ball butt and engraved staghorn inlays
L. 57.5, barrel 33.5 cm., W. 2150 g., caliber 16 mm.
HMD: J 1193

194. Wheel-lock pistol

Hans Stockmann, active 1590-1639
Dresden, c. 1610
Barrel in two stages, faceted at breech, cylindrical to-
ward muzzle; lock plain; wooden stock with pear-
shaped butt and engraved staghorn inlays
L. 76, barrel 53 cm., W. 1600 g., caliber 13 mm.
HMD: J 198

195. Wheel-lock pistol

Hans Stockmann
Dresden, c. 1610
Barrel in two stages, faceted at breech, cylindrical to-
ward muzzle; lock plain; wooden stock with pear-
shaped butt and engraved staghorn inlays
L. 76, barrel 52.5 cm., W. 1650 g., caliber 13 mm.
HMD: J 200

196. Wheel-lock pistol

Hans Stockmann
Dresden, c. 1610
Barrel in two stages, faceted at breech; cylindrical to-
ward muzzle; lock plain; wooden stock with pear-
shaped butt and inlays of engraved staghorn
L. 76, barrel 52.5 cm., W. 1750 g., caliber 13 mm.
HMD: J 203

189

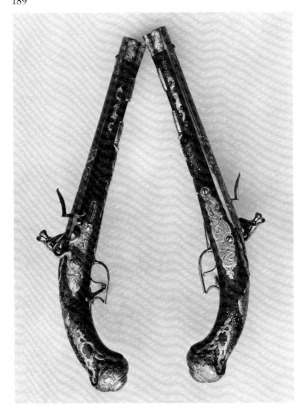

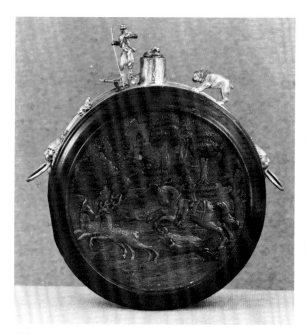

197. Powder flask

Bohemian (Eger), 1630-50
Boxwood carved with figural scenes; silver mountings
 with figural decoration
D. 14 cm., W. 340 g.
HMD: X 147

198. Powder flask

German, early 17th c.
Cast brass, gilt, figural appliqués in gilt brass
D. 9.6 cm., W. 190 g.
HMD: X 749

199. Powder flask

French, early 17th c.
Wood, covered with colored lacquer and mother-of-
 pearl dust; engraved and gilded brass mountings
L. 16.5 cm., W. 140 g.
HMD: X 775

197

201

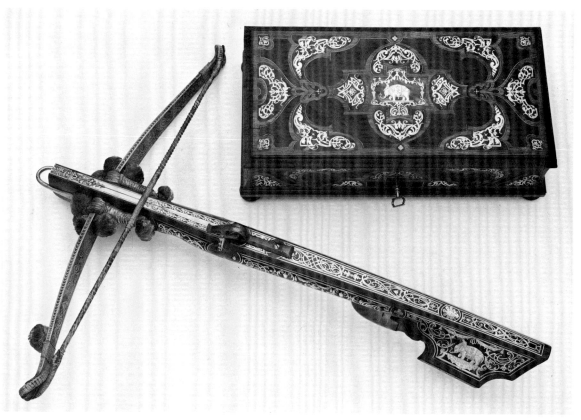

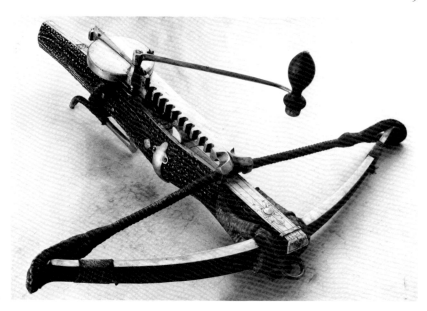

202

200. Powder flask

German, early 17th c.
Lathe-turned ivory; gilded iron mountings; ivory call-
horn with leather carrying strap
L. 14 cm., W. 300 g.
HMD: X 149

201. Pellet crossbow garniture: crossbow, spanner, bolt box

Johann Gottfried Haenisch, 1696-1778
Dresden, 1719
Wood and tortoise shell, inlaid with silver
Crossbow: L. 70, W. 56.5 cm.
HMD: U 252
Spanner: L. 69 cm.
HMD: U 221
Bolt box: 41.5 x 21 x 11 cm.
HMD: U 253

202. Crossbow with cranequin

German, end 17th c.
Renovated by Johann Gottfried Haenisch, 1737
Cranequin, 1624
Wooden stock overlaid with natural staghorn and en-
graved inlays; steel bow with gilded fixtures; polished
steel cranequin
Crossbow: L. 66, W. 66 cm., W. 5400 g.
HMD: U 263
Cranequin: L. 38 cm., W. 2580 g.
HMD: U 263

Part of a garniture that includes nos. 176 (two boar-
hunting spears), 187 (wheel-lock gun), and 188 (pair of
pistols).

203. Saddle

Turkish (?), 17th c.
Red velvet, gold-embroidered ornaments, silver
mountings embossed and gilt
W. 3200 g.
HMD L 605

LITERATURE

Max von Ehrenthal, *Führer durch das Königliche Historische
Museum zu Dresden*. Dresden, 1899.

Max von Ehrenthal, *Führer durch die Königliche Gewehrgalerie
zu Dresden*. Dresden, 1899.

Erich Hänel, *Kostbare Waffen aus der Dresdner Rüstkammer*.
Leipzig, 1923.

Johannes Schöbel, *Orientalica*. Dresden, 1961.

Jutta Nicht, *Historische Prunkkleidung*. Dresden, 1963.

Joachim Theumert, *Harnische*. Dresden, 1963.

Eva Henniger, *Pistolen*. Dresden, 1964.

Johannes Schöbel, *Helme und Schilde*. Dresden, 1972.

Dieter Schaal, *Jagdgewehre*. Dresden, 1973.

Johannes Schöbel, *Prunkwaffen. Waffen und Rüstungen aus dem
Historischen Museum Dresden*. Berlin, 1973.

Dieter Schaal, *Katalog Dresdener Büchsenmacher 16-18 Jh.*
Dresden, 1976.

Johannes Schöbel, *Jagdwaffen und Jagdgerät des Historischen
Museums zu Dresden*. Berlin, 1976.

With the reign of Augustus the Strong (1694-1733), the Dresden collections became an expression of the splendor and magnificence of the sovereign. Their rational reorganization and dazzling display were now to follow the same sumptuous formality that presided upon the ornate baroque architectural style and the seemingly unending series of parades and festivities promoted by the king.

In this section, intended as introduction and a transition to the four that follow, a series of splendid watercolors and several pieces of fanciful pageant armor evoke images of tournaments, carrousels, fireworks displays, and operatic performances, while Bellotto's view of the Zwinger recalls the aspect of this ensemble of pavilions and galleries, surrounding a large arena, which Augustus and his architect, Pöp- pelmann, designed as a combination orangerie and grandstand from which to watch the festivals. Two allegorical putti by Permoser and Kirchner convey the character of the exuberant sculptural decorations of the Zwinger, while some early Meissen figurines show how these porcelain statuettes were inspired by the costumes and characters in the courtly festivals and operas.

Court Festivities in Dresden under Augustus the Strong

Dresden, at the time of the baroque, emerges from the sources as a gaily festive, serene city. Its characteristic features had been shaped by a fortunate combination of architecture and landscape: situated on the river's banks in a broadening of the Elbe valley, surrounded by hills that grow into mountains in the far distance—a landscape both opulent and cheerful. "It is as if all the charms of nature have taken this city to their heart," a description of 1777 reads. "Forests and, at an agreeable distance, mountains, some close by and some more distant, surround the entire locality and present themselves to the eye as a delightful amphitheater. Arranged closely around the town are the most beautiful gardens for the free enjoyment of the inhabitants, as well as a large number of perfectly established places for summer entertainment. This town can never lack for anything."

Vineyards once flourished on the outskirts—as they do again today—and in the seventeenth century wine festivals were held at the tiny château of Hoflössnitz, situated in the midst of the Elector's vineyards. These celebrations, recorded in graphic representations, continued for many years. Even earlier, in the sixteenth century—as paintings in the exhibition tell us—Dresden was known for its festive tournaments and mock combats. Today, the tiltyard in the Stallhof wing of the Elector's palace, complete with the bronze pillars set up in 1588 for tilting at the ring, bears witness to these royal events.

It was in the eighteenth century, under Augustus the Strong, that the reputation of Dresden as a festival city reached its height. In his dual role as King of Poland and Elector of Saxony, Augustus commanded festivals of dazzling beauty. More often than not these were arranged with an eye to specific political aims, though it soon enough became evident that baroque celebrations were not the direct road to success in Saxon foreign politics. It can be assumed, too, that a festive mood created in this calculated manner could only temporarily conceal the everyday problems of Dresden's populace. It was not a substitute for reality, despite the exaggerated style of the contemporary praise for the Elector's wishes. In art, the works of the painters and sculptors, the goldsmiths and many other craftsmen who collaborated in producing these events, offer us a glimpse of the festivities. In later days, they are apt to be seen in a rosy light by those who are only too easily persuaded to imagine a splendid reality from these creations, though everyday life must have looked very different.

The decades that saw the art collections of Dresden gathered together were the same that saw the most brilliant of the festivities. If the treasures of the Green Vaults, with their splendor of precious metals and jewels, are by themselves a feast for the eye, there are, among them, many that preserve aspects of the festive life as it was conceived by the king and his artists. In Dresden there was a peculiar blending of the ceremonial and the boisterous, of the ruler's dignity and amusements for the populace, of fantastic masquerades and political-personal allusions, a conspicuous display of wealth with mercantile aims. Incomprehensible to us today, this wasteful mixture, the court thought, would serve a useful purpose. The components came together at their best under Augustus the Strong, who was inexhaustible in inventing and working out the smallest details of the masquerades and pageants. These were based on the tradition of the triumphs of antiquity and on the religious processions of the Middle Ages. Both had played important roles in the festivities of the Renaissance, and they were particularly suited to a baroque prince's claim to rule by means of the examples of the Caesars, backed up by the entire arsenal of antique mythology and contemporary allegory. Each one of the great festive parades of this period was accompanied by appropriately costumed musicians, often members of the Elector's own orchestra, and they completed an impression calculated to charm all of the senses equally.

In reading descriptions of the festivities of Augustus the Strong, with all their luxury and lavish invention, one might think of Duke Philip the Good of Burgundy (1396-1467), perhaps the most famous of all organizers of courtly festivals, but the name of Augustus' contemporary, Louis XIV, is even more apt. In Johann Alexander Thiele's depictions of the Shrovetide festivities of 1722 in the Zwinger, for example, one recognizes the tradition of the painter-chroniclers of the French monarch, Adam Frans van der Meulen and his successors, whose pictures of courtly cavalcades, entries, and festivals were much-admired models. Venice was another source of ideas for the Saxon electors, and Venetian masques and gondola parties were staged on the Elbe or on the lakes around Moritzburg Castle. The entire city—the Residenzschloss and the other palaces—was used at one time or another as a setting for the festivities, as well as the castles and parks of Pillnitz, Grossedlitz, and Moritzburg, joined later by Hubertusburg. But of all these locations it was the Zwinger that presented a unique frame for entertainments of every kind: a complex of pavilions and galleries, richly varied, yet also clearly and systematically proportioned. The Zwinger's architecture and sculpture gave a flowing rhythm and lavish decorative richness to the buildings' exteriors, balanced by the colors and lights of the sculpture and frescoed ceilings inside. If we recall pictures of a Zwinger painted even on the outside, with blue roofs and white stonework, we realize that here art created a festive mood, practically making a festival of the Zwinger itself.

Theater, in one or another of its varieties, appears to have been the central art of Dresden in the eighteenth century, and nothing was thinkable without music. We read of opera performances that lasted for seven hours, and of French and Italian comedies that had their permanent place in the schedules. The commedia dell'arte was a special favorite with both Augustus the Strong and his son and successor. Close by the "incomparable" Zwinger,

Iccander wrote in 1726, there stood "the new Italian Opera House, wherein the first opera was performed 3 September 1719, and it is a very handsome building." This date of 1719 marked a high point in the city's musical history, since Dresden was to be counted for decades among the leading musical centers of Europe, equally famous for its orchestra, its sacred music, and its operas.

In looking for a single celebration that could sum up the masquerades, hunting parties, shooting competitions, parades, shepherd games, balls, operas, comedies, carrousels, ladies' jousts, boating parties, festivals of the planets, and quadrilles of the Four Continents and Four Elements, one would doubtless select the festivities attending the wedding of Prince Elector Friedrich Augustus and Archduchess Maria Josepha of Austria, daughter of Emperor Joseph I. For this occasion, in 1719, there were pageants of masquerading Persians, Germanic tribesmen, American Indians, and Chinese; a ladies' festival and a parade of the Four Seasons in the Great Garden, the huge public park outside the city wall. In the caverns of a nearby mine, the Plauensche Grund, there was a Festival of Saturn and a festive parade of miners. Every day of this affair seems to have demanded a new set of costumes. The entry of Maria Josepha into Dresden took place on 2 September, an event "marvelous and splendid beyond all description," and not until the twenty-ninth was the final lavish entertainment staged. The celebration had lasted day after day almost an entire month.

Some of the fantastic costumes and arms worn by the electors and their guests are today in the Historical Museum. "One sees here in amazing quantities," Weinart wrote in 1777, "all that equipment, be it strange and precious horse harnesses and trappings, arms and armor, and other objects that were to be used in pageants and parades, knightly games, and pleasurable feasts." A large number of drawings, gouaches, and prints, mostly by Johann Samuel Mock, preserved in the Kupferstich Kabinett, illustrate these events and offer us sketches for the costumes, particularly those intended for the operas. This exotic world of Turks and Chinese, Africans and Indians, as well as the bucolic world of shepherds and shepherdesses and that of classical gods and heroes, was revived only a short time later in the small-size sculptures of Meissen porcelain, as modeled by Johann Joachim Kändler.

For the festive hunts, either riding to the hounds or in the stage-managed affairs in which the game was driven together to be massacred—a kind of pleasure that appears mysterious today—the arrangements were such that the performance was like something in a theater or even a Mardi Gras. "Around two o'clock," a contemporary account says, "a beautiful ship came floating down the Elbe, representing the sun, drawn by four sea horses. In it was seated Diana with her companions, together with musicians, who, while floating about for a while, sang various arias to the accompaniment of most lovely music. After they had finished, they went on shore near the shooting blind, after which the game, some 300 heads, among them twenty large stags and about ten wild boars, was driven into the water. . . . His Majesty the King, the Prince, and the Princess killed a great number in the water as well as on land, and whatever was not shot had to drown."

Again, in the matter of fireworks and illuminations, there was no limit to either the

inventiveness or squandering. It was at the usual kind of social event that these effects were staged, and a description of the fireworks on the occasion of the visit of the king of Denmark in 1709 gives us an opportunity to appreciate the skill of Saxony's pyrotechnicians: "There was a castle erected on ships moored in the river, attacked from both banks with cannon firing tracer shots, and it defended itself accordingly, during which time one could see the cipher of the King of Denmark high up on the tower of said castle illuminated in various colors; there were also, on the other bank of the river, near what is now the borough of Neustadt, a large number of images set in flames. The air was constantly full of fire, from the tracer shot and rising rockets. And on the ground everywhere, as on the water, innumerable firecrackers were to be seen." A gouache drawing by C. H. Fritzsche (206) has preserved a glimpse of this all too perishable splendor.

But even to the most eloquent of the panegyrists of the time it seems to have occurred eventually that all this beautiful make-believe world was separated by an unbridgeable gap from the everyday life of the Saxon people. Thus, in a biography of Augustus the Strong, in connection with the princely wedding of 1719, one reads: "If they were merry in Dresden, and if everything there was gorgeous and splendid to see, it was not the same elsewhere in the realm. On the contrary, it so happened that, by reason of a summer drought, there was a poor harvest, and the scarcity of grain caused a great rise in the cost of living, and because of that there was much misery."

In the second half of the century the contradictions between illusion and reality were better understood, inasmuch as they became increasingly plain after the disastrous effects on Saxony of the Seven Years War. The rulers now assumed the appearance of being enlightened, and a time came when middle-class proficiency and spiritual values were preferred to the baroque pathos of glittering court festivities. To most people of the time it became clear that with the end of the reign of Augustus III (1763) the era of spectacular wastefulness in Dresden had come to an end.

HARALD MARX

Court Festivities in Dresden under Augustus the Strong

ENTRIES BY:

Harald Marx [204]

Glaubrecht Friedrich [205-211]

Angelo Walther [212]

Martin Raumschüssel [213-214]

Dieter Schaal [215-221]

Gisela Haase [222-227]

Günter Reinheckel [228-230]

Ingelore Menzhausen [231-240]

Louis de Silvestre

Paris, 1675-1760; active Dresden 1716-48
French school

204. Portrait of King Augustus II of Poland

Inscription on back: Portrait de Sa Majesté Le Roi de
 Pologne et Electeur de Saxe. Peint à Dresde par Sil-
 vestre 1718
Canvas, 235 x 172 cm.
Inventory of 1722: A 753
Gal. no. 3943

A typical state portrait in the manner of Hyacinthe
Rigaud. It was originally in the Paratenzimmer in the
Residenz and later in the great throne room. Augustus
the Strong wears the decoration of the Polish Order of
the White Eagle on a blue ribbon and the star of this
order on his mantle. Beside him, on a table, rest the
insignia of the Polish crown and the state sword of the
Elector of Saxony (the sword, no. 145, is exhibited in
the Kunstkammer Gallery). The unusually detailed
information on the back of this portrait suggests that it
was the original upon which subsequent copies were
based.

C. H. Fritzsche

205. Carriages and Horsemen Proceeding to the Ladies' Jousting, 6 June 1709 (1710)

Brush, gouache, 585 x 915 mm.
Kupferstich Kabinett inv. no. C 1968-791
Literature: Sponsel, p. 87, pl. 6

A painter of the court theater, Fritzsche recorded some
of the festivities of 26 May—29 June 1709 in honor of
the visiting Danish king, Frederick IV, an ally of
Saxony. The jousting was staged in the Amphitheater,
a predecessor of the Zwinger, erected in front of the
Residenzschloss. Twenty-four ladies and seventy-two
cavaliers, all members of the nobility, competed, rid-
ing down one or another of the three courses to thrust
a lance through the suspended ring.

C. H. Fritzsche

206. Fireworks on the Elbe, 6 June 1709 (1709)

Brush, gouache, 595 x 920 mm.
Kupferstich Kabinett inv. no. C 1968-792
Literature: Sponsel, p. 88

The climax of the festivities during the state visit of the
Danish king, planned by Augustus the Strong himself.
Floating on the river was an elaborate construction
placed upon boats, representing the formidable for-
tress of Ryssel (Lille), in Flanders. It was attacked from
both banks with rockets and cannons firing tracer
shots, and it defended itself in kind. The tower of the
fort was decorated with a crown and the Danish order
of the Elephant, while the illuminated initials of Fred-
erick IV appeared on the base.

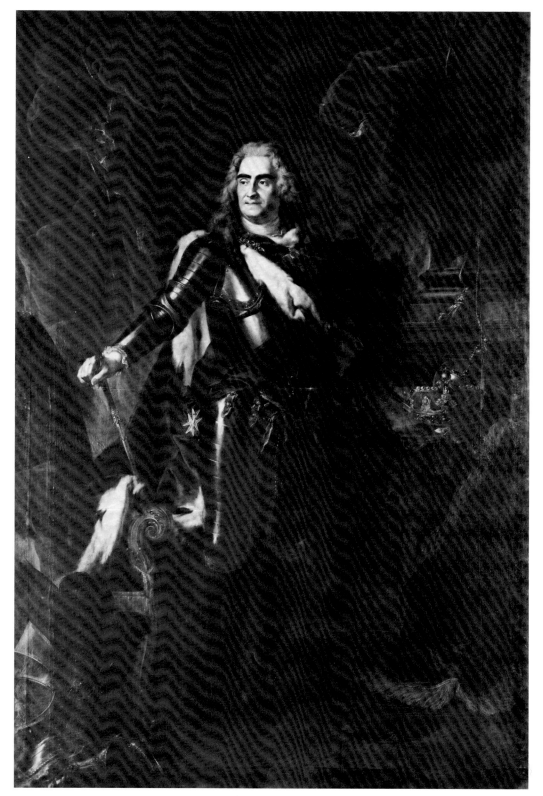

204

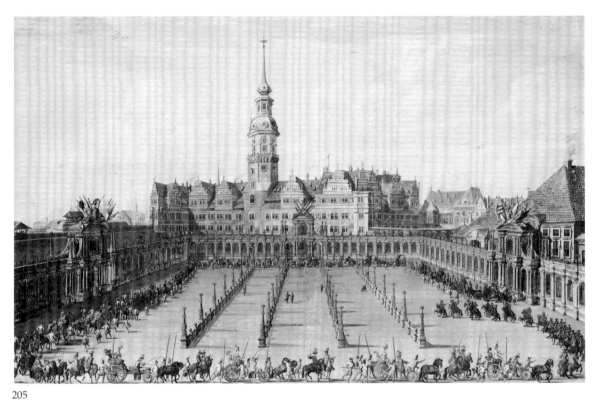

205

207

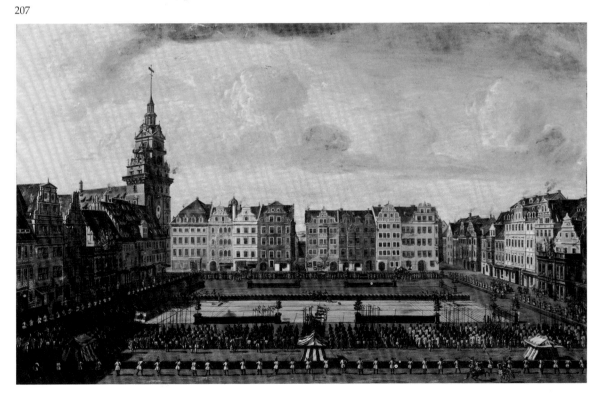

Johann Samuel Mock

1687—Warsaw 1737

207. Foot Tournament in the Old Market, 10 June 1709 (1709)

Brush, gouache, 575 x 905 mm.
Kupferstich Kabinett inv. no. C 1968-793
Literature: Sponsel, pp. 89-90

For this affair, modeled after the combat of the Horatii and the Curiatii, a celebrated episode in Roman legend, the Old Market was transformed into a festival ground. The Cartel, a set of printed rules, prescribed the tactics for the participants in single contests with sword and spear at the central barrier, and for group contests between companies of sixteen to a side, each side dressed in a different color.

Johann Samuel Mock

208. Night Jousting in the Riding School, 22 June 1709 (1709)

Brush, gouache, 575 x 910 mm.
Kupferstich Kabinett inv. no. C 1968-797
Literature: Sponsel, pp. 90-91

The seventy-two participants were dressed as gods—the Danish king as Mars, Augustus the Strong as Apollo—while the ladies of the court, looking on, appeared as goddesses. The contest was followed by a banquet that went on till early morning.

Carl Heinrich Jacob Fehling

Dresden 1683—Meissen 1753

209. The Carrousel of the Elements in the Zwinger, 15 September 1719 (1731)

Pen, brush, 580 x 900 mm.
Kupferstich Kabinett inv. no. Ca 200, sheet 15

One of the drawings recording the festivities at the marriage of Crown Prince Friedrich Augustus of Saxony and Maria Josepha of Austria, daughter of Emperor Joseph I. The festivities continued for twenty-eight days. The Zwinger, the great complex of buildings commissioned by Augustus the Strong and built by Matthäus Daniel Pöppelmann, was begun in 1711 and remains one of the masterpieces of European baroque architecture. The royal wedding provided the occasion for the first celebration in the Zwinger, even though the construction was still unfinished. This was the equestrian ballet of the Elements, with equestrian fencing, tilting at the ring, and tilting at the quintain.

Carl Heinrich Jacob Fehling

210. The Theater in the Great Garden, 23 September 1719 (1731)

Pen, brush, 558 x 864 cm.
Kupferstich Kabinett inv. no. C 200, sheet 66
Literature: Sponsel, p. 268, pl. 61

The marriage festivities of 1719 strengthened Dresden's leadership among European cities famed for their music and theater. Here we see a performance of a festival opera, *The Four Seasons of the Year*. In the foreground is the court orchestra, founded in 1548, which continues to perform today as the Dresden State Orchestra.

Carl Heinrich Jacob Fehling

211. The Great Garden with Festive Illuminations, 23 September 1719 (1731)

Pen, brush, highlights in white, blue paper, 591 x 870 mm.
Kupferstich Kabinett inv. no. Ca 200, sheet 68

The palace in the center, built 1678-83, was the first important baroque building in Dresden. In the distance, beyond the garden, one glimpses the town. In the foreground stands a temporary wooden structure for the closing festivities of the royal wedding: a temple of Venus, with tiered seating for the spectators on either side. Beyond the temple, gondolas and barges move upon the lake.

Bernardo Bellotto, called Canaletto

Venice 1721—Warsaw 1780

212. The Zwinger (1749-53)

Canvas, 134 x 237 cm.
Inventory of 1754: I 545
Gal. no. 629

The Zwinger, built between 1710 and 1732 on the land between the Residenzschloss and the outer fortifications of the old city, is one of the most beautiful and significant monuments of German baroque architecture. Six pavilions connected by arcaded galleries enclose a great festival "room" whose ceiling is the sky. The architect was Matthäus Daniel Pöppelmann, who had studied the architecture of baroque Italy and Vienna during his travels. The sculptor Balthasar Permoser and his workshop produced more than one hundred richly decorative figures and countless ornamental details which are integral to the building. In the severe ordering of the geometrical ground plan the

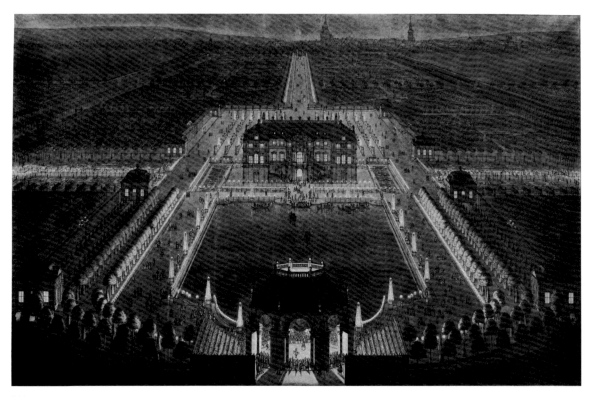

211

Zwinger is an expression of the absolutism of its commissioner, Augustus the Strong. Beginning in 1728, the buildings of the Zwinger served as museums for the various collections. Bellotto's view is from the Wall Pavilion, so called because it was set upon the old city fortification. Centered in the distance is the Stadtpavillon, today called the Glockenspiel after the Meissen porcelain carillon that has been installed there. To its left is the German Pavilion, so called for the German paintings that once hung there. The similar-looking building to the right was the Zoological Pavilion; today it houses the Porcelain Collection. Further to the right, partly obscured by the Mathematical-Physical Salon in the foreground (which faces the French Pavilion in the left foreground), is a long gallery pierced by the Crown Gate. Originally, this towered gate was to look across the open area to an extension of the buildings on the northeastern side reaching clear to the river. This plan was not realized, and in the mid-nineteenth century the open side was closed off by the construction of Gottfried Semper's Paintings Gallery, built 1847-55 in the style of an Italian Renaissance palazzo. Beyond the Zwinger, to the left, is Klengel's Comedy Theater, with a gabled wing of the Residenzschloss in the dis-

tance. To the right, the prominent tower is that of the Holy Cross Church in the Old Market, the highest roof belongs to the church of Santa Sophia, and beyond the Zoological Pavilion, at the right, is the Opera House, also designed by Pöppelmann. At the time of the painting, the Zwinger was open to public traffic.

Balthasar Permoser
Kammer near Traunstein 1651—Dresden 1732; active Dresden after 1688

213. Allegory of Summer
Signed BALTH. PER. 1724 fec.
Sandstone, H. 121 cm.
Zwinger

Permoser personified the seasons in the form of children, *Summer* being a naked boy holding a sheaf of wheat. The sculptures were made for the park of Widerau Castle, Saxony. They were acquired for the Zwinger in 1926. Though not originally designed for the Zwinger, they are similar to Permoser's work there.

213

214

Johann Christian Kirchner

Merseburg 1691—Dresden 1732; active Dresden after 1710

214. Putto as Woodsman

Sandstone, H. 84 cm.
Sculpture Coll. inv. no. ZV 3707

With an ax on his shoulder and a small fire at his feet, the putto represents Winter in a group of the Four Seasons from the park of the castle at Wohla. These figures can be attributed to Kirchner by comparison with his documented works. Kirchner worked with Permoser at the decoration of the Zwinger. Children in various costumes and with various allegorical attributes have an important place in Kirchner's production.

215. Mask

Dresden, c. 1709
Brass, embossed and gilt
D. 48 cm.
HMD: N 171

In the shape of a sun with long rays, this was worn by Augustus the Strong in a procession on the occasion of the visit to Dresden by the Danish king, Frederick IV. The following objects, through no. 219, were also used on this occasion.

216. Helmet

Dresden, c. 1709
Copper, embossed and gilt, set with glass stones
H. 28 cm., W. 2.296 kg.
HMD: N 164

Worn by the Danish king.

217. Shield

Dresden, c. 1709
Copper, chased and gilt, set with glass stones
Inscribed PRIVO DITE MI MORO
L. 49, W. 30 cm.
HMD: N 166

Carried by Augustus the Strong.

218. Shield

Dresden, c. 1709
Copper, chased and gilt, set with glass stones
Inscribed SIN RIVAL—SIN AMOY
L. 49, W. 32 cm.
HMD: N 167

219. Shield

Dresden, c. 1709
Copper, gilt, set with glass stones
L. 51, W. 30 cm.
HMD: N 169

Carried by the Danish king.

220. Helmet of the Janissary Guard of Augustus the Strong

Saxon, before 1699
Brass, embossed
H. 30 cm., W. 1525 g.
HMD: N 173

The Janissary Guard, founded in 1699 and disbanded in less than a year, consisted of 180 men and was intended as guard for the Lustschlösser, the pleasure castles outside the city to which the court retreated for relaxation. The privates of this unit wore high felt caps, the officers caps of silk; only corporals wore these helmets.

221. Two sabers of the Janissary Guard

Saxon, before 1699
Steel blades, etched with the cipher of Augustus the Strong; hilts cast bronze, silvered, with same cipher on the guard
L. 82, blades 67.5 cm., W. 1060 g.
HMD: III/33; III/35

222. Goblet

Dresden, Royal Electoral glass factory, 1715-20
Enameled by Johann Heinrich Meyer (1680-1752)
With applied portrait of Augustus the Strong in enamels, probably painted by Georg Friedrich Dinglinger (1666-1720)

Clear glass, cut, enameled and gilt, garnet. The foot, also of Saxon glass, is a replacement
H. 20.6 cm.
Inv. no. 37 290

According to the inventory of glass in Pillnitz Castle made in 1734, all but one of the garnets surrounding the portrait medallion were already missing. On the back of the goblet is a representation of the garden side of the Water Palace, a wing of the castle. The work done by J. H. Meyer, the court enameler on Dresden glass, is prized for the very original innovation in which painterly compositions, achieved in color, stood out in relief from the surface of the glass. The glass-house at Dresden was one of the first manufactories that Augustus the Strong had built. It was the brain-child of Ehrenfried von Tschirnhaus, a Saxon nobleman with scientific interests, and was constructed in 1700 by the Fremel brothers. Its productions served to gratify to the highest pitch the luxury requirements of the ruler. This necessity dictated almost the entire program of the factory, as to shapes, ornament, and the subject matter of the decorative themes.

223. Covered cup

Dresden, Royal Electoral glass factory, 1710-20
Clear glass, cut, with matte and polished engraving
The glass is "sick"
H. with cover 32.6 cm.
Inv. no. 41 066

Vessels with uncut or spirally twisted stems incorporating red and gold canes date from the first phase of Dresden production, that is, from the period during which Julius Heinrich Meyer was Director. Because of chemical imperfections in some of the batches, early Dresden glass frequently suffers from glass disease.

224. Flute glass

Dresden, Royal Electoral glass factory, c. 1720
Clear glass, matte and clear engraving
H. 25.5 cm.
Inv. no. 15 186

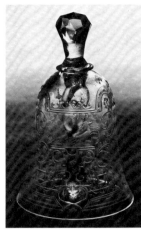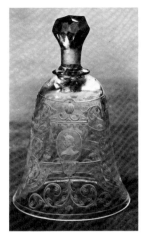

226

223 225

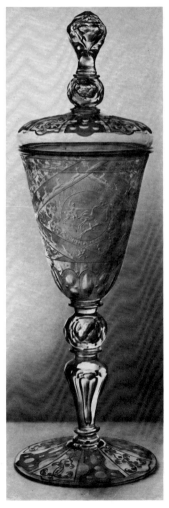

Flutes are listed in the first inventory of the factory, in 1709. Besides personal arms and monograms and allegorical scenes referring to its occasional function as the prize in shooting contests, the flute form in Dresden was provided with a most graceful and richly ornamental decoration in the form of continuous encircling lace work.

225. Covered cup

Dresden, Royal Electoral glass factory, 1720-30
Clear glass, cut, with matte and polished engraving
H. with cover 53.5 cm.
Inv. no. 37 743

Hunting scenes in medallions with the mottoes "La peine suit les plaisirs" and "Chasser Avant la prise." The glass-metal of the Dresden factory, renowned in its own time, shone like crystal without the aid of cutting or polishing. This appearance was emphasized by a comparatively restrained use of engraving.

226. Two table bells

Dresden, Royal Electoral glass factory, 1715-20
Clear glass, cut, with matte and polished engraving
H. 13.2 (with jumping animals)
Inv. no. 10 417
H. 14.1 cm. (with medallion portrait)
Inv. no. 17 425

The production of table bells was established during Mayer's directorship of the Dresden glass factory. The delicate strapwork with its enclosed hunting scenes alternating with scrolling feathery tendrils is a characteristic motif in engraved decoration at Dresden; together with matte bands on which small bell motifs are engraved, it is to be found on a number of objects. Judging by the fine engraved strapwork, both these

bells come from the same series as the table clock in the glass collection at Rosenborg Castle.

227. Covered cup

Dresden, Royal Electoral glass factory, c. 1730
Clear glass, cut, with matte and polished engraving
H. with cover 36.7 cm.
Inv. no. 37 096

The Four Elements are symbolized by creatures and mottoes: Lion (Earth) "Sans crainte"; Dolphin (Water) "Sans s'estionner"; Salamander (Fire) "Sans peine"; Eagle (Air) "Sans domage." This type of decoration and the combination of medallions with emblematic, allegorical, or hunting scenes is quite typical of the choice of engraved motifs found on Dresden glass.

228. Table

Albrecht Biller (Augsburg 1663-1720)
C. 1715
Walnut covered with chased and gilt silver
120 x 81 x 80 cm.
Inv. no. 37 533

Decorated with rich foliate and strapwork designs. In the center of the top, in an oval reserve, four women representing the Four Seasons dance before Chronos. This was part of a commission from the Dresden court. It included another table of almost identical workmanship, also in the Museum for Decorative Arts. Along with tables, chairs, and gueridons made about 1720 for the Duke of Brunswick, these are the most important silver furniture pieces of the eighteenth century.

227

228

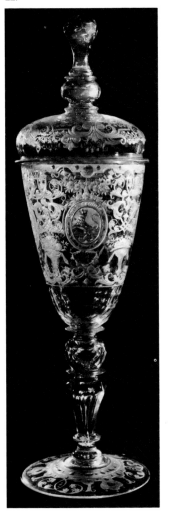

229, 230. Two gueridons

Johannes Biller (Augsburg 1696-1745)
C. 1730
Silver, chased
H. 100 cm.
Inv. no. 37 531a, 37 531b

Of an Augsburg family of gold- and silversmiths, Biller executed several orders for the Dresden court. These gueridons, triangular in shape instead of the more usual round shape, belonged to the furnishings of the Residenzschloss until 1945.

231. Masonic group

Model by Johann Joachim Kändler
Meissen, May 1744
Porcelain
H. 22.5 cm.
Inv. no. P. E. 179

Mentioned in Kändler's work records as a "Freemasons group, representing two Freemasons, one of whom is standing and measuring a globe, at the same time holding a hand over his mouth, while the other sits nearby and muses, both have their leather aprons and orders on." Not mentioned is the pug sitting in front of them, a reference to Masonry's continued existence, replete with secret customs, at many Catholic courts under a disguised name—the Pugs—after the Pope's excommunication and anathema of 1738.

232. Goldsmith

Model by Johann Joachim Kändler
Meissen, c. 1750
Porcelain
H. 22.5 cm.
Inv. no. P. E. 182

233. Cavalier and Lady with a Bird Cage ("crinoline group")

Model by Johann Joachim Kändler
Meissen, December 1736
Porcelain
H. 12.3 cm.
Inv. no. P. E. 527

Mentioned in Kändler's work records as "a group consisting of two figures, made for stock, representing a well-dressed young man seated on green grass and embracing a smartly dressed woman. Included is a small bird cage in which sit little birds."

234. Dancer

Model by Johann Joachim Kändler
Meissen, 1738
Porcelain
H. 18.8 cm.
Inv. no. P. E. 984

229

In Kändler's work records this is mentioned as "a dancer made after an engraving on copper by Watteau, with a feather in his hat, he has a small mantle hanging on his right shoulder." Kändler's source was an engraving after Watteau's *L'Indifférent*.

235. Comedian with a Lute

Model by Johann Joachim Kändler
Meissen, 1739
Porcelain
H. 16.5 cm.
Inv. no. P. E. 510

Mentioned in Kändler's work records as "a musician, dressed as an actor, playing on a lute."

236. The Court Jester Joseph Frölich

Model by Johann Joachim Kändler
Meissen, modeled 1733 (?), executed 1740
Porcelain
H. 24 cm.
Inv. no. P. E. 150

237. The Court Jesters Frölich and Schmiedel

Model by Johann Joachim Kändler
Meissen, September 1741
Porcelain
H. 23.9 cm.
Inv. no. P. E. 249

For four decades the salaried jester and juggler of Augustus the Strong and Augustus III, Frölich was—except for the kings themselves—the most frequently portrayed figure of the court, and representations of him exist in clay, ivory, sandstone, engravings, paintings, painted gilt-leather wall covers, and porcelain. After his death (1767) his literary legacy was published: *Political sweepings left behind by the famous and pious Herr Joseph Frölich written with gladness and sorrow, sweet and sour*. In it one finds the jester's revolutionary thoughts: "Look here, you little ones, you have big mouths and you have eyes as well, why do you not see and speak, when you should see and speak? Methinks you yourself are not of one mind." Frölich's companion, Schmiedel, a former postmaster, acted as the sad-witted butt of his rambunctious jokes.

238. The Grand Turk

Model by Johann Joachim Kändler
Meissen, 1741-42
Porcelain
H. 26.8 cm.
Inv. no. P. E. 499

Listed in Kändler's work records as "A Turk in full dress wearing a coat beneath a cape, and with a turban." After an engraving in M. de Perriol's *The Truest and Newest Illustrations of the Turkish Court*, Nuremberg, 1719, figs. 2 (Great Sultan) and 4 (Kislar-Agassi).

239. Grape Grower

Model by Johann Joachim Kändler
Meissen, 1745-50
Porcelain
H. 19 cm.
Inv. no. P. E. 672

240. Dancing Peasant Couple

Model by Peter Reinicke
Meissen, c. 1750
Enameled porcelain
H. 15 cm.
Inv. no. P. E. 192

LITERATURE

Königlich pohlnischer und churfürstlich Sächsischer Hof- und Staats-Kalender. First issue, 1728.

Daniel Fassmann, *Das glorwürdigste Leben und Thaten Friedrich Augusti des Grossen, Königs in Pohlen und Chur-Fürsten zu Sachsen . . .* Hamburg, Frankfurt/M., 1733.

Karl Ludwig von Pöllnitz, *La Saxe galante*. Amsterdam, 1734. German ed., Hellerau, 1927.

Johann Gottfried Mittag, *Leben und Thaten Friedrich Augusti III*. Leipzig, 1737.

Moritz Fürstenau, *Zur Geschichte der Musik und des Theaters am Hofe zu Dresden*. Dresden, 1861; reprint Leipzig, 1971.

Jean Louis Sponsel, *Der Zwinger, die Hoffeste und die Schlossbaupläne zu Dresden*. Dresden, 1924.

Erich Haenel and Erna von Watzdorf, *August der Starke. Kunst und Kultur des Barock*. Dresden, 1933.

Arthur Lotz, *Das Feuerwerk. Seine Geschichte und Bibliographie*. Leipzig, 1940.

Hans Schnoor, *Dresden. 400 Jahre deutsche Musikkultur*. Dresden, 1948.

Gertrud Rudloff-Hille, *Abteilung Barocktheater im Zwinger* (Catalogue State Art collections, Dresden). Dresden, 1954.

Friedrich Sieber, *Volk und volkstümliche Motivik im Festwerk des Barocks Dargestellt an dresdner Bildquellen*. Berlin, 1960.

Margarete Baur-Heinhold, *Theater des Barock. Festliches Bühnenspiel im 17. und 18. Jahrhundert*. Munich, 1966.

Wolfgang Hartmann, *Der historische Festzug*. Munich, 1976.

In line with his redistribution of the collections, Augustus the Strong moved the state treasures from a green-walled vault in the palace to a suite of specially decorated exhibition rooms. Since the old vault, opened up, became part of these rooms, the new installations became famous, beginning in 1730, as the "Green Vaults." Here, displayed in dazzling fashion in mirrored cabinets, before mirrored walls, one encountered objects of silver and silver gilt, drinking vessels made of nautilus shells, vases of semiprecious stones and rock crystal, and enameled and jeweled virtuoso pieces created by the court jeweler, Johann Melchior Ding- linger. Celebrated attractions in the Green Vaults were a blackamoor carrying a cluster of emeralds from South America, the creation of the sculptor Balthasar Permoser, and the rose-diamond garniture of the Saxon Crown Treasure.

The Green Vaults

During an enlargement of the Residenzschloss in the mid-sixteenth century, a Schatzkammer—treasure chamber—was constructed in one of the large ground-floor rooms of the new west wing. The walls were built two and a half meters thick, and heavy bars on the windows made the chamber secure. Vaulted ceilings were designed to withstand collapse during a fire. The only entrance to the chamber, a concealed one, was built within one of the walls. The opening to it was in one of the living rooms of the Elector. Here, then, was a secret treasury for money reserves, ornamental jewels, precious decorative objects, and state documents. Since the walls were painted green, the dominant color in the Saxon coat of arms, the treasury came to be known as the Grünes Gewölbe—the Green Vault or Green Vaults—a name that continues today even though the original vault was long ago combined with other spacious rooms in the wing to make a museum. The reconstruction began in 1723, on the order of Augustus the Strong. When it was completed, in 1730, the Residenzschloss possessed the world's first treasury-museum and first specialized museum for decorative art: a complex of exhibition rooms, storeroom, and supervisor's office, with a separate entrance to all this within the palace courtyard.

Although the new establishment had the main characteristics of a present-day museum, there were important differences, for this Schatzkammer was not conceived as an institution for providing scholarly information about its objects, but rather as what we might today call a total work of art. To this end, the exhibits were carefully composed. In the first room one viewed ivory and amber objects set in front of marble panels. In the second, one found objects of silver set in front of mirrors, the background red. In the third were objects of silver gilt and gold set in front of mirrors and green decorations. After this, one entered a hall of precious objects, where hundreds of works of art made of rock crystal, jasper, and agate, vessels made of nautilus shells, as well as coconuts and ostrich eggs, objects with enamel, and large objets de vertu created by Johann Melchior Dinglinger were displayed on gilt consoles on mirrored walls. Next, one entered the jewel room, containing the sets of jewels of the Saxon crown treasure, the most extensive collection of jewels in Europe. These were placed on black velvet, before glass walls and pillars decorated with ornamental painting in gold, blue, and red. Finally, in the last room, which was paneled in plain oak, one found the bronzes. In this manner one experienced a gradual heightening of impressions that climaxed in the jewel room and then ended with the sculptures.

The chief device of the interior architecture in this complex was the mirrored cabinet and wall. In and on these, the art objects were multiplied optically while the outlines of the rooms, by the same means, were dissolved, and the visitor found himself facing limitless riches of artfully attuned shapes and colors that increased in intensity—a glorious phantas-magoria fulfilling the wishes of late baroque taste. Baron von Pöllnitz, a well-known writer of the time, called the Green Vaults "one of the most beautiful places on earth."

Outstanding artists collaborated on the installation. The construction was directed by Matthäus Daniel Pöppelmann, the builder of the Zwinger. Court sculptors carved the tables, consoles, and other decorative elements. One of them was Johann Joachim Kändler, the creator of European porcelain sculpture. The court lacquerers Martin Schnell and Christian Reinow decorated the figured consoles and glass walls in the verre eglomisé technique.

Because the ensemble exhibited the highest artistic quality, it retained a timeless beauty even after the baroque style went out of fashion. To this assertion one may add that certain innovations in the Green Vaults were to become standard in museum practice. For example, three levels of viewing were used in the rooms, corresponding to the artistic qualities of the objects. The first level was made up of a row of gilt tables that stood against the walls. Upon them, placed near the viewer's eye, were the most important objects. Then followed the wall consoles, raised to the height of some two meters; on these were the works of secondary importance. The third level—consoles at heights of two to four meters—was reserved for objects of purely decorative function that added mainly to the general impression of the room. Thus, the emotional, exuberant German baroque was disciplined in Dresden by means of rational structuring. Equivalent schemes of presentation, according to the importance of the decorative works shown, have been reintroduced in museums established in the twentieth century.

From the sociological point of view, the newly built Schatzkammer was a place for feudal display, useful as a demonstration of the power built up through the Saxon-Polish union, an assertion of rank, a promise of stability. Within these splendid rooms one admired the richest and largest collection of precious objects in Europe. The greater part of them originated between the mid-sixteenth century and the first quarter of the seventeenth, the period when Dresden was the center of the international Protestant movement, a position it retained until the Thirty Years War. Although the Green Vaults contain objects of extraordinary quality from the Middle Ages, these are not numerous, thanks to the iconoclasm of the Reformation, which was violent in Lutheran Saxony and resulted in the melting down of both ecclesiastical and secular objects that did not correspond to the new spirit and style.

During the first third of the eighteenth century—the period of Augustus the Strong—many works by Dinglinger and numerous other small precious objects of the most elaborate execution were added to the collection, along with the sets of jewels already mentioned. Works of later date are represented only sporadically, because three years after the completing of the installation, the founder of the Schatzkammer died and his son and successor, Augustus III, enthroned a new taste: the rococo modified by classicism. Furthermore, this

Elector's artistic interest ran more to paintings. As a result, the Green Vaults lost favor even more quickly than Versailles did after the death of Louis XIV. Winckelmann's criteria of noble simplicity and quiet greatness defined quite different attitudes, and to men of the new generation the arrangements and contents of the treasury seemed as obsolete and absurd as the concept of absolutism. Nevertheless, thanks to their artistic excellence, the Green Vaults survived the Age of Reason intact, acquiring in the popular mind a fairy-tale quality that has endured to this day.

When Dresden was destroyed on 13 February 1945, the only rooms in the entire city that did not collapse were four of the Green Vaults—a tribute to the strength of their construction. Three of the rooms, suffering direct bomb hits, collapsed and burned out. The treasures were then safely away from the city, stored in the mountain fortress of Königstein. There they were taken into the custody of the Soviet army. Today, the greater part of the collection is exhibited in a modern manner in the Albertinum, the former arsenal that became a museum building in the nineteenth century. After the rooms of the Green Vaults are restored, it is planned that the entire collection will once again be seen as it was in the eighteenth century.

JOACHIM MENZHAUSEN

The Green Vaults

ENTRIES BY: Gerald Heres and Werner Kiontke [241-306, 308-317, 319-322]

Martin Raumschüssel [307]

Günter Reinheckel [318]

241

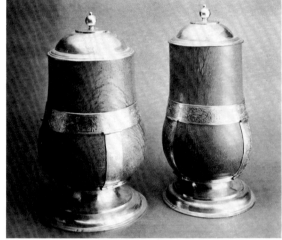

244, 245

Goldsmiths' Work

241. Silver bowl set with Roman coins

Italian, c. 1500
Silver gilt
D. 20.5 cm.
Inv. no. IV 44

242. Nautilus cup supported by a woodsman

German, c. 1570
Nautilus shell, silver gilt, turquoises, rubies, garnets
H. 17.8 cm.
Inv. no. III 177

243. Shell cup

Paulus Dulner (master 1552, d. 1596)
Nuremberg, c. 1570
Silver gilt and shell
H. 18 cm.
Inv. no. III 181

244, 245. Two tankards

Mounting by Urban Schneeweiss
Dresden, c. 1570
Serpentine from Zöblitz, silver gilt
H. 31 cm., 30.5 cm.
Inv. nos. V 399, 386

246. Small jug

Dresden, c. 1570
Serpentine from Zöblitz, silver gilt
H. 16.7 cm.
Inv. no. V 394

247. Standing mirror on column of rock crystal

Milan, before 1580
Restorations by J. H. Köhler, Dresden 1724
Mirror glass, rock crystal, gold, enamel, silver gilt,
 diamonds, rubies, emeralds, pearls
H. 77 cm.
Inv. no. V 171

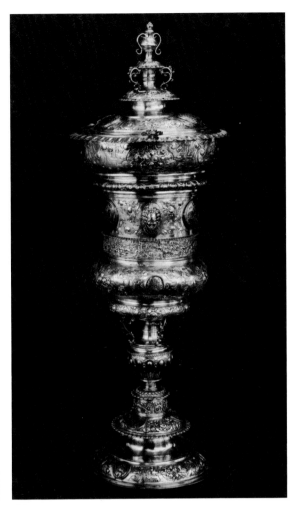

250

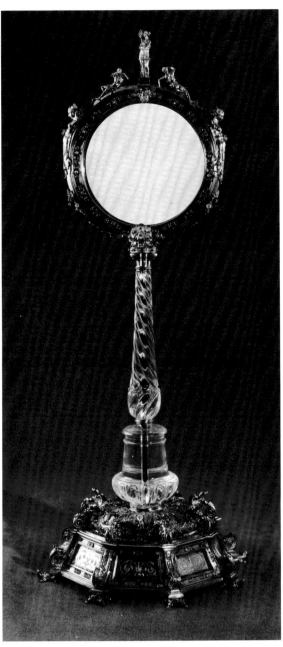

247

The art of stone-cutting, especially of rock crystal, flourished in Milan in the second half of the sixteen century. Duke Emanuel Philibert of Savoy gave this Milanese creation to the Dresden Elector in 1570. Before it was placed on display in the Green Vaults it was restored by the court jeweler Johann Heinrich Köhler. At that time it was necessary to replace the mirror glass and to recast some of the figures applied at the base.

248. Place setting: knife, fork, spoon

Genoa, 1579
Steel, silver gilt, turquoises, coral-branch handles
L. 31, 27.5, 24.5 cm.
Inv. no. III 174 d, e, f

249. Saltcellar matching 248

Probably Dresden, end 16th c.
Silver gilt, turquoises, coral branches
H. 13.1 cm.
Inv. no. IV 160

250. Cup and cover

Valentine Geitner
Dresden, before 1590
Silver gilt
H. 54 cm.
Inv. no. V 187

251. Double cup, one upside down over the other

Urban Schneeweiss
Dresden, c. 1590
Silver gilt
H. (together) 29 cm.
Inv. nos. IV 164, 304

252. Flask with chains

Jörg Ruel
Nuremberg, end 16th c.
Mother-of-pearl, silver gilt, emeralds
H. 27.2 cm.
Inv. no. III 192

253. Coconut cup and cover carved with scenes of Indians

Probably Friedrich Hillebrand
Nuremberg, end 16th c.
Coconut, silver gilt
H. 34.7 cm.
Inv. no. IV 325

254. Cup in shape of galley

Milan, end 16th c.
Rock crystal, gold, silver gilt, enamel, rubies
H. 18.8 cm.
Inv. no. V 264

255. Cup, stem in form of two dolphins

Giovanni Battista Metellino
Milan, c. 1700
Rock crystal, silver gilt, lapis lazuli
H. 21.5 cm.
Inv. no. V 249

In the shape of a shell, the bowl is decorated with sea plant and animal life. The Green Vaults own an extensive collection of works by Metellino, who followed the mannerist tradition of Milanese rock crystal cutting around the turn of the eighteenth century.

254, 255

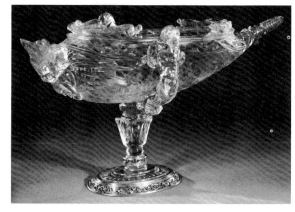

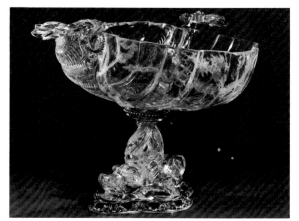

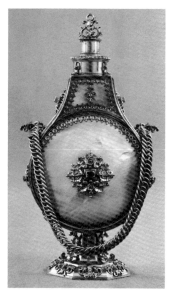

252

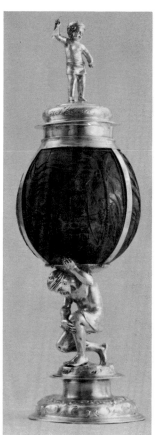

253

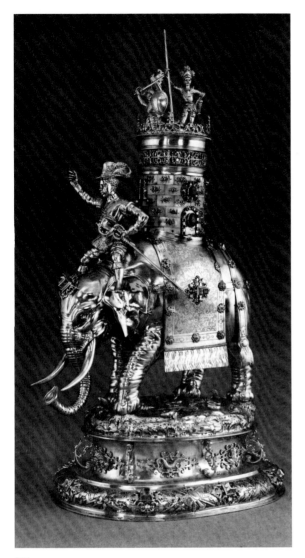

256

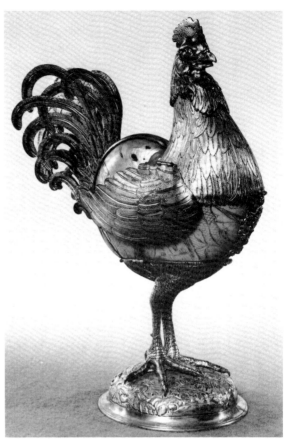

258

258. Drinking vessel in shape of a cock

Friedrich Hillebrand
Nuremberg, c. 1600
Nautilus shell, silver gilt
H. 30 cm.
Inv. no. III 156

256. Drinking vessel in shape of an elephant with a castle on his back

Urban Wolff
Nuremberg, before 1600
Silver gilt, mother-of-pearl, emeralds, rubies, one
 sapphire
H. 52 cm.
Inv. no. IV 120

257. Cup and cover

German, 14th, 16th, 17th c.
Amethyst, silver gilt, enamel, amethysts, diamonds
H. 20 cm.
Inv. no. VI 20

259. Coconut tankard

Probably Elias Geyer
Leipzig, c. 1600
Coconut, silver gilt
H. 30.6 cm.
Inv. no. IV 328

260. Drinking vessel in shape of a hippocampus

Elias Geyer
Leipzig, c. 1600
Mother-of-pearl, silver gilt, oil paint
H. 17.6 cm.
Inv. no. IV 289

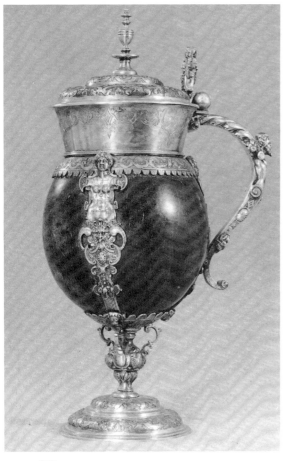

259

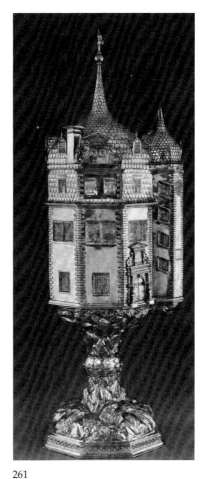

261

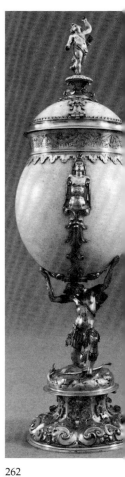

262

260

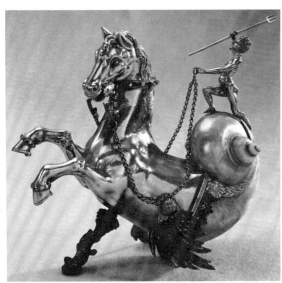

261. Cup and cover in shape of a castle

Georg Mond
Dresden, probably 1606
Silver gilt
H. 64.5 cm.
Inv. no. IV 345

The structure probably represents the pavilion that once existed in the garden of the castle in Pirna (Saxony). On the flag is the coat of arms of Saxony and the cipher of the Elector Christian II.

262. Ostrich egg cup and cover with stem in form of kneeling Indian

Probably Nuremberg, beginning 17th c.
Ostrich egg, silver gilt, oil colors
H. 42.2 cm.
Inv. no. III 116

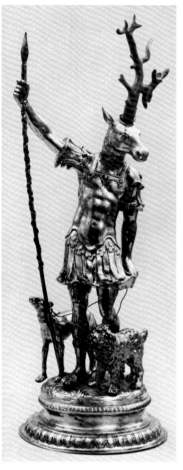

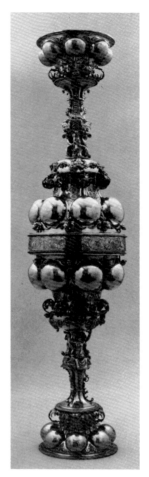

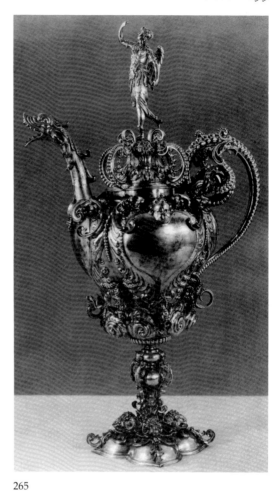

263 264 265

263. Drinking vessel in shape of Actaeon as hunter

Jeremias Ritter
Nuremberg, beginning 17th c.
Silver gilt, coral
H. 50 cm.
Inv. no. IV 261

264. Double cup

Andreas Rosa
Nuremberg, beginning 17th c.
Silver gilt
H. (together) 70 cm.
Inv. nos. IV 296, 301

265. Ewer

Christoph Jamnitzer (1563-1618)
Nuremberg, beginning 17th c.
Silver gilt
H. 46 cm.
Inv. no. IV 293

A figure of winged Fame stands upon the cover. The trumpet of glory, once held in her right hand, is lost. A basin belonging to the ewer was melted down in the eighteenth century. Christoph Jamnitzer was a grandson of Wenzel Jamnitzer.

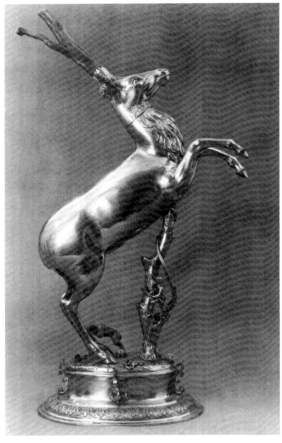

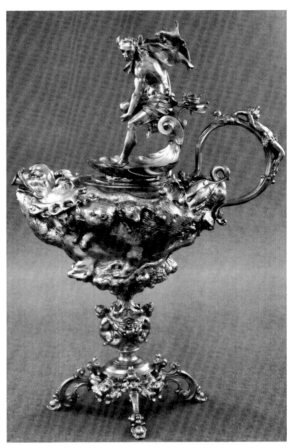

266

269

266. Leaping stag

> Andrea Rosa (master 1599)
> Nuremberg, beginning 17th c.
> Silver gilt, coral
> H. 42 cm.
> Inv. no. IV 119

267. Beaker

> Prague, beginning 17th c.
> Jasper, gold, garnets
> H. 12 cm.
> Inv. no. V 522

268. Jug

> Probably Dresden, c. 1620
> Saxon alabaster, silver gilt
> H. 18.4 cm.
> Inv. no. V 411

269, 270. Ewer and basin for rosewater

> Daniel Kellerthaler (c. 1575—c. 1651, master 1608)
> Dresden, 1629
> Silver gilt
> H. pitcher 41 cm; L. bowl 82 cm.
> Inv. nos. IV 57, IV 9

Of quatrefoil oval shape, the basin has on its bottom a relief representation of the competition between Apollo and Pan before King Midas. The rim is decorated with figurines of reclining nymphs and river gods, sea shells and putti. The body of the ewer is composed of parts of game animals; the figure on the lid—Midas in his punishment with ass's ears—corresponds to the theme of the relief on the basin. This garniture, an outstanding work of the early baroque period, was acquired by Johann Georg I.

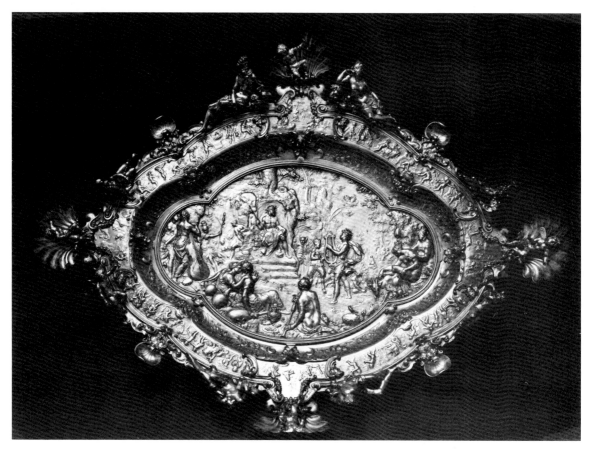

270

271. Cup and cover with stem in form of putto

Probably Dresden, c. 1640
Reddish yellow Saxon jasper, silver gilt
H. 34.7 cm.
Inv. no. IV 334

272. Bowl with cover

Dresden, mid-17th c.
Ostrich egg, silver gilt
H. 18 cm.
Inv. no. III 210

273, 274. Pair of drinking vessels in shape of vintners carrying pails

Strassburg, mid-17th c.
Wood, silver parcel gilt
H. 33 cm.
Inv. nos. VI 4, 6

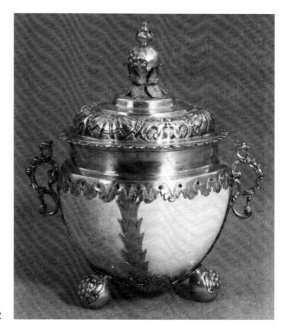

272

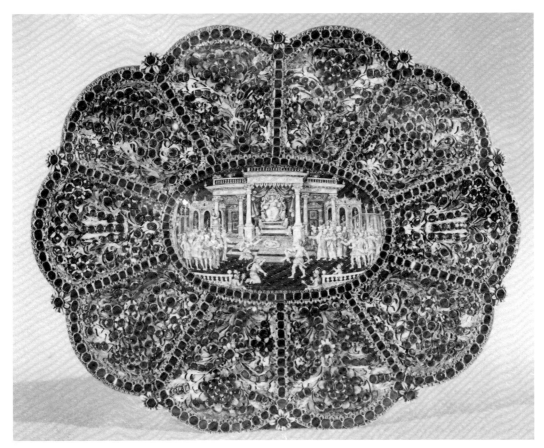

275

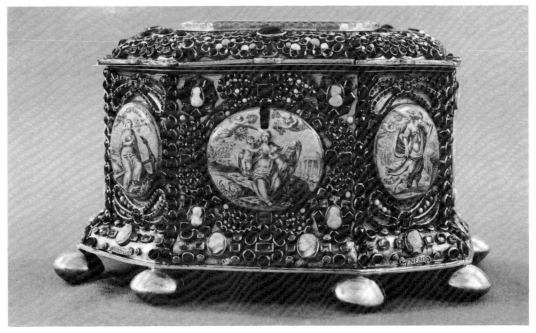

276

275. Dish

Samuel Klemm (1611-78, master 1644)
Freiberg in Saxony, 1656
Silver gilt, enamel, garnets
31.5 x 26 cm.
Inv. no. III 30

Oval center medallion painted in enamel with a figural scene, the Judgment of Solomon (signed S. Klem, dated 1656), surrounded by ten heart-shaped panels with enameled floral sprigs, jeweled with garnets. The entire framework is set with table-cut garnets. Samuel Klemm produced sacramental vessels for the most part. A miner's parade costume, which he made for Johann Georg II in 1677, is in the Green Vaults.

276. Jeweled casket with enamel medallions

Augsburg, end 17th c.
Silver gilt, enamel, chalcedony cameos, emeralds, garnets, amethysts
17 x 24 x 20 cm.
Inv. no. V 598

277. Jeweled and enameled casket

Johann Heinrich Mannlich (1660-1718)
Augsburg, end 17th c.
Silver gilt, rock crystal, smoky topaz
31.3 x 25.9 x 22.1 cm.
Inv. no. V 600

278-280. Three sets of ewers and basins

Augsburg, beginning 18th c.
Silver gilt
D. basins 57, H. ewers 30 cm.
Inv. nos. IV 147, 130; 114, 155; 182, 156

281, 282. Two wine coolers

Johann Christoph Treffler (d. 1722)
Augsburg, beginning 18th c.
Silver gilt
H. 21 cm.
Inv. nos. IV 190, 191

283. Coffee urn with stand

Johann Jacob Irminger (1635-1724) and Balthasar
 Permoser (1651-1732)
Dresden, 1722
Silver gilt
H. including tray 47.2 cm.
Inv. no. IV 255

Irminger became a Dresden citizen in 1682, and five years later, goldsmith to the court. Beginning in 1709,

he supplied models for Meissen porcelain manufacture. His two-handled coffeepot, together with its mate, also in the Green Vaults, belongs to a smoking set given in 1722 by Princess Maria Josepha to her husband, later Augustus III. The sculptural decoration—Neptune and Amphitrite on the handles, sea creatures on the bowl—was made after designs by Permoser.

281

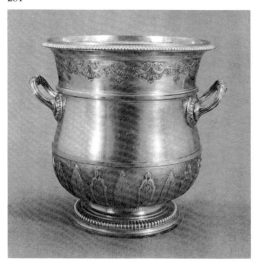

283

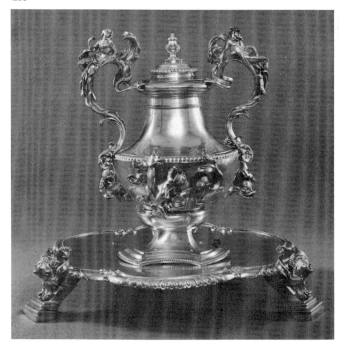

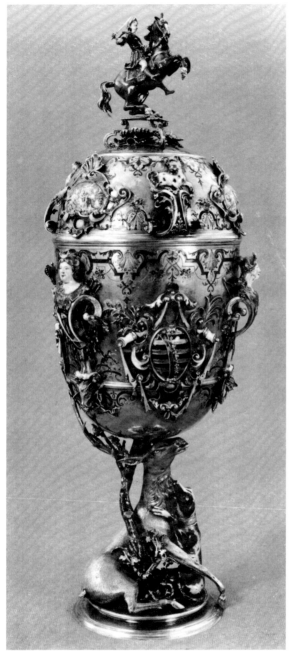

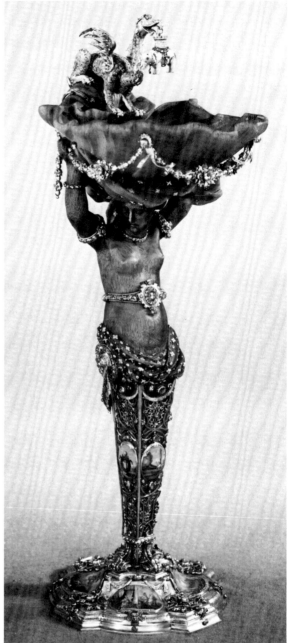

286 287

284. Onyx cup on silver-gilt baluster

> Probably Dresden, early 18th c.
> Onyx, silver gilt, enamel
> H. 17.5 cm.
> Inv. no. V 40

285. Flagon

> Johann Melchior Dinglinger (1664-1731)
> Dresden, end 17th c.
> Gold, enamel, diamonds
> H. 6.7 cm.
> Inv. no. VI 81

286. Hunting cup and cover

> Johann Melchior and Georg Christoph Dinglinger
> Dresden, c. 1712
> Gold and enamel
> H. 38 cm.
> Inv. no. IV 72

Decorated with the triple C cipher and the coats of arms of Saxony and Querfurt, this was presumably made on occasion of the marriage of the hunt-loving Duke Christian of Saxony-Weissenfels (to whom the Hunting Cantata of Johann Sebastian Bach was dedicated) to Sophie Christine of Stolberg, in 1712. In 1746 it entered the Green Vaults from the estate of the last Duke of Weissenfels.

287. Cup with stem in form of Moorish girl

> Johann Melchior Dinglinger
> Dresden, before 1717
> Rhinoceros horn, silver, gold, enamel, diamonds
> H. 37 cm.
> Inv. no. VI 119

Rhinoceros horn, thought to possess medicinal virtues, was a much-desired working material. Dinglinger designed a tapering shaft as the base of a caryatid figure of rhinoceros horn supporting a shell-shaped bowl, also of rhinoceros horn. Drapery spangled with gold stars connects the body and the filigree-like ornamentation of the stem, which is decorated with four enameled medallions with symbols and devices. Four larger enamel medallions around the base are painted with scenes from the Argonaut legend; they are signed on their backs by Georg Friedrich Dinglinger, and dated 1708/09. Silver straps studded with diamonds are looped around the figure's hips and arms. Trailing from the rim of the scalloped shell are silver garlands set with diamonds. At the back is a cartouche frame enclosing portrait busts of Jason and Medea, surmounted by a dragon. In its

mouth it carries the badge of the Danish Order of the Elephant; Augustus the Strong had become a knight of this order at a very early age, by virtue of his being the son of a Danish princess. In a letter to Augustus, written in 1717, Dinglinger states that he had worked together with his brother for eight years to create this "curious and precious piece." For it, he received 3500 thalers.

288. Blackamoor with pearl-filled tray

> Johann Melchior Dinglinger and Balthasar Permoser
> Dresden, c. 1720
> Ebony, gold, enamel, jewels, pearls, and mother-of-pearl
> H. 20 cm.
> Inv. no. VI 195

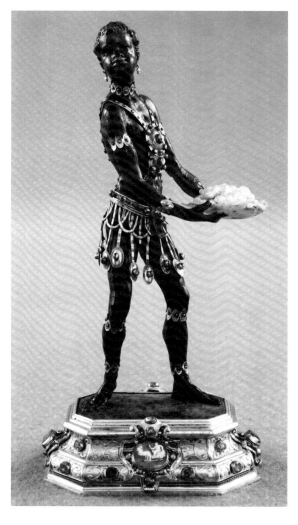

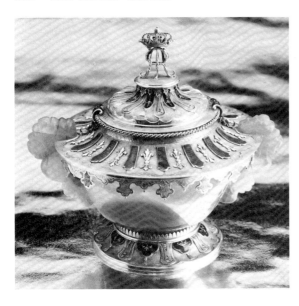

289. Bowl and cover

> Johann Melchior Dinglinger
> Dresden, c. 1720
> Jadeite, gold, enamel
> H. 9.3 cm.
> Inv. no. VI 13

The bowl itself was carved in China. Dinglinger added its base, rim, and lid, made of gold enameled in blue and red. The crowned monogram of Augustus the Strong forms the finial.

290. Vase of Kehlheim jasper

> Johann Melchior Dinglinger
> Dresden, before 1722
> Jasper, enamel, silver gilt, cameos, jewels
> H. 54 cm.
> Inv. no. V 136

291. Blackamoor with matrix of emeralds

> Johann Melchior Dinglinger and Balthasar Permoser
> Dresden, c. 1724
> Pear wood, lacquer, tortoise shell, silver gilt, gem
> stones, emeralds
> H. 63.8 cm.
> Inv. no. VIII 303

In 1581, when Elector Augustus paid a visit to Emperor Rudolf II in Prague, he was presented with a matrix in which sixteen emerald crystals are embedded, some of them of exceptional size. The cluster was found in Colombia, and presumably it had been presented to Emperor Charles V as an indication of the riches of the New World. At the time of the new installation of the

Green Vaults, Augustus the Strong ordered a figural carrier for the cluster. Permoser carved the figure; the pedestal, tree trunk, and tray of tortoise shell were presumably by the carver Wilhelm Krüger (1680-1756). The figure's tattoos and its feather crown, adopted from contemporary illustrations of travel descriptions, suggest that it is an American Indian. The allegorical significance is quite clear: America offers its treasures to the amazed Europe. A companion piece, carrying a rock crystal cluster, carved by J. H. Köhler, is in the Green Vaults.

292. Ewer

> Johann Melchior Dinglinger
> Dresden, before 1727
> Chased steel, silver gilt
> H. 40.5 cm.
> Inv. no. V 433

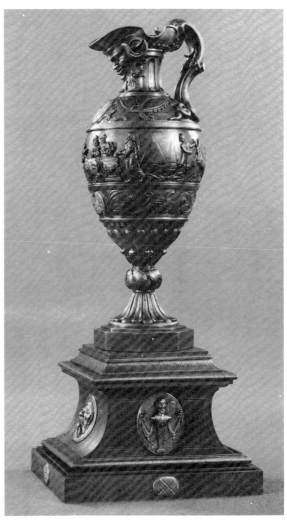

Dinglinger's only work in this metal, designed after an Italian print of 1582 of a vessel of classical antiquity. While it was still in his workshop, it was admired by visitors as "so delicately and artfully worked with raised figures that it might be mistaken for silver." The ewer rises from a massive, delicately chiseled pedestal, with a base decorated with medallions (cipher AR, arms of Saxony, Poland, and Lithuania) and a central section adorned with silver-gilt masks and herms of fauns. The central frieze of the ewer, in relief, is a scene of a sacrifice. Above and below, ornamental bands are interrupted by medallions with sacrificial instruments, cornucopias, and a sphinx. The spout is decorated with a grotesque mask with rams' horns.

293. Snuffbox

Johann Christian Neuber (1736-1808)
Dresden, c. 1780
Gold, semiprecious stones
D. 7.5 cm.
Inv. no. V 628

This is mounted with 77 different semiprecious stones found in Saxony; an accompanying booklet gives their names and places of origin. Neuber's creations in this mode were highly praised in the Weimar fashion periodical *Journal des Luxus und der Moden*, both for their educational value and their elegance, and their reputation spread throughout Europe.

Jewels

294. Signet ring of Martin Luther

Augsburg, c. 1530
Gold, carnelian
Inv. no. VIII 97

295. Ring inscribed "Memento mori" and fitted with a compass

German, 1538
Gold, enamel, rock crystal
Inv. no. VIII 99

296. Girdle chain

German, c. 1560
Gold, lapis lazuli
Inv. no. VIII 279

This belonged to Anna, wife of the Elector Augustus.

297. Pendant with letter A

c. 1570
Gold, enamel, diamonds
6.6 x 5 cm.
Inv. no. VIII 301

Two female genii holds a laurel wreath over the letter, which may refer either to the Elector Augustus or to his wife, Anna. Beneath the letter is a figure of a seated woman dressed in red.

298. Pendant with woman playing a lute, mounted on a stag

German, end 16th c.
Gold, enamel, rubies, diamonds
5 x 4.3 cm.
Inv. no. VI 7 h

The stag is enameled in brown and decorated with multicolored fruits, a lion's mask, and a suspended pearl. The lute-player—a personification of Music—wears a blue veil and a blue green robe over a chased gold dress. Two rings on the pendant allow it to be mounted on a chain.

299. Ring

German, end 16th c.
Gold, enamel, diamond
Inv. no. VIII 56

300. Pendant with arms of the Elector of Saxony

> c. 1610
> Gold, rubies, emeralds, diamonds
> 12.2 × 7.3 cm.
> Inv. no. VIII 271

Around the coat of arms of the dukedom of Saxony—barry or and sable, wreath of rue in bend—are the coats of arms of territories belonging to the Electorate of Saxony. Emphasized are those of Jülich, Cleve, and Berg, which were claimed by the Electorate in a controversy with Brandenburg. The whole is surmounted by crossed swords, the badge of the Grand Marshalship

301. Rose-diamond garniture of the Saxon Crown Treasure

> Dresden, second half 18th c.
> Inv. no. VIII 1-18

Ten waistcoat buttons, ten coat buttons, one pair of shoe buckles, four hat bands, one pair of belt buckles, one hat clasp, one shoulder clasp, cane handle, court sword with scabbard, and star and badge of the Order of the White Eagle. In addition, seven badges of the Order of the Golden Fleece, one of them jeweled with rose diamonds, the others with onyxes, opals, tiger-eyes, topazes, garnets, and hyacinths. Garnitures of jewels were part of the full dress of a prince in the period of absolutism. Being much subject to fashion, they were frequently broken up and recut and reset. Even the nine jewel garnitures of Augustus the Strong in the Green Vaults are only partly in their original condition, in spite of their relative completeness. After his great rose-diamond garniture was broken up, this new garniture was created by the court jewelers Pallard (c. 1750) and Globig (1782-89). It is the only surviving garniture with rose-cut diamonds.

302. Dancing dwarf

> Dresden, early 18th c.
> Baroque pearl, gold, silver, enamel, diamonds
> H. 8 cm.
> Inv. no. VI 97

This and the grotesque figurines 303-306 are composed of monstrous pearls mounted in enameled and jeweled gold and silver. The Green Vaults' collection of these jewelers' sculptures is the largest in existence. Though some of these figurines were acquired at the Leipzig Fair, they must have been created in the Dresden court workshops.

303. Dwarf with musket

> Dresden, early 18th c.
> Baroque pearl, gold, silver (parcel gilt), enamel, diamonds
> H. 13 cm.
> Inv. no. VI 85

304. Halberdier with dog

> Dresden, early 18th c.
> Baroque pearls, gold, silver, enamel, colored jewels, diamonds
> H. 16.3 cm.
> Inv. no. VI 112

305. Peddler

> Dresden, early 18th c.
> Baroque pearls, gold, silver, enamel, colored stones, diamonds
> H. 13.3 cm.
> Inv. no. VI 89

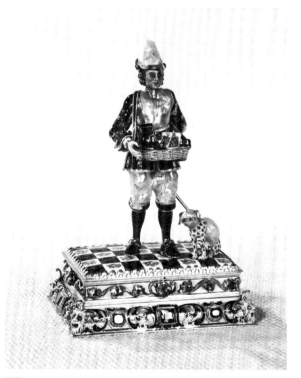

305

306. Joshua and Caleb

> Dresden, early 18th c.
> Gold, silver, enamel, emeralds, rubies, diamonds
> H. 13 cm.
> Inv. no. VI 23

Bronze

307. Equestrian statuette of Augustus the Strong

Style of François Girardon (1628-1715)
Paris, before 1715
Bronze, hollow cast. Light brown patina with traces of
dark lacquer
H. 105 cm.
Inv. no. IX 67

This was commissioned by Raymond Le Plat and de-
livered to Augustus in 1715. It once had a richly deco-
rated base with four cowering slaves; this was lost at
the end of World War II. An equestrian statuette of
Louis XIV, now in the Prado, Madrid, was the model
for this work. Though that version is attributed to
Girardon or his school, it differs considerably from the
small-size versions of the statute of Louis XIV that
stood in the Place Vendôme, Paris, until the Revolu-
tion. Pierre Quarrès has suggested that the Prado's
statuette may be an eighteenth-century replica after an
equestrian statute of Louis XIV by Etienne le Hongre in
Dijon (destroyed).

Ivories

308. Hercules and Omphale

Balthasar Permoser
Dresden, c. 1690
Ivory
Signed on base
H. (with base) 30 cm.
Inv. no. II 42

Hercules, nude, is seated on a rock, holding a distaff
and groaning in torment. Omphale, draped in his lion

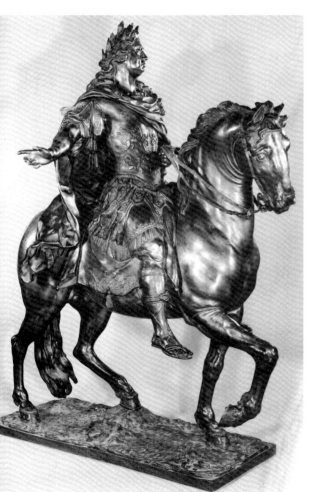

307

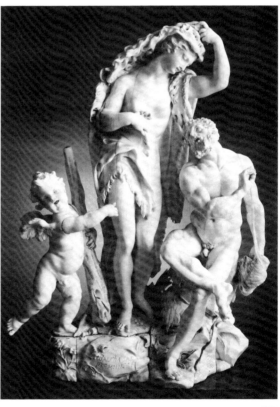

308

skin, gazes down on him. Amor struggles with Hercules' club and points a triumphant finger at the vanquished hero. This motif from classical mythology, recreated by artists of the Renaissance and the baroque in innumerable variations, has been enhanced with graceful playfulness by Permoser. In his Hercules we can find a mildly mocking rendering of the Laocoön group in the Vatican. The elegance of outline and grace of movement make this ivory group a forerunner of Meissen porcelain sculpture. On the rock base is the signature of Permoser, who was appointed court sculptor in 1689. Presumably this group was made soon afterward. It exists in several replicas, one of which is in the Green Vaults.

309. Gypsy woman on horseback

Johann Christoph Nessler (master 1699)
Dresden, early 18th c.
Ivory, silver gilt, agate
H. 16.5 cm.
Inv. no. VI 220

310, 311. Two beggars

Wilhelm Krüger (probably)
Dresden, early 18th c.
Ivory, silver gilt, jewels
H. 14 cm.
Inv. nos. VI 1730, 172 r

312, 313. Scaramouche and Colombine

Johann Christoph Ludwig Lücke (c. 1703-80)
Dresden, 1733
Ivory (partly stained brown), silver
H. 15 cm.
Inv. no. VI 236, 239

Horology

314. Watch with rock crystal case, set on a jasper obelisk

Prague (?), early 17th c.
Gold, rock crystal, agate, jasper, rubies, diamonds
H. 28 cm.
Inv. no. VI 60

315. Watch

Johann Poestdorffer
Dresden, beginning 17th c.
Case of rock crystal, silver gilt, enamel, brass
L. 9.1 cm.
Inv. no. VI 7 a

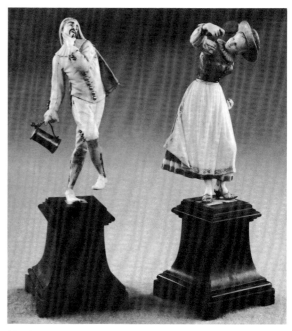

312, 313

316. Hanging clock

Johann Heinrich Köhler
Movement by J. G. Graupner
Dresden, delivered 1725
Wood, brass gilt, colored stones, diamonds, enamel
H. 29 cm.
Inv. no. VI 158

317. Monstrance clock

Johann Heinrich Köhler (1669-1736)
Dresden, 1725
Movement by Jehan Drouynot, Poitiers
Gold, silver gilt, enamel, cameos, jewels, pearls
H. 23 cm.
Inv. no. VI 25

Furnishings

318. Console table

Probably Johann Benjamin Thomae (1682-1751)
Dresden, c. 1730
Lindenwood, carved, gilt, painted in imitation of
 lapis lazuli
87 x 75 x 65 cm.
Inv. no. 37 614

Carved tables and seating pieces, usually gilt and painted, were often the work of sculptors. Thomae, a court sculptor, was often mentioned as a furniture

carver. He received his training from H. Taschau, the royal cabinetmaker. Among other things, Thomae worked on outfitting the Green Vaults. This table and its companion piece are listed in the 1733 and 1884 inventories of the Hall of Precious Objects. Originally, both tables had tops of Florentine pietra dura; the marble top is a replacement.

319-322. Four shields with arms of Saxon provinces

Dresden, early 18th c.
Copper gilt

LITERATURE

Beschreibung des Grünen Gewölbes in Dressden. Frankfurt/M., Leipzig, 1739.

A. B. von Landsberg, *Das Grüne Gewölbe in Dresden.* Dresden, Leipzig, 1st ed., 1831; 18th ed., 1862.

A. B. von Landsberg, *Das Grüne Gewölbe zu Dresden.* Dresden, 1862.

Johann Georg Theodor Graesse, *Beschreibender Katalog des Kgl. Grünen Gewölbes.* Dresden, 1st ed., 1872; 5th ed., 1881; English ed., 1872.

Johann Georg Theodor Graesse, *Das Grüne Gewölbe zu Dresden.* 2 vols. Berlin, c. 1876.

Ludwig Gruner, *The Green Vaults, Dresden.* London, 1876.

Julius and Albert Erbstein, *Das Königliche Grüne Gewölbe zu Dresden.* Dresden, 1884.

Jean Louis Sponsel, *Führer durch das Grüne Gewölbe zu Dresden.* Dresden, 1915; 2nd ed., 1921.

Jean Louis Sponsel, *Das Grüne Gewölbe zu Dresden. Eine Auswahl von Meisterwerken der Goldschmiedekunst.* 4 vols. Leipzig, 1925-32.

Joachim Menzhausen, *Grünes Gewölbe.* Dresden, 1967.

Joachim Menzhausen, *Das Grüne Gewölbe.* Leipzig, 1968.

318

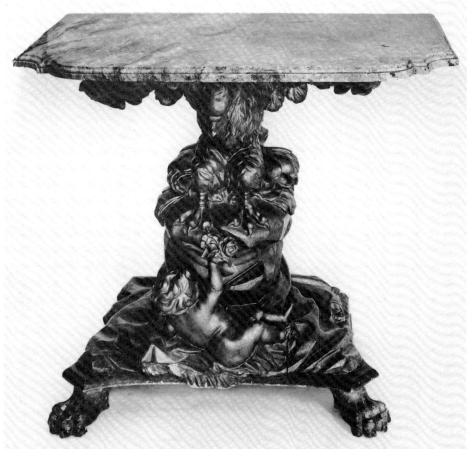

For Dresden's extraordinary collection of porcelains, and indeed for the European reinvention of true porcelain, one thanks Augustus the Strong. He accumulated the largest group of Arita wares outside Japan as well as enormous amounts of Chinese blue and white, famille verte, and blanc de chine. In pursuit of imitations of his beloved oriental pieces Augustus financed experiments to discover their elusive formula, and by 1710 Meissen, an old medieval town a few miles from Dresden, had become the home of Europe's first hard-paste porcelain manufactory. Quite logically, Dresden today possesses the world's largest and finest collection of Meissen pieces, both in the oriental manner and in the delicate idiom of the European rococo style.

Augustus planned to fill an entire palace with his still-growing collection of some twenty thousand porcelains, but the project was unfinished at his death in 1733. From the architects' plans for the sumptuous interiors one learns that the porcelains were to be arranged by category—Chinese, Japanese, and Meissen—with each room devoted to pieces of a single color displayed in formal patterns over the walls: a baroque setting of fitting splendor.

The Porcelain Collection

In the meadows opening onto the banks of the Elbe one finds to this day a large building with four wings—the Japanese Palace. The relief in the pediment over its entrance explains the original purpose of the building: The countries in which porcelain was manufactured are shown bringing their treasures to the enthroned "Saxonia." This, then, was to have been the Porcelain Palace of Augustus the Strong. When Augustus, who was like one possessed where porcelain was concerned, died in 1733, the building's exterior was not yet finished. Only the carefully drawn plans for the interior arrangement, preserved along with some 20,000 pieces of porcelain from China, Japan, and the factory at Meissen, give one an idea of the great, almost fantastic scope of the Elector's plan.

In more than thirty rooms and galleries on two floors, Oriental and Meissen porcelains were to be exhibited in such a way that one color scheme would dominate a room. There were to be rooms, for example, with porcelains entirely "dark blue with gold" or "purple with gold" or "peachbloom with gold," installed in such a way that figures as well as vessels would decorate the walls. There were designs for a chapel with altar, pulpit, organ, and twelve life-size apostles, all of porcelain, in an audience room with porcelain throne and canopy, and a gallery with hundreds of life-size porcelain animals.

Though Augustus III, after the death of his father, continued for a time with these plans, and though the Meissen factory went on to supply the palace with a few thousand life-size animals and birds, along with tureens and other tablewares, interest in the basic idea of a porcelain palace began to wane. A visitor who had read about the wonders of Dresden was very disappointed to discover, in 1741, that the rooms were merely laid out, so to say, in porcelain. Some forty years later another visitor commented bitterly, even while admiring the vast quantities of porcelain stored in the cellars of the palace, "Nothing about it is true at all!"

At this point the upper rooms of the palace were turned over to the Antiquities Collection, the Coin Collection, and a library. The vogue for Chinese wares, once widespread in Europe, had come to an end, and a substantial collection like this one was now considered to be more of scientific than aesthetic interest. Indeed, all the pieces that Augustus had brought together between 1710 and 1730 were now, in 1786, declared a "collection," subject as such to scientific classification.

And then, ninety years later, the porcelain was moved from the Japanese Palace. From the cellars (which, according to one witness, "had the dubious appearance of a pantry") it went to the upper stories of the Johanneum, the old gallery building. After another ninety years a longtime dream of the Dresden museum staff came true: the Porcelain Collection, after going through World War II with only minor losses, and having been in the Soviet Union for safekeeping, found its present home in the rooms and galleries of the Zwinger. Some of the plans developed for the old Japanese Palace were now realized. On the walls of the arched Zwinger gallery one can see arrangements of Chinese and Japanese pieces in the style of the original designs. Interest in antique porcelain is again increasing. While it was housed in the Johanneum, the collection was hardly visited. In the Zwinger it often has 2000 visitors a day.

The collection owns an early inventory from the year 1721, with supplements up to 1727. In this, the Chinese, Japanese, and Meissen pieces are registered separately. The volume, furthermore, refers to the inventory of the first, small porcelain palace—the Dutch Palace—that was enlarged and renamed the Japanese Palace in 1730. The identifying numbers found in this oldest inventory are wheel-cut and painted in black on the bottoms of the corresponding pieces. These are today's "Johanneum" numbers, a misnomer inasmuch as the porcelain was still in the Japanese Palace. Many of the numbers were not noted in the oldest surviving inventory, but they were recorded in a supplementary volume, now lost. In 1779, shortly before the collection went into the cellars of the palace, the numbers were re-recorded in five volumes of a new inventory. These volumes still exist. Pieces of porcelain were evidently given away or disappeared during the disturbances of the Seven Years War, since the numbers in the re-inventoried groups are not always in sequence. In the present catalogue the "Johanneum" number, where still recognizable, appears after today's inventory number.

In the exhibition we present a miniature version of the arrangement seen today in the Zwinger. In the first of seven wall arrangements is underglaze blue porcelain from the time of Emperor K'ang-Hsi (1662-1722), a ware believed to have been a favorite of Augustus the Strong. Flanking this are two of the well-known "dragoon" vases (356, 357), monumental Chinese pieces with paintings of lotus blossoms and sea dragons in underglaze blue. These belong to the group of porcelains that Augustus the Strong received from the Prussian king in return for his gift to that ruler of 600 soldiers.

Represented on one wall are three other kinds of Oriental porcelain. One of these is Japanese Imari porcelain. Made in the seventeenth and eighteenth centuries in the city of Arita, on the island of Kiushu, and exported to Europe, Imari ware entered the Dresden collection in such quantity that today the collection is the largest outside Japan.

In the center are examples of Chinese porcelain of the same period. In Europe it was known as famille verte for its predominantly soft green color.

The third group comprises white porcelain, called blanc de chine in Europe. Figures of gods and ceremonial utensils in blanc de chine came mostly from the workshops of Têhua, in the province of Fukien.

Of the remaining three sections the first displays Chinese and Japanese porcelains in company with copies of them made in the Meissen factory after Meissen succeeded in duplicating Oriental porcelain. The copies are so good, in fact, that the originals are distinguishable only by their slightly bluish glaze. Japanese Kakiemon porcelains, for which an especially large room was intended in the Japanese palace, were copied more frequently at Meissen than Chinese porcelains.

Dresden has the largest collection anywhere of old Meissen porcelains. It was in Dresden itself, in the vaults of the fortification later known as the Brühlsche Terrasse, that Johann Friedrich Boettger discovered how to make porcelain. The first factory in Europe for making it was founded in Dresden in 1710, then moved almost at once to the medieval castle of Albrechtsburg in nearby Meissen. The Dresden collection is especially rich in pieces produced in the time of Augustus the Strong. Boettger stoneware and Boettger porcelain, which were the first bowls and figures from the factory, make up a collection of more than 800 examples. Some of these are of great rarity, such as a coffeepot of Boettger stoneware painted with enamel colors and decorated with gem stones (449), or a lovely little cup with Boettger's "mother-of-pearl" glaze (474), one of three extant, all of which are in the collection. The collection is also rich in life-size porcelain animals, created for the Japanese Palace by the sculptors Kirchner and Kändler. About a hundred of these are still extant in Dresden.

From the classical period of the Meissen production we show vessels that can be seen practically nowhere except Dresden. These include yellow vases decorated with hunting scenes after the manner of the painter and print-maker Ridinger (498), pieces from the Yellow Hunting Service (500, 501), vases with chinoiseries painted by Adam Friedrich von Löwenfinck (495-497), and vases marked AR (Augustus Rex), decorated with unique "Indian" flowers developed for these very pieces by Johann Gregor Höroldt.

INGELORE MENZHAUSEN
Director
Porcelain Collection

The Porcelain Collection

ENTRIES BY: Friedrich Reichel [Oriental porcelain]

Ingelore Menzhausen [Meissen porcelain]

Blue and White Chinese Porcelain

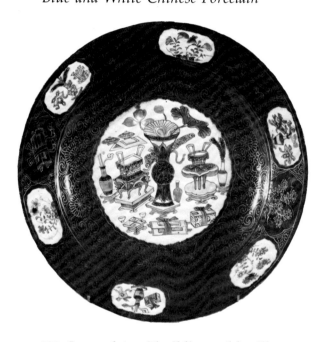

323. Large plate with gilding and famille verte decoration in reserve

China, Ching-tê Chên
C. 1700-20
Porcelain decorated in underglaze blue, enamel colors, and gold
H. 6, D. 38.6 cm.
Inv. no. P.O. 4014 / N: 134 〰

324. Large plate, mate to 323

H. 6.8, D. 39.2 cm.
Inv. no. P.O. 4015 / N: 134 〰

The still lifes in the central reserves probably have symbolic or allegorical meaning. It is easy to understand that a people as conscious of tradition as the Chinese would value antiquities—especially archaic sacred bronzes—as good-fortune amulets.

325. Shallow bowl with wavy rim, painted with landscapes and flower motifs

China, Ching-tê Chên
K'ang Hsi period (1662-1722)
Porcelain decorated in underglaze blue and enamel colors
H. 3.6, D. 21.7 cm.
Inv. no. P.O. 4016 / N: 42 +

326. Shallow bowl with wavy rim, painted with landscapes and flower motifs

China, Ching-tê Chên
C. 1700-20
Porcelain decorated in underglaze blue and enamel colors
H. 3.8, D. 21.7 cm.
Inv. no. P.O. 4017 / N: 38 +

327. Shallow bowl with five reserves in form of blossoms

China, Ching-tê Chên
K'ang Hsi period (1662-1722)
Porcelain decorated in underglaze blue and enamel colors
H. 3.3, D. 21.6 cm.
Inv. no. P.O. 4018 / N: 159 〰

328. Shallow bowl with painting of flower basket

China, Ching-tê Chên
K'ang Hsi period (1662-1722)
Porcelain decorated in underglaze blue and red
H. 4.2, D. 22.7 cm.
Inv. no. P.O. 4019

329. Shallow bowl, mate to 328

H. 4, D. 22.6 cm.
Inv. no. P.O. 4020 / N: 484 〰

The flower basket is perhaps meant as an attribute of Lan Ts'ai-ho, one of the Taoist Eight Immortals. The underglaze copper red was used only rarely, as it was often spoiled in the firing process.

330. Bottle-shaped vase with reserves painted with antiquities

China, Ching-tê Chên
K'ang Hsi period (1662-1722)
Porcelain decorated in underglaze blue
H. 30.5 cm.
Inv. no. P.O. 3983

331. Bottle-shaped vase, mate to 330

H. 31.2 cm.
Inv. no. P.O. 3984 / (N:) 136 (?) ᗯᗯ

332. Bottle-shaped vase, mate to 330

H. 29.8 cm.
Inv. no. P.O. 3986 / N: 310 ᗯᗯ

333. Bottle-shaped vase, mate to 330

H. 31.4 cm.
Inv. no. P.O. 3987 / N: 310 ᗯᗯ

334. Bottle-shaped vase with flared rim

China, Ching-tê Chên
K'ang Hsi period (1662-1722)
Porcelain decorated in underglaze blue
H. 24.4 cm.
Inv. no. P.O. 3993 / N: 416 ᗯᗯ

335. Bottle-shaped vase with flared rim, mate to 334

H. 24.5 cm.
Inv. no. 3994 / N: 416 ᗯᗯ

336. Bottle-shaped vase

China, Ching-tê Chên
K'ang Hsi period (1662-1722)
Porcelain decorated in underglaze blue
H. 21.6 cm.
Inv. no. 3997 / N: 311 ᗯᗯ

337. Bottle-shaped vase, mate to 336

H. 22.7 cm.
Inv. no. 3998 / N: 311 ᗯᗯ

338. Cylindrical vase with narrow neck

China, Ching-tê Chên
K'ang Hsi period (1662-1722)
Porcelain decorated in underglaze blue
H. 25.6 cm.
Inv. no. P.O. 4003 / N: 391 ᗯᗯ

339. Cylindrical vase with narrow neck, mate to 338

H. 24.8 cm.
Inv. no. P.O. 4004 / N: 391 ᗯᗯ

340. Jar and cover with ring handle

China, Ching-tê Chên
K'ang Hsi period (1662-1722)
Porcelain decorated in underglaze blue
H. 17, D. 13.4 cm.
Inv. no. P.O. 4005 / N: 461 ᗯᗯ

341. Jar and cover with ring handle

China, Ching-tê Chên
K'ang Hsi period (1662-1722)
Porcelain decorated in underglaze blue
H. 17.3, D. 14.6 cm.
Inv. no. P.O. 4006 / N: 485 ᗯᗯ

342. Jar, painted with prunus blossoms on cracked ice

China, Ching-tê Chên
K'ang Hsi period (1662-1722)
Porcelain decorated in underglaze blue
H. 25.3 cm.
Inv. no. P.O. 1164 / N: 47 ᗯᗯ

343. Jar, mate to 342

H. 25.5 cm.
Inv. no. P.O. 4007 / N: 47 ᗯᗯ

Such ginger jars were favored in China as New Year's gifts; their decorations allude to the coming of spring. Old pieces are a particularly beautiful blue, and were—especially before the First World War—very popular with collectors, which led to numerous imitations. In the eighteenth century these jars were sometimes overpainted with unfired colors, which brought about a similarity to the appearance of Japanese Imari porcelain.

344. Vase with narrow neck

China, Ching-tê Chên
K'ang Hsi period (1662-1722)
Porcelain decorated in underglaze blue and gold
H. 25.7 cm.
Inv. no. P.O. 4008 / N: 78 〰

345. Vase, mate to 344

H. 26 cm.
Inv. no. 4009 / N: 78 〰

346. Triple gourd vase with famille verte decoration

China, Ching-tê Chên
C. 1700-20
Porcelain decorated in underglaze blue and enamel colors
H. 27.1 cm.
Inv. no. P.O. 4010 / N: 140 〰

347. Triple gourd vase, mate to 346

H. 28 cm.
Inv. no. P.O. 4011 / N: 140 〰

348. Triple gourd vase with famille verte decoration

China, Ching-tê Chên
C. 1700-20
Porcelain decorated in underglaze blue and enamel colors
H. 23.2 cm.
Inv. no. P.O. 4108 / N: 143 〰

The popularity in Chinese and Japanese ceramics of the double or triple gourd shape is due to mythological associations: it is the attribute of Li T'ien-kuai, one of the Eight Immortals.

349. Vase with long neck, famille verte decoration

China, Ching-tê Chên
C. 1700-20
Porcelain decorated in underglaze blue and enamel colors
H. 18.8 cm.
Inv. no. P.O. 4012 / N: 147 〰

350. Vase with long neck, mate to 349

H. 18.7 cm.
Inv. no. P.O. 4013 / N: 148 〰

351. Coffeepot with curved handle and spout, famille verte decoration

China, Ching-tê Chên
K'ang Hsi period (1662-1722)
Porcelain decorated in underglaze blue and enamel colors
H. 20.6, L. 19.5 cm.
Inv. no. P.O. 4112 / N: 150 〰

352. Coffeepot, mate to 351

H. 21.5, L. 19.3 cm.
Inv. no. P.O. 4113 / N: 675 〰

353. Large vase with flared neck

China, Ching-tê Chên
K'ang Hsi period (1662-1722)
Porcelain decorated in underglaze blue and enamel colors
H. 53.1 cm.
Inv. no. P.O. 2910 / N: 45 〰

354. Large vase, mate to 353

H. 55.2 cm.
Inv. no. P.O. 1175 / N: 45 〰

355. Baluster vase with flared rim, famille verte decoration

China, Ching-tê Chên
C. 1700-20
Porcelain decorated in underglaze blue and enamel colors
H. 45 cm.
Inv. no. P.O. 8939 / I. 39

356. Monumental vase, so-called "dragoon vase," painted with lotus ornaments and sea dragons

China, Ching-tê Chên
K'ang Hsi period (1662-1722)
C. 1700
Porcelain decorated in underglaze blue
H. 96.2 cm.
Inv. no. P.O. 1008

357. Monumental vase, mate to 356

H. 96.2 cm.
Inv. no. P.O. 1013

The name "dragoon vase" reflects the rather inglorious history of the acquisition of these monumental porcelains. In 1717, Augustus the Strong made a gift of 600 soldiers from his army to King Friedrich Wilhelm I

of Prussia, who formed the soldiers into a new regiment of dragoons. In return, Augustus received from Friedrich Wilhelm 151 mostly large-scale vases and bowls from the Oranienburg and Charlottenburg palaces. This was the era of mercenary soldiering, when the inhuman practice of selling and hiring out of troops was widespread, especially among German princes, and also known in connection with the American War of Independence.

Blanc de Chine

358. Seated Bodhisattva

China
First half of the 14th c.
Porcelain
H. 28.5 cm.
Inv. no. P.O. 3793 / 32.33

This figure belongs to a small group of representations of Buddhist saints that were first recognized as belonging to the Yüan period (1279-1368) by the Dresden Museum director Ernst Zimmermann. An archeological find in Peking in 1955 confirmed this date. According to Buddhist doctrine, a Bodhisattva is a saint who has not yet reached, or has renounced, the last stage of enlightenment.

359. Girl playing lute, with two companions

China, Tê-hua
C. 1675-1725
Porcelain, with traces of painting in unfired colors
H. 45.8, W. 17 cm.
Inv. no. P.O. 6821 / N: 74 △

360. Seated Kuan-yin with child and two companions

China, Tê-hua
C. 1675-1725
Porcelain painted in unfired colors
H. 38.5, W. 19.1 cm.
Inv. no. P.O. 8619

Kuan-yin, goddess of mercy, was the Buddhist figure most often represented in the porcelain factories of Tê-hua. The child on her lap designates her role as goddess of fertility and childbirth.

361. Kuan-yin standing on cloud base

China, Tê-hua
C. 1675-1725
Porcelain, unpainted
H. 45, W. 12.2 cm.
Inv. no. P.O. 8638 / I.81

A cast of this figure was one of the earliest models used at the Meissen factory. It was produced in both brown Boettger stoneware and porcelain.

358

362. Lady with bird on a perch

China, Tê-hua
C. 1675-1725
Porcelain painted in unfired colors
H. 38, W. 10 cm.
Inv. no. P.O. 8633

362

Not only religious figures, but figures and groups that had to do with daily life or represented theater scenes were produced in blanc de chine.

363. Grotto with Buddhist saints

China, Tê-hua
C. 1675-1725
Porcelain
H. 21, W. 19 cm.
Inv. no. P.O. 8545 / II. B. 5

This is probably a simplified representation of the Shrine of Kuan-yin on the island of Pu-t'o near Shanghai, since Kuan-yin is shown in the highest position, and the figures total twenty-one.

364. Goddess Tou-mu

China, Tê-hua
C. 1700-1725
Porcelain
H. 25, W. 17.5 cm.
Inv. no. P.O. 8544 / (N:) 81 △

Tou-mu is the eighteen-armed Taoist goddess of the pole star and has significance similar to that of Kuan-yin. The lotus throne and Buddhist crown indicate that she was originally a Buddhist deity; the combination of different religious systems is characteristic of Chinese popular beliefs.

365. A European riding on a Buddhist lion (dog of Fo)

China, Tê-hua
C. 1675-1725
Porcelain
H. 28.5, L. 19.5 cm.
Inv. no. P.O. 8537

Blanc de chine figures riding on horses or mythological Chinese creatures are found frequently even today — a sure sign of their eighteenth-century popularity.

366. Three musicians in front of cliffs

China, Tê-hua
C. 1675-1725
Porcelain
H. 12.5, W. 10.5 cm.
Inv. no. P.O. 8583 / N. 32 △

367. Miniature figure: a European on a buffalo

China, Tê-hua
C. 1675-1725
Porcelain
H. 6.9, L. 6.7 cm.
Inv. no. P.O. 8601 / (N:) 36 △

The pipe, which is unrelated to the figure, produces a shrill sound, and marks this piece as a child's toy.

368. Octagonal incense burner with cover and stand

China, Tê-hua
C. 1675-1720
Porcelain, formerly painted
Burner: H. 11.5, D. 15 cm.
Saucer: H. 5, D. 17.1 cm.
Inv. no. P.O. 8273 / N: 16 ↗

Quite often, the blanc de chine in Europe was over-painted in unfired colors, and such was the case here. For the dating of this example, its documented presence in the Dresden collection by 1721 is an important point of reference. In that year, two such incense burners were listed as "red Chinese porcelain." The model was popular in Europe in the eighteenth century.

369. Water-dropper in the form of a crab in a bowl

China, Tê-hua
C. 1675-1725
Porcelain
H. 5.4, L. 13.5 cm.
Inv. no. P.O. 8477

Among the utensils that had their place on the writing tables in old China was the water-dropper, essential for mixing ink.

370. Oblong betel box with floral decoration in relief

China, Tê-hua
C. 1675-1725
Porcelain
H. 5, L. 10 cm.
Inv. no. P.O. 8277 / N. 214 W

371. Teapot mounted in European brass

China, Tê-hua
C. 1675-1725
Porcelain
H. 10.8, L. 12.5 cm.
Inv. no. P.O. 8244 / N. 135 (?)

372. Oval footed dish, with flowering branches in relief

China, Tê-hua
C. 1675-1725
Porcelain
H. 5.8, L. 9.2 cm.
Inv. no. P.O. 8294

373. Miniature cup, octagonal lobed, with flowers in relief

China, Tê-hua
C. 1675-1725
Porcelain
H. 3.5, D. 6 cm.
Inv. no. P.O. 8383 / N: 98

374. Miniature cup, mate to 373

H. 3.6, D. 6 cm.
Inv. no. P.O. 8384

Famille Verte Porcelain

375. Buddhist lion with her young on a square base

China, Ching-tê Chên
C. 1700-20
Porcelain, enameled on the biscuit
H. 44.7, L. 22.5 cm.
Inv. no. P.O. 3634 / (N:) 72 (I)

376. Buddhist lion with brocade ball on square base

China, Ching-tê Chên
C. 1700-20
Porcelain, enameled on the biscuit
H. 44.5, L. 27 cm.
Inv. no. P.O. 3635/ (N:) 72 (I)

The Chinese lion is the guardian of Buddhist shrines and temples; hence its designation as the Buddhist lion, or dog of Fo (Fo=Buddha). The female is said to suckle her young through her paw after it has hatched out of a brocade ball that has been rolled by the male. Representations of Buddhist lions were popular during the vogue of chinoiserie. The still-lifes on the base of this example have symbolic or allegorical meaning.

377. Parrot on openwork base

China, Ching-tê Chên
K'ang Hsi period (1662-1722)
Porcelain, enameled on the biscuit
H. 23.1 cm.
Inv. no. P.O. 4340 / N.90 I

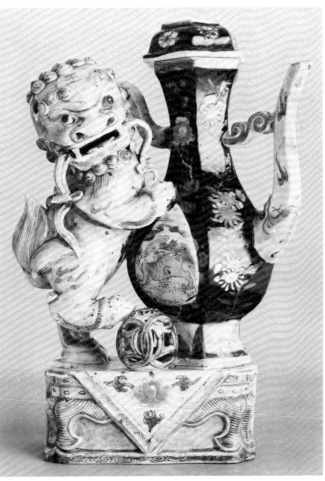

382

378. Green parrot on openwork base

China, Ching-tê Chên
K'ang Hsi period (1662-1722)
Porcelain, enameled on the biscuit
H. 24 cm.
Inv. no. P.O. 4341 / N.90 I

As early as 1700, parrots of Chinese porcelain were exhibited in European porcelain cabinets. In the eighteenth century they were reproduced in faience. In view of modern forgeries, pieces like this one, whose provenance is assured, are of special value.

379. Seated dog, spotted yellow and brown

China, Ching-tê Chên
K'ang Hsi period (1662-1722)
Porcelain, enameled on the biscuit
H. 15.9 cm.
Inv. no. P.O. 4328 / N. 193 I

380. Seated dog, spotted green and black

China, Ching-tê Chên
K'ang Hsi period (1662-1722)
Porcelain, enameled on the biscuit
H. 15.9 cm.
Inv. no. P.O. 4330 / N. 193 I

381. Wine pot in form of crouching monkey nibbling on fruit

China, Ching-tê Chên
K'ang Hsi period (1662-1722)
Porcelain, enameled on the biscuit
H. 14.3 cm.
Inv. no. P.O. 4312 / N: 46 I

382. Ewer with Buddhist lion at handle, on rectangular base

China, Ching-tê Chên
C. 1700-20
Porcelain, enameled on the biscuit
H. 20.8 cm.
Inv. no. P.O. 4310 / N: 187 I

383. Teapot in the form of a lotus pod

China, Ching-tê Chên
K'ang Hsi period (1662-1722)
Porcelain, enameled on the biscuit
H. 9.6, L. 18.2 cm.
Inv. no. P.O. 4293 / N: 108 I

384. Wall fountain with spigot of European brass

China, Ching-tê Chên
C. 1700-20
Porcelain decorated in enamel colors
H. 55.5, W. 24 cm.
Inv. no. P.O. 3640

The addition of a spigot in Europe—a step intended by the Chinese maker—is a clear indication that objects like this were intended for the Western market.

385. Four-sided baluster vase with cover

China, Ching-tê Chên
C. 1700-20
Porcelain decorated in enamel and unfired colors
H. 32 cm.
Inv. no. P.O. 4665 / N: 24 I

386. Hexagonal vase in the form of a flask

China, Ching-tê Chên
C. 1700-20
Porcelain decorated in enamel colors
H. 30.4 cm.
Inv. no. P.O. 4677 / N: 129 I

387. Hexagonal vase, mate to 386

H. 29.9 cm.
Inv. no. P.O. 4678 / N: 129 I

388. Four-sided vase with three angular projections

China, Ching-tê Chên
C. 1700-20
Porcelain decorated in enamel colors
H. 30.7 cm.
Inv. no. P.O. 6563

389. Four-sided vase with three angular projections

China, Ching-tê Chên
C. 1700-20
Porcelain decorated in enamel colors
H. 30.3 cm.
Inv. no. P.O. 6566

390. Vase with applied dragon figure

China, Ching-tê Chên
K'ang Hsi period (1662-1722)
Porcelain decorated in underglaze blue and enamel colors
H. 22.1 cm.
Inv. no. P.O. 4633 / N: 35 □

391. Vase

China, Ching-tê Chên
K'ang Hsi period (1662-1722)
Porcelain decorated in enamel colors
H. 21.9 cm.
Inv. no. P.O. 4637 / N: 139 I

392. Ewer of Near Eastern form

China, Ching-tê Chên
C. 1700-20
Porcelain decorated in enamel colors
H. 18.7, L. 14.5 cm.
Inv. no. P.O. 6327 / N: 39 I

Near Eastern forms and decorations were introduced to Chinese potters as early as the T'ang Dynasty (618-906), when Chinese stoneware and porcelain were produced for export to Islamic countries.

393. Flattened spherical box

China, Ching-tê Chên
C. 1700-20
Porcelain decorated in enamel colors
H. 10.5, D. 10.7 cm.
Inv. no. P.O. 6878 / N: 3 I

394. Beaker-shaped cup and saucer

China, Ching-tê Chên
C. 1700-20
Porcelain decorated in enamel colors
Cup: H. 6.8 cm.
Saucer: D. 12.9 cm.
Inv. no. P.O. 6389 / N: 87 I

395. Cup and saucer

China, Ching-tê Chên
C. 1700-20
Porcelain decorated in enamel colors
Cup: H. 4.4 cm.
Saucer: D. 12.9 cm.
Inv. no. P.O. 6381 / N: 152 I

396. Libation cup

China, Ching-tê Chên
C. 1700-20
Porcelain decorated in enamel colors
H. 5, L. 11.5 cm.
Inv. no. P.O. 6352 / N: 48 I

Besides pieces that owe their form to a deep feeling for ceramics, one sometimes finds pieces like this, shaped like ancient sacrificial bronzes.

397. Large plate with Hsi Wang Mu

China, Ching-tê Chên
Porcelain decorated in enamel colors
H. 5.3, D. 36 cm.
Inv. no. P.O. 6918 / N: 108 I

According to Taoist mythology, Hsi Wang Mu, the "Queen Mother of the West," is the queen of the genies. In her paradisiac garden grow peaches that give long life. The deer is symbolic of longevity.

Japanese Porcelain

398. Standing woman with fan

Japan, Arita
C. 1690-1700
Porcelain decorated in underglaze blue and enamel colors
H. 38 cm.
Inv. no. P.O. 119 / No. 8

399. Standing woman

Japan, Arita
C. 1690-1700
Porcelain decorated in underglaze blue and enamel
 colors
H. 37.5 cm.
Inv. no. P.O. 117 / No. 8

The hair style and dress of this figure, which became part of the Dresden collection before 1721, are in the fashion of the late seventeenth century. Such figures, which appear more frequently in European than in Japanese collections, usually represent geishas.

400. Covered vase with butterflies, figure of a woman as finial

Japan, Arita
C. 1690-1700
Porcelain decorated in underglaze blue, iron red, and
 gold
H. 33.7 cm.
Inv. no. P.O. 5215 / N: 130 +

401. Covered vase with openwork decoration, cat as finial

Japan, Arita
C. 1690-1700
Porcelain decorated in underglaze blue, iron red, and
 gold
H. 30.3 cm.
Inv. no. P.O. 4968

Among the numerous sets of Imari vases in the Dresden collection there are only a few with perforated outer walls. This laborious decorative technique presumably reached the workshops of Arita from China, where it was already practiced in the Ming period (1368-1644).

402. Covered vase with openwork decoration of birds and reticulation

Japan, Arita
C. 1690-1700
Porcelain decorated in underglaze blue, iron red, and
 gold
H. 26.2 cm.
Inv. no. P.O. 4891 / N: 131 +

403. Covered vase, mate to 402

H. 26.5 cm.
Inv. no. P.O. 4892 / N: 131 +

404. Vase, decoration similar to 402

Japan, Arita
C. 1690-1700
Porcelain decorated in underglaze blue, iron red, and
 gold
H. 19.5 cm.
Inv. no. P.O. 4893 / N: 131 +

405. Vase, mate to 404

H. 20 cm.
Inv. no. P.O. 4965 / N: 131 +

406. Table centerpiece, with four covered containers and a salt cellar

Japan, Arita
C. 1690-1700
Porcelain decorated in underglaze blue, iron red, and
 gold
H. 14, D. 31 cm.
Inv. no. P.O. 4870 / N: 115 +

Created for the European market, where much of the porcelain produced in Arita was sent, such centerpieces have European forms. This piece includes containers for various spices and two small ewers marked A for the Dutch word *Azijn*, or vinegar. Its tray was warped in the firing process.

407. Food container, composed of dishes in three tiers with cock as finial

Japan, Arita
C. 1690-1700
Porcelain decorated in underglaze blue, iron red, and
 gold
H. 31, D. 17.5 cm.
Inv. no. P.O. 5222 / N: 26 +

Three-tiered dishes reflect the Japanese custom of serving several foods simultaneously. Pieces of this type with Imari decoration are considered a great rarity in Japan.

408. Box with figures on the cover

Japan, Arita
C. 1690-1700
Porcelain decorated in underglaze blue and enamel
 colors
H. 13.6, D. 13.8 cm.
Inv. no. P.O. 4872 / N: 28 +

409. Candlestick of Japanese porcelain elements, assembled in Europe

Japan, Arita
Late 17th—early 18th c.
Porcelain decorated in underglaze blue and enamel
colors, with European brass mounts
H. 28 cm.
Inv. no. P. O. 427 / N: 39 +

410. Candlestick, similar to 409

H. 28 cm.
Inv. no. P. O. 428 / N. 39 +

Both candlesticks consist of two small vases, a saucer,
and a cover, added to a candle holder of brass; they
have been assembled to form a new piece in a fashion
characteristic of European chinoiserie.

411. Double gourd covered vase with Buddhist lion finial

Japan, Arita
C. 1690-1700
Porcelain decorated in underglaze blue, iron red, and
gold
H. 26 cm.
Inv. no. P. O. 374 / N: 85 +

412. Pear-shaped ewer with letter S (for syrup)

Japan, Arita
C. 1690-1700
Porcelain decorated in underglaze blue, iron red, and
gold
H. 18.2, L. 10.8 cm.
Inv. no. P. O. 4862

413. Small teapot with European brass mounts

Japan, Arita
C. 1690-1700
Porcelain decorated in underglaze blue, iron red, and
gold
H. 8.2, L. 14.3 cm.
Inv. no. P. O. 4909 / No. 17

414. Teapot with curved handle

Japan, Arita
C. 1690-1700
Porcelain decorated in underglaze blue, iron red, and
gold
H. 16, L. 15.5 cm.
Inv. no. P. O. 5238

415. Covered bowl

Japan, Arita
C. 1690-1700
Porcelain decorated in underglaze blue, iron red, and
gold
H. 9.4, D. 15.2 cm.
Inv. no. P. O. 4879 / N: 241 +

416. Ornamental dish containing modeled rock decorated with blossoms

Japan, Arita
C. 1690-1700
Porcelain decorated in underglaze blue, iron red, and
gold
H. 9.8, D. 16 cm.
Inv. no. P. O. 4903 / N: 259 +

417. Covered beaker with saucer

Japan, Arita
C. 1690-1700
Porcelain decorated in underglaze blue, iron red, and
gold
Goblet: H. 9.3 cm.
Saucer: D. 14.8 cm.
Inv. no. P. O. 5035 / N: 123 +

418. Small cup and saucer with landscape painting

Japan, Arita
C. 1690-1700
Porcelain decorated in underglaze blue and enamel
colors
Cup: H. 4.5 cm.
Saucer: D. 12.7 cm.
Inv. no. P. O. 5068 / N: 135 +

419. Small cup and saucer with shell pattern

Japan, Arita
C. 1690-1700
Porcelain decorated in underglaze blue, iron red, and
gold
Cup: H. 4.3 cm.
Saucer: D. 11.8 cm.
Inv. no. P. O. 3832 / N: 101 +

Oriental Porcelains and their Meissen Copies

420. Hexagonal covered vase, painted with figures, birds, and flowers in Kakiemon style

Japan, Arita
Last quarter 17th c.
Porcelain decorated in enamel colors
H. 31.3 cm.
Inv. no. P. O. 5663 / N: 1 □

421. Copy of 420

Meissen
C. 1725-30
Porcelain
H. 31.4 cm.
Inv. no. P.E. 651 / N: 138 W

At the time of Augustus the Strong, Kakiemon porcelain was so popular that the largest gallery of his Japanese Palace was to have been decorated with Meissen copies in the Kakiemon style.

422. Sake bottle of square section with Kakiemon floral decoration

Japan, Arita
Late 17th c.
Porcelain decorated in enamel colors
H. 21.8 cm.
Inv. no. P.O. 4766 / N: 12 □

423. Copy of 422, with cover

Meissen
C. 1725-30
Porcelain
H. 22.2 cm.
Inv. no. P.E. 5014 / N: 302 W

424. Twelve-sided bowl with decoration of phoenixes and geometrical motifs

Japan, Arita
Late 17th c.
Porcelain decorated in underglaze blue and enamel
 colors
H. 6.6, D. 24.9 cm.
Inv. no. P.O. 4788 / N: 50 +

The Japanese predilection for stylized ornamentation is especially noticeable in the round center reserve.

425. Copy of 424

Meissen
C. 1730
Porcelain decorated in underglaze blue and enamel
 colors
H. 6.4, D. 24.5 cm.
Inv. no. P.E. 5377 / N:53 W

426. Beer jug of European form with Imari decoration

Japan, Arita
C. 1690-1700
Porcelain decorated in underglaze blue and enamel
 colors
H. 14.7, W. 12.8 cm.
Inv. no. P.O. 4907 / N: 37 +

426

427. Copy of 426

Meissen
C. 1730-35
Porcelain decorated in underglaze blue and enamel
 colors
H. 15.2, D. 9.6 cm.
Inv. no. P.E. 5345 / N: 162 W

As porcelain created for Japanese consumption was only partly suitable for the European market, the Dutch East India Company sent European vessels to Japan to be copied. With its Western letter, 426 was clearly made for export. This piece was copied at Meissen.

428. Teapot, spout terminating in a serpent's head, with Imari decoration

Japan, Arita
C. 1690-1700
Porcelain decorated in underglaze blue, iron red, and
 gold
H. 11.3, L. 17 cm.
Inv. no. P.O. 4900 / N: 99 +

The form and decoration of this teapot draw upon ocean motifs: a serpent's head emerges from foaming

427

As the underglaze blue of Meissen porcelain—after the death of its inventor David Köhler (1723)—often turned gray or blackish, the reliable technique of enamel painting was chosen for the rendering of the finely detailed Chinese "cash pattern" (a design of pierced coins). The contrast of densely and loosely filled areas is typically Japanese.

432. Double flask

China, Ching-tê Chên
K'ang Hsi period (1662-1722)
Porcelain decorated in underglaze blue
H. 20.1 cm.
Inv. no. P.O. 2339 / N: 497 ⋙

433. Copy of 432

Meissen
C. 1725-30
Porcelain decorated in underglaze blue
H. 19 cm.
Inv. no. P.E. 5582

434. Shallow bowl with "onion pattern" decoration

China, Ching-tê Chên
K'ang Hsi period (1662-1722)
Porcelain decorated in underglaze blue
H. 3.8, D. 25.3 cm.
Inv. no. P.O. 7220

435. Plate with an early form of "onion pattern" decoration

Meissen
C. 1739-40
Porcelain decorated in underglaze blue
H. 2.9, D. 26 cm.
Inv. no. P.E. 2270

waves; the hexagonal diaper pattern on the lid suggests a tortoise shell.

429. Copy of 428

Meissen
C. 1725-30
Porcelain decorated in underglaze blue, iron red, and gold
H. 10.8, D. 10.6 cm.
Inv. no. P.E. 5327 / N: 461 W

430. Dish in the form of two overlapping leaves

Japan, Arita
Late 17th c.
Porcelain decorated in underglaze blue and brown
H. 4.9, L. 32 cm.
Inv. no. P.O. 1672 / N: 473 ⋙

431. Copy of 430

Meissen
C. 1725-30
Porcelain with brown glaze (Kapuzinerbraun) and blue enamel decoration
H. 4.5, L. 33.2 cm.
Inv. no. P.E. 5200 / N: 198 W

The "onion pattern," first mentioned in 1739, is still one of the most popular Meissen designs. It was copied by other factories later in the century. The early form differs somewhat from the later version: peach and pomegranate twigs are directed toward the center, and the dividing borders are considerably more complicated.

436. Teapot with molded decoration of fish emerging from waves

China, Ching-tê Chên
K'ang Hsi period (1662-1722)
Porcelain decorated in enamel colors
H. 11.2 cm.
Inv. no. P.O. 6334 / N: 177 I

437. Copy of 436

Meissen
C. 1727-30
Porcelain
H. 11.9, L. 20.8 cm.
Inv. no. P.E. 5326 / N: 303 W

The design of this teapot is based on Chinese legend and animal symbolism: just as the salmon (according to other notions, the carp) overcomes the rapids of Lung-mên and in so doing becomes a dragon, so the student, after having passed his exams, may hope for a career in the service of the state.

438. Teapot in the shape of a reclining phoenix

China, Yi Hsing
K'ang Hsi period (1662-1722)
Unglazed stoneware
H. 11.1, L. 17.8 cm.
Inv. no. P.O. 3898 / N: 52 (?)

The brown stoneware of Yi Hsing was known to seventeenth- and eighteenth-century Europeans mainly in the form of teapots. It was imitated in Holland, England, and in the beginning, also at Meissen. The mythological Chinese animal Feng-huang—in Europe often called simply "phoenix"—was usually depicted as a mixture of pheasant and peacock. As an armorial emblem of the Chinese empress, it was consequently an emblem of femininity.

439. Free copy of 438, in form of a reclining cock

Meissen
1734
Porcelain, decorated in enamel colors
H. 8.5, L. 19.2 cm.
Inv. no. P.E. 5355

The mold for this teapot is described in Kändler's work report for the month of May, 1734.

Boettger Stoneware and Porcelain

440. Statuette of Augustus the Strong

Johann Joachim Kretschmar (1677-1740)
Meissen, 1713
Boettger stoneware
H. 11.5 cm.
Inv. no. P.E. 2398

Created after a wood model by the Dresden court sculptor Kretschmar, who, with Balthasar Permoser, was responsible for the sandstone figures for the Zwinger. This statuette of the king in armor was produced until 1730. Three examples are extant in the Dresden collection.

441. Seated Chinese deity

Meissen, c. 1710-13
Gray fired Boettger stoneware, so-called "iron porcelain"
H. 10 cm.
Inv. no. P.E. 2389 / N 180 R

Modeled after a blue-painted Chinese Putai (god of contentment) from the K'ang Hsi period, in the Dresden collection.

440

447, 446

442. Kuan-yin

Meissen, c. 1710
Boettger stoneware
H. 37.8 cm.
Inv. no. P.E. 2373

Modeled after a blanc de chine figure in the Dresden collection, this piece shows fire cracks and has been polished in a small test area on its back.

443. Shallow covered bowl with two handles

Meissen, c. 1710-13
Boettger stoneware, polished
H. 5.5, D. 16 cm.
Inv. no. P.E. 1778 / N 67 R

444. Bowl with strapwork painted in gold

Martin Schnell (?)
Meissen, c. 1712
Lightly marbelized Boettger stoneware, polished
D. 25.7 cm.
Inv. no. P.E. 2337 / N 60 R

445. Butter dish with cover and two handles, wreaths of leaves in relief

Meissen, c. 1710-13
Boettger stoneware, partly polished
D. 13.7 cm.
Inv. no. P.E. 1776 / N 68

Such containers are identified as butter dishes in the inventory of 1721.

446. Tankard with cover

Meissen, c. 1710-13
Boettger stoneware, faceted
H. 19, D. 12.2 cm.
Inv. no. P.E. 2364 / N 132 R

447. Teapot with lid

Meissen, c. 1710-13
Boettger stoneware, faceted
H. 9.5 cm.
Inv. no. P.E. 2440 a/b / N 147

448. Tankard with silver-gilt mounts

Meissen, c. 1710-13
Boettger stoneware, polished
H. 17 cm.
Inv. no. P.E. 2247

A Brunswick-Lüneburg Reichstaler of 1695 has been inserted in the silver-gilt lid.

449. Coffeepot, painted in enamel and set with gem stones

Painted by Johann Friedrich Meyer
Meissen, c. 1710
Boettger stoneware, partly polished
H. 15.3 cm.
Inv. no. P.E. 206

A second coffeepot in the Dresden collection, enameled and set with garnets, shows on the bottom the monogram of the court enameler Johann Friedrich Meyer, who later decorated Saxon glass in a similar manner. Such pots were offered for sale by the Meissen porcelain factory as early as 1710.

450. Covered bowl with flower garlands

Probably painted by Martin Schnell
Meissen, c. 1712
Boettger stoneware, black-glazed and decorated in lacquer colors
H. 17 cm.
Inv. no. P.E. 2575 / N 26 P

The effect of black-glazed Boettger stoneware is reminiscent of Japanese lacquerwork. Martin Schnell, who led a well-known workshop for lacquered furniture in Dresden, is listed as an artist on the Meissen paymaster's list of 1712.

451. Flute vase with chinoiseries

Probably painted by Martin Schnell
Meissen, c. 1712
Boettger stoneware, black-glazed and decorated in lac-
quer colors
H. 19.6 cm.
Inv. no. P.E. 2572 / N 22 P

452. Bottle vase

Probably painted by Martin Schnell
Meissen, c. 1712
Boettger stoneware decorated in lacquer colors
H. 22.8 cm.
Inv. no. P.E. 863 / N 20 P

454

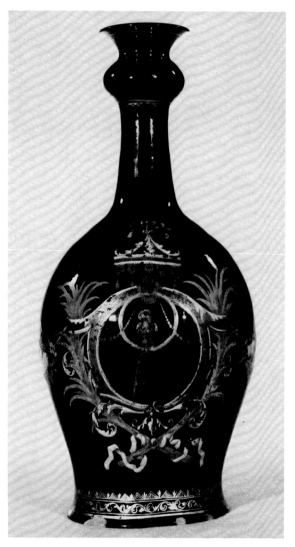

453. Pilgrim bottle with two lion's-head handles and two groups of molded blossoms

Meissen, c. 1712
Boettger stoneware, black-glazed and decorated with
lacquer colors
H. 27.8 cm.
Inv. no. P.E. 2550 / N 28 P

454. Vase with parrot

Probably painted by Martin Schnell
Meissen, c. 1712
Boettger stoneware, black-glazed and decorated with
lacquer colors
H. 37 cm.
Inv. no. P.E. 2553 / N 74 P

455. Coffeepot

Probably painted by Martin Schnell
Meissen, c. 1712
Boettger stoneware, black-glazed and decorated in red
and gold lacquer
H. 20.1 cm.
Inv. no. P.E. 2609

456. Teapot decorated in flat relief

Meissen, c. 1710-13
Boettger stoneware, black-glazed, with gilding
H. 9.2 cm.
Inv. no. P.E. 2599

The relief decoration of this and another Boettger
porcelain teapot was suggested by the blue and white
design of a boy sitting between climbing plants, from a
Chinese teapot made during the reign of Emperor
Wan-Li (1573-1619).

457. Oval sugar bowl on claw feet with cover

Meissen, c. 1710-13
Boettger stoneware, black-glazed, with gilding
D. 11.8 cm.
Inv. no. P.E. 2581

458. Octagonal tea caddy with cover, decorated in flat relief

Meissen, c. 1710-13
Boettger stoneware, black-glazed and decorated in red
and gold lacquer
H. 8.6 cm.
Inv. no. 2580 / N 39 P

459. Vase with grapevine decoration in relief

Meissen, c. 1715
Boettger porcelain
H. 42 cm.
Inv. no. P.E. 2909 / N 13

There are two of these vases in the Dresden collection, the most richly decorated examples of Boettger porcelain in existence. They are mentioned in the inventory of 1721 as "two pieces with especially delicate applied vineleaves and blades [as in grass], bouteillen with round bodies and straight necks and holes pierced in the mouth."

460. Covered goblet, with molded decoration of two female masks and flowers

Model probably by Johann Jacob Irminger
Meissen, c. 1710-13
Boettger porcelain
H. 32 cm.
Inv. no. P.E. 2721

In the inventory of 1721 these masks are described as "little Pallas heads," probably in reference to the Greek goddess Pallas Athena.

461. Vase with molded decoration of two male masks, grapevines and grape clusters

Model probably by Johann Jacob Irminger
Meissen, c. 1715
Boettger porcelain
H. 20.9 cm.
Inv. no. P.E. 2757

In the inventory of 1721 the masks are described as "heads of jealousy."

462. Covered goblet with decoration of two male masks and blossoming branches in relief

Model probably by Johann Jacob Irminger
Meissen, c. 1715
Boettger porcelain
H. 32 cm.
Inv. no. P.E. 2724 / N 18 W

463. Vase with decoration of wild rose branches in relief

Meissen, c. 1717
Boettger porcelain, with traces of painting in unfired colors
H. 17.9 cm.
Inv. no. P.E. 2752 / N 103 W

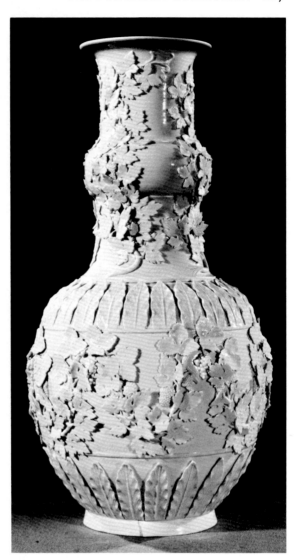

459

464. Coffeepot with decoration of fruit and flowers in relief

Model probably by Johann Jacob Irminger
Meissen, c. 1715
Boettger porcelain
H. 24.9 cm.
Inv. no. P.E. 2834 / N 13 W

465. Sake bottle with cover

Meissen, c. 1715
Boettger porcelain
H. 23.5 cm.
Inv. no. P.E. 1790 / N 74 W

468

In the inventory of 1721, such flasks are called bouteillen. Modeled of Boettger stoneware or Boettger porcelain after oriental examples, they were still being produced around 1730, mostly painted in the Kakiemon style, for decorations in the Japanese Palace.

466. Sake bottle with cover, with decoration of masks and flowers in relief

Meissen, c. 1715
Boettger porcelain
H. 23.5 cm.
Inv. no. P.E. 2871 / N 69 W

467. Tea caddy with cover, with decoration of wild rose branches in relief

Meissen, c. 1715
Boettger porcelain, with traces of painting in unfired colors
H. 13.3 cm.
Inv. no. P.E. 2895 / N 104 W

468. Kuan-yin

Meissen, c. 1710-15
Boettger porcelain, with fire cracks
H. 36.8 cm.
Inv. no. P.E. 2188 / N 81

Described in the inventory of 1721 as one of "eight Indian women with headdresses, standing on mountains and clapping their hands. All much cracked in the fire." Executed after a blanc de chine model that was sent to Boettger 28 November 1709.

469. Seated Chinese deity

Meissen, c. 1715
Boettger porcelain
H. 14.6 cm.
Inv. no. P.E. 146 / N 87

Described in the inventory of 1721 as one of "six sitting Pagodas with open mouths."

470. Plate with openwork rim

Meissen, c. 1715
Boettger porcelain
D. 18.8 cm.
Inv. no. P.E. 2949

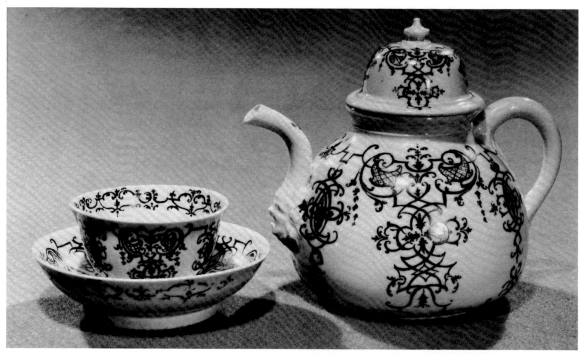

473

471. Double-walled bowl with openwork outer wall

Meissen, c. 1715
Boettger porcelain
H. 8.2, D. 15.8 cm.
Inv. no. P.E. 2947 / N 10 W

472. Double-walled goblet with openwork outer wall

Meissen, c. 1715
Boettger porcelain
H. 11.5 cm.
Inv. no. P.E. 2938

Double-walled vessels were modeled after blanc de chine pieces.

473. Teapot and two teabowls with saucers, with strapwork painted in silver

Meissen, c. 1715-20
Boettger porcelain
Teapot: H. 12 cm.
Cup: H. 4.2, D. 7.7 cm.
Saucer: D. 11.5 cm.
Inv. no. P.E. 930 and P.E. 928 e+f / N 58

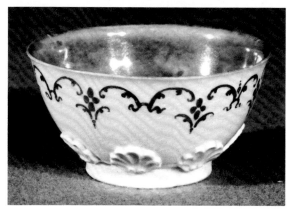

474

474. Teabowl and saucer with molded band of shells and gold rims

Meissen, c. 1717
Boettger porcelain decorated inside in rose luster
Cup: H. 4, D. 7.4 cm.
Saucer: D. 11.1 cm.
Inv. no. P.E. 921

This rose luster color, called "mother-of-pearl" glaze by Boettger, was one of the few glazes he succeeded in producing. Such dishes belong to the precious incunabula of Meissen porcelain.

475. Basin with gilt strapwork decoration

Meissen, c. 1715
Boettger porcelain
H. 7.5, D. 15.1 cm.
Inv. no. P.E. 2932 / N 61 W

Animal Sculptures

476. Tiger

Model by Johann Gottlieb Kirchner
Meissen, 1732-33
Porcelain
H. 75 cm.
Inv. no. P.E. 147

477. Leopard

Model by Johann Gottlieb Kirchner
Meissen, 1732/33
Porcelain
H. 74 cm.
Inv. no. P.E. 145

478. Lion

Model by Johann Gottlieb Kirchner (?)
Meissen, c. 1732
Porcelain
H. 50 cm.
Inv. no. P.E. 197

479. Lioness

Model by Johann Gottlieb Kirchner (?)
Meissen, c. 1732
Porcelain
H. 49 cm.
Inv. no. P.O. 709

480. Mother monkey with her young

Model by Johann Gottlieb Kirchner (?)
Meissen, c. 1732
H. 58 cm.
Inv. no. P.E. 698

481. Whippet and bulldog fighting

Model by Johann Gottlieb Kirchner (?)
Meissen, c. 1732
Porcelain
H. 46.5 cm.
Inv. no. P.E. 54

478

The lions, the mother monkey, and the dog groups belong to the most impressive of Meissen animal figures. However, they are not mentioned in the work reports of either Kirchner or Kändler, and therefore cannot be attributed with certainty to either sculptor. They may have been modeled after works of other Dresden sculptors of the period.

482. Vessel in form of a mythological animal

Model by Johann Gottlieb Kirchner (?)
Meissen, c. 1730
Porcelain
H. 58 cm.
Inv. no. P.E. 74
Executed after a copper engraving in Montfaucon, *L'Antiquité expliquée*, Paris, 1719-24, vol. III, plate 70, fig. 1.

483. Crown hawk

Model by Johann Joachim Kändler
Meissen, June 1734
Porcelain
H. 59 cm.
Inv. no. P.E. 79

Mentioned in Kändler's work reports as "one large Indian bird, by name 'King of the Wawon,' his height with base five quarter ells. The pedestal is covered with leaves in Indian fashion."

484. Heron

Model by Johann Joachim Kändler
Meissen, 1731
Porcelain
H. 62 cm.
Inv. no. P.E. 136

In his work report Kändler writes, "In the year 1731 I had to make for the porcelain factory a sculpture of the white heron that lived in the royal courtyard, in his natural size, just as he stands in the reeds with frogs and fish around him. I also had to pay 36 guilders for iron and screws that I needed for the armature, also for the clay and the pedestal on which it stands."

481

480

485. She-wolf with cubs

Model by Johann Joachim Kändler
Meissen, April 1735
Porcelain
H. 67 cm.
Inv. no. P.E. 696

Described in Kändler's work report as "a large palace
piece. A she-wolf in life-size, sitting on her hind legs
and holding her head high as if howling, so that her
fangs can be seen clearly. She has two young cubs
sitting under her, one somewhat younger than the
other—these will serve principally to keep the piece
erect in the kiln."

486. Leaping stag

Model by Johann Joachim Kändler
Meissen, August 1747
Porcelain
H. 27.5 cm.
Inv. no. P.E. 85

487. Deer hunt

Model by Johann Joachim Kändler
Meissen, 1758
Porcelain
H. 18 cm.
Inv. no. P.E. 35

488. Golden oriole

Model by Johann Joachim Kändler
Meissen, March 1734
Porcelain
H. 26.5 cm.
Inv. no. P.E. 67 / No. 283 W

489. Green woodpecker

Model by Johann Joachim Kändler
Meissen, March 1734
Porcelain
H. 30 cm.
Inv. no. P.E. 81 / No. 282 W

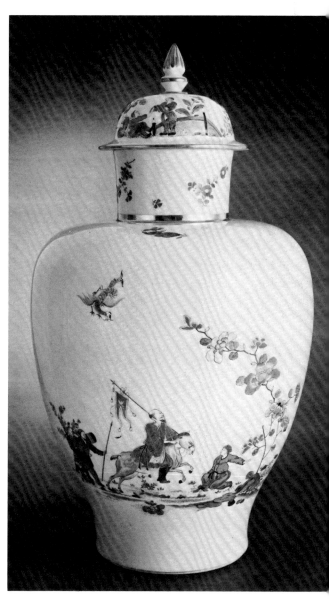

497

Meissen Porcelain 1725-1740

490. Covered vase, painted by Johann Gregor Höroldt, with Indian flowers and birds

Meissen, c. 1725
Porcelain
H. 37 cm.
Inv. no. P.E. 2010 a+b

491. Covered vase, painted by Johann Gregor Höroldt, with Indian flowers and birds

Meissen, c. 1725
Porcelain
H. 36 cm.
Inv. no. 2009 a+b

492. Vase, painted by Johann Gregor Höroldt, with Indian flowers and birds

Meissen, c. 1725
Porcelain
H. 25.6 cm.
Inv. no. P.E. 2015

493. Vase, painted by Johann Gregor Höroldt, with Indian flowers and birds

Meissen, c. 1725
Porcelain
H. 25.6 cm.
Inv. no. P.E. 2016

494. Vase, painted by Johann Gregor Höroldt, with Indian flowers and birds

Meissen, c. 1725
Porcelain
H. 29 cm.
Inv. no. P.E. 2013

Decorated with imaginative motifs that show oriental models in ever new variations, these vases are precious works of art from the early period of Höroldt's paintings. All are marked AR (Augustus Rex) on the bottom, and all belonged to the furnishings of the Tower Room in the old Residenzschloss, which from 1728 to 1939 served as a richly furnished porcelain cabinet.

495. Vase with chinoiseries painted by Adam Friedrich von Löwenfinck

Meissen, c. 1730-35
Porcelain
H. 33.5 cm.
Inv. no. P.E. 2008

496. Covered vase with chinoiseries painted by Adam Friedrich von Löwenfinck

Meissen, c. 1730-35
Porcelain
H. 35 cm.
Inv. no. P.E. 2003 a+b

497. Covered vase with chinoiseries painted by Adam Friedrich von Löwenfinck

Meissen, c. 1730-35
Porcelain
H. 39 cm.
Inv. no. P.E. 2005 a+b

The style of decoration of these vases is very similar to the style of six watercolors preserved in the Meissen factory archives and recognized as the work of Adam Friedrich von Löwenfinck. Both have the same artistic autograph. A Meissen porcelain painter from 1727 to 1736, Löwenfinck developed a style which differed in color and composition from that of Höroldt. His chinoiseries are influenced by those of Petrus Schenk the Younger of Amsterdam (probably the first quarter of the eighteenth century). These vases are marked AR (Augustus Rex).

498. Hunting vase with cover

Modeled by Johann Joachim Kändler and Johann Friedrich Eberlein
Painted by J. G. Heintze (?) with hunting scene after Ridinger and with Indian flowers and birds
Meissen, 1739
Porcelain
Vase: H. 44.4 cm.
Cover: H. 16.7 cm.
Vase inv. no. P.E. 3501
Cover inv. no. P.E. 3505

499. Hunting vase with cover

Modeled by Johann Joachim Kändler and Johann Friedrich Eberlein
Painted by J. G. Heintze (?) with a hunting scene of a banquet in the open, with king and queen in hunting costume, and with hunters, horses, and court jester.
Meissen, 1739
Porcelain
Vase: H. 35.5 cm.
Cover: H. 14.4 cm.
Vase inv. no. P.E. 3502
Cover inv. no. P.E. 3507

These were made for the hunting lodge known as Hubertusburg. Four of them are in the Dresden collection. Their decoration is unusual: the two large gold-bordered reserves each show a hunting scene, as well as Indian flowers and birds. In between, there are reserves with a blue-flaked ground, reminiscent of the blue ground of cracked ice found on ginger jars of the K'ang Hsi period. The dominant blue and yellow colors are repeated in the hunting costumes, evidently worn at the Court of Saxony at that time instead of the green dress customary elsewhere. These vases were made once again in the nineteenth century, but with a ground of turquoise blue instead of yellow.

500. Bowl from the Yellow Hunting Service

Meissen, c. 1732
Porcelain
D. 30.8 cm.
Inv. no. P.E. 1465 / N 148 W

501. Large bowl from the Yellow Hunting Service

Meissen, c. 1732
Porcelain
D. 40.7 cm.
Inv. no. P.E. 1352 / N 148 W

502. Large plate from the Coronation Service

Meissen, 1733/34
D. 29.1 cm.
Inv. no. P.E. 954 / N 147 W

503. Large plate from the Coronation Service

Meissen, 1733/34
D. 29.2 cm.
Inv. no. P.E. 1829 / N 147 W

504. Small plate from the Coronation Service

Meissen, 1733
D. 22.7 cm.
Inv. no. P.E. 1328 b / N 147 W

This service was delivered to the Japanese Palace in 1734. It had evidently been made for the coronation in Cracow of Augustus III as King of Poland, and it bears the Saxon-Polish coat of arms.

505. Covered vase

Women's head handles modeled by Johann Joachim Kändler
Hunting scenes painted by J. G. Heintze (?)
Meissen, c. 1735-39
H. 36.9 cm.
Inv. no. P.E. 3699 a/b

The hunting scene shows a wild boar hunt near the castle of Königstein, situated in the sandstone mountains along the Elbe, called "Swiss Saxony." In the background is the country seat of Friedrichsburg, built by Pöppelmann in 1731; in the far distance, the heights of Lilienstein.

LITERATURE

Carl Berling, *Das Meissner Porzellan und seine Geschichte*. Leipzig, 1900.

Jean Louis Sponsel, *Kabinettstücke der Meissner Porzellan-Manufaktur von Johann Joachim Kändler*. Leipzig, 1900.

Ernst Zimmermann, *Erfindung und Frühzeit des Meissner Porzellans*. Berlin, 1908.

Carl Berling, *Festschrift zur 200 jährigen Jubelfeier der ältesten europäischen Porzellanmanufaktur Meissen*. Leipzig, 1911.

Oscar Rücker-Embden, *Chinesische Frühkeramik*. Leipzig, 1922.

Ernst Zimmermann, *Chinesisches Porzellan und die übrigen keramischen Erzeugnisse Chinas*. Leipzig, 1923.

Ernst Zimmermann, *Meissner Porzellan*. Leipzig, 1926.

Fritz Fichtner, "Von der kursächsischen Kunstkammer zur Staatlichen Porzellangalerie Zwinger," *Berichte der Deutschen Keramischen Gesellschaft*. Berlin, 1941.

Carl Albiker, *Die Meissner Porzellantiere im 18. Jahrhundert*. Berlin, 1959.

Ingelore Menzhausen, *Böttgersteinzeug-Böttgerporzellan aus der Dresdener Porzellansammlung* (Catalogue). Dresden, 1969.

Otto Walcha, *Meissner Porzellan*. Dresden, 1973.

Porzellansammlung im Zwinger, Führer durch das Museum. 6th ed. Dresden, 1976.

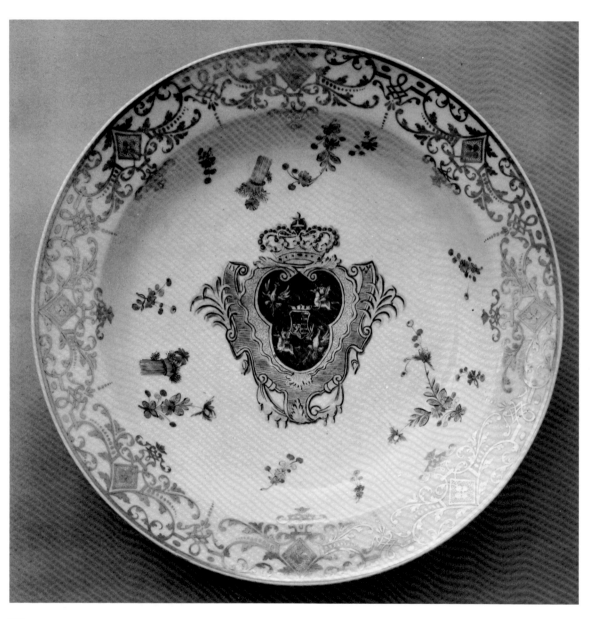

502

During the seventeenth century the collection of bronzes was in the Kunstkammer. After Augustus the Strong reorganized its holdings in 1721, the bronzes were divided between two of his newly formed galleries, the Green Vaults and the Cabinet of Antiquities. To both he added a number of important baroque bronzes, most of them acquired in Paris and intended for the decoration of the royal residences. The small selection presented here includes one of the most important bronzes that has come down to us from the Renaissance: the Laocoön *by Francesco di Giorgio.*

The Collection of Bronzes

The stylistic forms of the Renaissance found their way north to Dresden in the 1530s, at the time when a major building program had begun, including the enlargement of the Residenzschloss. Since the then prosperous mining economy of Saxony permitted the Albertinian princes an unprecedented volume of artistic commissions—more than native talent alone could fulfill—artists from the Netherlands and above all from Italy came to Dresden to work alongside Saxon and south German masters.

Most of the Italians in Dresden, according to the documentary evidence, remained a few years only and departed leaving no clear record of their individual achievements. Only the Luganese architect and sculptor Giovanni Maria Nosseni stayed on for good. The sculptor Carlo de Cesare, who worked with Nosseni on the royal burial vaults in Freiberg, departed like the rest. Nosseni, after completing a variety of many-faceted projects, died in Dresden a very old man.

The effect of all this on what is today the Sculpture Collection is that its earliest Renaissance works were not court commissions but rather sculptures that came to Dresden as diplomatic gifts from Italian princely courts. Notable, here, were the gifts of Grand Duke Francesco I of Tuscany to the electors Augustus and his successor, Christian I, of bronzes that came directly from the Florentine workshop of Giovanni Bologna, whose style influenced sculpture all over Europe and whose creations were coveted collectors' items at many courts. In the first inventory of the Dresden Kunstkammer (1587) several small bronzes are listed, four by this master. Three of them, *Nessus Abducting Dejanira, Mercury,* and *Faun and Sleeping Nymph,* were probably sent to Dresden as gifts from Francesco I after Christian I, in 1584, was named coregent. At the same time Giovanni Bologna himself sent his bronze of a striding *Mars* as his token of personal homage to the Dresden court. On this occasion, furthermore, Christian received from the Duke of Mantua a small bronze reduction of the antique equestrian statue of the emperor Marcus Aurelius, a work by Filarete (47). According to the inscription on the plinth, the sculptor had presented this to his patron, Piero de' Medici, in 1465. Filarete's signed and dated bronze, the earliest small bronze of the Renaissance, makes a splendid historical beginning for the Dresden collection. Thus Dresden had its part in the flowering of the art of the small bronze, a genre that reached the peak of its popularity in the second half of the sixteenth century.

Prior to 1610, on the evidence of the inventories, sculptures were not numerous in the Kunstkammer. Two bronzes, a *Leaping Unicorn* (49) and a *Recumbent Stag*, were purchased

197

from the workshop of Hans Reisinger in Augsburg (1589); a bronze bust of Christian I was commissioned from Carlo de Cesare by the Elector's widow immediately after his death (1591); and a magnificent bust of Christian II by Adriaen de Vries (52) was presented to Christian by Emperor Rudolf II when the young prince visited Prague in 1606. Then, in 1620, the collection of sculptures was greatly increased through a purchase from the estate of Giovanni Maria Nosseni. This brought the Kunstkammer a large group of reproductive casts as well as original bronzes by Adriaen de Vries, Giovanni Bologna, and Carlo de Cesare.

During the seventeenth century the bronzes were shown in the Kunstkammer as a group. Their number was substantially increased under Augustus the Strong, who commissioned his artistic adviser, the French architect Raymond Leplat, to buy for him during his visits to Rome, Florence, Venice, and Paris. In this period of absolutism, a fundamental change occurred in the function of the small bronze. From being merely an object coveted by collectors and learned connoisseurs, it came to represent the magnificence of the prince. In the eyes of the king, sculptures of noble bronze must have seemed particularly appropriate to decorate the state rooms of the Residenzschloss. In this regard, Augustus the Strong followed the example of Louis XIV, who had the palace and park of Versailles decorated with innumerable sculptures made for him by artists of many countries.

In 1699 and again in 1715 Leplat purchased especially French baroque bronzes in Paris, most of them more or less free re-creations of large sculptures at Versailles or archaeologically faithful reductions of antique works. The purchase of 1699 went to decorate the palace in Warsaw, but a few years later, owing to the uncertain political situation in Poland, they were transferred to Dresden.

As these acquisitions had been intended from the beginning for the decoration of rooms in the castle, so, after the fire of 1701, other bronzes were removed from the Kunstkammer and used for the decoration of the Paintings Cabinet, the Residenz rooms, and the Green Vaults. When, in 1721, the Green Vaults became a museum, some of these works became part of its permanent holdings, while others were transferred to the Antiquities Cabinet, the forerunner of today's Sculpture Collection. In some undocumented manner, a few of the bronzes, including the *Laocoön* of Francesco di Giorgio (506), one of the most important Renaissance bronzes ever, became the property of Count Brühl. These works re-entered the Antiquities Cabinet from Brühl's estate in 1763, but, significantly, no trace remains of their original provenance.

With Leplat's purchases, the acquisitions history of the collection virtually ends, since the few pieces that were added later did not alter the character of the whole. The division of the bronzes between the Sculpture Collection and the Green Vaults remains in effect today. Our exhibition brings together some of the most beautiful bronzes from both museums.

MARTIN RAUMSCHÜSSEL
Director
Sculpture Collection

The Collection of Bronzes

ENTRIES BY: Martin Raumschüssel

Francesco di Giorgio Martini
Siena 1439—Siena 1501-02
Active Siena, Urbino, Tuscany, Milan, Naples

506. Laocoön (c. 1490)

Bronze, heavy cast. Black lacquer patina. H. 113 cm.
Sculpture Collection inv. no. H 21/78

Probably designed as a fountain figure, variously interpreted as Hercules, Aesculapius, Neptune, or Laocoön. The dramatic effect of the statuette's surface agitation, the figure's startled upward movement, the excited expression, and especially the priest's fillet in the hair, would indicate an image of Laocoön. If so, this representation after classical legend originated independently of the Vatican's Laocoön group, which was not found until 1506. The attribution to Francesco di Giorgio is based on a comparison with his angel candelabra on the ciborium of the high altar in the cathedral of Siena. How this statuette came to Dresden is unknown; it entered the collection in 1763 from the estate of Count Brühl.

Giovanni Francesco Susini
Sculptor and bronze founder, Florence, d. 1646

507. Paris Abducting Helen

Inscription: IO·FR·SUSINI·FLOR·FAC·MDCXXVI
Bronze, hollow cast. Reddish brown transparent lacquer patina. H. 52.2 cm.
Sculpture Collection inv. no. H. 153/9

The relief on the base, showing Aeneas before the burning city of Troy, designates the theme of the group as the rape of Helen. In Baldinucci's *Notizie de' Professori*, 1688, there is mention of a Paris-Helen group by Francesco Susini, perhaps to be identified with this. The opening up of the form by means of diverging axes is already baroque in style and shows the distinct difference between this work, though it is in the workshop tradition of Giovanni Bologna, and Bologna's group of the *Rape of the Sabine Women* in the Bargello, Florence.

507

François Duquesnoy

Brussels 1597—Leghorn 1643
Active Rome

508. Cato (c. 1620-30)

Bronze, hollow cast. Blackish brown lacquer patina. H.
 67 cm.
Sculpture Collection inv. no. H 155/29

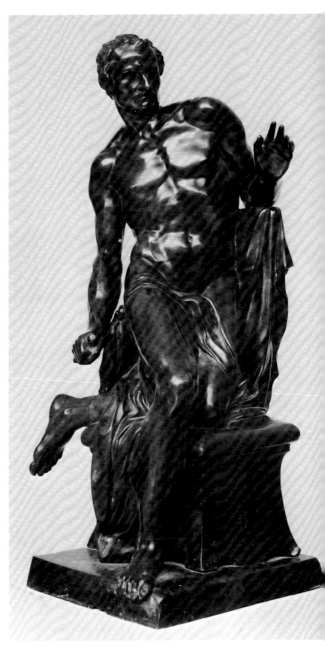

509. Portia (c. 1620-30)

Bronze, hollow cast. Blackish brown lacquer patina. H.
70.2 cm.
Sculpture Collection inv. no. Hs 14/59

The figures of father and daughter, two deeply moral
and liberty-loving Romans who, despairing over the
fall of the republic, committed suicide, are conceived

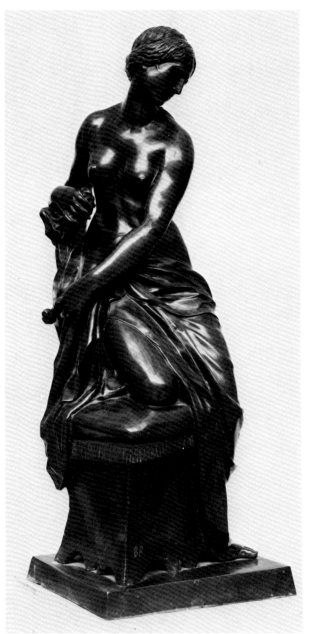

as contrasting companion pieces. The figure of Cato
embodies masculine active will, that of Portia feminine
submissiveness. Portia's facial type and expressivity
foreshadow the later religious works of Duquesnoy.

Michel Anguier
Eu 1612—Paris 1686

510. Mars (c. 1670)

Bronze, hollow cast. Blackish brown lacquer patina. H.
54.5 cm.
Sculpture Collection inv. no. H. 154/12

This is not one of Anguier's bronzes in which the
composition of a lost park sculpture of Versailles

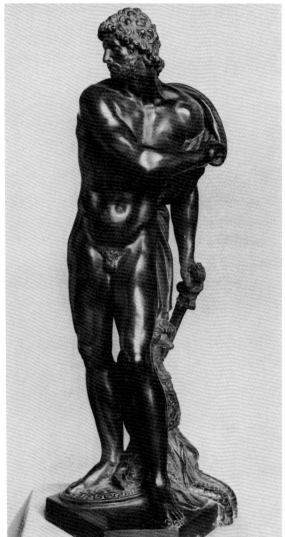

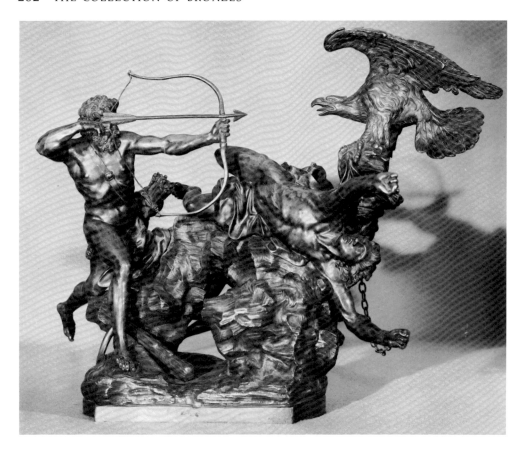

(known through prints) is transmitted. All the same, it can be attributed to Anguier with considerable certainty, since it is similar to the reduction of a striding Neptune that belonged to the statues of Versailles. Above all, the figure agrees with the description of what Mars should look like, an opinion stated by Anguier in a lecture in August 1676. The statuette shows the vigor that is characteristic of classical French sculpture before the time of Louis XIV.

François Lespingola
Joinville (Meuse) 1644—Paris 1705

511. Hercules Freeing Prometheus

Bronze, hollow cast. Brown lacquer patina. H. 42.6 cm.
Green Vault inv. no. IX. 88

The only bronze statuette that can be connected with Lespingola through written evidence. The Dresden figure is mentioned twice: in the 1775 list of bronzes purchased in Paris by the architect Raymond Leplat,

artistic adviser to Augustus the Strong, and again in the testament of Lespingola, recently published (information kindly supplied by A. Radcliffe).

Giovanni Battista Foggini
Florence 1652—Florence 1727
Active in Florence, Pisa, Leghorn, Pistoja, Pescia

512. Race between Hippomenes and Atalanta (c. 1690)

Bronze, hollow cast. Reddish brown transparent lacquer patina. H. without (modern) base 41.2 cm.
Sculpture Collection inv. no. H. 153/4

Desired by many suitors, the fleet-footed Arcadian huntress Atalanta would marry only one who could outrace her. Aided by the gods, Hippomenes defeated her by dropping three golden apples, which she paused to gather. In our group, the apple she bends toward is missing, as is the original base. Other bronzes in this mythological series are in Florence (*Mercury Killing Argus*) and Munich (*Venus and Adonis*).

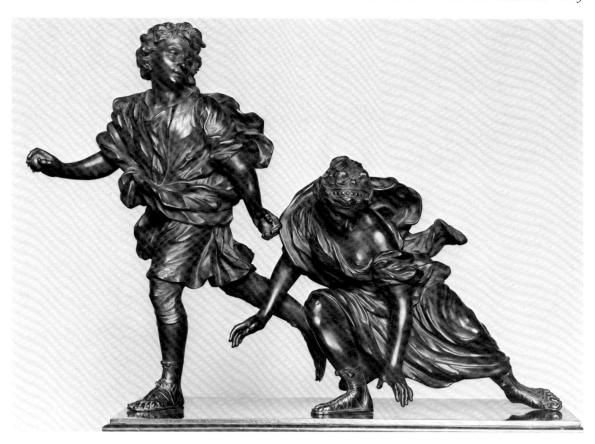

LITERATURE

Raymond Leplat, *Recueil des Marbres Antiques qui se trouvent dans la Galérie du Roy de Pologne à Dresde.* Dresden, 1733.

Johann Gottfried Lipsius, *Beschreibung der Churfürstlichen Antiken-Galerie in Dresden.* Dresden, 1798.

Wilhelm Gottlieb Becker, *Augusteum. Dresdens antike Bildwerke enthaltend.* Vols. 1-3. Leipzig, 1804-1811; suppl. 1837.

Heinrich Hase, *Verzeichnis der alten und neuen Bildwerke und übrigen Alterthümer in den Sälen der Kgl. Antiken-Sammlung zu Dresden.* 5th rev. ed. Dresden, 1839.

Hermann Hettner, *Die Bildwerke der Königlichen Antiken-sammlung zu Dresden.* 4th rev. ed. Dresden, 1881.

Paul Herrmann, *Verzeichnis der antiken Originalbildwerke der Staatlichen Skulpturensammlung zu Dresden.* 2nd rev. ed. Dresden, 1925.

Walter Holzhausen, "Die Bronzen der kurfürstlich sächsischen Kunstkammer zu Dresden," *Jahrbuch der Preussischen Kunstsammlungen* 54, 1933, suppl.

Walter Müller, *Die Bronzen der Kurfürstlichen Kunstkammer.* Dresden, 1936.

Walter Holzhausen, "Die Bronzen Augusts des Starken in Dresden," *Jahrbuch der Preussischen Kunstsammlungen* 60, 1939.

Hans Robert Weihrauch, *Europäische Bronzestatuetten, 15.-18. Jahrhundert.* Braunschweig, 1967.

Martin Raumschüssel, *Antike Terrakotten. Eine Auswahl aus den Beständen der Skulpturensammlung.* Dresden, 1969.

Heiner Protzmann and Martin Raumschüssel, *Antikenab-teilung im Albertinum.* 3rd rev. ed. Dresden, 1973.

"Skulpturen," *Gemäldegalerie Neue Meister* (Catalogue). Dresden, 1975.

Steffen Wenig and Martin Raumschüssel, *Ägyptische Alter-tümer aus der Skulpturensammlung Dresden* (Catalogue). Dresden, 1977.

In 1722 Augustus the Strong assembled the paintings from his churches and palaces in a great building known as the Stallgebäude, and there they remained until the middle of the nineteenth century. After the massive purchases of his son, Augustus III, the gallery contained more than three thousand paintings and was one of the wonders of Europe. The Seven Years War (1756-63) temporarily halted collecting. Significant additions were made subsequently, but even today the Dresden Picture Gallery preserves its princely flavor of the baroque period.

The selection shown here represents the various schools according to their prominence in the collection. Emphasis is given to Italian painting of the sixteenth and seventeenth centuries, to large-scale baroque compositions, and to the little cabinet pictures of Dutch masters of the seventeenth century, with smaller but very fine samplings of German and French painting.

The Old Masters Picture Gallery

In the center of Dresden are the historic buildings: Daniel Matthäus Pöppelmann's Zwinger, the Hofkirche, built by Chiaveri, and the Opera House, built by Gottfried Semper. The Picture Gallery, also by Semper, was added to this ensemble in the nineteenth century.

The Picture Gallery of Old Masters was founded during the reign of Augustus the Strong, and the collection grew apace until the Seven Years War (1756-63). From the writings of prominent people of the day, we know that the collection was an important factor in the artistic and cultural life of Europe, as well as a source of inspiration and creative enthusiasm for artists of many countries and schools. In her book *De l'Allemagne* (1810) Madame de Staël observed that "Various outstanding painters have settled in Dresden; the masterpieces in the Gallery encourage talent and stimulate competition." In addition to those who settled in Dresden permanently, attracted by its artistic treasures, an even greater number came simply as eager visitors.

Dresden was often called Florence on the Elbe, and its fame as an art center dates in great part to the eighteenth century, the time "when heaven and earth were moved in order to bring together on the Elbe whatever could still be pried loose," as Karl Justi wrote in his biography of Winckelmann.

Every collection, regardless of its size or content, has a definite character and a certain inner consistency, and in this the collections in Dresden were no exception. The Paintings Collection, as is now increasingly evident, was not an accumulation of art treasures made by chance but a series of independent categories planned from the very beginning, organic in growth and possessed of their own significance. Like the collections in Vienna, Madrid, and Leningrad, which were also founded by their ruling houses, Dresden's were greatly expanded during the eighteenth century.

The main period of collecting in Dresden extended throughout the first half of the eighteenth century. The taste of that period determines the image of the Gallery even today—recognizable, for example, in the uniformly rococo frames that date about 1746 and are still in use. Important individual additions made to the collection in the nineteenth century hardly changed the impression. As early as the sixteenth century and even before the establishment of the Paintings Collection, there were paintings in the Kunstkammer by the elder Cranach and numerous small panels by the Netherlandish artist Hans Bol.

The early history of the Dresden Gallery ended in 1722, when Augustus the Strong called for an inventory of all paintings existing in the nearby castles as well as in Dresden, and had them brought together in the stables at the Jüdenhof. But although he laid the cornerstone for the Paintings Gallery, it was his son, Augustus III, who made acquisitions on an even greater scale and gave the Gallery the character it still possesses.

The art of the high Renaissance and of the baroque was preferred by eighteenth-century princes, because it accorded with their ideas of the grandeur due an absolute ruler. Earlier art, accordingly, received less attention. Netherlandish painting was little understood, and it is represented in the collection by a relatively small number of examples, in comparison with the Italian and Dutch paintings that comprise the two major schools.

A picture of the collecting activities, sometimes quite amusing, can be obtained from diaries and correspondence of the time. Diplomats and ambassadors were involved in the dealings, with Count Brühl conspicuously in the foreground. He was aided by his adviser, Carl Heinrich von Heinecken. Another rival for the favor of the king was Count Algarotti, who, in 1742, suggested in a detailed program the building of a museum in Dresden. Algarotti went to Italy himself and brought back to Dresden the *Sisters* of Palma Vecchio as well as Strozzi's *Female Musician with Viola da Gamba* (522), and he served as intermediary in the acquisition of Liotard's *Chocolate Girl*. In 1741, 268 paintings, among them two small panels by Frans Hals and Vermeer's *The Procuress* came from the Wallenstein collection in Dux (Bohemia). The following year eighty-four paintings came to Dresden from the Imperial Gallery in Prague, among them Rubens' *Wild Boar Hunt* and the series of parables by Domenico Fetti (520).

Protracted negotiations were required to bring about the acquisition of the best paintings from the gallery in Modena. Rossi, Algarotti's rival, negotiated with the Italian ambassador, Count Villio, and with Duke Francesco III of Modena, and finally succeeded in acquiring the Modena collection for the sum of 100,000 zecchins. This collection included such important pieces as four panels by Correggio, the *Sacrifice of Abraham* by Andrea del Sarto, Titian's *Tribute Money*, Holbein's *Portrait of the Sieur de Morette*, Rubens' *Saint Jerome* and three paintings by Velázquez, as well as other works by Italian masters, such as Carracci's *Lute Player* (524) and Titian's *Portrait of a Lady in White* (516).

Purchases were made also in Antwerp and Paris, where, through the agents Le Leu and de Brais, Dresden acquired not only paintings by Bril (542) and Vermeer's *Girl at a Window Reading a Letter* (559), but also important works of early German painting, for example, Dürer's portrait of Bernhard von Reesen (537) and Holbein's double portrait of Thomas and John Godsalve (538).

Among the last and most important of the purchases for the Gallery was Raphael's *Sistine Madonna* from the church of San Sisto in Piacenza, for which the price of 20,000 ducats was paid in 1754. The negotiations for this work were protracted, since the authorities in Piacenza insisted on having a substitute painting first.

Such are, in brief, the main areas of collecting of the Dresden Gallery. In putting together the exhibition, we have tried to convey to the visitor the particular nature of the Gallery and to show the characteristic patterns in which its collections were acquired.

The entire activity of acquisition came to a sudden stop, as mentioned earlier, in the Seven Years War. In 1759 the paintings were packed in crates and sent to the fortress of Königstein, where they stayed, removed from Dresden, through the unsettled times. But even greater dangers threatened the paintings in our century: during the bombing attack on Dresden, 13 February 1945, 159 paintings were burned, among them famous works by Cranach, Krell, Krodell, Palma, Parmigianino, Trevisano, Rubens, and numerous minor Dutch masters.

As the result of a decision by the Ministerial Council of the USSR, the paintings that at the end of the war had been sent for safe-keeping to the museums of Moscow, Kiev, and Leningrad, were returned to their old home in Dresden. After a long lapse of time, on 3 June 1956, the doors of the reconstructed Semper Gallery finally reopened. We must indeed be grateful for the fact that despite all these dangers so large a part of the collection has survived to this day.

ANNELIESE MAYER–MEINTSCHEL
Director
Old Masters Picture Gallery

The Old Masters Picture Gallery

ENTRIES BY: Angelo Walther [513-528]

Harald Marx [529-540]

Anneliese Mayer-Meintschel [541-562]

Italian School

Ercole de' Roberti
Ferrara c. 1450—d. 1496
Ferrarese school

513. Christ on the Way to Golgotha (c. 1482-86)

Poplar, 35 x 118 cm.
Acquired in 1750 from the church of San Giovanni in
Bologna
Gal. no. 45

This picture with its pendant, *The Taking of Christ*, also
in Dresden (Gal. no. 46), was part of the predella of the
high altar in San Giovanni in Monte, near Bologna,
mentioned by Vasari. These panels flanked a *Pietà* that
is now in the Walker Art Gallery, Liverpool. In their
forceful expression the Dresden paintings are among
the greatest achievements of Ferrarese art during the
late quattrocento. In this dramatic work, figures are
crowded into a frieze-like composition against a bar-
ren, inhospitable, rocky landscape. The many ele-
ments suggestive of movement, plastically conceived
with daring foreshortenings, are characteristic of
Roberti, whose strength lies in expressive gesture. The
influence of Mantegna, as well as that of the young
Giovanni Bellini and of Cosimo Tura, is evident.

Pinturicchio (Bernardino di Betto Biagio)
Perugia c. 1454—Siena 1513
Umbrian school

514. Portrait of a Boy (c. 1480-85)

Poplar, 50 x 35 cm.
Inventory of 1722: A 73, as portrait of Raphael by an
unknown master
Gal. no. 41

According to the inventory of 1722, this work was
formerly believed to be a portrait of the young Raphael
by an unknown painter. Later, it was suggested that
Raphael's father, Giovanni Santi, was the artist, or that
it was a self-portrait by the young Raphael himself.
Indeed, a certain resemblance can be found between
the sitter in this picture and the features of the young
Raphael as we see them, for example, in a drawing in
the Ashmolean Museum, Oxford. In any case, the
portrait clearly belongs to the school of Perugino, to
whom Venturi (1911) and Canuti (1931) assigned it.
Since about 1860 (Schäfer, Waagen) the painting has
been assigned to Pinturicchio, an attribution upheld
by Lermolieff (1891). Carli (1960) comments on the
similarity of this painting to a portrait of a youth in the
National Gallery of Art, Washington (Kress Collec-
tion), recently attributed by Shapley (1968) to the so-

called Master of Santo Spirito. The usually accepted dating for the Dresden painting is about 1480-85, the period when Pinturicchio was working under Perugino ,on the frescoes in the Vatican's Sistine Chapel. The transition from boyhood to young manhood has been captured here with psychological sensitivity in a painterly approach distinguished by refined draftsmanship.

Palma Vecchio (Jacopo d'Antonio Negretti)
Serinalta near Bergamo c. 1480—Venice 1528
Venetian school

515. Jacob and Rachel (after 1520)

Canvas, 146 x 250 cm.
Inscribed in foreground on sack: G.B.F.
Guarienti Inventory (1747-50): No. 438 (as by Giorgione), from the Casa Malipiero, Venice
Gal. no. 192

The attribution to Giorgione, with which the painting was acquired, was retained until the late nineteenth century, since it appeared to be confirmed by the inscription, interpreted as "Giorgio Barbarelli fecit." Crowe and Cavalcaselle (1876) suggested Cariani. Only Lermolieff (1891) correctly recognized the hand of Palma Vecchio, who probably painted the picture after 1520. The mystery of the inscription has still to be

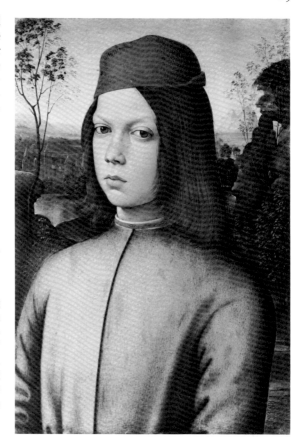

solved. The painting shows Jacob, the forefather of the Israelites, as after his long wanderings from Canaan to Mesopotamia he meets the beautiful Rachel, later to become his wife (Genesis 29: 9-12). In the poetic spirit of Giorgione, Palma represented the biblical scene as a Venetian pastorale, and in so doing created one of the most beautiful landscapes in the whole of Italian art. According to Schubring (1916), the scene is the meeting of Paris with the shepherdess Oenone, as related by Homer.

Titian (Tiziano Vecellio)
Pieve di Cadore 1476/77 or later—Venice 1576
Venetian school

516. Portrait of a Lady in White (Titian's daughter Lavinia?) (c. 1555)

Canvas, 102 x 86 cm.
Acquired in 1746 from the ducal gallery, Modena
Gal. no. 170

This painting was listed in the catalogue of 1765 as *Mistress of Titian*. Crowe and Cavalcaselle (1877) believed Titian had portrayed here his daughter Lavinia

in her wedding costume, with the small flag-shaped fan that was apparently a part of it. Lavinia married in 1555, which would correspond with the supposed date of the painting. Hadeln (1931) rejected this identification, pointing out that the sitter shows little resemblance to the documented portrait of Lavinia by Titian, also in Dresden (Gal. no. 171); this portrait must have been painted no later than 1561, when Lavinia died during the birth of her sixth child. It is thought that the birth of so many children in quick succession must have changed her appearance. Here, the sitter exhibits a charming mixture of reserve and coquetry. The pyramidal composition, characteristic of Titian, became the definitive model for portraits by Rubens, Van Dyck, Velázquez, and Rembrandt. During a period of intense interest in Titian's art, Rubens copied this very painting (Vienna, Kunsthistorisches Museum).

Titian

517. Portrait of a Painter with a Palm Branch (1561)

517

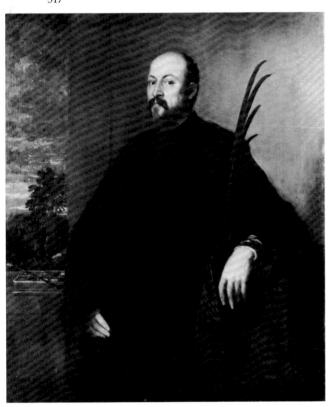

518

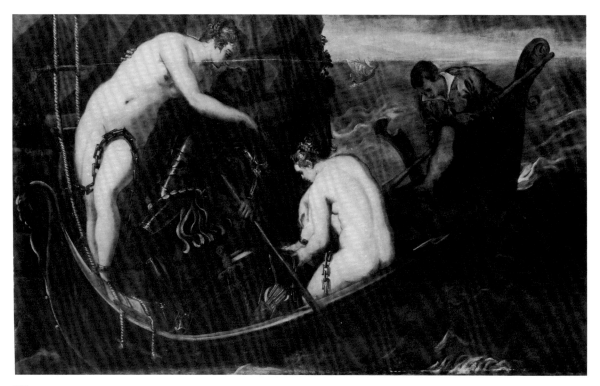

519

Inscribed at bottom left: MDLXI/ ANNO . . . NATVS/ AETATIS
SVAE XLVI/ TITIANVS PICTOR ET/ AEQVES CAESARIS
Canvas, 138 x 116 cm.
Guarienti inventory (1747-50): 432, from the Casa Mar-
cello, Venice
Gal. no. 172

On the basis of a later inscription that has since been
removed, this passed for a long time as a portrait of the
poet Pietro Aretino. Cook (1905) identified the subject
as the painter Antonio Palma, nephew of Palma Vec-
chio and father of Palma Giovane. Antonio Palma was
born in 1515 and thus in 1561 was forty-six, as stated in
the inscription. The palm branch and paint box are
references to his name and profession. The small-
headed, elongated, mannerist figure type embodied
here owes its inspiration to Byzantine art. The figure's
sloping shoulders, tapering face, and palm-branch
emblem, as well as the overall spiritualization of the
portrait are reminiscent, on the one hand, of repre-
sentations of saints on Greco-Byzantine icons, and on
the other, of figures by El Greco, who was profoundly
influenced by Titian's later work. In its loose, painterly
manner, the landscape with the sunset is stylistically
later than the figure and may have been reworked by
Titian at some other time.

Jacopo Tintoretto (Jacopo Robusti)
Venice 1518-1594
Venetian school

518. Portrait of a Lady in Mourning (c. 1550)

Canvas, 104 x 87 cm.
Acquired in 1746 from the ducal gallery, Modena
Gal. no. 265A

In the inventory of 1754 this portrait is listed as
Caterina Cornaro, Queen of Cyprus, by Titian. How-
ever, the identification cannot be upheld, since
Caterina Cornaro died in 1510 at the age of fifty-six.
The work was listed in the Dresden catalogues under
the name of Titian until 1899, when Woermann joined
Berenson and Loeser in attributing it to Tintoretto.
Later, in 1915, Osmaston proposed Veronese. How-
ever, the character of the painting and the type of the
sitter point convincingly to Tintoretto, who shows
himself here an equal of Titian in painterly delicacy.

Jacopo Tintoretto

519. The Rescue of Arsinoë (soon after 1560)

Canvas, 153 x 251 cm.
Inventory of 1754: I 398, bought in Mantua by Algarotti,
1743
Gal. no. 269

According to Wickhoff (1902), this painting illustrates a story from *Pharsalia*, by the Roman poet Lucian, which was embellished in the course of its medieval revision to become a romantic adventure of chivalry. The knight Ganymede, wishing to accede to the throne of Egypt, freed Arsinoë, sister of the deceased Ptolemaic ruler, and her companion from a tower standing in the sea, where Caesar had imprisoned them. In order to pass through a narrow window, the women had to disrobe. Tintoretto has made the women still more seductive by contrasting their nudity with Ganymede's steel armor, as well as with the chains on their thighs—all of this conforming to mannerist principles. The elongated figures with small heads and the tortuous movements are typical of mannerist style, as is also the diagonal composition, appropriate to the tense moment depicted.

Domenico Fetti
Rome 1589 (?) — Venice 1624
Roman and Venetian schools

520. The Parable of the Lost Coin (c. 1618-22)

Poplar, 55 x 44 cm.
Acquired in 1742 through Riedel from the Imperial
 Gallery, Prague
Gal. no. 418

This is one of the series of representations of biblical parables by Fetti, most of which exist in several repetitions. Eight of the best of this series are in the Dresden Gallery. The scene represented here illustrates the Gospel according to Saint Luke (15:8-10). Roman naturalism, deriving from Caravaggio, is coupled with the charms of the Venetian painting tradition. Fetti transforms a homely subject into a monumental image through dramatic use of light and shadow, creating at the same time a painterly jewel.

Domenico Fetti

521. Portrait of a Scholar (Archimedes?)

Canvas, 98 x 75.5 cm.
Acquired in 1743 from Italy through Ventura Rossi
Gal. no. 692

In the realistic style of Caravaggio, the artist portrays a scholar whose interests are suggested by the objects arranged like a still life on his work table. The inclusion of symbols of vanity suggests worldly transience. Posse (1929) identified the subject as Archimedes, but P. Askew (1965) suggests that he may be the Greek astronomer Aristarchos of Samos, a forerunner of Copernicus. Until the end of the nineteenth century this work was believed to be by Ribera, and it was later assigned to his school. Askew, rejecting Posse's attribution to Fetti, sees in this picture a work by Giovanni Serodine, a Roman follower of Caravaggio.

Bernardo Strozzi, called Il Prete Genovese
Genoa 1581 — Venice 1644
Genoese and Venetian schools

522. Female Musician with Viola da Gamba (c. 1635)

Canvas, 126 x 99 cm.
Acquired in 1743 by Algarotti from the Casa Sagredo,
 Venice
Gal. no. 658

The powerful plastic structure and the rich color of this painting lead one to recognize Strozzi as one of the outstanding painters of seventeenth-century Italy. Influences of Caravaggio, of Flemish painting—especially as conveyed by Rubens during his stay in Italy at the beginning of the century—and of Venetian colorism are equally apparent here. The young woman's thoughtful expression contrasts strikingly with the sensuous, realistic conception of her figure. The large stringed instrument is a viola da gamba, a "knee-viola" with six strings. The forerunner of the modern cello, it was a much loved solo instrument in the seventeenth century.

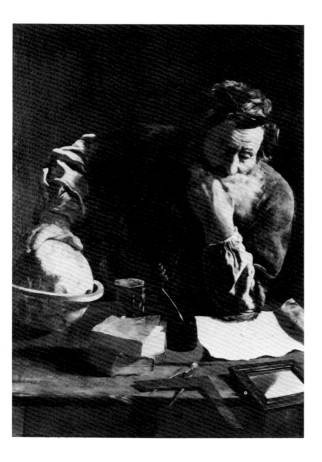

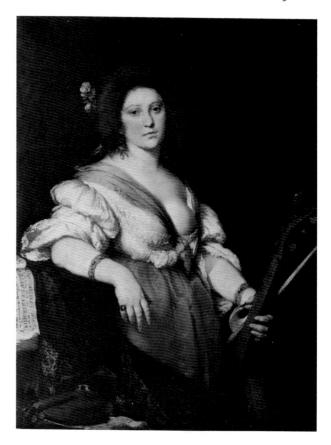

Antonio Canal, called Canaletto
Venice 1697-1768
Venetian school

523. The Square in Front of San Giacomo di Rialto in Venice (shortly before 1730)

Canvas, 95.5 x 117 cm.
Inventory of 1754: I 558
Gal. no. 583

To the right of the church the square is bounded by a large palace and a row of goldsmiths' and silversmiths' shops. The appropriately named Ruga degli Orefici (Goldsmiths' Row) leads to the Rialto bridge in the background, with its three stepped passages and two rows of shops. In front of the church's portico, paintings are offered for sale. In the foreground are poultry vendors with their baskets. Through sharp contrasts of light and shade the artist has conceived the buildings plastically and achieved a dramatization of his subject. A similar composition is in the National Gallery of Canada, Ottawa.

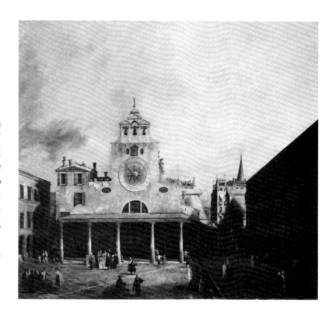

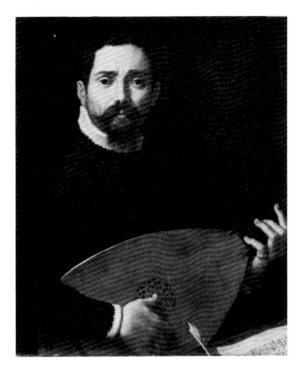

525. Saint Francis with Angel Playing Violin (c. 1623)

Canvas, 162 x 127 cm.
Acquired in 1756 from the Casa Ranuzzi, Bologna
Gal. no. 356

An outstanding early work, this Saint Francis was produced immediately after Guercino returned to Cento from Rome (1623). It reveals Caravaggio's influence both in the powerful modeling by means of contrasting light and shade and in the stark realism aimed at capturing the rustically plebeian figure of the saint. The dramatic lighting corresponds to the subject matter: Saint Francis receiving the stigmata. The angel embodies the vision seen by the hermit in his mystical ecstasy. Related compositions are in the Louvre and in the national museums in Warsaw and Bucharest.

Giuseppe Maria Crespi, called Lo Spagnuolo

Bologna 1665—1747
Bolognese school

Annibale Carracci

Bologna 1560—Rome 1609
Bolognese school

524. Portrait of a Lute Player (c. 1593-94)

Canvas, 77 x 64 cm.
Acquired in 1746 from the ducal gallery, Modena
Gal. no. 308

This monumental and provocatively lifelike portrait may be the one that Malvasia saw in Modena in 1678, and identified as the musician Mascheroni, a close friend of Carracci. In the nineteenth century it was thought to represent the composer Giovanni Gabrielle (or Gabrieli), known as "Il Sivello" (1557-1612), but Denis Mahon (1947) has pointed out that the evidence for such an identification is insufficient. A drawing for the figure is at Windsor Castle, and a preliminary sketch for the head is in the Albertina, Vienna; other studies are in the Uffizi, Florence, and the Kupferstichkabinett, Berlin-Dahlem.

Giovanni Francesco Barbieri, called Guercino

Cento near Ferrara 1591—Bologna 1666
Bolognese school

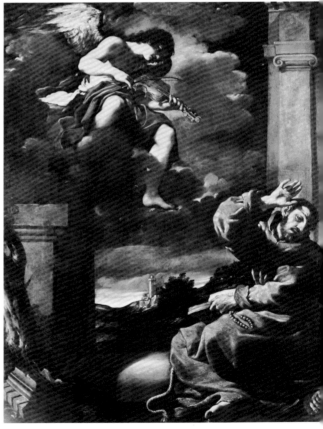

526. Ordination of a Priest (1712)

Canvas, 127 x 95 cm.
Acquired mid-18th c. in Rome from the estate of Cardinal Ottoboni
Gal. no. 393

Along with scenes depicting Baptism, Confirmation, Communion, Marriage, Confession, and Extreme Unction, this canvas belongs to the series of the Seven Sacraments that Crespi painted in 1712 for the Roman Cardinal Ottoboni. They count among the artist's masterpieces. The special attraction of these highly unusual paintings, all of which are in Dresden, lies in the straightforwardness and modest simplicity with which the eccelesiastical events are portrayed. In the artist's internalization of the subject, as in his almost monochromatic tonality and chiaroscuro effects, one sees the influence of Rembrandt. The ordination is performed by the bishop seated at the right, who holds in one hand the chalice and with the other touches the Host.

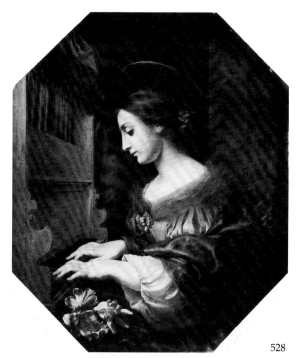

528

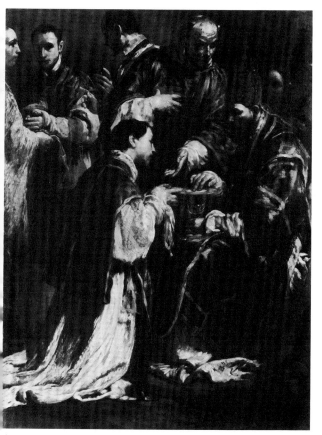

Giuseppe Maria Crespi

527. Confirmation (1712)

Canvas, 125 x 93 cm.
Acquired with no. 526
Gal. no. 395

In the Catholic Church, confirmation is the sacrament bestowed upon children by a bishop in order to strengthen their faith. The bishop here, in a white pluviale and with miter and crozier, leans toward the small confirmee, who kneels before him, and on whose shoulder the sponsor places his hand in accordance with the rite. An acolyte holds a bowl containing the chrismatory. Besides two clergymen, another confirmee with his sponsor is to be seen at the left edge of the picture. Within the series, this painting is an expression of humble piety, with which the solemnity of the Church dignitaries corresponds.

Carlo Dolci
Florence, 1616—1686
Florentine school

528. Saint Cecilia at the Organ (1671)

Canvas, 96.5 x 81 cm.
Acquired 1742 through de Brais; ex coll. Carignan, Paris
Gal. no. 509

This painting was commissioned by Cosimo de' Medici, Grand Duke of Tuscany, and is considered to be a masterpiece of its period. Toward the end of the second century, Saint Cecilia, a member of the Roman family of the Cecilians, was martyred for her Christian faith. Beginning about 1400, she was venerated as the patron saint of music, and was usually shown at an organ. The white lilies symbolize her virginity. The intensified sentimentality of the interpretation, revealed here in the saint's absorbed attitude, longing expression, and the exaggerated agitation of her hands is typical of the religious art of seventeenth-century Florence. The technique is marked by the subtle application and porcelain-like smoothness of the iridescent colors. Dolci repeated this subject several times.

French School

Nicholas Poussin
Les Andelys 1594—Rome 1665
French school

529. The Realm of Flora (1631-32)

Canvas, 132 x 182.5 cm.
Inventory of 1722: A 376
Gal. no. 719

Flora is surrounded by mythological persons who, after death, were transformed into flowers (Ovid's

530

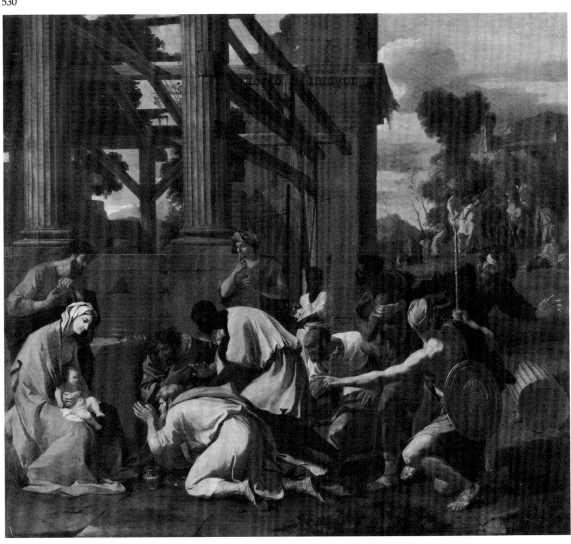

Metamorphoses). At the far left is a herm of the god of nature, Pan. Next to it, Ajax, a hero of the Trojan war, hurls himself upon his sword. In the foreground, Narcissus gazes at his reflection, with a nymph at his side. Slightly to the left, behind him, Clytië follows with her eyes the sun-chariot of her beloved Apollo. In the right foreground Crocus and Smilax recline. Behind them stands Adonis, the lover of Venus, and to his left, Hyacinth, friend of Apollo. Poussin's conception was apparently inspired by a poem by his benefactor and friend, Giambattista Marino.

Nicholas Poussin
530. Adoration of the Magi

> Signed bottom right, on shaft of the column: Accad:
> rom. NICOLAUS PUSIN faciebat Romae. 1633
> Canvas, 160 x 182 cm.
> Acquired in Paris, 1742, through de Brais
> Gal. no. 717

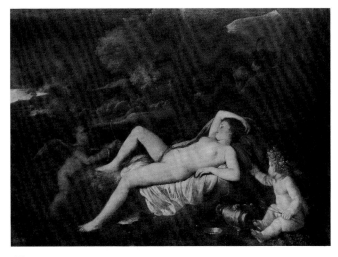

531

In a letter to the Sieur de Chantelou in 1647 Poussin explained that different subjects require different artistic treatments. As can be seen when one compares *The Realm of Flora*, dated 1631-32, with this *Adoration* of 1633, Poussin adapted his style to his subject matter. The luminous delicacy of the colors and the relaxed dance-like rhythm of the first painting differ clearly from the strong, bright colors distributed over the surface, and the dramatic composition of the *Adoration*. In the latter everything is directed toward the Holy Family placed to the far left, at the very edge of the picture. The three kings, who look like simple men of the people, as Bernini noted in 1665, are both deeply moved and full of uncertainty. The stable in Bethlehem is built within the ruins of a Roman temple, suggesting that Christianity grew out of antiquity, while art itself received ever new inspiration from the creations of the classical past.

Nicholas Poussin
531. Venus Resting with Amor

> Canvas, 71 x 96 cm.
> Inventory of 1722: A 528
> Gal. no. 721

Before 1812 this painting of Venus had been identified as a *Sleeping Nymph*. J. G. von Quandt believed that the subject was a bacchante, an interpretation endorsed by Kurt Badt in 1969. This painting, in which Titian's influence has been seen, is hesitantly attributed to Poussin by Jacques Thuiller, who points out that the type of slim, youthful woman does not appear in his documented works, and it is excluded from his oeuvre by Doris Wild (*Gazette des Beaux-Arts*, 1967).

Antoine Watteau
> Valenciennes 1684—Nogent-sur-Marne 1721
> French school

532. The Banquet of Love

> Canvas, 61 x 75 cm.
> Guarienti Inventory (1747-50)
> Gal. no. 782

Watteau's "fêtes galantes" may have been inspired by Ruben's representation of *The Garden of Love,* although other Flemish masters, such as David Teniers the Younger, may also have influenced him. He has, however, transformed the Flemish model into something completely his own, replacing the crude village festivities with the civilized sociability of Parisian aristocrats. This late work is characterized by the delicacy of its color scheme and the sensitivity of its brushwork. The artist's initial sketch for the work, a late one, is in the Art Institute of Chicago.

Jusepe de Ribera, called Lo Spagnoletto
Játiva near Valencia 1591—Naples 1652
Spanish school

534. Saint Agnes in Prison

Signed bottom center: Jusepe de Ribera español, F. 1641
Canvas, 203 x 152 cm.
Acquired in 1745 through Count de Bene de Masseran,
 Spanish ambassador at the Dresden court
Gal. no. 683

Because she steadfastly refused to renounce her faith
in Christ, Saint Agnes was stripped of her clothing and
dragged naked through the streets of Rome to a place
of confinement. She prayed, and her already long hair
grew longer until she could wrap it around herself. An
angel appeared in her cell, bringing a white garment to
cover her, and the place was bathed in a glowing light.
This painting is from the artist's late period.

Spanish School

Diego Rodriguez de Silva y Velázquez
Seville 1599—Madrid 1660
Spanish school

533. Portrait of a Gentleman, Probably the Royal Chief Master of the Hunt, Juan Mateos (c. 1631-32)

Canvas, 108.5 x 90 cm.
Acquired in 1746 from the ducal gallery in Modena
Gal. no. 697

This painting was formerly ascribed to Rubens, then to
Titian, and was correctly attributed to Velázquez only
in 1856. It is an unfinished work—the hands are only
sketched. Karl Justi, in 1888, tentatively identified the
subject as Juan Mateos.

German, Flemish, and Dutch Schools

Lucas Cranach the Elder
Kronach 1472—Weimar 1553

535. Portrait of Duke Heinrich the Pious (1514)

Transferred from wood to canvas, 184 x 82.5 cm.
In Kunstkammer, 1641; in Historical Museum, 1838, inv.
no. H 98; in Paintings Gallery, 1905
Gal. no. 1906 G

This work originally shared a frame with its pendant,
a portrait of Duchess Katharina of Mecklenburg. The
painting of the duchess is signed with the monogram
LC, the winged serpent, and dated 1514. The wreaths
of carnations and jewels with symbolic clasped
hands indicate that they are betrothal portraits. Duke
Heinrich (1473-1541), a member of the Albertinian
branch of the House of Wettin, married Katharina in
1512; their son Moritz was to become Elector of
Saxony. Cranach made a second life-size, full-length
portrait of Duke Heinrich in 1537 (Gal. no. 1915, lost
in the war). It is possible that this type of portrait was
conceived by those who commissioned it, since we
know of no instances of it in European art before
Cranach. It may have been inspired by tomb effigies,
with their life-size figures in stone or bronze, all in a
narrow format. In the 1530s Jakob Seisenegger
painted many portraits of this type, and his examples
may have influenced Titian. Later in the century,
life-size, full-length portraits were generally pre-
ferred. Cranach's mannerist style, in which indi-
vidual decorative elements are combined in an essen-
tially abstract composition, answered the need for
pomp and circumstance in a society that judged a
person's rank by the richness and elegance of his
clothing.

South German Master, c. 1520

536. Portrait of a Man with a Black Cap in His Hand

Lindenwood, 61.5 x 45.5 cm. including 13 mm. strip
added on all sides
Catalogue of 1765: GE 70
Gal. no. 1905

This panel was originally in the Kunstkammer, where
it was listed as a portrait of the father of Martin Luther
by Hans Holbein the Younger. The attribution to Hol-
bein was maintained in the catalogues of the Gallery

536

until 1817, when the sitter was identified as Martin
Luther himself. Thereafter it was listed as *Portrait of a
Man* by an unknown German master. Since 1835 the
painting has been variously attributed to Johann
Asper, Hans Burgkmair, and to a member of the family
of Ulrich Apt, the Augsburg painter. Most recently,
Gert von der Osten (*Wallraf-Richartz-Jahrbuch* XXXV,
1973), assigned this fascinatingly candid painting to
Wolf Huber, basing his attribution primarily on the
placement of the figure against an open sky. The paint-
ing is in an excellent state of preservation.

Albrecht Dürer
Nuremberg 1471-1528
German school

537. Portrait of Bernhard von Reesen (1491-1521)

Signed with monogram: AD, dated 1521
The letter in the subject's hand is inscribed: Dem pernh
. . . zw . . .
Oak, 45.5 x 31.5 cm.
Acquired in Paris in 1743 through the Saxon agent Le
Leu
Gal. no. 1871

This work was painted during Dürer's stay in the Netherlands. The subject appears powerful and confident, but at the same time thoughtful; his eyes, somewhat vague in expression, are turned to the left and look into the distance; the angular shapes of the head are softened by delicate modeling. The portrait almost breaks out of the frame: diagonal lines dominate, pushing strongly against the edge of the composition, creating an effect of tension that communicates itself to the viewer. Only with difficulty have the hands of the sitter been accommodated. Dr. Erna Brand is responsible for the discovery of the sitter's identity. Mentioned in Dürer's travel journal in the entry for 16 March 1521, von Reesen came from a respected merchant's family in Danzig and seems to have been active in Antwerp just before his death. He paid Dürer eight guldens for the portrait.

Hans Holbein the Younger
Augsburg 1497/98 — London 1543
German school

538. Double Portrait of Thomas Godsalve and His Son Sir John

Dated top left: Anno. Dmi. M. D. xxvii
Inscribed on paper held by Thomas: Thomas Godsalve
de Norwico Etatis sue Anno quadragesimo septo
Oak, 35 x 36 cm.
Acquired in Paris, 1749, through Le Leu
Gal. no. 1889

This work was painted during Holbein's first stay in England. Thomas Godsalve (1481-1542) was a notary

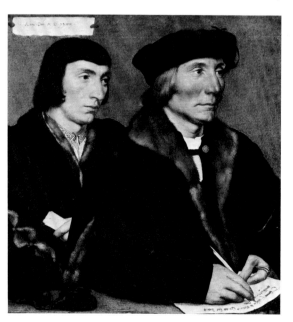

and judge at Norwich. His son John (c. 1510-66) served as Secretary and Keeper of the Seal for Thomas Cromwell, Chancellor of the Exchequer under Henry VIII. John was knighted in 1547. The family resemblance as well as the difference in temperaments has been captured by Holbein with the most economical of artistic means.

Hans Baldung, called Hans Baldung Grien
Schwäbisch Gmünd 1484-85 — Strassburg 1545
German school

539. Mucius Scaevola

Signed bottom right on chest: H G Baldung Fec. 1531
Inscribed left, beneath the fire: 1531 MUCI
Lindenwood, 98 x 68 cm.
Acquired 1927
Gal. no. 1888 B

According to Livy (II, 12 f.) and Plutarch (IV, 17), Gaius Mucius, with the consent of the Roman Senate, tried in 508/07 B. C. to assassinate the Etruscan king, Porsenna, as he was besieging Rome. Because of a mistake in identification, another man was killed. Captured and threatened with torture and execution, Gaius Mucius demonstrated his fearlessness by holding his right hand over a basin of burning coals. The "theatrical treatment" (Bussman) of the scene and the glassy clarity of the enamel-like, "unreal" colors give an impression of frozen action. The unnaturally pale faces and the awkward linearity of the composition are evidence of Baldung's rejection of Renaissance realism in favor of mannerism.

Adam Elsheimer
Frankfurt am Main 1578 — Rome 1610
German school

540. Jupiter and Mercury in the House of Philemon and Baucis (c. 1609-10)

Copper, 16.5 x 22.5 cm.
Mentioned in inventory of 1754
Gal. no. 1977

Ovid tells in his *Metamorphoses* the story of these two wandering gods, who, having been turned away from many doors, finally found a friendly welcome in the home of an old married couple. The influence of Caravaggio in this small painting is unmistakable, but the mode of expression is purely personal. It has been suggested that Rembrandt derived his *Supper at Emmaus* (Musée Jacquemart-Andre, Paris) from this work, but the composition of the Rembrandt is more dynamic. Closer to Elsheimer's painting is Rembrandt's *Philemon and Baucis* of 1658 (National Gallery

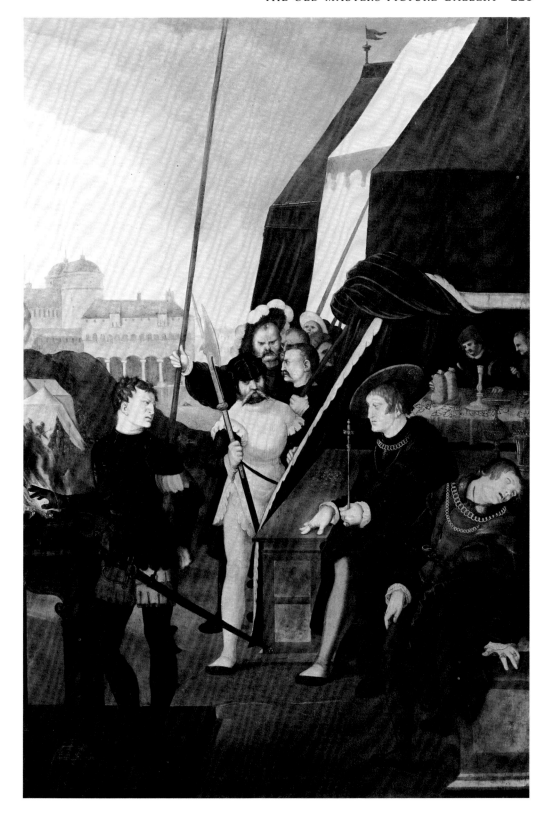

539

540

of Art, Washington). Rembrandt may have known H. Goudt's engraving (1612) of Elsheimer's painting. This engraving of the composition drew the following comment from Goethe: "His [Jupiter's] eyes fall on a woodcut hanging on the wall, where he sees represented one of his amorous escapades, carried out with the help of Mercury. If such a feature is not worth more than a whole warehouse of genuine antique chamberpots, then I will give up all thinking, composing of poetry, all aspiration and writing."

Herri met de Bles
Bouvignes 1510-55 (?)
Netherlandish school

541. Sermon of Saint John the Baptist

Signed on tree at left with owl (the artist's "signature")
Oak, 27 x 41 cm.
Acquired 1921
Gal. no. 806 C

In most of his small panoramic landscapes Herri met de Bles follows Netherlandish tradition and is especially close to works of Joachim Patinir. Many variants of his paintings exist in which only the subject in the foreground is changed while the background landscape remains the same. The variant stylistically closest to our painting is in the Kunsthistorisches Museum, Vienna; however, the costumes in the Vienna picture are oriental rather than European. G. J. Hoogewerff believed that the figures in our painting were painted by M. Cock; G. Franz (1969) attributes them to an anonymous artist, whom he calls Master II.

Paul Bril
Antwerp 1554—Rome 1628
Flemish school

542. View of the Roman Forum with Columns of the Temple of Castor and Pollux and Hadrian's Basilica

Signed and dated bottom center: P. Bril. 1600
Copper, 21.5 x 29.5 cm.
Acquired in Paris, 1742, through de Brais
Gal. no. 858

Van Mander (1604) has described this picture as a "comely little copper piece with comely ruins and statuary, being in the manner of the Campo Vaccina of the old market square of Rome." In Bril's day, the Forum served as a cattle market. It was not only the picturesqueness of the ruins that interested him but also the motley crowd of traders in the marketplace. He has created here a new form of landscape in which the human figure and the natural world are of equal interest.

Roelant Savery
Kortrijk 1576—Utrecht 1639
Flemish-Dutch school

543. Ruined Tower by a Waterfowl Pond

Signed and dated bottom center: ROELANT·SAVEREŸ FE·1618
Oak, 29.5 x 42 cm.
Guarienti Inventory (1750): no. 1673
Gal. no. 931

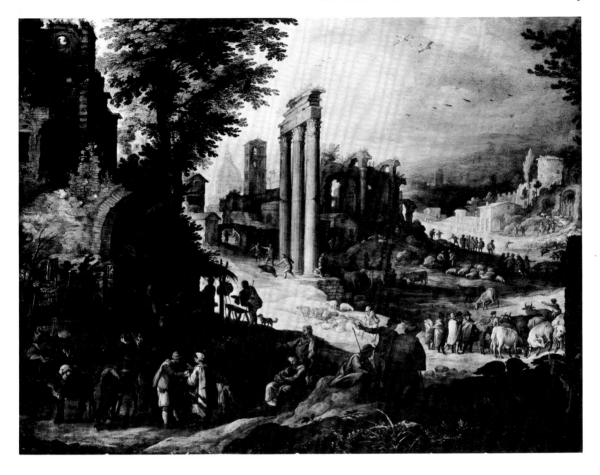

Joos de Momper
Antwerp 1564-1635
Flemish school

544. Mountain Landscape with Trunks of Fir Trees in a Stream

Oak, 53 x 71.5 cm.
Gal. no. 870

In the inventory of 1754 this was listed as a work by Brueghel, but the attribution was corrected in the Abrégé of 1782. Known exclusively as a landscape artist, Momper represents a link between late mannerist and early baroque landscape painting. This composition, with its three separate scenes, goes back to mannerist tradition, while the sketchy, lively brushwork belongs to the dynamic art of the baroque. The painting can be dated after 1591, when Momper returned from his journey to Italy.

Adriaen Brouwer
Oudenaarde 1605/06—Antwerp 1638
Flemish school

545. Brawl among Peasants at a Card Game

Oak, 26.5 x 24.5 cm.
First appears in catalogue of 1817
Gal. no. 1059

According to H. Gerson (1965), this is one of Brouwer's late works. The painting owes its particular charm to the firm handling of color and effects of light.

David Teniers the Younger
Antwerp 1610—Brussels 1690
Flemish school

546. Temptation of Saint Anthony

Copper, 69 x 86 cm.
Inventory of 1722: A 1150
Gal. no. 1079

Teniers was a versatile artist who produced large gallery pictures as well as smaller, more delicate works. His subjects were biblical or mythological, and he

could express the splendor and pathos of the great masters or, equally well, the everyday life of peasants. He also had a command of the fantastic, as can be seen in the present work.

Jan Wildens
Antwerp 1586-1653
Flemish school

547. Winter Landscape with a Hunter

Signed and dated bottom left: IAN·WILDENS FECIT 1624
Canvas, 194 x 292 cm.
Inventory of 1722: B 1233
Gal. no. 1133

Wildens, an assistant in Rubens' Antwerp workshop, was in Italy from 1613 to 1618. That quality which distinguishes Flemish painting from Dutch—a broad treatment that sometimes becomes decorative—is found in Wildens' work. The diagonal composition seen here was a pictorial device he often relied on. The figure is an important part of the composition; this huntsman, evidently a nobleman, walks homeward with his scenting hound and his greyhounds. The

special charm of the work lies in the light, cool colors, and in the contrast between the easy movement of the hunter and his dogs, and the stark, wintry trees at the left.

545

Anthony van Dyck
Antwerp 1599—London 1641
Flemish school

548. Drunken Silenus

Signed at top center, on jug: AVD
Canvas, 107 x 91.5 cm.
Gal. no. 1017

Silenus, the tutor of Dionysos, is usually represented as old and bald. He could not walk when he was drunk, and when he tried to ride a donkey, he fell off it. In the baroque interpretation of this subject Silenus is supported by bacchantes and satyrs. In this early work, the nervous painterly manner, the lively drawing, and the easy interplay of light and dark all testify to the artist's mastery. A variant made about 1615 is in the Royal Museum, Brussels.

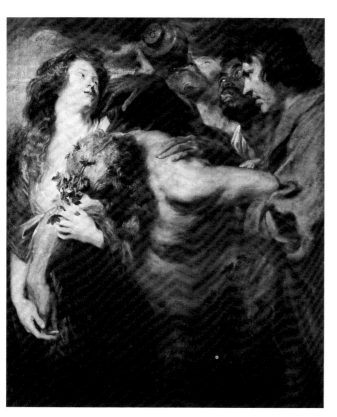

Peter Paul Rubens
Siegen 1577—Antwerp 1640
Flemish school

549. Mercury and Argus (c. 1638)

Oak, 63 x 87.5 cm.
Acquired in Paris, 1742, through de Brais
Gal. no. 962 C

Io, daughter of the Argive king, was one of the mistresses of Zeus. She was transformed into a white cow by Zeus' jealous wife, Hera, but Zeus sent Mercury to rescue her. By playing his flute, Mercury put the guard Argus to sleep and then killed him, freeing Io. Rubens has chosen the climax of the story, as told in Ovid's *Metamorphoses* (I, 568-721). Argus has fallen asleep and Mercury draws his sword, while the cow looks on as if she had human reason. Rubens varied this composition in a work painted in 1638 for the Torre de la Parada, now in the Prado, Madrid. A sketch is in the Royal Museum, Brussels.

Peter Paul Rubens

550. Quos Ego!

Canvas, 326 x 384 cm.
Acquired through Count Brühl
Gal. no. 964 B

This is a mythological-allegorical composition from the triumphal arch erected on the occasion of the governor of Flanders' entry into Antwerp, 17 April 1635. The subject is taken from a passage in the *Aeneid* (I,

135) in which Neptune orders a storm to subside:
"Quos ego—sed motos praestat componere fluctus."
A sketch for this picture is in the Fogg Museum, Cam-
bridge, Massachusetts; drawings after it are in the
British Museum (by Theodore van Thulden), the
Rijksmuseum, Amsterdam (by Erasmus Quellinus),
and in the Albertina, Vienna. The scene was engraved
by Theodore van Thulden in his *Pompa Introitus Fer-
dinandi,* Antwerp, 1642. This painting belonged pre-
viously to Cardinal Infante Ferdinand and the Duc de
Richelieu.

Gerard Dou
Leyden 1613-75
Dutch school

553. Still Life with Candlestick and Pocket Watch

Signed bottom center on wall: G Dov
Oak, 43 x 35.5 cm.
Inventory of 1754: II 572 (ex coll. Cabinet de Bye, Leyden, 1665)
Gal. no. 1708

Dou was highly esteemed during his lifetime, and his paintings were sometimes priced higher than those of Rembrandt. One of the first collectors of his work was Johan de Bye. To exhibit Dou's paintings, de Bye rented a room opening toward the street for forty guilders. Dou built small boxes—kastjes—to protect his works from damage and dust, and this painting was originally the cover of such a box. The painting inside, *In the Wine Cellar*, formerly in Dresden, was lost in 1945. The hourglass, candle, and book in the present work were taken from an emblem in Hadrianus Junius' *Emblemata* (Antwerp, 1659, p. 11), under the motto "Vita mortalium vigilia." The clay pipe and tobacco lying on the latest newspaper refer to a Dutch saying, "Veeltijde wat nieuws, selden wat goets"—"Often something new, seldom anything good."

Jan Asselijn
Dieppe or Dieman 1615—Amsterdam 1652
Dutch school

551. Young Herdsman with Cows

Signed left bottom with monogram: A
Canvas, 44 x 36 cm.
Inventory of 1722: A 459
Gal. no. 1594

A. C. Steland-Stief (1971) places this canvas in the artist's late Amsterdam period (1648-52). With Carel Dujardin, Adam Pynacker, and Nicolaes Berchem, Asselijn was one of the many Netherlandish landscape painters active in Rome during the seventeenth century.

Nicholaes Pietersz Berchem
Haarlem 1620—Amsterdam 1683

552. A Merchant Prince Receiving a Moor at his Harbor Palace (c. 1665)

Signed bottom left: C. Berchem f
Transferred from wood to canvas, 94 x 98.5 cm.
Acquired 1727 through Leplat
Gal. no. 1479

Willem Claesz Heda
Haarlem 1594—1680/82
Dutch school

554. Breakfast with a Blackberry Pie

Signed and dated below in center: HEDA. 1631
Oak, 54 x 82 cm.
Acquired in 1875 from the Amsterdam art market
Gal. no. 1371

A new branch of painting flourished in Holland in the seventeenth century: the still life. These paintings can be localized by subject alone, since individual towns had their preferred motifs. In Leyden one painted still lifes with books, hourglasses, broken clay pipes, and candles. In the Hague, the still life with fish was preferred, in Haarlem, still lifes with glasses and beakers. The broken glass and watch in our painting are symbols of vanity and of the fleeting nature of life.

Gerard Ter Borch
Zwolle 1617—Deventer 1681
Dutch school

555. Officer Reading a Letter (c. 1657/58)

Oak, 37.5 x 28.5 cm.
Inventory of 1722: A 525
Gal. no. 1833

In 1722 this picture was listed as by Metsu; it was correctly attributed to Ter Borch in the inventory of 1754. This artist generally depicted a single figure in an interior or a very small group, elegantly dressed and quietly occupied in comfortable surroundings. His light is often twilight. A pendant to this painting is in the National Museum, Warsaw.

Gabriel Metsu
Leyden 1629—Amsterdam 1667
Dutch school

556. Portrait of the Artist with His Wife Isabella de Wolff in an Inn

Signed and dated top left: G. Metsú 1661
Oak, 35.5 x 30.5 cm.
Inventory of 1722: A 551. Entered the Kunstkammer 1700
Gal. no. 1732

This painting is described in the 1722 inventory as "a young Dutch Girl and a fellow." K. Schäfer, in the catalogue of 1860, identified the subject as "the artist at breakfast with his wife in an inn," but this designation was subsequently forgotten until B. J. A. Renckens (1959) rediscovered the identity of the sitters. Metsu represents the world in all its detail; the objects depicted in this interior are as important as the people. In a self-portrait, one would expect to find an expression of the artist's ego, but there is no trace of this here. If one did not know that these are portraits of the artist

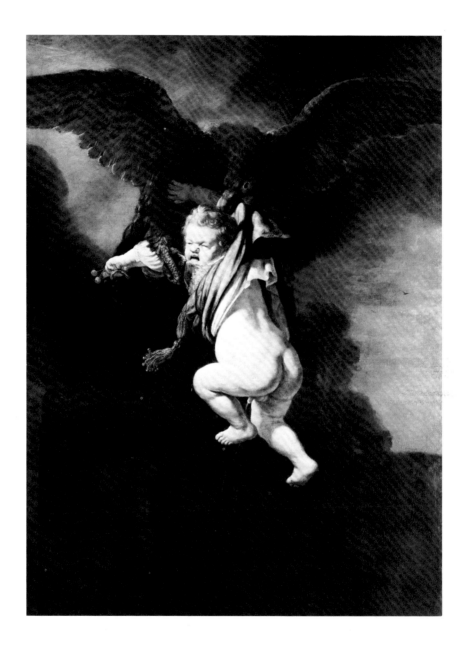

and his wife, one would think that the subject is simply a pair of lovers at breakfast. The carefully balanced, detailed painting, and the refined tonalities place this artist in the first rank of genre painters.

Rembrandt Harmensz. van Rijn
Leyden 1606 — Amsterdam 1669
Dutch school

557. The Abduction of Ganymede

Signed and dated on the drapery: Rembrandt. fe 1635
Canvas, 171 x 130 cm.
Acquired in Hamburg, 1751, through Heinecken (auctioned in Amsterdam, 1716)
Gal. no. 1558

According to the Greek myth, Zeus fell in love with Ganymede, a tall, beautiful youth, and had an eagle transport him to Mount Olympus to become his cupbearer. Rembrandt's painting was done soon after his drawing in the Kupferstich Kabinett. The two figures at the sides in the drawing are replaced here by groups of trees and the battlements of a building. A darkness bathed in green and brown sets the tone for a scene of the squealing child as he is torn away from peaceful cherry-eating. It is hard to imagine how an artist could abandon established traditions more thoroughly.

Rembrandt Harmensz. van Rijn

558. Samson Proposing the Riddle at the Wedding Feast

Signed and dated bottom center: Rembrandt. f. 1638
Canvas, 126.5 x 175.5 cm.
Inventory of 1722: A 1144
Gal. no. 1560

Much praised during Rembrandt's lifetime, this work represents a high point in his artistic development prior to the painting of the *Night Watch* (1642), Rijksmuseum, Amsterdam. In 1641 Philips Angels, in his *In Praise of the Art of Painting*, extolled this painting for its well-conceived storytelling. It is believed that the flutist in the right background is a self-portrait.

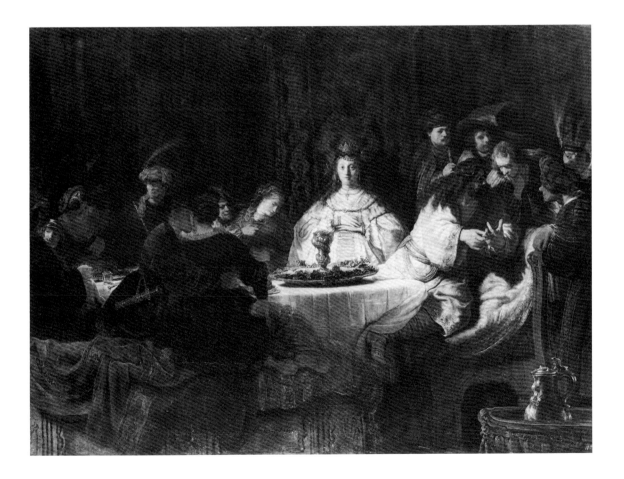

Johannes Vermeer
Delft 1632-75
Dutch school

559. Girl at a Window Reading a Letter (c. 1658)

Signed right background; only traces of the signature
 remain
Canvas, 83 x 64.5 cm.
Acquired 1742 in Paris through de Brais
Gal. no. 1336

Vermeer often employed the device of the curtain,
which, when drawn aside, provides the spectator with
a glimpse of an intimate scene. In such paintings a
restrained mood is rendered with extraordinary mas-
tery. Here a young girl reading a letter is revealed. All
else is quiet, the single focus of the scene being the act
of reading. Daylight pours through the window, il-
luminating the chamber. It falls on the green-clad fig-
ure of the girl. The surrounding forms are simple and
restful, but these as well as the most humble objects in
the painting are transfigured by the gentle spell cast by
refracted light. The play of light and reflection gives a
mysterious quality of life to everything.

Jan van Goyen
Leyden 1596—The Hague 1656
Dutch school

560. Summer near a River

Signed lower left, on boat: VG 1643
Oak, 68 x 91 cm.
First mentioned in catalogue of 1817
Gal. no. 1338 C

Jacob Isaackzoon van Ruisdael
Haarlem 1628/29—Amsterdam 1682
Dutch school

561. The Jewish Cemetery (c. 1660)

Signed left on a stone: J v Ruisdael
Canvas, 84 x 95 cm.
Inventory of 1754 II: 490
Gal. no. 1502

This famous painting depicts the graveyard of Ouder-kerk, not far from Amsterdam. Another version, also of about 1660, is in the Detroit Institute of Arts, and the subject is known in several different drawings, two of which are attributed to Ruisdael himself. W. Stechow sees this painting as an allegory of decay, a "memento mori," mitigated by the addition of the rainbow as a symbol of the Redemption and the Resurrection. Goethe described the painting in his *Ruysdael als Dichter* (1816).

Philips Wouwermans
Haarlem 1619—1668
Dutch school

562. Cavalry Combat before a Burning Windmill

Signed bottom left with monogram: Phils W.
Canvas, 54.5 x 66.5
Ex coll. Tugny, Paris; Crozat, Paris; acquired 1749
 through Le Leu
Gal. no. 1463

The Gallery owns forty-five paintings by Wouwer-
mans, probably the largest collection of his work in the
world. This is an indication of the favor the artist
enjoyed in the eighteenth century in Dresden. In his
early period, Wouwermans produced landscapes en-
tirely of the Haarlem type. Later, he painted hunting
scenes and scenes of mounted combat, such as this
one, from his middle period.

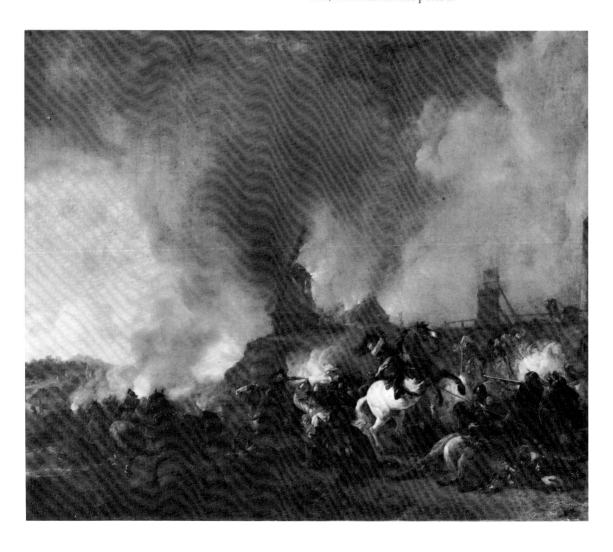

LITERATURE

Johann Anton Riedel and Christian Friedrich Wenzel, *Catalogue des tableaux de la Galerie Electorale à Dresde*. Dresden, 1765.

Friedrich Matthäi, *Verzeichnis der Königlich Sächsischen Gemälde-Galerie zu Dresden*. Dresden, 1835.

Julius Hübner, *Verzeichnis der Königlichen Gemälde-Gallerie zu Dresden. Mit einer historischen Einleitung*. Dresden, 1856.

Wilhelm Schäfer, *Die Königliche Gemälde-Gallerie im Neuen Museum zu Dresden*. 3 vols. Dresden, 1860.

Karl Woermann, *Katalog der Königlichen Gemäldegalerie zu Dresden*. 1st ed., Dresden, 1887; 7th rev. ed. 1908.

Hans Posse, *Die Gemäldegalerie zu Dresden*. Part 1: "Alte Meister." Berlin, Dresden, 1920.

Hans Posse, *Die Staatliche Gemäldegalerie zu Dresden. Vollständiges beschreibendes Verzeichnis der älteren Gemälde*. Part 1: "Die romanischen Länder." Dresden, 1929.

Hans Posse, *Katalog der Staatlichen Gemäldegalerie zu Dresden*. 8th ed., Dresden, 1912; 12th ed., 1930.

Hans Posse, *Die Gemäldegalerie zu Dresden. Die alten Meister*. Dresden, 1937.

Wolfgang Balzer, *Dresdner Galerie. 120 Meisterwerke des 15. bis 18. Jahrhunderts*. Leipzig, 1956. French ed., 1956.

Gertrud Rudloff-Hille, *Die Dresdner Galerie. Alte Meister*. Berlin, 1956; Munich, 1960; English ed., London, 1960.

Gemäldegalerie Dresden (Catalogue). 1st ed., Dresden, 1956; 19th ed., 1977. English ed., 1962, 5th English ed., 1976.

Ruth and Max Seydewitz, *Das Dresdener Galeriebuch. Vierhundert Jahre Dresdener Gemäldegalerie*. Dresden, 1957.

Anneliese Mayer-Meintschel, *Holländische und vlämische Meister des 17. Jahrhunderts. 50 Neuerwerbungen* (Catalogue). Dresden, 1962.

Henner Menz, *Die Dresdener Gemäldegalerie*. Munich, Zurich, 1962; French ed. Paris, 1962.

Hans Ebert, *Kriegsverluste der Dresdener Gemäldegalerie. Vernichtete und vermisste Werke*. Dresden, 1963.

Bernardo Bellotto genannt Canaletto in Dresden und Warschau (Catalogue of the joint exhibit by the Staatlichen Kunstsammlungen, Dresden, and the National Museum, Warsaw). Dresden, 1963.

Erna Brand, *Anton Graff 1736-1813* (Catalogue). Dresden, 1964.

Anneliese Mayer-Meintschel, *Niederländische Malerei, 15. und 16. Jahrhundert. Gemäldegalerie Alte Meister* (Catalogue I). Dresden, 1966.

Michael W. Alpatow, *Die Dresdener Galerie. Alte Meister*. Dresden, 1966.

Max Seydewitz, *Die Dresdener Gemäldegalerie. Alte und Neue Meister*. Leipzig, 1967.

Venezianische Malerei, 15. bis 18. Jahrhundert (Catalogue of the joint exhibition by the National Museum, Warsaw, the National Gallery, Prague, the Museum of Fine Arts, Budapest, and the Gemäldegalerie Alte Meister, Dresden). Dresden, 1972.

Europäische Landschaftsmalerei 1550-1650 (Catalogue of the joint exhibition by the National Museum, Warsaw, the National Gallery, Prague, the Museum of Fine Arts, Budapest, the State Hermitage Museum, Leningrad, and the Gemäldgalerie Alte Meister, Dresden). Dresden, 1972.

Harald Marx, *Neuerwerbungen deutscher Malerei* (Catalogue). Dresden, 1974.

Harald Marx, *Die Gemälde des Louis de Silvestre* (Catalogue of French paintings, suppl.). Dresden, 1975.

This section introduces the major shift in taste that occurred in Dresden, as in the rest of Europe, with the spread of neoclassicism in the second half of the eighteenth century and the birth of the romantic movement.

One of the first writers to contribute to the fame of the Dresden picture gallery was Johann Joachim Winckelmann, who found inspiration for his first writings on the Imitation of the Painting and Sculpture of the Greeks *(1755) in his study of the Italian paintings in Dresden and of the sculptures in the Cabinet of Antiquities. One of the statues of women discovered at Herculaneum in 1711 and acquired by Augustus III in 1736 serves as a symbol of the reputation of the Dresden collection of antique sculpture, and of the anti-baroque, neoclassical taste that Winckelmann did so much to introduce. A marble bust of George Washington, made by the Dresden sculptor Joseph Herrmann in 1823, recalls the city's transition from the neoclassical to the romantic era. This trend culminated in the work of Gottfried Semper, an architect whose writings on the public character of museums influenced the formation of the Victoria and Albert Museum in London. In 1847-55 the royal Picture Gallery in Dresden was erected according to Semper's designs, and the paintings and graphics in the royal collections moved there. With its controlled lighting and symmetrical floor plan, Semper's approach to museum design has been shared by countless museums around the world, not least in the United States.*

Dresden from Winckelmann to Gottfried Semper

In 1755 Johann Joachim Winckelmann's *Imitation of the Paintings and Sculpture of the Greeks* was published in Dresden, and the program for neoclassicism was presented to Europe. This event occurred outside the court sphere, and only a few years later the Seven Years' War (1756-1763) shattered the power of absolutism in Saxony. The period of sensational art acquisitions there thus came to an end. Thereafter the arts in Dresden were guided by bourgeois principles. Neoclassicism, latent since the 1720s, now came to the fore, though in works that mirrored the impoverishment of the country. The rebuilding of the capital city—devastated by the bombardment by the Prussians in 1760—did not produce any spectacular architecture. It was only after an interval of eighty years—in 1841—that a building of international quality, Gottfried Semper's first opera house, was again constructed in Dresden.

In the last decades of the eighteenth century the city was more important as a cultural mecca than an intellectual center. Because of the beauty of its surroundings and the richness of its art collections, Dresden drew artists and scholars from the north and east of Europe. Friedrich Schiller "exclaimed in rapture" when, in 1785, he saw the Elbe valley for the first time, and it was here that he wrote "Ode to Joy," which was used by Beethoven for the finale of the Ninth Symphony.

About 1800, after some economic recovery, Dresden became the center of German romanticism. Practically every important author of the period stayed there at one time or another, and, following their studies in the Picture Gallery—with particular attention to the *Sistine Madonna* by Raphael—they produced the fundamental romanticist works. The most important event of the turn of the century, however, was the arrival in Dresden of the young North German painter Caspar David Friedrich in 1798. He came "because of the closeness of the most excellent art treasures" and the beauty of the countryside, and both influences were to become immortalized in his paintings and those of the artists in his circle. The French sculptor David d'Angers later declared that Friedrich had discovered the "tragedy of landscape." Among Friedrich's contemporaries were the eminent doctor and naturalist Carl Gustav Carus. He was a pioneer in the field of gynecology, the author of the most important treatise on the romanticist concept of landscape painting, and the friend and biographer of Goethe. His own rather objectively painted landscapes hold up, even next to the genius of Friedrich.

These artists lived in Dresden at the same time as the poet Tieck, a translator of Shakespeare and the program director at the court theater, and the master of the royal orchestra, Carl Maria von Weber, who composed *Der Freischütz*, the first and greatest German romantic opera. The court, however, took little notice of these artistic and intellectual activities. Its stuffy atmosphere is best described by Washington Irving, who, in a letter to his sister from Dresden in 1823, wrote, "The old court has particularly pleased me from its stiff old-fashioned formalities and buckram ceremonies."

In 1834 the architect Gottfried Semper was called to Dresden as a professor at the Academy. Two years later he reinstalled the galleries of classical art and small bronzes by redesigning their baroque-style exhibition space at the Japanese Palace in the Pompeiian manner. Later he built one of the most important synagogues in Germany, which was to be destroyed by the Nazis, and, in 1841, with his design for his first opera house at Dresden, he created the prototype for functionally designed opera architecture and prepared the way for Richard Wagner, who was to become conductor of the orchestra. It was Semper's opera house that witnessed the premieres of Wagner's *Rienzi, Der Fliegende Höllander*, and *Tannhäuser.* Wagner also completed *Lohengrin* in Dresden, shortly before the Revolution.

With Semper and Wagner, a generation born in the nineteenth century came of age in Dresden. Both architect and composer had grown up among the aftereffects of the Napoleonic age, and republican ideas were as natural to them as the lingering principles of feudalism were obsolete. Both men saw their art as concerned with social ideals. "The public collections and monuments are the true teachers of a free nation," wrote Semper in 1852. His designs for large public squares, the best of which were executed at Dresden, were dominated by theater and museum architecture in thoughtfully modified Renaissance forms. They are monumental manifestations of a democratic consciousness, just as Wagner's early operas are. In 1849 both men took part in the bourgeois revolution, and both were forced to flee the country after the Prussian troops defeated the democrats. With that, cultural activity in Dresden almost ceased until the end of the nineteenth century.

JOACHIM MENZHAUSEN

Dresden from Winckelmann to Gottfried Semper

ENTRIES BY: Heiner Protzmann [563]

Glaubrecht Friedrich [564-571]

Martin Raumschüssel [572]

563. "Kleine Herkulanerin" (Small Herculanean Lady)

Attic, by a follower of Praxiteles
Roman copy of early Imperial period, after an original (probably a bronze) of the end of the 4th c. B.C.
White marble, H. with restoration 180 cm.
Sculpture Collection inv. no. Hm 328

The head, worked as a separate piece, is now missing. The present head is a restoration in plaster after the parallel copy in the Albertinum (Hm 327). There are some additional restorations in plaster on the right hand and in the folds of the garment. The statue's early Hellenistic origin is indicated by its austere rectangular outline and the elegant yet restrained rhythm of the composition. It was found— together with a second replica (Hm 327) and the "Grosse Herkulanerin" (Hm 326)—at the beginning of the eighteenth century on the site of the still unexcavated city of Herculaneum, which had been destroyed by the eruption of Mount Vesuvius, A.D. 79. The finder of the statues presented them to Prince Eugen of Savoy, in Vienna. They came to Dresden from the prince's estate in 1736. J. J. Winckelmann saw the Dresden collection of classical statuary, then exhibited in the pavilions of the Grosse Garten, during the winter before his departure for Rome (1755). These three "Vestals," as he called them, were of particular interest to him, not only because they were the first major discoveries from Herculaneum, where in the meantime excavations had begun, but also by virtue of the high style of their drapery (J. J. Winckelmann, *Gedanken über die Nachahmung der griechischen Werke in der Malerei und Bildhauerkunst* [Dresden, 1755]). In his *Abhandlung von der Fähigkeit der Empfindung des Schönen in der Kunst und dem Unterrichte in derselben* (Dresden, 1771), he again expressly mentioned these statues, which apparently had been exhibited in a specially favored position when he saw them. As a result, the three statues, among the most famous classical antiquities in Dresden, influenced the beginnings of European neoclassicism.

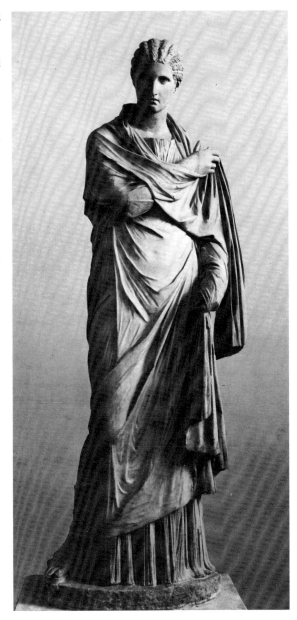

Johann Friedrich Bause
Halle 1738—Weimar 1814

564. Portrait of Johann Joachim Winckelmann (1776)

> After the painting by Anton Maron (Vienna 1733-Rome 1808), painted in Rome, 1768
> Engraving, 266 x 193 mm.
> Kupferstich Kabinett inv. no. A 19054

Winckelmann (Stendal 1717—Trieste 1768), the founder of scientific archaeology, was from 1748 to 1755 librarian for the Minister of State, Count Bünau, in Nöthnitz near Dresden.

Johann Gotthard Müller
Bernhausen 1747—Stuttgart 1830

565. Portrait of Friedrich Schiller (1793)

> After the painting by Anton Graff (Winterthur 1736—Dresden 1813), begun 1786, finished 1791
> Engraving, 337 x 255 mm.
> Kupferstich Kabinett portrait cat. no. 1839

Schiller (Marbach 1759—Weimar 1805) lived in Dresden-Loschwitz when he was completing his play *Don Carlos* (1785-87).

Carl Christian Vogel von Vogelstein
Wildenfels 1788—Munich 1868

566. Portrait of Caspar David Friedrich (1823)

> Black chalk, brush, 239 x 185 mm.
> Kupferstich Kabinett inv. no. C 3006

Friedrich (Greifswald 1774—Dresden 1840) lived in Dresden from 1798 until his death.

Joseph Anton Selb
Stockach 1784—Munich 1832

567. Portrait of Carl Maria von Weber (after 1825)

> After a drawing by Ferdinand Piloty (Homburg 1786—Munich 1844) after the painting by Ferdinand Schimon (Pest 1797—Munich 1852)
> Lithograph, 306 x 217 mm.
> Kupferstich Kabinett portrait cat. no. 2029

Weber (Eutin 1786—London 1826), the founder of romantic opera, was conductor of the Dresden court orchestra 1817-26.

Gustav Heinrich Gottlob Feckert
Cottbus 1820—Berlin 1899

568. Portrait of Robert Schumann (c. 1845)

> After a drawing by Adolph Menzel (Breslau 1815—Berlin 1905)
> Lithograph, 447 x 352 mm.
> Kupferstich Kabinett inv. no. A 1916-932

Schumann (Zwickau 1810—Endenich near Bonn 1856) lived in Dresden 1844-50.

Unknown artist

569. Portrait of Gottfried Semper (c. 1845)

> Lithograph, 205 x 178 mm.
> Kupferstich Kabinett, Sax 13

Semper (Hamburg-Altona 1803—Rome 1879) was active in Dresden as an architect from 1834 to 1849, where he designed, among other projects, the old Court Theater (1838-41, burnt 1869), the synagogue (1839-40), the Paintings Gallery (1847-54), and the new Court Theater, now the Opera House (1871-78).

Franz Seraph Hanfstaengl
Baierrein 1804—Munich 1877

570. Portrait of Carl Gustav Carus (c. 1855)

> Lithograph, 360 x 278 mm.
> Kupferstich Kabinett inv. no. A 1928-474

Carus (Leipzig 1789—Dresden 1869), a friend of C. D. Friedrich, was active in Dresden as physician, painter, and author from 1815 until his death.

W. Jab
Berlin (dates unknown)

571. Portrait of Richard Wagner (after 1860)

> Lithograph, 395 x 270 mm.
> Kupferstich Kabinett, Sax. 15

Wagner (Leipzig—Venice 1883) lived in Dresden 1814-27 and again 1842-49, when he conducted the court orchestra and composed his operas *Tannhäuser* and *Lohengrin*.

Joseph Carl Herrmann

Dresden 1801 — Loschwitz near Dresden 1869

572. Portrait bust of George Washington (1823)

Signed GEFERTIGT IN ROM VON PROFESSOR HERRMANN IM
ATELIER THORWALDSENS
Inscribed on escutcheon G. WASHINGTON
Carrara marble, H. 74 cm.
Sculpture Collection inv. no. ZV 3629

This was commissioned by a Dresden merchant, Heinrich Schütz, who had served in the Philadelphia militia as a volunteer in 1796 and had seen Washington personally on many occasions. The bust was publicly exhibited in Schütz's landscaped gardens. The sculptor, then living in Rome, used as his model the illustration of Canova's colossal statue of Washington as found in the volume *Opere di scultura e plastica di Antonio Canova*.

572

In 1856 a vast collection of works on paper—drawings and prints—was transferred from the Zwinger to Semper's newly constructed Picture Gallery. The collection was originally in the Kunstkammer; in 1720 Augustus the Strong set it up as a separate collection. Today, encyclopedic in scope, it ranges from the earliest woodcuts and Italian Renaissance drawings to contemporary American prints.

Since prints from the collection are represented elsewhere in the exhibition, this section concentrates on one aspect of the drawings collection that is particularly fine: works of the northern schools. The survey begins in the German Renaissance of the late fifteenth and early sixteenth centuries, highlighted by the beautiful animal drawings of Lucas Cranach the Elder, who became a court artist in 1505. Two centuries later, Anton Raphael Mengs, one of the initiators of the neoclassical style, was named painter to the court; his self-portrait dates from the mid-1700s. An important group of Rembrandt drawings includes a study for his painting The Abduction of Ganymede. *The extraordinary landscape watercolors by Caspar David Friedrich, a romantic, serve as a transition to the paintings by modern masters.*

The Prints and Drawings Cabinet

The Dresden Kupferstich Kabinett—Print Room—dates from 1720, when the works on paper, drawings as well as prints, heretofore in the Kunstkammer, were made an independent collection. Works from the Kupferstich Kabinett are shown in five areas of our exhibition, a fact that should confirm the many-sidedness of the collection, now a very large one, encompassing practically all types and techniques, from precious master drawings and rare engravings to posters and photographs.

Aesthetic considerations could not be the only criterion in the formation of such a large collection over such a long period of time. From another standpoint, what makes the collection special is that it can truly be said to portray the entire panorama of human life, with scenes of faraway countries as well as the more familiar aspects of home, images of religions and ideologies, of sciences and technologies, records of historical happenings as well as daily occurrences, likenesses of famous persons and of simple, unknown persons as well, the celebrations of sovereigns and princes and also the misery and struggles of the oppressed. The reward, indeed the necessity, of using this cultural-historical approach was corroborated in the publication by Hans Wolfgang Singer, for many years curator of the Kabinett, of his multi-volume catalogue of 141,471 portraits assembled from seventeen collections of graphic art.

While it can be said that the cosmographic structure of the old Kunstkammer had its effect on the structure of the Kupferstich Kabinett, another decisive factor was the early perception of artistic quality as the standard for acquisitions. Soon after the foundation of the Kunstkammer (1560), the worth of a great master was recognized in the purchase of 113 woodcuts, 69 copper engravings, and several books, all by Albrecht Dürer. All this came from the estate of Lucas Cranach the Elder, and probably much of it had served as models in his workshop. Thus, the provenance of Dresden's Dürer prints can be traced practically to the time of their origin. But this rise above provincial pragmatism was soon cut short by interior causes, such, apparently, as those which led to the fall from power of Chancellor Nikolaus Krell (who, as a student in Paris, had learned liberal ideas), and exterior causes, such as the catastrophe of the Thirty Years War (1618-48). Not until the 1660s were there again signs of artistic vigor in the Kunstkammer, notably, then, in the acquisition of 22 engravings by Lucas van Leyden and Hans Burgkmair's series of proofs for his *Triumph of Maximilian*.

New with the type of collection that originated under Louis XIV in Paris was the grouping of large numbers of engravings along broad historical lines. In line with the encyclopedic attitude of the eighteenth century, this rationalistic inventorying of cultural heritages was presently carried out everywhere. The Dresden Kupferstich Kabinett, it may be noted, was the first drawings cabinet founded by an absolute ruler (other than the French king) in which the encyclopedic principle was applied. The fact that the Kabinett was ahead of the other museums in Dresden in this respect points to farsighted planning. The "Kupferstich Salon" in the Zwinger served as the base for the wide-ranging art plans of Augustus the Strong, particularly those having to do with commissions for painters, sculptors, goldsmiths, and architects. The collection was perhaps even more important to Augustus III in his concern for building up the paintings collection, since all engravings made after paintings by famous masters were arranged in the Kabinett in convenient "painters' volumes."

At the same time the "peintre-graveurs" were not neglected. A protocol of 10 January 1744, written by Johann Heinrich Heucher, tells us of the very great value Augustus III put on excellent early impressions of Rembrandt's etchings, and of how he compiled with great connoisseurship a Rembrandt oeuvre of 388 sheets.

The scholarly and artistic standing of the collection was raised further, after 1746, under the leadership of Carl Heinrich von Heinecken, till it became one of the most important collections of the time, comparable to those in Paris and Vienna. In only twenty-six years, the period ending with the outbreak of the Seven Years War (1756), a systematically arranged collection of 130,000 sheets was assembled. Heinecken even succeeded in obtaining twenty-one works from the eccentric genius Hercules Seghers, who was then little appreciated. Further, Heinecken was closely connected with the art centers of Paris, Italy, and the Netherlands. As a result, the complete *Prisons* of Piranesi, as well as his other works, reached Dresden almost as soon as they were executed. Unexpected for that time was the interest in fifteenth-century engravings; it led to the acquisition of 1281 examples by 1756, including 134 prints by Master ES, today the pride of the Kabinett.

Drawings were acquired also, though with less dedication than was accorded prints. In principle, Augustus the Strong laid the foundation with two large acquisitions of drawings. One of these was the collection of the Leipzig architect Gottfried Wagner, purchased in 1728, consisting of 10,202 drawings. The fact that such a large collection was owned by a representative of the middle class, incidentally, indicates the extent to which this period of cultural flowering was sustained by the Saxon bourgeoisie. Further, the special emphasis given the forty-two drawings by Rembrandt in the Wagner collection points to one of the main strengths in the collection as it exists today. In the other large acquisition of 341 drawings, made in 1723, Rembrandt was again the important name, with 13 drawings by him singled out. Today, Netherlandish and German artists of the sixteenth and seventeenth centuries constitute the strongest categories in the Kupferstich Kabinett, a fact reflected in our exhibi-

tion. Neither Augustus III nor Heinecken proved to be interested in systematically completing the collection of master drawings, for which reason, perhaps, not a single example of the work of the two most important of the court painters, Silvestre and Bellotto, was added to the collection.

In the long period of stagnation after the end of the Seven Years' War the Kabinett served as a model for the organization of collections as far away as St. Petersburg—thanks to the interests of Count Brühl—and Vienna, thanks to those of Duke Albert of Saxony.

In 1831, with the age of absolutism ended, the king, Frederick Augustus II, became a constitutional monarch. Considering himself free to act privately, he built up an excellent collection of 110,000 sheets. This wholly private collection existed side by side with the old royal Kupferstich Kabinett. After the House of Wettin fell from power in the November Revolution, 1918, much of the collection was sold; the fate of the remainder, following the bombing of Dresden in 1945, is unknown.

In 1856, the Kupferstich Kabinett was placed in Semper's gallery building. Four years later it received a significant addition in the form of seventy-two master drawings from the Woodburn collection, among them works by Fra Angelico, Signorelli, Lorenzo di Credi, Fra Bartolomeo, and Hans Holbein the Younger. A second flourishing period for the Kabinett began a few years later under the leadership of Max Lehrs. The collection was reorganized according to the latest curatorial and scholarly points of view, and it was opened to the public at large. Furthermore, the holdings were enlarged. Drawings by Grünewald, Dürer, Piazzetta, Guardi, Tiepolo, Piranesi, and Goya were acquired, filling gaps in the roster. Whole new divisions were created for German and French art of the nineteenth century, for the Japanese colored woodcut, for photography, and for the poster. Praiseworthy efforts for contemporary art were made by Woldemar von Seydlitz. Not only were the best new talents of Germany recognized at an early moment—for instance those of Max Klinger, Max Liebermann, and Käthe Kollwitz—but the new outlook became international. Works by Whistler, Seymour Haden, James Ensor, and Edvard Munch were collected earlier in Dresden than they were in other museums. Beginning in 1895, the work of Toulouse-Lautrec was purchased systematically.

This progressive attitude contrasted sharply with the chauvinism of the Germany of Wilhelm II, and it was sustained through personal commitment: the most modern of works, for example the two years' publication of the *Album Vollard,* were paid for by von Seydlitz himself as a precaution against losing the opportunity to acquire them. Doubtless because of the political climate, the Kupferstich Kabinett, where modern art from other countries was concerned, acquired only graphic art.

After 1918 a good collection of German expressionism was in the making, but this was lost in 1937, when 381 works were confiscated as "degenerate art."

During World War II the entire holdings of the Kabinett were moved out of Dresden to the castle of Weesenstein, where they survived the bombing of 13 February 1945. Sub-

sequently the collection was transferred to Moscow and Kiev for safekeeping. Twelve thousand graphic works and 1350 drawings, among them significant works by Dürer, Cranach, Altdorfer, Friedrich, and Menzel remain missing from this time of disorder at the war's end.

Immediately after the war, as early as December 1945, on the occasion of a Kollwitz exhibition, the new building up of a graphic collection was begun. By 1958, 5500 works by German artists of the twentieth century had been acquired. An important further addition was the Johann Georg collection, with its 1227 drawings of the romantic period. Since the return of the collections from the Soviet Union in 1958, the filling out of the contemporary sector has been intensified and gradually enlarged internationally. In the newly founded section of the socialist countries there are 1100 Soviet and 260 Polish examples as well as examples from Yugoslavia, Cuba, Bulgaria, Czechoslovakia, Hungary, and Romania. From the school of Paris, works by Hartung, Friedlaender, Soulages, Dubuffet, Wols, Chagall, and especially—thanks to a gift by Daniel Henry Kahnweiler—Picasso stand out. Also represented are graphic artists of the Federal Republic of Germany, Austria, Switzerland, Japan, Italy, Sweden, Finland, and Great Britain. Of American artists, Motherwell, Matta, Warhol, Rosenquist, Dine, and Johns are represented thus far. An important ongoing task is the creation of an all-embracing collection of the art of the German Democratic Republic.

Along with this acquisitional activity, the Kupferstich Kabinett mounts numerous exhibitions, issues publications, and opens its treasures to as many people as possible, in the hope that this will promote and deepen the understanding of the quiet but widely radiating beauty of graphic art and drawings.

WERNER SCHMIDT
Director
Kupferstich Kabinett

The Prints and Drawings Cabinet

ENTRIES BY: Christian Dittrich [Netherlandish artists]

Glaubrecht Friedrich [German artists]

Gertraute Lippold [599-603]

Master of the Housebook
Worked c. 1475, Rhineland

573. King with coat of arms and servant

Verso: King and queen with coat of arms
Pen and brown ink, D. 145 mm.
Kupferstich Kabinett inv. no. C 2093
Literature: Woermann 12; A. Strange, *Der Hausbuchmeister*, Baden-Baden, 1958, p. 30

Sketch for a stained-glass roundel, attributed to the Housebook Master by M. J. Friedländer (1897); attribution questioned by F. Winkler (1932); attributed by Strange to the artist of the mining scene in the *Housebook*, folio 35 recto.

Martin Schongauer
Colmar c. 1450 — Breisach 1491

574. Heads of two men

Pen and brown ink, 112 x 144 mm.
Kupferstich Kabinett inv. no. C 1920-62
Literature: F. Winzinger, *Die Zeichnungen Martin Schongauers*, Berlin, 1962, pp. 57-58, no. 29

The head of the older man on the left has the individual characteristics of a genuine portrait; the Turkish head next to it is simply an oriental type. A late work certainly by Schongauer, with extraordinary painterly freedom in the use of the pen.

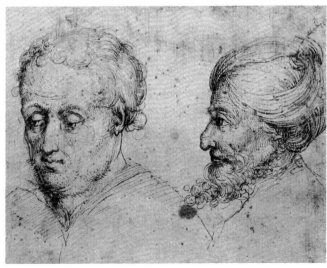

Albrecht Dürer

Nuremberg 1471—1528

575. Wild Man supporting a coat of arms (c. 1500)

Pen and brown ink, charcoal, 295 x 191 mm.
Kupferstich Kabinett inv. no. C 2160
Literature: F. Winkler, *Die Zeichnungen Albrecht Dürers*,
Berlin, 1936-39, no. 168

Probably the model for a stained-glass window, in
motif dependent on the *Bearers of coats of arms* engraved
by Martin Schongauer (Bartsch 103-105). Similar sub-
jects are to be found in paintings by Dürer of around
1500, and on the copper engraving *Coat of arms with
human skull* of 1503 (Bartsch 101). The hairy wild men
of the Middle Ages, regarded as a primitive, animal-
like species, had varied symbolic meanings. They
were thought to have been prehistoric inhabitants of
the woods, heathen mixtures of man and beast, play-
ful spirits of nature, demons of storm and death.

Albrecht Dürer

576. Head of a Child (c. 1523)

Black chalk, heightened with white, on green prepared
paper, 107 x 92 mm.
Kupferstich Kabinett inv. no. C 1890-19

Albrecht Dürer

577. Head of a Child (c. 1523)

Black chalk, heightened with white, on green prepared
paper, 176 x 153 mm.
Kupferstich Kabinett inv. no. C 1890-23
Literature: F. Winkler, nos. 867, 868

Studies from life for the *Crucifixion*, an engraving
begun by Dürer. Only the outlines were made, and it
exists only in a few trial proofs (Meder 25). These two
drawings were for the heads of winged angels that
appear under the right arm of the cross.

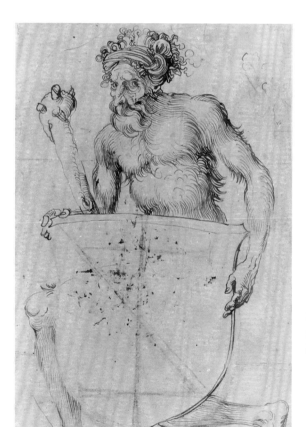

Lucas Cranach the Elder

Kronach 1472—Weimar 1553

578. Spotted wild boar (c. 1530)

Pen and brown ink, watercolor, gouache, 163 x 240 mm.
Kupferstich Kabinett inv. no. C2174
Literature: Rosenberg, *Die Zeichnungen Lucas Cranachs d.
Ä.*, Berlin, 1960, no. 64

A study after nature. Cranach's princely patrons were keen hunters, and souvenir pictures of successful hunts and unusual trophies were in the Saxon court tradition. Saxon electoral castles, as a rule, contained animal portraits in life-size format.

Lucas Cranach the Elder

579. Four dead partridges (c. 1530)

Watercolor and gouache, 450 x 323 mm.
Kupferstich Kabinett inv. no. C 1193
Literature: *Lukas Cranach*, catalogue, Basel, 1974, no. 144

Preparatory drawing for the painting *Hercules and Omphale* of 1532 (Stockholm, private collection), and *The Payment* (Stockholm, Nationalmuseum). Possibly painted by one of Cranach's sons (Hans Cranach?). In the Cranach workshop, drawings of this kind served as models for animal still lifes.

Lucas Cranach the Elder

580. Young stag (c. 1530)

Charcoal and watercolor, 481 x 377 mm.
Kupferstich Kabinett inv. no. C 1960-32
Literature: W. Schade, *Altdeutsche Zeichnungen*, 1963,
no. 80

Cranach's representations of animals show his great skill as a draftsman: quick, accurate, and capable of rendering the observed object in all its individuality.

Matthias Grünewald

Würzburg 1475-80—Halle-an-der-Saale 1528

581. The Apostle Peter, kneeling (1511)

Black and white chalk, 147 x 267 mm.
Kupferstich Kabinett inv. no. C 1910-41
Literature: W. Schade, *Altdeutsche Zeichnungen*, 1963,
 no. 124

Preparatory drawing for the lost painting *Transfiguration of Christ on Mount Tabor,* formerly in the Dominican monastery in Frankfurt am Main. According to Sandrart's description in the *Teutschen Academie*, the painting showed the frightened disciples of Peter, James, and John, after awakening from sleep, perceiving the transfigured Christ and a bright cloud in which appeared Moses and Elias (Matthew 17, 1-9).

Jan Gossaert, called Mabuse

Probably Maubeuge 1478—Middelburg 1533-36

582. Standing soldier with halberd (c. 1505-08)

Contemporary inscription: Joha: de Malbodio
 (Latinized form of Maubeuge)
Pen and brown ink on white paper, 278 x 168 mm.
Kupferstich Kabinett inv. no. C 790
Literature: F. Winkler, "Jan Gossaert," *Old Master Drawings* X, 1935/36, p. 31, fig. 32

In Max Lehrs' handwriting is the notation: "Pen drawing by a good artist who calls to mind Mabuse, done around 1520." Winkler went further by unequivocally attributing it to Mabuse. A comparable drawing of a soldier in a fantastic suit of armor, in the Städelsches Kunstinstitut, Frankfurt am Main, may have been made as late as 1600.

Hans Leonhard Schäufelein

Probably Nuremberg c. 1480—Nördlingen 1539

583. A woman on horseback

Pen, 294 x 214 mm.
Kupferstich Kabinett inv. no. C2139
Literature: F. Winkler, *Die Zeichnungen Hans Süss von Kulmbachs und Hans Leonhard Schäufeleins*, Berlin, 1942, p. 153, no. 54

A work characteristic of Schäufelein, for whom a horse that looks like a mule is typical. Similar representations of the period are designated "Beautiful maiden on a horse" or "Courtesan on a horse."

Hans Süss von Kulmbach

Kulmbach c. 1480—Nuremberg 1522

584. Morris Dance (c. 1508)

Charcoal, pen and brown ink, 217 x 274 mm.
Kupferstich Kabinett inv. no. C 2239
Literature: F. Winkler, *Die Zeichnungen Hans Süss von Kulmbachs und Leonhard Schäufeleins*, p. 54, no. 23

An outstanding work by Kulmbach, probably a preliminary idea for a stained-glass window. The association of the grotesque dance group—in its center is Lady Love, holding an apple as the prize—with entwined thorny branches was probably suggested by an engraving by Israhel van Meckenem (Geisberg 465). The jumping Morris (Moorish) dance was widely fashionable in the fifteenth century. Representations of it were popular in Germany as decorations in town halls, the places where public dances were held.

587

Hans Süss von Kulmbach

585. Saint Gall

> Charcoal, pen and brown ink, gray gouache, 348 x 269 mm.
> Kupferstich Kabinett inv. no. C2195
> Literature: F. Winkler, *Die Zeichnungen Hans Süss von Kulmbachs und Hans Leonhard Schäufeleins*, p. 96, no. 134

One of the best works of Kulmbach, this design for a stained-glass window is one of a group of similar drawings. In accordance with the legend, St. Gall is shown with a bear, which drags a tree trunk. The bear was grateful to the saint for pulling a thorn from its paw. In Nuremberg a chapel in the castle was consecrated to the abbot and bishop Gallus, founder of the monastery of St. Gall in Switzerland.

Wolf Huber

Feldkirch (Austria) c. 1485—Passau 1553

586. Man wearing a biretta (1522)

> Black and white chalk on red prepared paper, 271 x 200 mm.
> Kupferstich Kabinett inv. no. C2131
> Literature: Woermann 64; M. Weinberger, *Wolfgang Huber*, Leipzig, 1930, pp. 125, 134

A study for the officer leading foot soldiers in the painting of *The Raising of the Cross* (Vienna), but also to be appreciated as a portrait. This drawing of an unknown man is one of a series of male heads by Huber; another in Berlin is monogrammed WH and dated 1522.

Pieter Bruegel

Breda c. 1525—Brussels 1569

587. The wide valley (c. 1553-54)

> Pen and brown wash, 104 x 323 mm.
> Kupferstich Kabinett inv. no. C 1125
> Literature: Woermann 131; L. Münz, *Bruegel, The Drawings*, London, 1961, no. 8, ill.

This study of alpine mountain ranges was probably made during Bruegel's return journey from Italy. From the free-flowing pen strokes one may assume it to be taken directly from nature, as were the Chatsworth, Cambridge, and Dresden studies, among others.

Hendrick Goltzius

Mühlbracht 1558—Haarlem 1617

588. Head of a laughing fool (c. 1610)

> Monogrammed bottom right in red crayon: HG
> Red crayon on yellowish paper, contours pricked, 190 x 149 mm.
> Kupferstich Kabinett inv. no. C 897
> Literature: Woermann 119; E. K. J. Reznicek, *Die Zeichnungen von Hendrick Goltzius*, Utrecht, 1961, no. 306, fig. 424

This fantasy study was perhaps a preparatory work for an etching or a painting of about 1610, according to Reznicek. The hat is probably a fool's cap, in spite of other interpretations.

Abraham Bloemaert

Dordrecht 1564—Utrecht 1651

589. The Annunciation to the Shepherds (c. 1594-98)

Pen and brown ink, gray gouache, on yellowish paper; left and upper edges silhouetted and restored; 306 x 377 mm.
Kupferstich Kabinett inv. no. C 908
Literature: G. Delbanco, *Der Maler Abraham Bloemaert,* Strassburg, 1928, p. 74, 9

When Delbanco recognized this drawing, always attributed to Bloemaert, as the study for the painting of around 1600, destroyed with the Suermondt Museum, Aachen, in the Second World War, he disregarded minor differences between the drawing and the painting. The drawing is, however, somewhat earlier than the painting, probably contemporary with the drawing *Christ and the Adulteress*, dated 1595 (New York, The Metropolitan Museum of Art). The composition, slightly altered, was engraved by J. Saenredam, 1599 (Bartsch 24), C. J. Visscher, and Sirens.

Peter Paul Rubens

Siegen 1577—Antwerp 1640

590. Central figure of the Laocoön group (c. 1601-02)

Black chalk, 456 x 296 mm.
Kupferstich Kabinett inv. no. C 1874-22 a
Literature: Burchardt/d'Hulst, *Rubens Drawings,* Brussels, 1963, no. 15

The Vatican's Laocoön group (Rhodes, first or second century B.C.) must have been drawn several times by Rubens during his stay in Italy. A series of copies of his studies from the antique in the Kobberstiksamling, Copenhagen, contains views of this group. However, the present study is thought to be Rubens' only surviving study of the subject by his own hand. Drawings after antiquities, a practice suggested to Rubens by his brother Philip, had a twofold purpose: they would further his humanistic education and at the same time provide him with models for engravings, to be published later. Rubens used this particular study for his painting of about 1630, *The Brazen Serpent* (National Gallery, London). He used other details in other paintings, including one of his earliest Italian altarpieces, *The Crowning of Christ with Thorns,* of about 1602 (Grasse, Chapel of the Hospital).

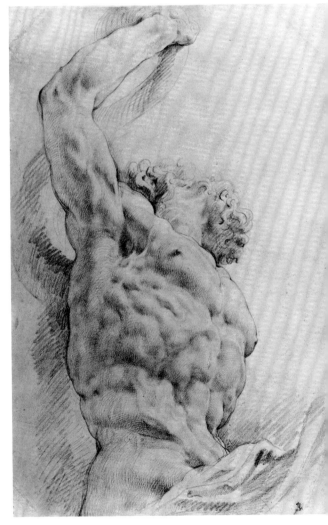

590

Rembrandt Harmensz. van Rijn
Leiden 1606 — Amsterdam 1669

591. Standing soldier (c. 1626-27)

Inscribed by unknown hand: Van Segen
Red crayon heightened with white, 305 x 185 mm.
Kupferstich Kabinett inv. no. C 1496
Literature: O. Benesch, *The Drawings of Rembrandt*, London, 1954, no. 3

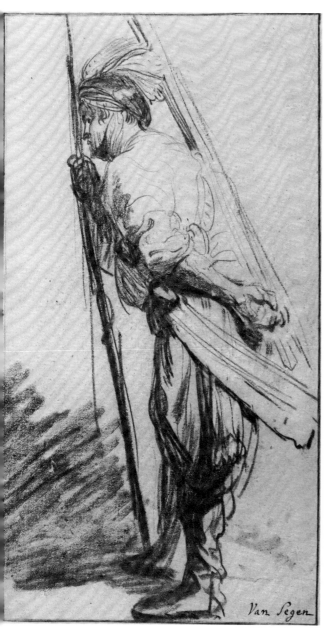

One of Rembrandt's earliest drawings, probably executed in competition with his teacher Pieter Lastman, who drew the same model (Munich, Staatliche Graphische Sammlung). A similar figure is found in Rembrandt's painting *David Bringing the Head of Goliath*, 1627, now in Basel.

Rembrandt

592. The Abduction of Ganymede (c. 1635)

Pen and brush in bister on white paper, 185 x 160 mm.
Kupferstich Kabinett inv. no. C 1357
Literature: Woermann 292; Benesch 92

A preparatory study for the painting in the Dresden Gallery, which omits the parents lamenting their son. The face of the wailing boy can be found in other contemporary drawings by Rembrandt that deal with everyday life: Berlin (Benesch 401); Budapest (Benesch 411); Bremen (Benesch 402); Amsterdam (Benesch 379 recto); New York, Pierpont Morgan Library (Benesch 313).

Rembrandt

593. The Velper Gate, Arnhem (c. 1652-53)

Pen and blackish brown ink on browned paper, 178 x 257 mm.
Kupferstich Kabinett inv. no. C 1330
Literature: Woermann 322; Benesch 1305

Comparing this with two views by A. Waterloo (Amsterdam, Arnhem), Lugt identified the subject as the Velper Gate. The gate was pulled down in 1831. The drawing clearly shows the influence of the Titian circle, especially of Campagnola, as do Rembrandt's etchings of this period (Bartsch 104, 211).

Rembrandt

594. Christ on the Sea of Galilee (c. 1654-55)

Pen and brown wash, 197 x 300 mm.
Kupferstich Kabinett inv. no. C 1395
Literature: Woermann 290; Benesch 954

Model for a drawing, related in style, attributed to Rembrandt's school, in the Hofstede de Groot Collection. The older religious interpretation of this work has been questioned by Benkendorf (Dresden, 1960). Although the two ships near the coast and the unclear figure of the sleeping Christ diverge from the usual rendering of the theme, the Christian interpretation is still valid.

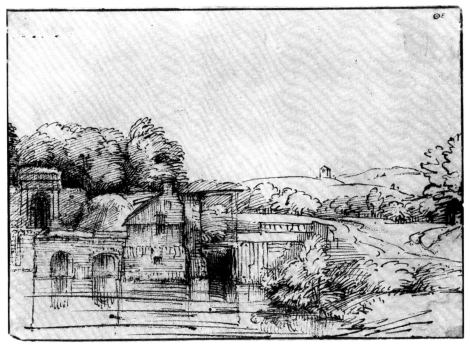

593

594

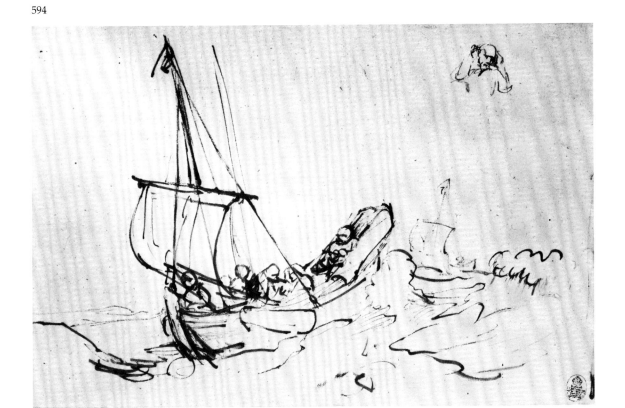

Rembrandt

595. Young man at a drawing board (c. 1655-56)

Pen and brush, brown wash, 182 x 139 mm.
Kupferstich Kabinett inv. no. C 1359
Literature: Benesch 1095

Wichmann (1925) saw a relationship between this drawing and the portrait of Rembrandt's son Titus in the Kunsthistorisches Museum in Vienna. Sumowski (1961) noted similarities with drawings by Hoogstraten of the late 1650s.

Rembrandt

596. Peter at the Deathbed of Tabitha (c. 1662-65)

Pen and bister, 190 x 273 mm.
Kupferstich Kabinett inv. no. C 1302
Literature: Woermann 328; Benesch 1068

Rembrandt produced few drawings and etchings in the last decade of his life. The few works that have been preserved are of great rational clarity and of great accuracy in detail, but pay little attention to unimportant details. Everything to do with form is reduced to its constructive elements. Woermann discarded the drawing's old title, *Jairus' Daughter Raised from the Dead*, but surmised a biblical theme. Wichmann recognized the drawing as *The Raising of Tabitha by Peter* (Acts 9:40).

Anton Raphael Mengs
Aussig 1728 — Rome 1779

597. Youthful self-portrait (c. 1745)

Black and red chalk, heightened with white, on brownish paper, 261 x 202 mm.
Kupferstich Kabinett inv. no. C 2464
Literature: Herbert von Einem, "Ein unveröffentlichtes Selbstbildnis und seine Einordnung in die Selbstbildnisse des Künstlers," *Wallraf-Richartz-Jahrbuch* 35, 1973, pp. 343-352

The earliest preserved work among the relatively rare drawings of this artist. As the son of the court painter Ismael Mengs, he spent his youth in Dresden and Rome. In 1745, he was named painter to the Saxon court at age seventeen. From 1749 on he worked in Rome, Naples, and Madrid.

Johann Heinrich Fuseli
Zurich 1741 — Putney Hill near London, 1825

598. A lady viewing sculptures (1798)

Graphite, pen, gray ink, watercolor, heightened with white, 409 x 246 mm.
Kupferstich Kabinett inv. no. C 1914-85
Literature: G. Schiff, *Johann Heinrich Füssli*, Zurich, 1971

Both this type of figure and the accentuated elegance of the clothing can be found in many of Fuseli's decorative compositions. As the sculptures are probably also Fuseli's invention, the museum locale represented here cannot be readily determined.

Caspar David Friedrich
Greifswald 1774 — Dresden 1840

599. Stubbenkammer (1801)

Pen and brown ink, 235 x 268 mm.
Kupferstich Kabinett inv. no. C 1968-357
Literature: Helmut Börsch-Supan and Karl Wilhelm Jähnig, *Caspar David Friedrich, Gemälde, Druckgraphik und bildmässige Zeichnungen*, Munich, 1973, no. 90, p. 270

Drawn during a walking tour of the island of Rügen, where Friedrich discovered his relationship to the world of nature—the point of departure for his landscape paintings. The chalk cliffs of the Stubbenkammer form the northeastern cape of the island.

596

600

Caspar David Friedrich

600. Rock formations in the Riesengebirge

Inscription: den 12 t Juli 1810
Graphite and watercolor on yellowish paper, 172 x 284
 mm.
Kupferstich Kabinett inv. no. C 2603
Literature: Neidhardt-Hinz, *Caspar David Friedrich und
 sein Kreis*, catalogue, Dresden, 1974, no. 168, p. 217

A study for the painting *Remembrance of the
Riesengebirge* (Leningrad), drawn during Friedrich's
walking tour with George Friedrich Kersting.

Caspar David Friedrich

601. Rock formations near the Kochel Falls

Inscription: den 17 t Juli 1810; nimmt beinahe den gan-
 zen Vordergrund ein; Schatten
Graphite and watercolor on yellowish paper, 251 x 350
 mm.
Kupferstich Kabinett inv. no. C 2606
Literature: Neidhardt-Hinz, 1974, no. 169, p. 218

A study for the painting *Morning in the Riesengebirge*
(Charlottenburg Palace, West Berlin), which Friedrich
began soon after his walking tour with Kersting.

Caspar David Friedrich

602. Stony beach with moonrise (c. 1835-37)

Graphite and sepia wash on yellowish paper, 232 x 357
 mm.
Kupferstich Kabinett inv. no. C 2605
Literature: Börsch-Supan and Jähnig, no. 484, p. 44

In his later years, Friedrich took parts of his early
monumental drawings and developed them as inde-
pendent compositions, with a different philosophical
content. The rocks in the foreground were taken from
a drawing in sepia of the Königstuhl.

Caspar David Friedrich

603. Ruins of the monastery of Eldena

Inscription on verso: Die Abtei bei Greifswald in Pom-
 mern den 17 t März 1836 C. D. Friedrich
Graphite and watercolor on yellowish paper, 227 x 235
 mm.
Kupferstich Kabinett inv. no. C 1937-415
Literature: Börsch-Supan and Jähnig, no. 454

Friedrich's last representation of these ruins, which
appear like a leitmotiv throughout his work. The
thirteenth-century Cistercian abbey, near Greifswald,
was destroyed by Swedish troops in 1638.

603

LITERATURE

Carl Heinrich von Heinecken, *Idée generale d'une Collection Complette d'estampes*. Leipzig, Vienna, 1771.

Karl Woermann, *Handzeichnungen alter Meister im Königlichen Kupferstich-Kabinett zu Dresden*. 10 vols. Munich, 1896-98.

Max Lehrs, *Geschichte und kritischer Katalog des deutschen, niederländischen und französischen Kupferstichs im XV. Jahrhundert*. 9 vols. Vienna, 1908-34.

Hans Wolfgang Singer, *Unika und Seltenheiten im Kgl. Kupferstich-Kabinett zu Dresden*. Leipzig, 1911.

Hans Wolfgang Singer, *Allgemeiner Bildniskatalog*. 14 vols. Leipzig, 1930-36. *Neuer Bildniskatalog*. 5 vols. Leipzig, 1937-38.

Werner Schade and Werner Schmidt, *Französische Graphik von Manet bis Matisse* (Catalogue). Dresden, 1959.

Wolfgang Benkendorf, *Rembrandt und seine Schüler. Zeichnungen aus dem Dresdner Kupferstich-Kabinett* (Catalogue). Dresden, 1960.

Glaubrecht Friedrich and Werner Schmidt, *Käthe Kollwitz* (Catalogue). Dresden, 1960.

Werner Schade, *Altdeutsche Zeichnungen* (Catalogue). Dresden, 1963.

Werner Schmidt and Wolfgang Winter, *Henri de Toulouse-Lautrec* (Catalogue of works in the Dresden Kupferstich-Kabinett). Dresden, 1964.

Werner Schmidt, *Französische Graphik von Géricault bis Picasso* (Catalogue). Dresden, 1965.

Glaubrecht Friedrich, *Skatter från Dresden, 100 tyska mästarblad från 1400- talet till Dürer, ur Kupferstich-Kabinett* (Catalogue). Stockholm, 1966.

Christian Dittrich, *Hundert Zeichnungen alter Meister aus dem Dresdener Kupferstich-Kabinett* (Catalogue). Salzburg, 1966.

Christian Dittrich, *Cent dessins de maîtres anciens du Cabinet des Estampes de Dresde* (Catalogue). Brussels, 1967.

Glaubrecht Friedrich, *Stara nemačka grafika iz kolekcije Grafičkog Kabineta u Drezdenu* (Catalogue). Belgrade, 1967.

Werner Schmidt, "Dresden, Kupferstich-Kabinett der Staatlichen Kunstsammlungen," *Das grosse Buch der Graphik*. Brunswick, 1968.

Christian Dittrich, *Rembrandt. Die Radierungen im Dresdener Kupferstich-Kabinett* (Catalogue). Dresden, 1969.

Wolfgang Winter and Werner Schmidt, *Graphik in der DDR* (Catalogue). Dresden, 1969.

Werner Schade, *Dresdener Zeichnungen 1550-1650. Inventionen sächsischer Künstler in europäischen Sammlungen* (Catalogue). Dresden, 1969.

Dialoge. Kopie, Variation und Metamorphose alter Kunst in Graphik und Zeichnung vom 15. Jahrhundert bis zur Gegenwart (Catalogue). Dresden, 1970.

Christian Dittrich, "Der 'Rembrand Graveur' des Johann Heinrich von Heucher. Eine wiederaufgefundene Specification aus dem Jahre 1744 im Dresdener Kupferstich-Kabinett," *De Kroniek van het Rembrant huis*, 25. 1971, nos. 3-4.

Christian Dittrich, Gertraude Lippold, and Werner Schmidt, *Šedevry risunka iz sobranija Drezdenskogo Kabineta Grafiki* (Catalogue). Leningrad, 1972.

Glaubrecht Friedrich and Gertraude Lippold, *Apo ton Dürer mechri semeron* (Catalogue). Nicosia, 1972.

Zeichnungen in der Kunst der DDR (Catalogue). Dresden, 1974.

Christian Dittrich, Gertraude Lippold, and Werner Schmidt, *Kresby mistru XVI.-XX. stoleti ze Statnich umeleckych sbirek v Drazdanech* (Catalogue). Prague, 1974.

The Gallery of Modern Masters was founded in 1848. At first dedicated to purchasing paintings by contemporary Dresden artists, it subsequently acquired works by German romantics, realists, impressionists, and twentieth-century painters.

The selection here concentrates on German romantics who are enjoying renewed interest in the United States. Caspar David Friedrich, working in Dresden, sets the keynote with his dreamlike, almost hallucinatory sensibility. The romantic response to nature is also shown in the work of such major exponents as Carus, Oehme, and Dahl.

The Picture Gallery
of Modern Masters

Bernhard August von Lindenau (1779-1854) was the first major figure in the history of the collection of New Masters. Secretary of State from 1830 to 1843, he was instrumental in the creation of the first Saxon constitution and the adoption of what was for that time a progressive system of city charters. When this enlightened statesman was displaced by his opponent, the reactionary politician von Könneritz, in 1843, he assigned his pension of 3083 thalers for the promotion of the arts and sciences. Part of the pension, 700 thalers (the price of a cow then being 20 thalers), he placed at the disposal of the Paintings Gallery for acquisitions, doubtless assuming that it would be used to purchase art from beyond the borders of Saxony. The Council of the Dresden Academy, which then directed the Paintings Gallery, followed von Lindenau's example in 1848, designating half the income from its exhibitions for the same purpose.

It is indicative of the patriotic feeling of that time that the Council decided to give priority to the acquisition of works by "artists of our nation, preferably still living." But it must be remembered that prior to Bismarck's founding of the Second Empire (1871) the term "our nation" was not synonymous with "Germany"; in the period of political restoration following the final defeat of Napoleon, it meant "Saxony." The purchases, therefore, were to be made within the kingdom of the House of Wettin, and especially within Dresden, the residence city. As a consequence, during the first decades the acquisitions were mostly paintings by classicists within the immediate Dresden circle, and Nazarenes, a group of young German painters influenced by Italian high Renaissance art, and of little importance in later years.

In the 1870s the provincial acquisition policy began to change. It had, as Robert Sterl put it, "granted significance only to the colleagues from Brühl's Terrace"—where the Academy stood. Sterl believed the change in policy was the result of a failure of creative powers among the academicians and "decadence among the late Nazarenes."

Despite limited financial resources, Karl Woermann, appointed Director of the Gallery in 1882, succeeded, through a wise and circumspect policy of acquisition, in shaping the future aspect of the Gallery of New Masters. His ambition was "to show the various currents

in the history of nineteenth-century art and, at the same time, to give justice to developments in the present." During his directorship the first paintings of Adolph Menzel, Fritz von Uhde, Hans Thoma, Arnold Böcklin, Carl Spitzweg, and Gotthard Kuehl were acquired. From outside Germany came works by the Belgians Laermanns and Meunier, as well as a painting each by the Americans Alexander Harrison and George Hitchcock. The most important addition of this period was Courbet's monumental masterpiece, *The Stonebreakers*.

Acquisition funds were increased through the support of the Dresden Museums Association and the Patrons Society of the State Paintings Gallery, founded in 1911 and 1917 respectively. The collection of German romantic painting was enlarged and twenty-four works from the oeuvre of Ferdinand Rayski became the foundation for the largest collection of this painter's work in Germany. Other additions were canvases by Wilhelm Trübner and the Romano-German Hans von Marées.

The most extensive enlargement of the collection, made in the field of German expressionism, occurred under the directorship of Hans Posse, Woermann's successor. Important works by Max Liebermann and Lovis Corinth were acquired, as well as all the paintings made by Max Slevogt during his journey through north Africa in 1914. Works by Manet, Monet, Renoir, Degas, Toulouse-Lautrec, and Gauguin entered the collection in the 1920s, along with paintings by Edvard Munch, James Ensor, and Vincent van Gogh. In this period, too, the Patrons Society lent the Gallery works by Kirchner, Kokoschka, Nolde, Pechstein, Schmidt-Rottluff, Chagall, Feininger, Beckman, Hofer, and Klee. With these works a new, comprehensive collection of modern art began to take shape, but the greater part of it was lost in 1937 through the action of the National Socialists against "degenerate art." Even more severe losses were suffered in the air attack on Dresden in 1945, when some of the most valuable paintings perished in the flames, among them Courbet's *The Stonebreakers*, Böcklin's *Spring Round*, Rayski's *Wild Boars*, and works by Feuerbach, Hodler, Liebermann, Marées, Puvis de Chavannes, Schwind, and Thoma.

Only one painting by the expressionist Karl Schmidt-Rottluff, *Landscape with Trees* (619), escaped the seizure of "degenerate art" by the National Socialists and then survived the bombing of Dresden. After the war, two more of his paintings were acquired, *Woman's Head and Mask* (617) and *After the Bath* (618). These works, together with Otto Dix's *Longing* (620) and his portrait of Dr. Glaser (621) show that the gaps left in the Gallery by Fascism and war have begun to be filled.

For many years prior to 1965 the collection of New Masters was divided into two parts, with the art of the twentieth century housed in the Semper Gallery and the art of the nineteenth century in a building on the Brühlsche Terrasse. Then, for a time after the war, the collection was exhibited in Pillnitz Castle, outside the city. A new, independent directorship was created in 1959 for the Paintings Gallery of New Masters, and some years later, in 1965, the entire collection was placed in its present quarters in the Albertinum, on the Brühlsche Terrasse. Here, in modern exhibition rooms, the visitor can acquaint himself with the

development of the art of the nineteenth and twentieth centuries. At present, the collection is separated into the following groups: German Romantic and Late Romantic Art; Realism of the Nineteenth Century; Impressionism and Related Movements; Proletarian Revolutionary Art; and Socialist Art of the German Democratic Republic, the USSR, and other Socialist countries. The purchasing activity is today, as it has been for the past thirty years, devoted mainly to the last two categories. Thus, recent acquisitions have included Otto Dix's celebrated war triptych and Hans Grundig's triptych entitled *The Thousand-year Reich*. The contemporary works being acquired offer a valid representation of the socialistic development of our country.

JOACHIM UHLITZSCH
Director
Paintings Gallery of New Masters

The Picture Gallery of Modern Masters

ENTRIES BY: Hans Joachim Neidhardt [604-613]

Waltraut Schumann [614-622]

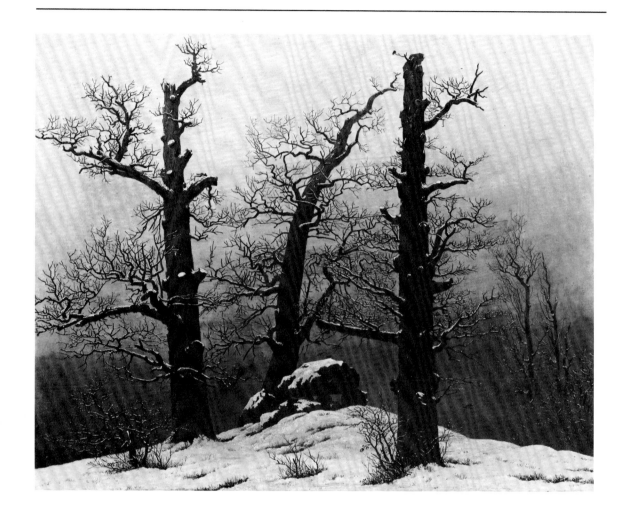

Caspar David Friedrich

Greifswald 1774 — Dresden 1840. In Dresden after 1798
German school

604. Dolmens in the Snow (1807)

Canvas, 61 x 80 cm.
Gal. no. 2196

Dolmens, the "giants' graves" of German folklore, were ancient Germanic burial sites. In Friedrich's work they appear often, as references to the shortness of human life or to a mystical, heroic past. The bare but still powerful oaks must have a similar significance. The military defeat suffered by Prussia at Jena and Auerstädt in 1806 resulted in the submission of the German states to the rule of Napoleon. Friedrich's painting, done the following year, seems to call for the reawakening of the German patriotic spirit.

605

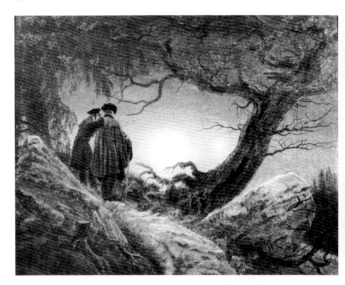

Caspar David Friedrich

605. Two Men Contemplating the Moon (1819/20)

Canvas, 35 x 44.5 cm.
Gal. no. 2194

According to F. W. Wegener, the figures are the artist himself and his favorite pupil, August Heinrich. The asymmetrical composition, unusual for this artist, suggests compositions of the eighteenth century. The leafless oak tree serves as a reminder of the brevity of life, while the moon is a traditional object of romantic longing.

Caspar David Friedrich

606. The "Grosse Gehege" near Dresden (1832)

Canvas, 73.5 x 103 cm.
Gal. no. 2197 A

The subject of this painting is a wildlife reserve to the west of the town, on the south side of the Elbe. The river, which is shown here during the low water season, occupies the foreground. The subject, an autumn evening shortly after sunset, may be interpreted symbolically: the earthly realm lying in darkness, the heavenly realm filled with light.

Carl Gustav Carus
Leipzig 1789—Dresden 1869
German school

607. Spring Landscape (c. 1823)

Canvas, 37 x 30 cm.
Gal. no. 2215 J

An obstetrician by profession and a self-taught artist, Carus settled in Dresden in 1814. He knew Caspar David Friedrich and was strongly influenced by his work. Placing young, vigorous trees in full bud near a bare, dead oak, he effectively expresses the thought of birth and death.

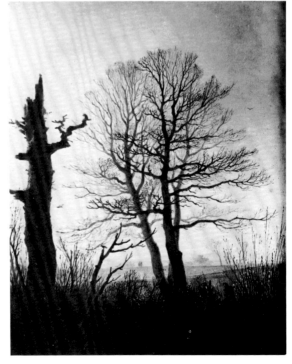

607

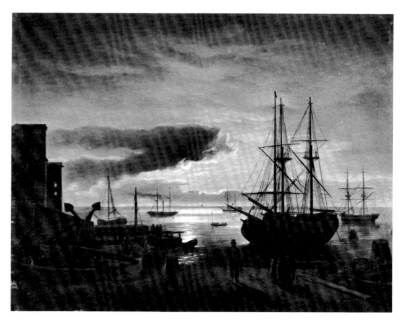

608

609

Johann Christian Clausen Dahl
Bergen, Norway 1788—Dresden 1857
Norwegian school

608. Copenhagen Harbor by Moonlight (c. 1835)

Canvas, 54 x 72 cm.
Gal. no. 3609

Ernst Ferdinand Oehme
Dresden 1795—1855
German school

609. Colditz Castle

Signed bottom right: EO 1828
Canvas, 83.3 x 72 cm.
Gal. no. 2217D

Adrian Ludwig Richter
Dresden 1803—1884
German school

610. Morning Near Palestrina in the Appenines

Signed bottom right: L. Richter 1829
Canvas, 77.5 x 100 cm.
Gal. no. 2228 D

Working in Italy from 1823 to 1827, Richter came under
the influence of the painters J. A. Koch and J. Schnorr
von Carolsfeld. On a walking tour in September 1824
he made the studies from nature that became the basis
for this painting.

Adrian Ludwig Richter

611. Bohemian Pastoral Landscape

Signed bottom left: L. Richter 1841
Canvas, 70 x 104 cm.
Gal. no. 2229 A

After his trip to the mountain region of central
Bohemia, a journey he made in 1834, Richter often
painted the Saxon-Bohemian landscape.

611

Ferdinand von Rayski
Pegau 1806 — Dresden 1890
German school

612. Portrait of the King's Chamberlain Count Zech-Burkersroda (1805-72) (1841)

Canvas, 143 x 102
Gal. no. 2242 B

This is one of the finest works of this outstanding artist, who made numerous portraits of the Saxon nobility. Working in the tradition of Anton Graff, Rayski constructed his paintings with broad surfaces in a painterly manner, imparting to the conventional likenesses a new, more realistic quality.

Julius Scholtz
Breslau 1825 — Dresden 1893
German school

613. Grandmother and Granddaughter

Signed bottom center: Jul. Scholtz 1863
Canvas, 149.5 x 114 cm.
Gal. no. 3009

Robert Hermann Sterl
Dresden Gross-Dobritz 1867 — Naundorf near Dresden
1932
German school

614. Men Towing Boats on the Volga (1910)

Canvas, 82 x 122 cm.
Private collection, Dresden

Sterl made four journeys to Russia prior to the First World War, studying and painting the life of the common people there. This painting, one of his finest works, makes use of the same subject as I. E. Repin's celebrated *Volga Boatmen*.

Oskar Zwintscher

Leipzig 1870—Dresden-Loschwitz 1916
German school

615. The Melody (1903)

Canvas, 110 x 150 cm.
Gal. no. 3868

Oskar Zwintscher

616. Portrait of a Lady with a Cigarette

Signed bottom right: OZ (monogram) 1904
Canvas, 82 x 68 cm.
Gal. no. 2690

615

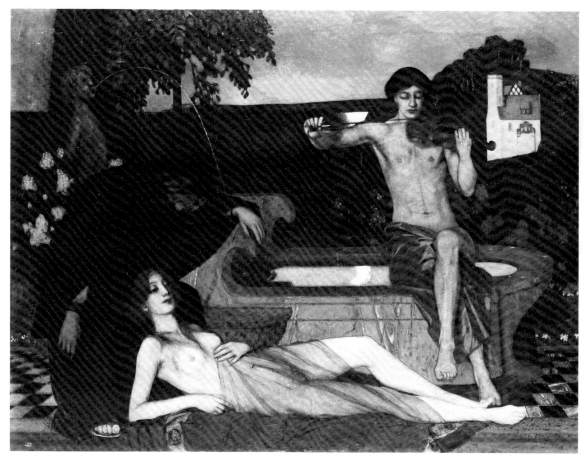

Karl Schmidt-Rottluff

Rottluff near Chemnitz (now Karl-Marx-Stadt)
 1884 — West Berlin 1976
German school

617. Woman's Head and Mask

Signed bottom right: S. Rottluff 1912
Canvas, 84 x 76 cm.
Gal. no. 3925

Karl Schmidt-Rottluff

618. After the Bath

Signed bottom left: S. Rottluff 1912
Canvas, 87 x 95 cm.
Gal. no. 78/1

Karl Schmidt-Rottluff

619. Landscape with Trees (1928)

Signed bottom left: S. Rottluff
Canvas, 98.5 x 112 cm.
Gal. no. 2621 B

617

618

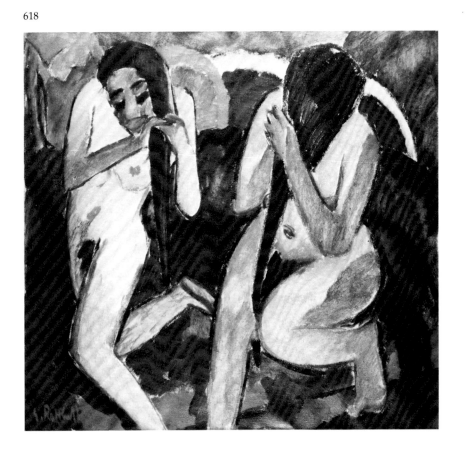

619

In 1915 Schmidt-Rottluff founded the expressionist painters' group the Brücke along with Bleyl, Heckel, and Kirchner. He was influenced by African sculpture. His shapes became both simpler and bewilderingly exaggerated and his colors became bright and jarring. This was explained at the time as a protest against the middle class, for the purpose of the unification of humanity. The explosive expressionism of Schmidt-Rottluff's works before the First World War gave way later to simplification and a striving for harmony.

Otto Dix

Untermhaus near Gera 1891 — Hemmenhofen, Bodensee 1969
German school

620. Longing (Self-portrait) (1918)

Signed bottom right: Dix
Canvas, 53.5 x 52 cm.
Gal. no. 3781

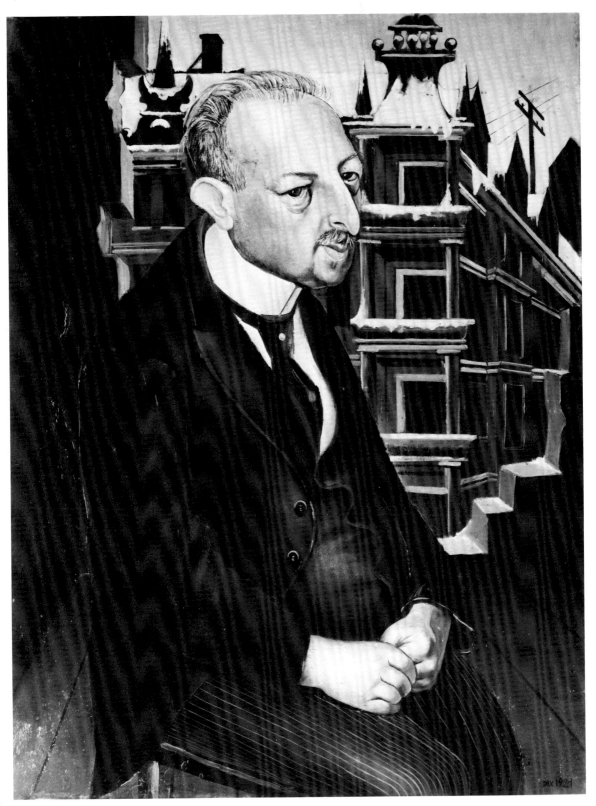

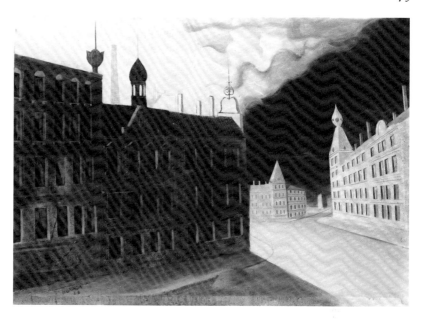

Otto Dix

621. Portrait of Dr. Glaser

Signed bottom right: DIX 1921
Canvas, 105 x 80.5 cm.
Gal. no. 3775

Fritz Glaser was a Dresden lawyer. The heavy lids over
eyes set off their normal axis, the large ears and small
mouth, contrast strangely with the small chubby
hands. In most of Dix's portraits of the twenties, with
their sharply true-to-life conception of the model exe-
cuted in the technique of the old masters, the artist
shows an ironic approach. This was typical of the
socialist art of the time, which stood in opposition to
the middle-class structure of German society and
served as a judgment of the period.

Hans Grundig

Dresden 1901—1958

622. Cold Night

Signed below left: H. Grundig 28
Oil on canvas, 61 x 90 cm.
Gal. no. 3769

An empty street, illuminated by a flash of lightning in
the middle of the night, turns into a frightening ghost
town of bleak, impersonal tenement houses. The
painting symbolizes the growing uneasiness of this
Communist artist in the face of the increasing consoli-
dation of reactionary forces in the Germany of 1928.

LITERATURE

Hans Posse, *Die Gemäldegalerie zu ·Dresden*. Part 2: "Neuere
 Meister." Berlin, 1921.

Die Staatliche Gemäldegalerie zu Dresden (Catalogue). Dresden,
 1930.

*Gemäldegalerie Dresden. Abteilung 19. und 20. Jahrhundert im
 Schloss Pillnitz*. Dresden, 1957.

Gemäldegalerie Dresden Neue Meister (Catalogue). Dresden,
 1959.

Gemäldegalerie, Neue Meister 1800-1960 (Catalogue). Dresden,
 1960; 2nd ed., 1963.

Horst Zimmermann, *Dresdner Galerie Neue Meister*. Leipzig,
 1964.

*Sozialistische Gegenwartskunst und proletarisch-revolutionäre
 Kunst des 20. Jahrhunderts* (Catalogue). Dresden, 1963.

*Zweihundert Jahre Hochschule für Bildende Künste Dresden
 1764-1964* (Catalogue). Dresden, 1964.

Gemäldegalerie Neue Meister Dresden (Catalogue). 1st ed.,
 Dresden, 1965; 4th ed., 1975.

*Vom Werden des neuen Menschen. Das Menschenbild in der Kunst
 Dresdens 1946-1971* (Catalogue). Dresden, 1971.

Hans Joachim Neidhardt, *Neue Meister in der Dresdner Gemäl-
 degalerie*. Dresden, 1971.

Caspar David Friedrich und sein Kreis (Catalogue). Dresden,
 1974.

200 Jahre Malerei in Dresden. Gemäldegalerie Neue Meister
 (Catalogue). Dresden, 1976.

Hans Joachim Neidhardt, *Die Malerei der Romantik in Dresden*.
 Leipzig, 1976.

In the twentieth century, Dresden's stimulating artistic climate fostered progressive ideas. The exhibition ends with the powerful colors and forms of German expressionism, given early impetus in the work of the Brücke, the name adopted by a group of artists working together in Dresden from 1905 to 1913. Brücke–Bridge–means a bridge into the future. Exhibition posters made by the Brücke artists, now in the Dresden graphics collection, are in themselves classic examples of twentieth-century art.

Early Twentieth Century Posters

The appointment of the German impressionist Gotthard Kuehl in 1895 as a professor at the Dresden Academy, heretofore in the grip of academic conservatism, came at a time when French impressionism was first becoming known in Germany. The result for Dresden was a new artistic climate. Ernst Barlach, Otto Mueller, Kurt Schwitters, Otto Dix, and Georg Grosz were some of the new generation who studied at the Academy, to be followed after the First World War by Hans Hartung, Johnny Friedlaender, and Hans Grundig. Due also to Kuehl's influence, Dresden became a place for important contemporary art exhibitions, German and international, in the period 1897-1912. These exhibitions stimulated the cultural life of the city. The International Arts and Crafts Exhibition of 1906 led to the renunciation of historicism, and the first International Hygiene Exhibition bore witness to the spirit of the new century. The same year, 1911, saw the world première, in Dresden, of Richard Strauss's *Der Rosenkavalier*, an event then regarded as a high point of postimpressionism.

Enlivened by these and other events, art collecting in Dresden took a progressive turn. The dealers Emil Richter and Ernst Arnold showed French impressionist paintings and introduced Dresden to works by van Gogh, Cézanne, and Munch. Significant private collections of modern art were formed, for example those of Oscar Schmitz and Ida Bienert, with works by Degas, van Gogh, Picasso, Chagall, Klee, Kandinsky, and Mondrian.

The founding of the Dresden expressionist artists' group called the Brücke—the Bridge—in 1905 (predating by six years the founding of the Blue Rider group in Munich) coincided with the first exhibition, in Paris, of the "fauves." But while expressionism started in Dresden, it met with only limited interest during its first period, despite the efforts of Richter and Arnold to encourage its acceptance.

Closely related to the expressionist paintings, with their flat compositional elements, clear luminous colors, and lapidary forms, were the original posters created by the artists in connection with their own exhibitions and graphic editions. These posters belong to the incunabula of modern graphic art. After 1910 the practice of creating artists' posters was continued by Oskar Kokoschka, Lovis Corinth, and Gustav Klimt.

277

Following the war, with the fall of the monarchy and the formation of the free state of Saxony, Dresden saw further notable events in the world of the arts—and this despite the catastrophe of the inflation. Such writers as Theodor Däubler, Walter Hasenclever, and Friedrich Wolf lived and worked in Dresden; plays by Wedekind, Toller, and Kaiser were produced; Hindemith, Busoni, and Schreker were heard at the Opera. It was the painters of Dresden, however, who set the most important precedents. The artist-members of the newly formed Gruppe 1919 addressed themselves to the artistic problems of the Bridge, adding radical political ideas to their program. Otto Dix, a member of the new group, after experimenting with futurism and dadaism, developed his own type of verism. Kokoschka, with his lithographic portraits in which he stressed the psychological element, and with his landscapes—his "views of Dresden"—became for a short time, like Dix, a determining force. This period of creativity reached its high point in 1926, when Dresden's great International Art Exhibition surveyed all the artistic currents of the time.

HANS-ULRICH LEHMANN
Assistant Curator
Kupferstich Kabinett

623

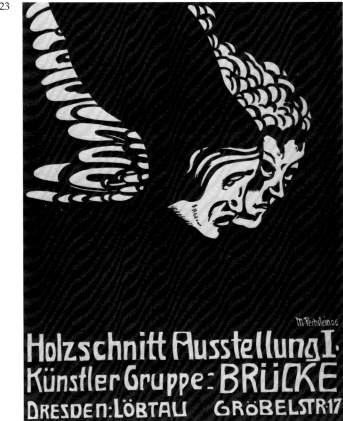

Early Twentieth Century Posters

ENTRIES BY: Hans-Ullrich Lehmann

Max Pechstein
Zwickau 1881 — Berlin 1955

623. Poster for Woodcut Exhibition I of the Artists' Group Brücke, Dresden-Löbtau, Gröbelstrasse 17 (1906)

Lithograph in blue on reddish paper, 587 x 459 mm.
Kupferstich Kabinett inv. no. A 1963-380

Seifert, a lamp manufacturer and one of the first non-creative members of the Brücke, gave his exhibition room in the working-class suburb of Dresden-Löbtau for the first exhibition of Brücke paintings, October, 1906. This was followed by the Woodcut Exhibition I, December 1906-January 1907. Both offered the first public manifestations of expressionism in Germany. Although the artists were still influenced by the Jugendstil (art nouveau), the new visions of Munch, van Gogh, and Gauguin were already discernible.

Ernst Ludwig Kirchner
Aschaffenburg 1880 — Davos 1938

624. Poster for Exhibition of the Artists' Group Brücke at Emil Richter's, Dresden, Pragerstrasse (1907)

Lithograph in green on yellowish paper, 862 x 605 mm.
Literature: Annemarie and Wolf-Dieter Dube, *E. L. Kirchner, Das graphische Werk*, Munich, 1967, no. 456
Kupferstich Kabinett inv. no. A 1974-324

In spite of the bold disposition of color in broad areas, there are still reminiscences of the soft lines of the Jugendstil in this poster. In Kirchner's other lithographs of the period, influences of Munch, van Gogh, and Toulouse-Lautrec are more pronounced.

Ernst Ludwig Kirchner

625. Poster for Gauguin Exhibition in the Gallery Arnold, Dresden, Schlossstrasse (1910)

Woodcut in blue on yellow paper, 820 x 590 mm.
Literature: Dube 713
Kupferstich Kabinett inv. no. A 1963-381

In 1905 Arnold had already exhibited van Gogh, and in 1906 he had exhibited French neoimpressionists, among them Signac, Seurat, Renoir, Sisley, and again van Gogh. Kirchner's poster was meant as a homage to Gauguin, whom the young expressionists of the Brücke honored as one of their spiritual fathers. That the leading Dresden gallery should entrust the young Kirchner with the poster for such an exhibition was considered recognition of an important kind.

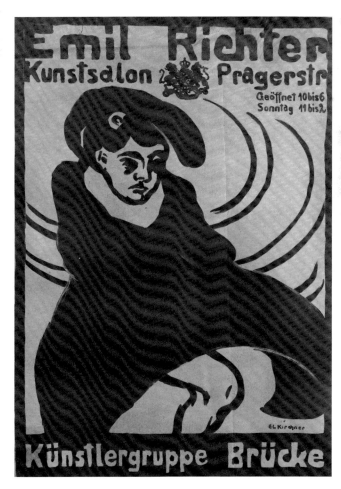

624

Ernst Ludwig Kirchner

626. Poster for Exhibition of the Artists' Group Brücke in the Gallery Arnold, Dresden, Schlossstrasse (1910)

Woodcut in red and black on yellow paper, 822 x 590 mm.
Literature: Dube 715
Kupferstich Kabinett inv. no. A 1963-382

Forms of sharp angles and jagged peaks are characteristic of Kirchner's woodcuts around 1910. The exhibition itself, held only four years after the first public showing of the young expressionists, proved a great success, testifying to the progressive thinking in Dresden at this time. As important as the poster was the exhibition's catalogue, containing twenty original woodcuts by Brücke artists of their fellows' paintings, thus showing a mutual bond in the sense of a common style.

Otto Dix

Untermhaus near Gera 1891 —Singen near Hemmenhofen, Bodensee, 1969

627. Poster for Gruppe 1919 Exhibition at Emil Richter's, Dresden, Pragerstrasse (1919)

Lithograph on brown paper, 920 x 590 mm.
Literature: Florian Karsch, *Otto Dix, Das graphische Werk*, Hanover, 1970, no. 338
Kupferstich Kabinett inv. no. A 1969-661

Members of the Dresdner Sezession Gruppe 1919, the group that revitalized the expressionism of the Brücke along different lines, included Conrad Felixmüller, Otto Dix, Peter August Böckstiegel, Wilhelm Heckrot, Hugo Zehder, Otto Schubert, and Lasar Segall. The poster belongs to Dix's expressionistic-dadaistic period of 1919/20. The stimulating artistic climate of Dresden after the First World War was again closely connected with the avant-garde art dealer Emil Richter, as well as with the Gallery Arnold.

Oscar Kokoschka

Vienna 1886, lives in Villeneuve

628. The Artist and the Muse. Poster for Summer Exhibition of the Artists' Association, Dresden (1921)

Three-color lithograph on white paper, 900 x 590 mm.
Literature: Hans M. Wingler and Friedrich Welz, *Oscar Kokoschka, Das druckgraphische Werk*, Salzburg, 1975, no. 148
Kupferstich Kabinett inv. no. A 1921-443

Kokoschka lived in Dresden beginning in 1917, first as a convalescent, and then from 1919 to 1923 as a professor at the Academy. To his Dresden years belong a number of portrait lithographs in large format, one of them the self-portrait that appears in this poster.

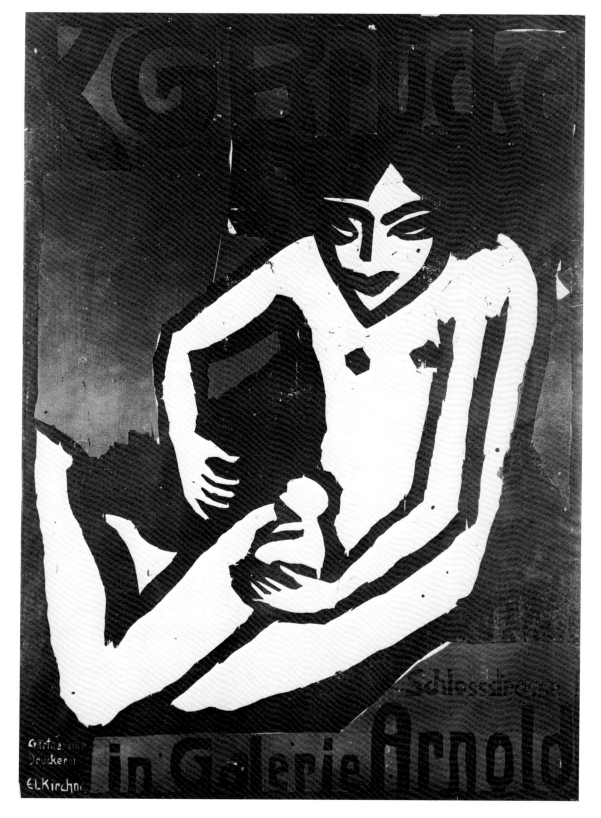